The Dawn of ITALIAN PAINTING

1250–1400

ALASTAIR SMART

The Dawn of
ITALIAN
PAINTING
1250–1400

PHAIDON

For Ninian and Libushka

Phaidon Press Limited
Littlegate House, St Ebbe's Street, Oxford

First Published 1978
© 1978 by Phaidon Press Limited
All rights reserved

ISBN 0 7148 1887 9 (cloth)
ISBN 0 7148 1769 4 (paper)

Printed in Great Britain
Text printed by Ebenezer Baylis & Son Limited, Worcester
Monochrome plates printed at the University Press, Oxford
Colour plates printed by Burgess and Son Limited, Abingdon

CONTENTS

SOURCES OF PHOTOGRAPHS

Andrea de Giovanni, Assisi, Plates 18, 30, 38, 41, 42, 43, 49, 76, 77, 79, 93, 119, 122, 123; Soprintendenza alle Gallerie di Bologna, Plates 165, 170; Fratelli Alinari, Florence, Plates 2, 3, 4, 6, 7, 8, 9, 10, 13, 14, 15, 16, 17, 19, 20, 21, 22, 23, 24, 26, 28, 32, 33, 34, 35, 39, 40, 55, 56, 57, 58, 59, 60, 63, 67, 68, 69, 70, 71, 72, 74, 75, 78, 80, 81, 83, 84, 85, 86, 87, 88, 89, 90, 91, 92, 94, 95, 96, 98, 100, 103, 107, 108, 109, 110, 111, 115, 116, 118, 120, 125, 136, 144, 147, 149, 150, 151, 152, 153, 154, 155, 156, 157, 158, 159, 160, 163, 164, 167, 168, 169, 173, 179, 180, 181, 182, 183; Scala, Florence, Plates 1, 5, 25, 29, 31, 61, 64, 65, 66, 97, 101, 105, 129; Soprintendenza alle Gallerie di Firenze, Plates 62, 104, 134, 135, 145; Kunsthistorisches Institut, Florence, Plate 121; Biblioteca Medicea-Laurenziana, Florence, Plate 82; Biblioteca Ambrosiana, Milan, Plate 113; Soprintendenza alle Gallerie della Campania, Naples, Plate 103; Eremitani Church, Padua, Plate 178; Antonello Perissinotto, Padua, Plate 172; Opera della Primaziale Pisano, Pisa, Plate 143; Vatican Museums, Rome, Plate 73; Soprintendenza alle Gallerie di Siena (P. Cesare Grassi), Plates 11, 12, 45, 46, 47, 48, 50, 51, 52, 114, 117, 124, 126, 127, 128, 130, 131, 138, 139, 141, 142; Museo Civico, Udine, Plate 171; Service de documentation photographique de la Réunion des musées nationaux, Paris, Plates 102, 137, 166, 175; Sotheby Parke Bernet & Co., London, Plate 27; Witt Library, University of London, Plates 132, 133, 140, 148; Walker Art Gallery, Liverpool, Plate 112; University of Nottingham, Plates 36, 53; Captain P. J. B. Drury-Lowe, Locko Park, Derby, Plate 54; Isabella Stewart Gardner Museum, Boston, Plate 162; Fogg Art Museum, Cambridge, Mass., Plate 99; Pierpont Morgan Library, New York, Plate 44; Pennsylvania University Press, Philadelphia, Plates 174, 176, 177.

Fig. A is based on a plan in *Art and Architecture in Italy, 1250 to 1400*, by John White (Harmondsworth, 1966), Fig. B is from *Mural Painters in Tuscany*, by Eve Borsook (London, 1960), and Fig. C is based on a plan in *Camposanto Monumentale di Pisa: Affreschi e Sinopie*, by P. Sanpaolesi, M. Bucci and L. Bertolini (Pisa, 1960).

PREFACE

It is the experience of many people that once they begin to look at early Italian painting they become so enthralled that no other period of art history seems thereafter quite as fascinating. In the present book I have attempted to provide an introduction to the period (from about 1250 to about 1400) which will appeal both to students and to the general reader; and I have also tried to show *why* the early Italian masters—even the minor ones—deserve our attention and admiration.

Our knowledge of Italian art of the thirteenth and fourteenth centuries has grown immeasurably within the past two decades or so: indeed, if this book had been written only a few years earlier many of its pages would have been quite different. The most exciting development of all, the rediscovery of numerous frescoes which in less appreciative times had been covered by whitewash or otherwise hidden from sight, has been due to a distinguished group of Italian scholars and restorers—to whose achievements the American and British public were able to pay tribute on the occasion of the great exhibition of detached frescoes held in New York in 1968 and in London in 1969. And who knows what discoveries still lie ahead?

This process of recovery and restoration has gone hand in hand with a new understanding of the techniques employed by the early Italian masters. The application of such knowledge has often produced remarkable results: no doubt the most striking instance was the examination by Leonetto Tintori and Millard Meiss of the procedures used by the painters of the celebrated frescoes of the *Legend of St Francis* at Assisi, which revealed the day-to-day sequence in which the whole decoration was carried out, as well as producing much valuable information of other kinds. Art history has become more scientific and more 'archaeological': we now understand more fully how important it is to consider not only the physical properties of a particular work of art but also its function and its place in the specific setting (whether in a church or elsewhere) for which it was designed. The value of this approach will be evident to any newcomer to the period who leafs through Eve Borsook's pioneering *Mural Painters of Tuscany*.

We are now witnessing a large process of reassessment. Modern research—some of it so recent that it has not yet had its full effect—has shattered many generally accepted views. Much is in the melting-pot; and nothing could be more encouraging to future students, who simply by keeping their eyes open—and their minds—may well come to make discoveries of crucial importance. Let me take as an example one of the most dramatic reassessments of very recent years. It concerns the famous frescoes of the *Triumph of Death* painted on one of the walls of the Camposanto at Pisa and the similar series (now known only from fragments) executed by Orcagna in the church of Santa Croce in Florence. Until lately it was taken for granted that both these works were inspired by the terrible Black Death of 1348, and therefore that they were painted in the 1350s or 1360s; and many scholars agreed that the Camposanto frescoes were probably by the Pisan artist Francesco Traini. A few

years ago, however, Joseph Polzer gave cogent reasons for dating the Camposanto series well before 1348. This means that our whole attitude to the significance of the Black Death in the history of fourteenth-century art is in need of revision. Meanwhile it has been proposed by Luciano Bellosi, on the basis of fresh evidence, that the author of the Pisa frescoes was not Traini but the mysterious Florentine master Buonamico Buffalmacco, who figures amusingly in some of the *novelle* of Boccaccio and Sacchetti, but about whose art we know little for certain.

I choose this example of radical reassessment partly because the Camposanto frescoes are among the greatest surviving masterpieces of fourteenth-century Italy, and partly because the answers that we give to the new questions that have been raised will determine our view of many cognate matters, such as the problem of Buffalmacco, a documented artist who was regarded in his own time as one of the most eminent Florentine masters; the nature and extent of Traini's activity as a painter; the relationship of the arts to conditions in Tuscany in the middle and later years of the century; and, not least, the bearing of the Camposanto question upon that of Orcagna's Santa Croce frescoes. Millard Meiss, who in his classic *Painting in Florence and Siena after the Black Death* had assumed the influence of the plague upon the theme of the Triumph of Death, discussed Polzer's findings in an article appropriately entitled 'Notable Disturbances in the Classification of Tuscan Trecento Paintings', while in a magisterial study of Orcagna's *oeuvre* Miklòs Boskovits redated the Santa Croce frescoes, with persuasive arguments based chiefly on style, to about 1345. My own more eccentric reasons for postulating an early date for the Santa Croce frescoes—based upon Orcagna's little scene of an eclipse, which I have related to an eclipse that occurred in 1339— may possibly be acceptable as a modest contribution to the problem.

In brief, there are some most 'notable disturbances' in the historiography of the period; and the example I have cited is only one among many. And why should we be surprised? For this is a period in which there are few documents and not very many certain dates. It behoves us to take into serious consideration any radical hypothesis if it is based on well-reasoned arguments. It may seem invidious to have selected the question of the Camposanto and Santa Croce frescoes as representative of the reassessments under way in contemporary scholarship; but it must suffice. The main point is that there is no period in art history about which it seems more appropriate to keep an open mind.

I must record my gratitude to the staff of the Phaidon Press for their helpfulness in the preparation of this book for publication—and especially to Miss Teresa Francis for her thoughtful efficiency, and to Dr I. Grafe for his constructive scrutiny of my text. At a time that was beset by various pressures my wife Marita relieved me of many burdens, and was a constant support. Finally, I wish to express my thanks to my colleague Robin Simon, who gave me much useful advice and offered a number of valuable suggestions.

<div align="right">A.S.</div>

INTRODUCTION

The glow of dawn leads on to the blaze of noon, but its quality is quite distinct. And if the full light of Renaissance painting can be likened to a noonday amenable to the objective scrutiny of the natural world, the rise of the early Italian Schools suggests, rather, a slow dawn whose spreading light, while gradually revealing the forms of things, retains its mystery. Well may the poet or the visionary feel at sunrise that heaven lies about him: so it is, certainly, with Italian painting of the thirteenth and fourteenth centuries, in which man and Nature are seen always *sub specie aeternitatis*.

There is no more inspiring period in the history of European art, for it was indeed as though a new day had dawned, full of new tasks to be undertaken; and there is a freshness about the art of a Giotto or a Duccio or a Simone Martini that must always charm, and a purity that must always give delight, because in these masters art itself was renewed and had not yet been burdened by the weight of theory. At the same time there are many aspects of the period that herald the achievements of the fifteenth-century Renaissance; for in the years around 1300 artists had begun to explore the natural world as had scarcely been done since classical antiquity—creating a convincing pictorial space, modelling figures in the round and giving them life, and introducing firmly designed buildings and enchanting passages of landscape.

The Renaissance masters certainly carried these and other explorations much further, building especially upon Giotto's discoveries. Yet only a generation ago, because such. developments in the thirteenth and fourteenth centuries were emphasized at the expense of other values, and were interpreted as mere beginnings, the early Italian painters were still commonly referred to as 'primitives' (*primitivi*)—a term that implied not only their historical position in relation to their heirs in the Renaissance but also their supposed inferiority in skill and their lack of sophistication. Today it is no longer possible to accept this 'meliorist' view of artistic development, which derives in the main from Vasari's great history of the arts in Italy, published in 1568: according to Vasari, the art of painting had gradually improved from the time of Cimabue and Giotto, until it attained perfection in Michelangelo. Although nobody would deny that Giotto and other artists of the Dugento and Trecento anticipated some of the fundamental principles of Renaissance painting, it is important that we should regard the early Italian masters not simply as precursors of the Renaissance (of whose advent they had, after all, no inkling) but primarily as artists concerned with the values of their

own times: to see them through Renaissance or post-Renaissance eyes will be to mis-understand them and to misread their art.

In the process we shall avoid the temptations and pitfalls of what might be called 'pro-leptic historicism'—that is to say, an interpretation of historical development which over-stresses the impact made by the great innovators upon a particular period, and which thereby does less than justice to the preservation in others of cherished and often vital tradi-tions. It is not that we should go to the opposite extreme and undervalue the importance of new discoveries: it is simply a question of maintaining a proper balance in the evaluation of two polarities, which were sometimes, but by no means invariably, in conflict. Giotto's fresco of the *Crucifixion* in the Arena Chapel (*Plate 19*) is not a greater work than Cimabue's fresco of the same subject at Assisi (*Plate 17*), although it is undoubtedly more 'advanced' in style; and while many of the outstanding qualities of Giotto's fresco were the fruit of innovating genius, the elements of Cimabue's composition that link it most closely to older Byzantine traditions are equally significant.

The history of Dugento and Trecento painting presents a variegated pattern of stylistic change; but the period as a whole resolves itself into four principal stages of development. The first stage embraces the birth and gradual maturation in Tuscany of independent and distinctively Italian schools, especially in Lucca, Pisa, Florence and Siena, a development that attained its climax, in the late Dugento, in the Byzantinizing art of Cimabue. The second, extending to the middle of the fourteenth century, was a period of transformation and radical innovation: having its roots in the heroic classicism of Cavallini, it produced in Giotto the supreme creator of the new realism which was to alter the course of European painting. Giotto's older contemporary Duccio provides a bridge between these first two phases, but he stands, nevertheless, at the head of the Sienese School of the Trecento, just as Giotto stands at the head of the Florentine. Duccio's followers were not wholly won over to Giotto's revolutionary concept of spatial composition; and Simone Martini in particular typifies the alternative (and characteristically Sienese) response to the challenge of the new age—a response in which sumptuous decorativeness took precedence over plastic values, and mystical contemplation over the evocation of the visible world.

The third stage, straddling the middle years and the third quarter of the fourteenth century, confronts us with a dramatic reaction on the part of many artists against the ideals of the early Trecento. Meiss believed that the often disturbing characteristics of this period reflected the suffering and despair occasioned by the terrible outbreak of bubonic plague in 1348, which we know as the Black Death; but this theory cannot be accepted without qualification, especially since not all the works cited by Meiss can be dated after the year 1348. At all events, for reasons that will be considered in due course, there is a general tendency among the artists of the mid-fourteenth century—such as Orcagna and Andrea

Vanni—to revive pre-Giottesque traditions. This, then, is a phase of reassessment and, as Meiss discerned, of the recovery of the Dugento.

It is followed by a final, and perhaps not unexpected, counter-reaction—a further process of reassessment, which may be described, correspondingly, as the period of the recovery of the early Trecento and of the ideals of Giotto. Among the exponents of this Giottesque revival not the least important were two painters active in Padua—the Florentine Giusto de' Menabuoi and the Veronese Altichiero. It is interesting that the Paduan humanist Pier Paolo Vergerio should have observed in the year 1396 (not long after the completion by Giusto and Altichiero of their masterpieces in the Baptistery and the Santo) that contemporary painters followed only the example of Giotto.

It is convenient, then, to distinguish these four principal stages of stylistic change within our period, and we may define them by the terms Birth, Transformation, the Recovery of the Dugento, and the Recovery of the early Trecento. In discerning this pattern in early Italian painting we must not, however, imagine that broad stylistic tendencies can be neatly fitted into an exact chronological framework, nor overlook the complexities and cross-currents that defy simple categorization. But when allowance has been made for such considerations it would be difficult to challenge the generally accepted view which assigns special significance to the heroic years of Trecento painting in Tuscany—those first three decades that are dominated in Florence by Giotto and in Siena by Simone Martini. To a large degree the subsequent history of Trecento, and even early Renaissance, painting can be seen in the light of the contrasting ideals upheld by these two great masters—ideals which are already foreshadowed in earlier developments in the late Dugento, as typified by the work of the Florentine Coppo di Marcovaldo and that of Guido da Siena, the true founder of the rival Sienese School. While Giotto anticipated Masaccio and Fra Angelico, the colouristic and decorative art of Simone Martini prepared the way for the International Style, to be developed in fifteenth-century Italy by Pisanello, Masolino, Gentile da Fabriano and others.

In an age dominated by religious concepts such secular paintings as Ambrogio Lorenzetti's *Good and Bad Government* at Siena are relatively rare. It is true that many secular works have now disappeared—among them Giotto's astrological decorations in the Palazzo della Ragione at Padua and his allegory of *Vanagloria*, with its depictions of ancient heroes, which he painted in 1335 for Azzo Visconti's palace in Milan. But the artists of the Dugento and Trecento were primarily servants of the Church; and it is characteristic of the period that Cennino Cennini, whose *Libro dell'arte* of the 1390s preserves the workshop traditions of Giotto's School, should have opened and closed his treatise with invocations to the three Persons of the Trinity, the Blessed Virgin Mary, St Luke ('the first Christian painter'), St Francis and other saints. Moreover, there is a passage in the *Libro* that illuminates as well as any other text of the period, and better than any modern analysis, the nature of the painter's

task and of the ultimate ideal to which he aspired: 'Painting . . . calls for imagination, and skill of hand, in order to discover things not seen, hiding themselves under the shadow of natural objects.' Naturalism—an important development of the period—takes its place within the context of the orderly medieval picture of the Universe, according to which, as Coulton once expressed it, 'the Unseen matters far more than the Seen'.

The most numerous works commissioned in the period were altarpieces on panel, executed in tempera by established procedures, which by the fourteenth century seem to have been strictly controlled by the guilds; in Florence the painters belonged to the guild of the Medici e Speciali (Doctors and Pharmacists), possibly because the patron of the guild, St Luke, had reputedly been both physician and painter. The religious impulses of the age— profoundly moulded, as we shall see, by Franciscan ideas—encouraged a demand for devo- tional images of the Virgin, and, together with crucifixes, these were to provide the most common subject-matter for altar-paintings. In the early fourteenth century the elaborate Gothic type of altarpiece was developed, with predella panels at the base containing sacred narratives, and often with further scenes set into richly ornamental pinnacles above the main panel or panels.

But the chief glory of Trecento painting is without doubt the revival of the art of fresco, which now replaced mosaic as the principal medium for large-scale decoration. The fresco painter enjoyed advantages that the mosaicist lacked: not only was he able to work with greater speed and to employ less costly materials, but his art was more adaptable to the new demand for naturalistic representation and for the lifelike rendering of human action. At Assisi, in the later frescoes executed in the Upper Church, and in the Arena Chapel at Padua, decorated by Giotto, we witness the triumph of *buon fresco*, a technique which had been employed in classical times but which had virtually fallen into disuse. In *buon fresco* (or 'true fresco') the colours were painted into a thin plaster layer known as the *intonaco* while the plaster was still wet. This was applied to the smoothed-out wall surface (the *arriccio*), on which the painter normally roughed out his design. The painting of any one area of the composition had to be completed before the plaster had dried; and therefore the final *intonaco* surface was built up in patches, each patch notionally corresponding to a day's work (and hence called the *giornata*). By a chemical process the fresco becomes literally one with the wall itself, and this is among the factors that make it so durable a medium. Fresco is also one of the most beautiful of all forms of painting, inviting the visitor to a decorated church or chapel to caress the smooth, radiant surfaces, much as the fourteenth-century worshipper must have been tempted likewise to touch with reverent hands the images of his saints pictured on the walls around him.

True fresco must be distinguished both from *mezzo fresco* (employed, for example, in the earlier Biblical scenes in the Upper Church at Assisi), in which the artist painted on partly dry plaster, and from *a secco* painting, in which all the work was done on plaster that was

already dry; but it should be added that even in *buon fresco* it was often the practice to add certain details *a secco*; and furthermore there were some colours, notably azurite—a deep blue frequently employed in the representation of draperies, such as the traditional blue mantle of the Virgin—that could be used only in this way.

The most perfectly preserved of all the early decorations in *buon fresco* is Giotto's sublime cycle in the Arena Chapel at Padua, datable about 1303–6; but presumably before this time he had already executed major frescoes elsewhere—perhaps in his native Florence—that are now lost to us. The achievements of Giotto and his followers in Florence were to be matched by those of such Sienese masters as Simone Martini and Pietro and Ambrogio Lorenzetti, who were all supreme exponents of fresco painting. The vast decorations in the Camposanto at Pisa, upon which many painters laboured, the equally celebrated murals by Andrea Bonaiuti in the Spanish Chapel at Santa Maria Novella in Florence, and those by Giusto and Altichiero in Padua may be cited as particularly important examples of fresco painting in the middle and later years of the century.

Yet so little were the 'primitives' regarded in later times, and especially in the seventeenth and eighteenth centuries, that what remains of the major fresco decorations of the period is but a fragment of the riches which once adorned every city of Italy. It seems almost a miracle that the destruction was not even greater. Moreover, there is now a new miracle—to which I have alluded in the Preface to this book—in the form of the recovery by Italian restorers of frescoes by early masters which had been whitewashed over in less appreciative times. But with so many losses, the history of the period is inevitably patchy. One shudders to remember that the Arena Chapel itself was only saved from demolition through the efforts of the Marchese Pietro Selvatico, the distinguished Paduan historian, whose portrait bust now stands appropriately in the chapel gardens. Even so, we know only a portion of Giotto's life's work; and it might well have been that the greatest painter to appear since the classical age would be known to us only as another half-legendary Apelles.

ONE

Late Dugento painting in central Italy

A story preserved in the *Mirror of Perfection*, a biographical account of St Francis of Assisi compiled in the early fourteenth century, may fittingly serve as an introduction to a period in which the development of a new, naturalistic art was profoundly stimulated by the spirit of the Franciscan movement, with its joyous acceptance of the beauty of the created world, and by the patronage afforded by the wide-flung foundations of the Order. Francis, lying on a sick-bed in the bishop's palace at Assisi, bandaged in sack-cloth and covered with the rough habit of the same material which he wore as the apostle of Holy Poverty, is teasingly addressed by one of his disciples: 'Many baldacchinos and silken palls shall be placed over this little body of thine, which now is clothed with sack-cloth'; to which the saint replies, 'Thou sayest truth, since so it will be for the praise and grace of my God.' The story contains, no doubt, an element of hindsight, as though the author wished to assure his readers that the costly and richly adorned edifices that had been erected in St Francis's honour, and which seemed to the members of the Spiritual party within the Order to contradict the Rule of Poverty, had received, after all, their founder's prophetic approval and blessing. However that may be, the establishment of Franciscan communities, early in the thirteenth century, in such cities as Assisi, Florence, Pisa, Lucca, Arezzo and Siena initiated a vast programme for the building of convents and churches, many of them on an impressive scale— the first and most magnificent of such buildings being the double church of San Francesco at Assisi, founded at the time of Francis's canonization in 1228, two years after his death (*Plates 40, 67*).

The decoration of these churches and those of the Dominican Order, established at about the same time, undoubtedly fulfilled a deep spiritual need, which is reflected no less clearly in contemporary literature, and especially in the writings of the Franciscans. The demand for devotional pictures, such as Madonnas and crucifixes, was encouraged by St Francis's own devotion to the Virgin and other saints and, above all, to the Cross of Christ; and it is in this light that we should see the commission given in 1236 to Giunta Pisano by Brother Elias, the founder of the Franciscan basilica at Assisi, for a painted crucifix which once stood in the Lower Church. Nor should we underestimate the vivid impression made upon the age by the colourful events of St Francis's life; and as early as 1235, the date inscribed on the impressive altarpiece by Bonaventura Berlinghieri in the church of San Francesco at Pescia (*Plate 1*), we observe the beginnings of a new Franciscan iconography, which was to culminate in the rich pictorial imagery of the famous frescoes of the *Legend of St Francis* in

the Upper Church at Assisi (*Plates 30, 31, 38, 40–42, 93*) and in Giotto's frescoes in the Bardi Chapel at Santa Croce in Florence (*Plates 62, 125*), another Franciscan foundation.

By the later years of the thirteenth century the same impulse towards an evocative pictorialism had found its supreme literary expression in a book that exerted a lasting influence upon the visual arts, the *Meditationes Vitae Jesu Christi*, or *Meditations on the Life of Christ*, a work believed at one time to have been written by St Bonaventura but now assigned to John de Caulibus of San Gimignano. In a manner that brings to mind the art of Giotto and Duccio, the writer revisualizes the Gospel events, filling out the bare narratives of the Evangelists with additional incident, and attempting to penetrate to the innermost feelings of the participants in the divine drama as they listened to Christ's teachings or witnessed his miracles or his Passion. In the words of the author's preface, 'In order to make a deeper impression on the mind, I shall relate those things as if they actually happened, according to certain imaginary representations which the mind is capable in different ways of forming.' These glosses upon the Gospel story are offered, as the fruit of pious meditation, for the devout contemplation of the reader, who is invited to imagine that he is present at each scene: 'You must bring yourself to be present at those things that are related . . . as if you heard them with your own ears, and saw them with your own eyes.'

The power of the visual image to evoke a fervent response in the beholder is attested in this period by the veneration accorded to certain sacred pictures, generally of the Crucified Christ or the Virgin, to which miraculous virtues were attributed. According to legend, the Franciscan movement itself had had its origin in the words addressed to St Francis by the crucifix that once stood over the altar in the church of San Damiano, outside Assisi; and the early writers speak with awe of the miraculous cures performed by a painting of the Madonna at Orsanmichele in Florence—a work whose function as a devotional image was eventually assumed by the picture by Bernardo Daddi (*Plate 97*) which adorns Orcagna's celebrated Tabernacle (*Plate 96*). If the skill of the painter was often the object of superstitious wonder, this fact only serves to underline the primary function of such images, which were intended to be venerated as mirrors of the Divine Image and as the *exempla* of God's dealings with man.

It is scarcely to be supposed that Berlinghieri's full-length figure of St Francis (*Plate 1*) was meant to be a portrait in the modern sense. It suggests rather an attempt to translate into the language of painting the early Franciscans' insistence upon their founder's spiritual likeness to Christ: indeed the Poverello of Assisi, as he is here presented, takes on an unmistakable resemblance to Byzantine images of Christ the Lord. The inscription that can be faintly discerned over the figure of St Francis in Cimabue's much repainted fresco of the *Madonna Enthroned* in the Lower Church at Assisi, 'This is the true image of St Francis', may be no more than an assertion of the claims of the basilica of San Francesco to be held in honour as the mother church of the Order at a time when the Spirituals were upholding the

priority of the old Portiuncula church of Santa Maria degli Angeli, where the saint had begun his spiritual life, and where he had asked to be laid to rest. Certainly, there existed then in the Portiuncula church another full-length image of St Francis, by an anonymous follower of Giunta Pisano—the so-called 'Master of St Francis' (*Plate 2*)—which must have been devoutly venerated at the time, for according to the parchment displayed by the rather awkward figure the picture was painted on the simple board which had served as the saint's bed. Much remains speculative about these works of the thirteenth century and about the circumstances that called them into being, but that is only to be expected of a period of art history from which so few documents have survived.

Bonaventura Berlinghieri is identifiable only from his signature on the Pescia dossal (*Plate 1*), and Giunta Pisano from signatures on three crucifixes, including one in Santa Maria degli Angeli (*Plate 3*). But such signatures are as rare as the documents, if not rarer, and the surviving *oeuvre* even of the great Cimabue has been pieced together largely on the basis of a contemporary reference to his authorship of a figure of St John in the mosaic decoration of the apse of Pisa Cathedral: no work signed Cenni di Pepi (to give him his real name, 'Cimabue', meaning 'oxhead', being one of those familiar nicknames that the Italians have always loved to bestow upon their celebrated men) has come down to us. Yet these virtually fortuitous indications introduce us to three of the leading personalities of the century—the Lucchese master Berlinghieri and the Pisan Giunta, both standing, as it were, on the threshold of the new age, and the Florentine Cimabue, who brought to a glorious consummation the Byzantinizing style of which the art of Berlinghieri and Giunta was prophetic.

Giunta—an artist increasingly touched by Gothic influence—may be said to have established the canon for the representation of the Crucified Christ in thirteenth-century Italy: in his hands there emerges from its origin in Italian Romanesque traditions a new type of crucifix, whose essential features Cimabue himself was to modify but little. Instead of the numerous scenes represented in the earlier type on either side of the Crucified, Christ's body is now placed against a plain 'apron', while the grieving figures of the Virgin and St John the Divine are made to occupy the terminals of the cross; above the *titulus* the half-length image of the *Salvator Mundi* replaces the traditional Ascension. And where, previously, Christ had been represented as the triumphant Lord, his body erect and his eyes open, he was now shown as the *Christus patiens*—the God-Man who suffered for the sins of the world, —his eyes closed in death, and his body, as it hangs from the cross, pulled outwards by its weight. It was this image, imbued as it was with a new humanity, and conveying a heightened emotion which is essentially Gothic in character, that Cimabue was to elevate to the level of the sublime in his crucifix for Santa Croce in Florence (*Plate 20*) and in his vast fresco of the *Crucifixion* in the Upper Church of San Francesco at Assisi (*Plate 17*).

The scenes from the legend of St Francis painted by Berlinghieri on either side of the

cult-image of the Saint in the Pescia altarpiece have their prototypes in the episodes from Christ's Passion represented on Romanesque crucifixes, just as the figure of St Francis takes the place traditionally reserved for the Saviour. The same scheme was to be used by later painters in representations of St Francis (*Plate 7*) and of other saints (*Plates 8, 29, 78, 155*). One of the important features of the Pescia altarpiece is the artist's personal interpretation of what is a fundamentally Byzantine idiom—a feature already noticeable in the work of his father Berlinghiero—which lends a majestic expressiveness to the central figure of the saint. Another is the presence in the lateral scenes of a vivacious narrative style which is yet controlled by austere, geometric design. It would be quite wrong to criticize the central figure for its lack of naturalism; and the fact that St Francis does not stand, earthbound, upon the ground, as Giotto's figures do, should not be misunderstood: the image is supranatural, and was meant to be so. For it is the image of a saint glorified in heaven and displaying the divinely imprinted wounds of the Crucified, which Francis had received on the mountain of La Verna (represented in the first of the scenes depicting his life and miracles), whereby he had become 'transformed', in the words of one early Franciscan writer, 'into the likeness of Christ'. In the same manner, the scenes themselves are raised to an ultramundane level of experience.

For reasons that are obscure, the Pisan and Lucchese schools founded by Giunta and the Berlinghieri began to lose their ascendancy around the middle of the century, although it was Pisa that produced, in the persons of Nicola Pisano and his son Giovanni, two of the supreme geniuses in the history of European sculpture. The major developments in painting outside Rome were to take place in Florence and Siena. Indeed, in Pisa itself there are signs of a reaction against the new style introduced by Giunta. The one crucifix securely attributable to Enrico di Tedice (*Plate 4*), a Pisan master documented in 1253, while reflecting Giunta's influence in the treatment of the Crucified, reverts in the main to the older Romanesque tradition. By the last quarter of the century—as is evident, for example, in the work of Raniero di Ugolino, who was probably Enrico's nephew—the Giuntesque style had become receptive to Florentine and Sienese influence, and the crucifixes and Madonnas of Raniero and his circle reflect the impact of the new art of Coppo di Marcovaldo, Cimabue and Duccio. This tendency in Pisan painting of the late Dugento is well represented by the beautiful *Madonna with Scenes from the Lives of the Virgin and her Parents* from the Priory of San Martino in Cinzica (*Plate 6*), a large dossal that has been ascribed with good reason to Raniero. This panel is characterized by a liveliness of handling that contributes to the vividness of the narratives. Iconographically, it is of some importance, since it provides a unique sequence of episodes from the same legend of St Joachim and St Anne which Giotto was to recount, with added drama and humanity, in his fresco cycle in the Arena Chapel.

In Florence the beginnings of a distinctive tradition, indebted though it was to the Lucchese and Pisan schools, can be traced in the work of two forerunners of Coppo and

2

Cimabue—the 'Bigallo Master' (so named from a cross in the Bigallo Museum) and another anonymous painter, known as the 'Bardi St Francis Master' from his major surviving panel, the *St Francis Altarpiece* (*Plate 7*), executed for the Bardi Chapel at Santa Croce in Florence. Of the two, the Bardi St Francis Master is by far the more important, for he was the originator of a manner in which the Berlinghieresque and Giuntesque traditions underwent a radical revision in favour of a more substantial plasticity of modelling. To grasp the significance of this innovation, which affected the development of both Coppo and Cimabue, we have but to compare the Bigallo Master's essentially flat and linear treatment of the figure with the nascent chiaroscuro that is so striking a feature of the scenes from the life of St Francis in the Bardi Chapel altarpiece. A similar style is to be found in some of the earlier mosaics on the vault of the Florentine Baptistery, and the question has arisen whether the Bardi St Francis Master participated in the execution of the mosaics.

This vast scheme of decoration (*Plate 9*), undertaken mostly in the second half of the century although hard to date precisely, also shows points of similarity with the styles of other Florentine painters whose names are known to us—Coppo himself and Meliore—as well as with that of a further *anonimo*, the so-called 'Magdalen Master', who was active in the closing years of the century. Vasari has handed down an old tradition to the effect that the mosaics were begun by a certain Apollonio, supposedly a Greek, and Andrea Tafi, whose name is familiar to students of Italian literature from the stories told about him by Boccaccio and Sacchetti; but neither Apollonio nor Tafi is a merely legendary figure, for both names appear in contemporary documents. It is possible, therefore, that the designations 'Bardi St Francis Master' and 'Magdalen Master' conceal the identities of Apollonio and Tafi, although without further evidence such an inference must remain highly speculative. The attempts that have been made to discern in some of the later mosaics in the Baptistery the hands of Cimabue and Giotto are even more perilous. What cannot be denied is that the Baptistery decorations constitute the principal artistic monument to have survived in Florence from the period immediately preceding the appearance of Giotto.

The most impressive part of the whole elaborate scheme, in which narratives from the Old Testament and from the lives of Christ and St John the Baptist unfold, tier upon tier, around the immense octagon of the vault, is that given over to the *Last Judgment*, extending vertically from the uppermost to the lowest of the four registers, and laterally across three of the eight fields. The terrible scene is dominated by the gigantic Christ, one hand extended with open palm towards the blessed, the other turned downward in the direction of the damned. Most moving of all are the hopeless expressions and gestures of some of the condemned souls (*Plate 10*), as they contemplate their fate with ineffable sorrow. It is not fanciful to imagine the young Dante standing within his 'bel San Giovanni' and gazing long at these images of human desolation, responsibe as he would surely have been to the artist's power to render the torments of the guilty heart:

> *Dentro a quella cava*
> *dov' io tenea or li occhi sì a posta,*
> *credo ch' un spirto del mio sangue pianga*
> *la colpa che là giù cotanto costa.*

(Within that den where I held my eyes so intently just now, I think a spirit, one of my blood, weeps for the guilt that costs so much down there.)

Inferno XXIX, 18–21; trans. John D. Sinclair, London, 1948.

The character of the imagery possesses a strong Tuscan flavour, and the decorations as a whole bear witness to the thoroughness with which Florentine art of the second half of the century assimilated older Byzantine traditions, breathing into them a new life. At the same time certain features of the mosaics—notably the division of the narratives by fictive columns (echoing the actual columns supporting the dome)—seem to derive from Roman mural decoration; and a comparable system reappears in the Roman-inspired frescoes in the Upper Church at Assisi (*Plates 41, 42*).

Whatever its authorship, the *Last Judgment* introduces us to the pre-Giottesque world of Coppo and Meliore, whose styles are so close to passages in the mosaic that it is hard to resist Ragghianti's conclusion that they were its main authors: this attribution has yet to receive due attention. The two painters may well have formed a partnership, since Coppo is known to have joined Meliore in decorating a chapel in Pistoia Cathedral. Both masters fought at the Battle of Montaperti in 1260 during the unsuccessful war against the Sienese, one of the unhappy consequences of the protracted struggles between the Guelphs and the Ghibellines. Siena had embraced the imperial cause supported by the Ghibellines, while Florence, a Guelph city, remained loyal to the Pope. It is horrifying to recall that, after the defeat of the Florentines at Montaperti, the victors, in concert with the representatives of other Ghibelline cities, proposed the utter destruction of Florence—a disaster prevented only by the courageous opposition of Farinata degli Uberti, whose defence of his native city is immortalized in the tenth Canto of Dante's *Inferno*. Yet if, politically, Florence was humiliated by the defeat of Montaperti, the battle and the peace that followed may have had positive consequences for the history of Tuscan art; for whether or not, as the story has it, Coppo was taken prisoner by the Sienese, he afterwards received a commission from the Servites (or Servants of Mary) for a large altarpiece of the *Madonna Enthroned* (*Plate 11*) —the so-called *Madonna del Bordone*—for their church of Santa Maria dei Servi at Siena. The impression made by this work, which is dated 1261, is indicated by its influence on a *Madonna* executed by Guido da Siena for San Bernardino which bears the date 1262 (*Plate 12*). Thus early were established those connections between the Florentine and Sienese Schools of the Dugento which were to be epitomized, later in the century, by the commission given to Duccio to paint the celebrated *Rucellai Madonna* (*Plate 5*) for a chapel in

Santa Maria Novella, the Dominican church of Florence, and by all that the ideals of the great Sienese master and the Florentine Cimabue (*Plate 13*) had in common.

Coppo's Sienese *Madonna* conforms to the Byzantine tradition of the *Hodegetria* (meaning Guide, or Instructress), wherein the Christ Child is placed to one side of the Virgin and turns towards her, in contrast to the type of the *Nikopoia* (or Bringer of Victory), where he is placed directly in front of her body, enclosed within its outline, in allusion to the Virgin's theological role as the 'God-Bearer'. Another splendid example by Coppo of the latter type is the *Madonna* of Santa Maria Maggiore in Florence, which combines sculpture with painting, the Virgin and Child being carved in relief. Both traditions persist together in Tuscan painting of the late Dugento, but it was the *Hodegetria* type that held the key to the future evolution of the Italian Madonna, since it allowed the artist to represent the two figures more naturally and gave him freedom to dwell upon the theme of maternal and filial love. Coppo's Siena *Madonna* and his masterpiece, a later *Madonna* in Santa Maria dei Servi at Orvieto (*Plate 15*), stand at the head of this development, and the tender intimacy of the Madonnas of Ambrogio Lorenzetti (see *Plate 120*) represents the fulfilment of an ideal that Coppo was among the first to glimpse, and which Guido da Siena transmitted to Sienese Trecento painting. In Guido's *Madonna* for San Bernardino (*Plate 12*) the Christ Child recalls the figure in Coppo's Siena altarpiece (*Plate 11*); and the popularity of the new image, as it was refashioned by Coppo, is evident from its reflection in other Tuscan panels of the period. There are, however, difficulties in attempting a precise assessment of the relationship between the art of Coppo and that of Guido; for our task is hampered by the fact that in the early fourteenth century such works as Coppo's *Madonna del Bordone* and Guido's *Madonna* in the Palazzo Pubblico at Siena (which will be discussed presently) were considerably repainted, evidently with the aim of giving them a more 'up-to-date', Ducciesque appearance.

The relatively inferior quality of the San Bernardino *Madonna* suggests that Guido himself was responsible for little more than the design, and that he entrusted its execution largely to his workshop; nor does the picture reveal any marked appreciation either of Coppo's technical virtuosity or of his mastery of plastic form. To understand what Guido learnt from Coppo about the modelling of draperies and the articulation of figures in space we must turn to his noble *Madonna* of about 1275 or later in the Palazzo Pubblico at Siena (*Plate 25*), a work painted for the Dominican church and one that occupies a crucial position in the history of Tuscan art, not least on account of the controversies to which it has given rise. Here there is an entirely new spaciousness of design, as well as that delight in the decorative and in brilliant colour effects which seems from the beginning to have distinguished the Sienese genius from the Florentine. While Coppo di Marcovaldo, with his emphasis upon austere monumentality, looks forward to Giotto, Guido da Siena anticipates Duccio.

The date 1221 inscribed on the base of the Virgin's throne in the Palazzo Pubblico *Madonna* is now generally regarded as a late addition, presumably made when the painting was retouched in the early fourteenth century. Perhaps it alludes to the establishment of the Dominican community in Siena; alternatively, it may preserve the memory of a once venerated image of the Virgin which Guido's altarpiece replaced. Stylistic criticism assigns the Palazzo Pubblico panel to the last third of the century, and it was probably painted within the last quarter. So advanced a work, if executed in 1221, would be an inexplicable phenomenon in the history of Dugento painting; and we may certainly discount those arguments in favour of the early date that have been inspired by the desire to discredit Vasari's insistence upon the priority of the Florentine School in the *renovatio* of the arts in Italy.

Coppo's son, Salerno di Coppo, is mentioned in a fascinating document of 1274 which is preserved at Pistoia. This contains a petition from the authorities of Pistoia Cathedral, which Coppo had decorated with frescoes (now lost), requesting Salerno's release from a debtors' prison so that he might assist his father on a number of panels for the choir, including a crucifix; there is a further reference to another crucifix destined for an altar. One of the crucifixes (*Plate 16*) has come down to us. It is a historiated cross (having scenes on the apron) of the pre-Giuntesque type, and in this respect belongs to a dying mode, for the historiated crucifix was to disappear by the end of the century. Nevertheless, the treatment of the individual narratives on the apron contains intimations of the naturalism of the succeeding age, and in a limited sense the scene of the *Kiss of Judas* already presages the art of Giotto (*Plate 65*) in the compactness of its rendering of dramatic action, if not in its conviction of reality. The precise authorship of the Pistoia cross is debatable. If it is the joint work of Coppo and Salerno, as the documentary evidence would seem at first sight to suggest, Coppo would probably have painted the figure of the Crucified, leaving the lateral scenes to his son. The style, however, is uniform throughout, and is so different from that of a crucifix by Coppo at San Gimignano that Salerno has plausibly been suggested as the sole author.

The rhythmic sway of the Crucified Christ anticipates the expressive manner of Cimabue. One of the 'progressive' aspects of this figure is the treatment of the hands, the fingers no longer being pressed flat against the beam of the cross but allowed to hang limp in a graceful downward curve—a mode of representation that was to become the rule for the masters of the Trecento. If the Pistoia cross was painted entirely by Salerno, he was a worthy son to his father, whatever the circumstances that led to his incarceration. According to the document of 1274, his remuneration for the works for Pistoia Cathedral was to be set against his debts; but in 1276, as another document informs us, he still owed one hundred lire to the Commune, six lire being set against this debt for his execution of a further commission, the painting of the ceiling of the Cathedral choir. Thereafter Salerno disappears from history.

Meliore is a still more shadowy figure, being known by only one certain work, a dossal in the Uffizi, representing *Christ in Benediction with Four Saints*, which is signed and dated 1271. The panel reveals a conscientious Byzantinism and has little in common with the less rigid manner of Coppo, but corresponds closely to the style of some of the subsidiary parts of the Baptistery *Last Judgement*. It seems clear that Meliore was a comparatively minor figure in Florentine Dugento painting, and if, together with Coppo, he is to be identified among the authors of the Baptistery mosaics, he worked there only in a sub-ordinate capacity. His importance lies in his role as one of the principal channels of Byzantine influence in Florence. On the other hand the Magdalen Master, who takes his name from the large dossal in the Accademia in Florence representing *St Mary Magdalen and Scenes from her Life* (*Plate 8*), and whose style has sometimes been detected in the earlier parts of the Baptistery decorations, evidently controlled one of the most active workshops in Florence in the closing years of the century. His development, which can be traced from the 1260s to at least the 1290s, reveals his receptivity to new ideas as he assimilates in turn the lessons of Coppo, Meliore and Cimabue.

The panel *St Mary Magdalen and Scenes from her Life*, datable about 1285, reflects all these interests, which become the fabric of an extremely personal and easily recognizable style rooted in more ancient Lucchese traditions. In many respects this work has a place in the history of Florentine painting analogous to that of Berlinghieri's *St Francis* altarpiece (*Plate 1*) in the history of painting in Lucca: both artists consummate in their work the vital tendencies of their age, and both stand at the end of a particular stage of stylistic evolution. The Magdalen Master may be said to have stopped short at the point at which Giotto began: he took from Coppo all that he required to give his figures an appearance of substantiality, but he never dreamt of any further exploration of visual experience, such as drove Giotto to create, with inexorable logic, a new art of spatial realism out of a fundamental rethinking of aesthetic problems; but in adhering to the virtues of his age the Magdalen Master nevertheless pre-served them for the following generation, and laid the foundations of that relatively in-dependent current in fourteenth-century Florentine painting of which such artists as the St Cecilia Master, Jacopo del Casentino and Pacino di Buonaguida were among the principal representatives.

A scene such as the *Noli me tangere* on the Accademia dossal adds to the grave, aulic tone of Berlinghieri's narratives a note of joyous amenability, but the intimacy of the presentation does not permit us to forget the otherworldly nature of the event. The Madonnas by this master, congenial and charming in like manner, keep their distance; and in this stereotyped world of Byzantine numinousness the more down-to-earth figures of the *Ognissanti Madonna* of Giotto (*Plate 14*) would have been quite out of place. The art of Giotto was to be compounded, in great measure, of the confluent tendencies of High Gothic naturalism and the realistic classicism of the Roman School headed by Cavallini, which was itself

receptive to Gothic influence. Each in its own way offered a challenge to accepted values, and reflected that impulse towards a more vivid evocation of the visible world which has been touched upon earlier. In retrospect, it is possible to discern signs of uneasiness about the implications of such radical change, and it would be highly interesting, for example, to know what Cimabue felt about the revolutionary aims of his reputed pupil. Cimabue's celebrated *Maestà* (*Plate 13*), painted for Santa Trinita in Florence, undoubtedly presents a forcible contrast to Giotto's own *Madonna* for Ognissanti. The *Santa Trinita Madonna* is probably datable in the early 1280s, and two decades or more—an interval comprehending one of the decisive revolutions in the history of the visual arts—separate the two works. A comparison between them tells us much, although not everything, about what was gained and what was lost in the process.

In the *Santa Trinita Madonna* the richly gilt throne conforms to the traditional Byzantine type, and the spatial treatment, admittedly limited in scope, does not draw attention away from the otherworldly nature of the image. In the *Ognissanti Madonna*, on the other hand, Giotto has placed the Virgin upon a canopied Gothic *sedile* somewhat reminiscent in its style of the work of his contemporary Arnolfo di Cambio, the designer of the façade for the new cathedral of Florence. There can be no doubt in the spectator's mind about the substantiality of this graceful structure, which is supported by a massive marble base. Cimabue's angels reverently bear from the heavens the enthroned *Regina coeli* for our veneration; Giotto's angels, having set the throne upon the earth, surround her with their homage, inviting us to follow suit. These are all solid, corporeal beings, and their forms, like that of the throne itself, are defined by a consistent system of lighting, with its source to the right of the spectator. The attempt to create an illusion of space now embraces the entire composition, and it is worthy of note that the two angels kneeling in the foreground must turn their heads slightly back in order to gaze upon the Virgin and her Child.

It is possible that Giotto had studied with attention the *Rucellai Madonna* which the Compagnia dei Laudesi had commissioned from the great Sienese master Duccio di Buoninsegna for their chapel at Santa Maria Novella (*Plate 5*), especially since there are similarities in the attitudes given by Giotto and Duccio to the Virgin and the Christ Child; but in a more fundamental sense the differences between the two pictures are very wide: the firm structure of Giotto's design is anticipated rather in Cimabue's *Santa Trinita Madonna*, as is also its rational ordering of colour balance.

Giotto gave his figures a far greater mass and weight. Yet in his quest for naturalistic conviction he inevitably sacrificed some of the virtues of the older tradition which Duccio preserved—above all, that sense of the numinous which the searching 'portraiture' of the *Ognissanti Madonna* partly obscures, but which is conveyed in Duccio's painting by the character of the imagery as a whole, from the ethereal quality of the angels to the otherworldly beauty of the radiant colours. (And if we should ask ourselves why it should seem

appropriate to describe an artist's palette as 'otherworldly', the answer is surely quite simple: a medieval painter undertaking the sublime task of conveying an idea of the heavenly world of Christian faith would consciously robe his divine figures and the very court of heaven in all the splendour that was due to them as supernatural beings quite separate from common humanity, but whose analogue was to be seen in the regal magnificence of earthly courts.) Within the terms of a more structural—indeed Florentine—approach to composition, Cimabue's *Madonna* of Santa Trinita and his frescoed *Madonna* in the Lower Church at Assisi (see *Plate 72*) present a similar contrast to Giotto's altarpiece.

Cimabue's principal work at Assisi is the monumental series of frescoes in the choir and transepts of the Upper Church, which are to be dated after his recorded presence in Rome in 1272 and almost certainly from 1279. This immense scheme of decoration was to be continued by other masters along the nave, the entire programme embracing a period of some twenty-five or thirty years. The nave frescoes, constituting an Old Testament and a New Testament cycle (occupying the two upper registers of the side walls and the corresponding area of the entrance wall) and the famous scenes illustrating the *Legend of St Francis* (occupying the lowest register of the side walls, below the windows, and the lower part of the entrance wall), were executed in three distinct stages, with the consequence that these successive phases mirror in the most striking manner the stylistic evolution that took place between the age of Cimabue and the age of Giotto. It is plausible to associate the commencement of the two Biblical cycles with a Bull promulgated in 1288 by the first Franciscan Pope, Nicholas IV, in which he insisted upon the need for further expenditure on the decoration of the basilica. The artists were evidently Roman, or at least Roman-trained; and Jacopo Torriti, who is best known for his mosaics at Santa Maria Maggiore in Rome (*Plate 32*), seems to have been the dominant influence during the initial phase of the work. Both cycles, however, were completed in a much more advanced style, probably in the late 1290s, by an artist of exceptional genius whom we know as the Isaac Master and whom many scholars identify with the youthful Giotto himself. Finally, about the year 1300 (although the precise date is speculative), a group of associated painters brought the decoration of the Upper Church to a fitting close by setting forth, in twenty-eight episodes, the narrative of the life and miracles of St Francis as expounded in the official biography written by St Bonaventura in the mid-thirteenth century.

The total scheme comprehends what is virtually a compendium of Franciscan theology, in which the ministry of St Francis is given cosmic significance within the context of God's plan for man's salvation. The main themes expressed in the wall decorations are supported by the ceiling frescoes and by narrative scenes in several of the windows in the choir and transepts and in the nave. It is significant that in the central medallion on the ceiling of the nave the image of St Francis is added to the traditional *personae* of the *deësis*—Christ, the Virgin and St John the Baptist. As we shall see, the Franciscans' exalted view of the divine

mission of their founder is emphasized in the twenty-eight frescoes of the *Legend* by explicit comparisons between Francis and Christ. Such comparisons are frequently found in early Franciscan literature. St Francis was widely believed to have inaugurated a new era, the Age of the Holy Spirit. According to the teachings of Joachim of Fiore, the Age of the Holy Spirit was to succeed the two earlier phases of world history, the Age of the Father, the period of the Old Testament, when mankind lived under the ordinance of the Law as revealed by God to Moses, and the Age of the Son, that is to say the era of the New Dispensation of Christ. Although this 'Trinitarian' reading of history was condemned as heretical until the papacy of Nicholas IV, the Order of Friars Minor never wavered in its conviction that its founder had been entrusted by God with a unique mission. Indeed, not long after his death the reference in the Book of Revelation to the angel who bore 'the seal of the living God' was being interpreted as a prophetic reference to the Poverello of Assisi, who bore in his hands and feet and in his side the marks of the Crucified, the sacred stigmata miraculously imprinted upon his body on the mountain at La Verna. It is this apocalyptic interpretation of the person and ministry of St Francis that runs through Cimabue's frescoes in the Upper Church, together with implicit allusions to Francis's special devotion to the Virgin, to St Michael (who, as Bonaventura had emphasized, brought souls to Judgment and was anxious for their salvation), to the Apostles and to the Cross of Christ; in other words, attention is directed to that exceptional piety which illuminated St Francis's whole ministry, so that he seemed to his disciples a man set apart from common humanity.

The apse was reserved, accordingly, for scenes from the life of Mary, introduced by the angel's announcement of her birth to her father, St Joachim, and culminating in her Assumption and, in place of the traditional Coronation, a representation of *Christ and the Virgin Enthroned*. The narratives in the right transept are devoted, in like manner, to stories from the lives of the chief Apostles, St Peter and St Paul, and the left transept to some of the apocalyptic visions of St John the Divine recorded in the Book of Revelation—among the most important of these scenes being *St Michael quelling the Serpent and Demons*, *St John on Patmos* and *The Four Winds*.

The last of these three frescoes contains the allusion to St Francis already mentioned. It illustrates the famous passage in the Apocalypse (Revelation 7:1–3) which describes the adoration of the holy Lamb by 'a multitude which no man could number', and which opens with these words: 'And after these things I saw four angels standing on the four corners of the earth, holding the four winds of the earth, that the winds should not blow on the earth, nor on the sea, nor on any tree. And I saw another angel ascending from the east, having the seal of the living God: and he cried with a loud voice to the four angels, to whom it was given to hurt the earth and the sea, saying, Hurt not the earth, neither the sea, nor the trees, till we have sealed the servants of our God in their foreheads.' In ancient custom the signet-ring of a king denoted the seal of his royal protection: the angel of St John's vision therefore

marks the souls that are to be saved with a symbolic seal placed upon their foreheads. That St Francis should have been identified with the Angel of the Apocalypse represents a staggering affirmation of his role in the divine scheme for man's salvation, and it is evident that the terms of the commission given to Cimabue required a clear expression of the saint's exaltation to a place among the angelic hosts: the frescoes were to glorify his heavenly rather than his human nature. Where St Francis is represented in his human aspect, as in the two gigantic *Crucifixions* that fill the short lateral walls of the transepts, he is shown in an attitude of virtual self-immolation as he kneels at the base of the cross, 'seeking obliteration', in the words of one sensitive critic, 'in Christ Crucified'.

Only the *Crucifixion* in the left transept (*Plate 18*) can be ascribed to Cimabue himself, the other having evidently been entrusted to his assistants. All Cimabue's frescoes in the Upper Church, which must originally have been brilliant in colour, have suffered irreparable damage, and through a process of oxydization the white lead employed in the lights has turned black, with the consequence that a negative photograph conveys to some extent a more satisfactory idea of their original state than that obtainable by a visitor to the basilica. Yet the destruction of most of the detail in the *Crucifixion* scarcely affects our impression of the whole. This sublime wreck of a masterpiece still bears the stamp of a supreme creative imagination; and here we are confronted by an aspect of Cimabue's genius of which the *Santa Trinita Madonna* affords us no hint—his dramatic sense, which in the Assisi *Crucifixion* assumes a cosmic scale. If the *Crucifixion* by the Master of St Francis in the Lower Church (*Plate 17*) provided some of the basic iconographical ingredients of Cimabue's composition, its style appears almost pedestrian beside this stupendous epic of the redemptive sacrifice of Christ. The human witnesses of the tragic scene and the angelic hosts alike seem to be caught up in seething waves of emotion, epitomized by the imploring arms of Mary Magdalen, who reaches up towards the Crucified—a gesture repeated by others who stand on the opposite side of the cross. Yet at the extremities of the composition this intensity of outward feeling gives way to quieter, more inward contemplation and awareness, and the Virgin turns gently to St John to accept the protection of her adopted son—a passage all the more moving for its reticence, for the Virgin does not swoon as in most later, more 'humanized' representations, but preserves a grave dignity. To turn to Giotto's interpretation of the Crucifixion in the Arena Chapel (*Plate 19*) is to become aware, somewhat disconcertingly, that the vast spiritual world of Cimabue's timeless vision of Golgotha has been shrunk to the confines of a narrower, more earthly stage.

Nevertheless the art of Cimabue stands at the end of a road. While it would be misleading to affirm that he exerted no influence upon the succeeding generation of painters, he was certainly the last major exponent of the Italo-Byzantine style. There is truth in Dante's famous observation, in illustration of the vanity of earthly fame:

Credette Cimabue nella pintura
tener lo campo, ed ora ha Giotto il grido
(Cimabue thought to hold the field in painting, but now Giotto's name is on everyone's lips.)

Purgatorio, XI, 94–5; trans. John D. Sinclair, London, 1948.

There were few painters, particularly in Florence, who could avoid coming to terms with the implications of Giotto's revolutionary aesthetic.

Even where Giotto's personal influence is disputable, there is suggestive evidence of a general awareness, even within Cimabue's immediate circle, of the challenge of the new ideas which were to be consummated in the art of Giotto, but which were already manifesting themselves quite unmistakably in the last decade of the thirteenth century. The two frescoes devoted to the story of St Michael which were commissioned from an unknown follower of Cimabue for a chapel at Santa Croce in Florence show a marked progression from a Cimabuesque manner in *St Michael quelling the Dragon* to a more Giottesque manner in the *Miracle of Gargano*. Again, the final narratives in the mosaic decoration of the Florentine Baptistery, the scenes from the life of the Baptist, which are almost certainly datable after about 1295—the approximate date of the composition of a *Life of St John the Baptist* (the *Vita di San Giovambattista*) from which the author (or authors) of the mosaics apparently drew inspiration—reveal an attempt to accommodate to an essentially Cimabuesque idiom the demand for more closely observed forms and for a more convincing realization of spatial relationships.

No less interesting is the development of a painter who must have been one of Cimabue's direct pupils, Deodato Orlandi of Lucca. An early crucifix by this master at Lucca, painted in 1288 (*Plate 21*), conforms closely to the Cimabuesque type; but a later crucifix (*Plate 23*), executed by him for the Convent of Santa Chiara at San Miniato al Tedesco and dated 1301, the year before Cimabue's death, shows a remarkable change in favour of the new realism which was now in vogue in Florence and of which the *locus classicus* in the history of the Florentine crucifix is the large cross at Santa Maria Novella (*Plate 22*) traditionally ascribed to Giotto—a work to which we shall return.

Deodato Orlandi lived on at least into the middle of the second decade of the new century, and it is possible that he was the author of the extensive series of frescoes in the nave of San Piero a Grado, near Pisa, illustrating scenes from the lives of St Peter and St Paul (*Plate 24*), a cycle probably datable within the first few years of the fourteenth century. No work better indicates the difficulties faced by an artist trained in older traditions—deriving in this case both from Cimabue and from the lost early Christian frescoes in Old St Peter's (which are known to us from later drawings)—when he attempted to come to terms with the realistic tendencies of the new age. It is not surprising that such a painter should have been

fascinated by problems of illusionism. Certainly the author of these frescoes spent great pains upon the attempt to deceive the eye, as is evident from the fantastic motif of projecting beams painted above and below the narratives; and yet the perspective system runs counter to that employed in the niches below, containing portraits of the popes. Similar perspectival problems are tackled in the scenes themselves, but they are never satisfactorily solved. More important, perhaps, is the artist's attempt to breathe life into his figures and to achieve a convincing evocation of actuality. It is clear enough from his portrayal of individual expressions and gestures that he was gifted with considerable powers of observation. Yet the total effect of this spirited and ambitious work, which comprises as many as thirty-one scenes, remains confused and unsatisfactory, and we are left with an impression of irreconcilable elements, of an unresolved conflict between tradition and innovation. As the art of Giotto demonstrates above all, the new era that was dawning demanded a fundamental reassessment of the painter's language. The way to the discovery of the new principles upon which the art of the Trecento was largely to be founded had already been opened in the great works undertaken by Cavallini in Rome; and it is to the innovations introduced by this master that we must now turn our attention.

Cavallini and the Roman School

For centuries Vasari's insistence upon the primacy of the Florentine achievement in the revival of the arts in Italy obscured the immense contribution of Rome to the stylistic developments of the late thirteenth century from which Trencento painting sprang. Cimabue himself and another Florentine, the sculptor-architect Arnolfo di Cambio, both worked in Rome, and both were indebted, in a limited degree, to Roman traditions deriving from late antiquity. Many of the decorative elements in Cimabue's Assisi frescoes, with their ornamental *putti*, animals and floral motifs, have their ultimate origins in ancient prototypes. It may be added that the ceiling fresco of *St Mark*, in the group of the *Four Evangelists* on the crossing, includes a notable representation of the Campidoglio in a schematic view of the Holy City.

Arnolfo di Cambio is first recorded in the 1260s as one of the assistants of the Pisan sculptor Nicola Pisano, who was then completing his famous pulpit for Siena Cathedral. One of Arnolfo's most important works is the tomb of Cardinal de Braye in San Domenico at Orvieto, which is datable after May 1282; but he received most of his early commissions in Rome, where he was responsible for two celebrated *ciboria* (or altar-canopies) for San Paolo fuori le Mura (*Plate 26*) and Santa Cecilia in Trastevere, the first of which was completed in 1285 and the second in 1295. In 1300, two years before the presumed date of his death, Arnolfo is named in a document of the Council of One Hundred as architect of the new Cathedral of Florence, Santa Reparata (later renamed Santa Maria del Fiore); the document calls him 'the most celebrated and expert master in the art of church building of any known in the region', and predicts that in his hands the cathedral will become the most beautiful church in Tuscany. One of Arnolfo's tasks was to provide sculptural decorations for the façade, and although he died before his ambitious scheme could be realized, a number of the sculptures survive, including a *Madonna and Child* destined for the central portal.

The recognition given to Arnolfo by the Council of One Hundred as 'the most celebrated and expert master in the art of church building' lends support to the view that before being placed in charge of the works at Santa Reparata he had already designed the lovely Franciscan church of Santa Croce in Florence (see *Plate 62*). Santa Croce was founded in 1294–5, and although the nave was not completed until late in the fourteenth century, its famous chapels, patronized by such great banking families as the Bardi, the Peruzzi and the Baroncelli (incongruous though such patronage may seem in relation to a church of the Franciscan Order, with its ideal of Holy Poverty), were erected much earlier, and the Bardi Chapel, which Giotto was to decorate, was in being by 1310. The church is majestic in scale, with a

long wooden roof and with five chapels on each side of the soaring choir; the visitor is immediately impressed by a sense of space and airy lightness, emphasized by the gracile piers supporting the roof of the nave, which direct the eye to uninterrupted vistas. The design owes much, no doubt, to a knowledge of the early Christian basilicas of Rome, as well as to the influence of French Gothic; but the sheer grace and elegance of Santa Croce indicate an architect of unique and original genius, such as we know Arnolfo to have been from his Roman *ciboria* and from what we can deduce about his plan for Santa Reparata.

Arnolfo was one of the principal channels of Gothic influence in Italy, although, like his master Nicola Pisano, he was evidently attracted as well by the classic restraint of ancient art. His own sculptures—such as the *Madonna and Child* and the *Santa Reparata* for the façade of Florence Cathedral—represent a harmonious synthesis between essentially classical ideals and Gothic taste. The *ciborium* at San Paolo fuori le Mura demonstrates still more clearly Arnolfo's skill in fusing Gothic elaboration of detail with an ordered system of proportion deriving from Roman prototypes. The Victories supporting the roundels of the four-sided canopy are direct quotations from antiquity, while other decorative motifs were inspired by the long tradition established in the twelfth century by the stone-workers whom we know as the Cosmati (so named from the fact that many of them belonged to the Cosma family), who specialized in all forms of monumental sculpture. Their work was carried out in a variety of media, notably marble, porphyry and coloured glass, much of it plundered from ancient Roman monuments.

This development of new ideals in sculpture and architecture inevitably left an impress upon late thirteenth-century painting and mosaic decoration; and thus Rome became the main centre of artistic activity. Not the least important factor involved was the historic decision of the Orsini Pope, Nicholas III, to restore to their former splendour some of the great churches of Rome, including Old St Peter's, presumably in order to assert the power and supremacy of the papacy in a time of political uncertainty and strife. The consequence was the initiation, from the 1270s, of a vast programme for the decoration in fresco of Old St Peter's, San Lorenzo, and San Paolo fuori le Mura. All these great fresco cycles are now lost, but fairly accurate records of them are preserved in seventeenth-century drawings. The most important are those formerly at San Paolo, comprising the *Life of St Paul* on the left wall of the nave, below the windows, and an Old Testament cycle on the right wall, each majestic series unfolding in two rows. The first of the two cycles can be dated with some degree of confidence between 1277 and 1279, and the second within the following decade. The completed scheme embraced subsidiary figures of prophets, apostles and saints on the wall spaces between the windows and, below the narratives, portraits of the popes in roundels, four of which survive. The impressiveness of the decoration as a whole can be judged from a view of the interior of the basilica painted in the eighteenth century by Giovanni Paolo Pannini (*Plate 27*).

According to Ghiberti's *Second Commentary*, written in the mid-fifteenth century, the painter entrusted with this immense task was the Roman master Pietro Cavallini. However, the surviving portraits of popes are not in Cavallini's style as we know it elsewhere, although they show a certain relationship to it. If their author was in fact the principal artist at work in San Paolo, it is even possible that Cavallini was his pupil and that he first steps on to the stage of history at San Paolo as a member of the anonymous master's *bottega*. On the assumption, then, that more than one painter was involved, and that one of them was Cavallini, it is clear that their main task was to recreate a fifth-century fresco decoration which had suffered extensive damage. In certain cases they seem to have been content to work over still existing designs; but many of the frescoes were evidently new compositions, since they introduce innovatory principles of pictorial construction, notably in the treatment of space and perspective and in the modelling of the human figure in the round.

These innovations within the late thirteenth-century Roman School are most clearly seen in Cavallini's surviving work in Rome (the mosaics of the *Life of the Virgin* at Santa Maria in Trastevere and the partly destroyed fresco of the *Last Judgment* at Santa Cecilia in Trastevere) and in a group of frescoes in the nave of the Upper Church of San Francesco at Assisi (*Plates 35, 36*) by the so-called Isaac Master, a contemporary of Cavallini who derives his sobriquet from two scenes at Assisi devoted to the story of Isaac. With these masters, the problems of foreshortening and recession in the representation of architecture begin to be solved, and attention is given to the modelling of the human form and draperies in terms of subtle gradations of light and shade.

The sculptural treatment of the Apostles in Cavallini's *Last Judgment* (*Plate 33*), in which a strong light chisels the forms, and the remarkable evocation of an inhabitable space in the Isaac Master's fresco of the *Rejection of Esau* at Assisi are important aspects of this process of stylistic change, out of which the art of Giotto himself was to emerge. Even before Giotto's time (or at least before the date of his earliest surviving works) these innovations exerted a strong influence upon late thirteenth-century painting and mosaic decoration in central Italy and in other regions. It has often been suggested that one important consequence of the terms of the commission for the refurbishing of the decorations at San Paolo was that Cavallini's style came to be shaped to some extent by his intimate contact with the spirit of early Christian art and with its echoes of the ideals of late Antiquity. But, in addition, the Roman masters of the Dugento would have had access to a number of ancient mural decorations that no longer survive. Often in Cavallini and his contemporaries the figure-style, the classical fall of the draperies and the treatment of architecture possess an unmistakably antique flavour, which is often heightened—as in the noble Isaac at Assisi (*Plate 35*)—where the study of ancient sculpture may also be presumed. Even the markedly reddish coloration of the Isaac Master's flesh-tints recalls the method found in ancient painting. While the influence of Gothic naturalism upon the period should not be underestimated, it

may be said of Cavallini and the Isaac Master that, like Nicola Pisano before them, and like Giotto afterwards, they found a way to a new realism through the recovery of the ancient heritage of Rome.

The art of Cavallini can best be studied at Santa Maria in Trastevere. (Apart from the *Last Judgment* at Santa Cecilia, one of the masterpieces of the final decade of the century, the only surviving frescoes attributable to Cavallini are some apse decorations in San Giorgio in Velabro, together with a series of Old and New Testament scenes and a *Last Judgment* in the convent church of Santa Maria Donna Regina at Naples. These are usually dated around 1320 and ascribed, at least in the main, to Cavallini's pupils, although Cavallini, who lived to a great age, is documented in Naples in 1308.) The apsidal mosaics at Santa Maria in Trastevere were commissioned by Bertoldo Stefaneschi, the brother of the more famous Cardinal Gaetano Stefaneschi, who was to become the patron of Giotto. In a central composition beneath the six scenes of the *Life of the Virgin* the donor is shown kneeling before a *tondo* containing the figures of the Virgin and Child, to whom he is being presented by St Peter and St Paul. The mosaics complete a twelfth-century scheme, below which the narratives of the Virgin's life extend across the lower part of the apse and its enclosing archway. It used to be assumed, on the most tenuous evidence, that they are datable precisely in the year 1291. They must certainly precede Torriti's apse mosaics at Santa Maria Maggiore (*Plate 32*), which they influenced, and which were completed by 1295, and—despite recent arguments to the contrary—they were probably executed before the frescoes at Santa Cecilia.

The *Birth of the Virgin* (*Plate 34*) and the *Adoration of the Magi* (*Plate 39*) represent together all that is best in this noble work, which Ghiberti considered the finest mosaic decoration known to him. The birth scene establishes at once that tone of august gravity which finds its consummation in the final episode, the *Dormition of the Virgin*, with its reference to the then increasingly popular (although still unofficial) doctrine of Mary's bodily assumption into heaven. By his choice of scenes Cavallini emphasizes the passage from childbed to death-bed, and the compositional concordances that bring the two outer narratives into meaningful association extend inwards into the four scenes within the apse itself, where two compositions dominated by lofty architectural structures bracket two open-air scenes containing mountainous landscape backgrounds. The ideal of symmetry evinced in Cavallini's method of design must have made a deep impression upon his followers, and it is an essential feature, for instance, of the design of the *Legend of St Francis* at Assisi (*Plate 41*). Still more impressive are the sublime *gravitas* and intellectuality of these compositions, creating a world of majestic order and harmony fit for the heroic beings of Cavallini's imagination, who seem to fulfil their solemn roles on a timeless stage.

In the *Adoration* the classical emphasis of Cavallini's style freezes the actions of the Magi into virtual immobility, enhancing the sense of timelessness; and we become conscious of

the primacy given by Cavallini to *disegno* itself, to the achievement of a total harmony of formal relationships. The varied, interlocking arrangement of the figures of the three Magi must be accounted one of the most beautiful passages in early Italian art; indeed the relationships established between all the figures and their landscape or architectural 'supports' could have been achieved only by a supreme master of pictorial composition. Here also we observe a highly intellectualized approach to spatial problems, effectively solved in the representation of the building on the right, which is shown in an oblique view, with its jutting roof and projecting corbels convincingly rendered as being seen from below. On the other hand the hill-town on the left, representing Jerusalem, is inconsistently viewed from above—an anomaly that demonstrates that Cavallini was not yet capable of arriving at a wholly systematic solution to such problems of perspective.

All the actors in this solemn scene betray a grave awareness of each other, an active response conveyed principally by the intense glances of their eyes; and it is this quality of humanity and latent drama in Cavallini's art that relates him so closely both to the Isaac Master and to Giotto. To estimate the extent of Cavallini's influence upon Giotto it is only necessary to compare the *Adoration of the Magi* at Santa Maria in Trastevere with the same subject as Giotto interpreted it in the Arena Chapel (*Plate 55*).

The similarities between Cavallini's *Birth of the Virgin* and the Isaac Master's *Rejection of Esau* at Assisi are no less significant. In the mosaic the hesitation of the two servants who approach St Anne's bed, diffident of their intrusion into the privacy of her thoughts as she tenderly contemplates her newborn child, foreshadows the more complex nuances of psychological response—again conveyed in reserved gestures and meaningful glances—that inform the figures of Esau and his companion in the Assisi fresco as they approach the blind Isaac. The compositional affinities between the mosaic and the fresco indicate the Assisi painter's direct debt to the eminent Roman master, for there can be little, if any, doubt that the mosaics at Santa Maria in Trastevere antedate this area of the fresco decorations in the Upper Church at Assisi.

Nevertheless, so little is known about the Isaac Master—notwithstanding recent attempts to identify him with the young Giotto—that this powerful and original painter remains one of the most mysterious figures of the period. We cannot altogether discount the possibility that earlier in his career he was as much a creator of the new style as Cavallini himself. But, as far as we know from the evidence at our command, it was Cavallini's example that inspired both the Isaac Master and Giotto to model their figures in gradated tones determined by the fall of light from a single source, although it should be added in qualification of this observation that in Cavallini's *Last Judgment* a divided system of lighting is employed, all the Apostles to the left of the enthroned Christ being illuminated consistently from the left, and all those on the other side from the right. The gradual development of a new consistency of lighting, which was so essential to the demands of realism, must have been

3

one of the fruits of the study of classical painting by Cavallini, Giotto, and their contemporaries.

The rediscovery of the antique played some part in the formation of two other distinguished Roman masters of the period, the mosaicists Jacopo Torriti and Filippo Rusuti, whom we may briefly consider at this point before returning to the Isaac Master and to the frescoes at Assisi. Torriti's great mosaic in the apse of Santa Maria Maggiore has already been mentioned (*Plate 32*). This splendid work was commissioned by Nicholas IV who occupied the papal throne from 1288 to 1292, and it was executed between 1290 and 1295. It represents the *Coronation of the Virgin*, with five scenes of the *Life of the Virgin* below, and shows some indebtedness to Cavallini's series at Santa Maria in Trastevere. The scene of the *Coronation* is set within a circular aureole surrounded by an intricate arrangement of ornamental wreaths and garlands, interspersed with delightful representations of peacocks and a variety of other birds and animals, the whole being conceived in terms of essentially flat decoration in which brilliant and subtle colour effects dazzle the eye. This is certainly one of the loveliest mosaic decorations in the whole of Italy. The style fuses Gothic elements—notably a sort of ornamental naturalism—with Byzantine influence. There are echoes of Cavallini in the handling of the narratives and in the firm drawing of the figures, although Torriti pays less attention to interior modelling and relies more upon the expressive role of the bounding outline. We also detect, not only in the purely ornamental motifs, but also in the grandeur of the figures and in the drapery-style, hints of a knowledge of the antique.

Elsewhere in Santa Maria Maggiore, in the remains of a fresco decoration in the transepts, we discover vestiges of the stylistic reformulations that we associate particularly with Cavallini and the Isaac Master: here there survive from a Biblical cycle some large roundels containing over-life-size busts of prophets and saints. The advanced style of these figures has led some scholars to ascribe them to the young Giotto—an attribution that would make more sense if it were possible to establish that Giotto and the Isaac Master were one and the same painter, for the affinities between these frescoes and the scenes by the Isaac Master at Assisi are very close—so much so that the roundels may provisionally be assigned to some associate of his or even to a pupil.

We are on surer ground when we consider the exterior mosaics on the façade of Santa Maria Maggiore, comprising, in two registers, a large representation of Christ enthroned, with flanking figures of apostles and saints, together with symbols of the four Evangelists, and, in the lower register, four narratives of the miraculous foundation of the church by Pope Liberius. These mosaics bear the signature of Filippo Rusuti, who was evidently responsible for the upper register, the narrative scenes below being in a different, and more advanced, style. The decoration was probably executed from about 1292, and there is some indirect evidence for its completion by 1297. The grandeur of Rusuti's figure-style is striking, and Cavallini's influence, although undeniable, does not by any means detract from

Rusuti's powerful individuality. But perhaps greater interest attaches to the narrative scenes, in which the figures are firmly set in space and modelled in the round, as well as being portrayed as individual, sentient beings. Many of the compositional features of these scenes are found again in some of the celebrated frescoes of the *Legend of St Francis* in the Upper Church at Assisi, which Vasari erroneously believed to be an early work by Giotto, and this influence provides further testimony to the importance and impact of the stylistic developments that were taking place in late thirteenth-century Rome.

Both Torriti and Rusuti have been identified, on stylistic grounds, among the numerous painters who shared in the decoration of the Upper Church of San Francesco at Assisi, but not all such attributions have won universal acceptance. Whether or not the impressive *Kiss of Judas* (*Plate 28*) can be assigned to Torriti himself, this masterpiece of late Dugento painting remains one of the most memorable achievements in the entire scheme of decoration. The fresco belongs to the Old and New Testament cycles which fill the upper two registers of the side walls of the nave and the upper area of the entrance wall (above the *Legend of St Francis*, which occupies the lowest register on each of the three walls). (The altar in the Upper Church is at the west end of the nave; the Old Testament cycle occupies the north wall and the New Testament cycle the south and entrance walls.) The Biblical cycles at Assisi, which have suffered considerable damage and loss, were probably one of the fruits of a Papal Bull promulgated in May 1288 by Nicholas IV, the first Franciscan pope, which called for further expenditure on the basilica and its decoration. The painters employed in the nave worked from the altar end towards the entrance, and the early scenes on both the side walls conform, in general, to the monumental but somewhat linear idiom that characterizes the work of Rusuti and Torriti in Rome. About half-way along the nave, however, a startling change is apparent. For some reason the earlier painters were succeeded at this point by an artist of a very different stamp—the Isaac Master.

When we compare the treatment of space and the human figure in the *Kiss of Judas* with the method of the Isaac Master we can see how profoundly the new style whose beginnings we have traced in the art of Cavallini affected the final stages in the execution of the Biblical cycles at Assisi. About half-way through the programme the somewhat descriptive and decorative idiom of Torriti and his associates is suddenly rejected in favour of a 'Cavallinesque' modernism which gives priority to the creation of an almost tangible illusion of the three-dimensional world. This is an extraordinary occurrence, and it is hard to think of a precedent for so radical a change of stylistic direction within a single fresco decoration. Evidently the appeal of the new style overrode the desirability of preserving the aesthetic unity of the two parallel cycles. By comparison with the frescoes of the Isaac Master, the *Kiss of Judas*, majestic and deeply pondered though it is, may seem remote from normal human experience, but it possesses much of that intense, otherworldly quality which we associate with Byzantine art, and which its painter expressed with impressive power.

The art of the Isaac Master is even more revolutionary than that of Cavallini himself, and it anticipates Giotto's *dolce stil nuovo* as we know it from the frescoes in the Arena Chapel at Padua. It is not surprising that Giotto's own stylistic origins have been detected by many scholars in this area of the decorations at San Francesco; without accepting the extreme view that the Isaac Master (who may well have been a Roman) was none other than the young Giotto himself, we cannot exclude the possibility that Giotto was deeply influenced by the Isaac Master in his formative years, whether or not he was his pupil. In many ways the Isaac Master and Giotto thought alike; and if it is true of Giotto that he laid the foundations of Renaissance painting, the same is true of the mysterious Isaac Master.

The painter now vies with the sculptor in his capacity to represent the three-dimensional world; the illusion of a recessed space dissolves the surface of the wall, and we look, as it were, through a 'window' akin in its effect to the framework of a bas-relief. Form assumes a new plastic value; and by virtue of a consistent adherence to the logic of spatial representation it becomes possible for the painter to create a range of subtle relationships between his *dramatis personae* and to set all his figures convincingly within their architectural or landscape setting. Pictorial expression acquires a new dimension, enabling the painter to rival not only the tactility of the art of sculpture but also the vivid realism of the contemporary religious drama: the *tableau vivant* gives place to scenic action. How closely the Isaac Master resembles Giotto can be judged from a glance at the moving *Lamentation over the Dead Christ* at Assisi, which it is convenient to illustrate with the beautiful watercolour copy made by Eduard Kaiser in 1876 (*Plate 36*), when the damage that the fresco has suffered was not quite so extensive as it is now. (Eduard Kaiser, a member of the Viennese Academy, copied a number of the Assisi frescoes for the Arundel Society, and was advised on his work by Ruskin. His copies of the Biblical frescoes at Assisi are so faithful that they can be trusted for every detail of the compositions, and in the case of the *Lamentation* he shows us more of the figures of Christ and the four angels than is now visible in the original.) The design of the Assisi fresco, while having its precedents in Byzantine iconography, strikingly anticipates that of Giotto's famous version of the subject in the Arena Chapel (see *Plate 37*), painted about 1305: such elements of the composition as the flight of grieving angels, the group of mourners—including the Virgin, St John the Divine and Mary Magdalen (who tenderly clasps one of Christ's wounded feet)—the standing figures of Joseph of Arimathea and Nicodemus, and the rocky scarp which seems to bear down towards the head of the Saviour, drawing our attention to this central focus of intensely felt sorrow—all these features reappear, in a more developed form, in Giotto's masterpiece at Padua.

A careful comparison between the *Birth of the Virgin* at Santa Maria in Trastevere and the *Rejection of Esau* at San Francesco will demonstrate the extent of the Assisi painter's advance beyond the point arrived at by Cavallini. In the Assisi fresco, the simple but graceful architecture now encloses the human actors in a spatial 'envelope' that is almost tangible; the distance

between their overlapping forms is subtly and yet firmly suggested; and the three-dimensional treatment of the figures and the light that models their every form and feature in a powerful *sfumato* lend the whole scene a conviction of reality hitherto unapproached in post-classical art. Perhaps above all, the artist concentrates our attention upon the human implications of this tragic story of a son's rejection by his father, as though he were conscious of a need to penetrate beyond the meaning attached to it by patristic and medieval thought, according to which Isaac's choice of Jacob as his heir and his rejection of Esau, his first-born, signified the displacement of the Old Law of Moses by the New Covenant of Christ. The figure-style, notably in the massive Isaac—reminiscent of an ancient river-god, and particularly calling to mind the *Tiber* statue in the Piazza del Campidoglio in Rome—suggests that the artist was profoundly influenced by the antique.

The apparent influence of Cavallini's *Birth of the Virgin* upon the design of the *Rejection of Esau* is alone sufficient to enable us to date the Isaac Master's frescoes at Assisi after the mosaics at Santa Maria in Trastevere, executed in the 1290s. A further indication as to dating, which is more suggestive than absolutely decisive, is afforded by the presence on the vaulting, in this area of the nave, of representations of the *Four Doctors of the Church*. These figures are probably to be connected with the Decretals promulgated in 1297 by Boniface VIII, giving official sanction to the cult of the *doctores* (Saints Ambrose, Augustine, Jerome and Gregory), in which case most, if not all, of the Isaac Master's frescoes would have been completed around or after that year. Presumably, like Cavallini, the Isaac Master had a Roman training; like Cavallini also, he may have worked mainly in Rome—a hypothesis that has recently received some support from the recognition in a crucifix at San Tommaso dei Cenci in Rome of close stylistic similarities with the Assisi *Lamentation*. The closest of these similarities, however, relate to some of the subsidiary figures in the fresco, such as those in the background towards the left and centre, which may have been executed by an assistant of the Isaac Master. Indeed, a number of different hands are detectable in the two Biblical cycles in this area of the church, so that it would appear that the Isaac Master commanded a quite extensive workshop. Although it is tempting to consider the possibility that one member of the shop was the young Giotto—a hypothesis that might explain the links that undoubtedly exist between some of the compositions and corresponding frescoes by Giotto in the Arena Chapel—his workmanship is nowhere clearly discernible, so that even if we feel we detect his spirit at Assisi, we find ourselves pursuing a ghost rather than a physical presence.

The lowest register in the Upper Church, containing the famous scenes—twenty-eight in number—of the *Legend of St Francis*, must postdate the Biblical narratives; it is difficult, therefore, to place the *Legend* much earlier than 1300. There is strong evidence that it had been completed by 1307. Vasari, in the second edition of his *Lives of the Painters, Sculptors and Architects*, published in 1568, ascribed the *Legend of St Francis* to Giotto; but the attribution, although still accepted by most Italian scholars and a very few others, has no justifica-

tion. It is a view that is all the more extraordinary because the same scholars would never dream of placing the same reliance upon Vasari's assertions about other early Italian masters. It is as though a legend has hardened into a dogma, which it has become impious to question. In actual fact it can be shown that the Assisi frescoes were executed by several painters who worked in collaboration, together with a band of assistants. Group enterprises of this nature were not uncommon at the time. Before we consider these painters and their styles it should be said that while it is not for his reliability in matters of attribution, especially in this period, that we value Vasari's celebrated book, the *Lives* are by any standard a wonderful achievement—being the first attempt to write an integrated history of the arts in Italy between the time of the Pisani and that of Michelangelo, and to discern in the whole variegated gallimaufry of stylistic change a consistent and logical pattern.

Vasari writes with enthusiasm about the skill with which, in Scene XIV of the *Legend*—the *Miracle of the Spring (Plate 43)*—the painter represented a man in the act of drinking from a stream which St Francis had miraculously made appear in the dry terrain:

> And among the scenes there is one that is particularly beautiful, in which a thirsty man, whose desire for water is vividly represented, stoops to the ground as he drinks from a spring, with so great and so truly marvellous a conviction of reality that he appears almost like a real person drinking.

It is understandable that Vasari should have associated this naturalism with the innovations of Giotto. The new realism of Giotto reveals itself to us today as the consummation of earlier tendencies, such as we have already noted in the work of Cavallini, Arnolfo, and the Isaac Master; but Vasari, who believed that Cavallini was Giotto's pupil, thought of the revolution effected in Italian painting in the years around 1300 as having been undertaken by Giotto virtually single-handed.

But the *Legend* is not in Giotto's style; and even the naturalism that Vasari admired in it has little in common with Giotto's more searching realism. Its style is closer to that of Cavallini, although distinct from it, and clearly belongs to that late thirteenth-century development in Rome which we have already outlined; and it is notable, for example, that a number of the architectural features of Cavallini's mosaics at Santa Maria in Trastevere can be paralleled in the representations of buildings in the *Legend*, particularly in some of the early scenes. It is even possible, as Paeseler has suggested, that the *Legend* was modelled upon a lost fresco cycle which, according to Ghiberti, Cavallini painted in the church of San Francesco a Ripa in Rome. We know from a seventeenth-century Franciscan writer, Ludovico da Modena, that this cycle, which occupied the nave walls and the transept, included 'many miracles of our Holy Father', but unfortunately we do not know its date, and so it is conceivable that the Assisi frescoes, painted in the Mother Church of the Franciscan Order, were executed earlier. Nevertheless, the hypothesis that the Assisi cycle depends to a

large extent upon the lost Roman cycle might explain some of its puzzling features. Among these is its workshop character, one effect of which is that it possesses a unity of theme but not of style: in fact we should speak not so much of its style as of its styles, or of a 'family of styles', since the cycle was executed by a number of painters whose styles are closely related.

This diversity of style at Assisi is partly disguised by the fact that the clustered columns that support the nave vault divide the wall areas into separate bays. Each of the eight bays on the side walls contains three scenes, except for the two large bays at the entrance end, which each contain four scenes, while the entrance wall has two scenes flanking the doorway, which is surmounted by *tondos* of the *Virgin and Child* and two *Angels*. While it is true that stylistic variations often occur within a particular bay, their total effect is undoubtedly lessened by this division of the cycle into groups of scenes. Apart from a number of inferior assistants, four main masters can be distinguished. The first—often referred to as the St Francis Master—began the cycle with the painting of Scene II, the *Gift of the Mantle* (*Plate 38*), the execution of Scene I, *St Francis honoured by a Simple Man of Assisi* (*Plate 30*), by the so-called St Cecilia Master, being left until later. The St Francis Master was thereafter chiefly responsible for the remaining frescoes on the north wall. The frescoes on the entrance wall—which include Scene XIV, the *Miracle of the Spring*, so much admired by Vasari—together with other nearby frescoes on the north and south walls, such as the *Death of the Knight of Celano* (Scene XVI), show a difference of style which is less easy to account for in terms of the St Francis Master's artistic development than by recognizing the intervention of a new painter. In turn this style gives way, on the south wall, to the distinctive manner of the painter whom I have named the Master of the Obsequies of St Francis, who was responsible for the scenes relating to St Francis's death (*Plates 31, 42*).

Finally the St Cecilia Master brought the whole enterprise to completion by painting the three scenes in the last bay on the south wall, together with the first scene on the north wall, *St Francis honoured by a Simple Man of Assisi*, which opens the entire narrative. This anonymous master derives his sobriquet from his authorship of the well-known altarpiece of *St Cecilia and Scenes from her Life* (*Plate 29*), now in the Uffizi. The St Cecilia Master worked chiefly in Florence, and this altarpiece was painted for the Florentine church of Santa Cecilia at some time before the church was burnt down in the fire which swept through the city in 1304. At least one of the painters of the *Legend*, therefore, seems to have been a Florentine.

No other works securely attributable to the St Francis Master are known, and so we have little to go on apart from the evidently Roman origins of his style. But the author of the *Miracle of the Spring* and the *Death of the Knight of Celano* shows such close affinities with another Florentine painter, whose name we do know, that it is tempting to make a positive attribution. This painter is Pacino di Bonaguida, who worked both as a miniaturist and as a painter of altarpieces (see *Plates 44, 80, 83*), and whom we shall consider when we come to

Giotto's Florentine contemporaries. In the same way, there are strong similarities between the style of the Master of the Obsequies and that of an early fourteenth-century Umbrian painter, Marino da Perugia, who is known from documents and from a signed *Madonna* (*Plate 160*). The difficulty about making definite attributions upon the basis of such resemblances is that we inevitably have to compare frescoes with pictures in another medium (whether tempera paintings on panel or miniatures); but the resemblances exist, and if they are not to be accounted for by common authorship they seem at least to establish the influence of the Assisi frescoes or of their authors; and on either assumption the question is raised as to whether both Pacino and Marino belonged at one time to the busy workshop at San Francesco. Pacino was certainly employed by other Franciscan communities, and Marino worked in nearby Perugia, where he was to become head of the painters' guild.

It is possible that the delay in the painting of the first fresco in the cycle, *St Francis honoured by a Simple Man of Assisi*, was occasioned by work that remained to be done in fixing in place the rood-beam which originally spanned the nave, from wall to wall, in the vicinity of the altar. The second scene, the *Gift of the Mantle*, introduces us to the principal painter of the earlier narratives (those on the north wall). It is usually assumed that this painter—the St Francis Master (the 'Giotto' of the Vasarian tradition)—was the *capomaestro* in charge of the whole enterprise. The alternative is to assume that this role was given to the St Cecilia Master, who was by far the most accomplished of all the painters of the cycle, and whose influence on the St Francis Master may have been profound; but it would then be difficult to explain why he played so small a part in the execution of the frescoes, apparently bringing the decoration to completion instead of initiating it. The St Francis Master undoubtedly had much in common with the St Cecilia Master, but his forms tend to be ampler and weightier, his figures more substantial although less mobile, and his colour bolder but less subtle. By contrast the St Cecilia Master seems to be all elegance and grace.

The sculptural quality of the St Francis Master's figures recalls the art of Cavallini, who must also have influenced his method of design. It is instructive to compare the *Gift of the Mantle* with Cavallini's mosaic of the *Adoration of the Magi*. The frescoes in this first bay all depict incidents in Francis's early life that prefigured his later sanctity; and here he is shown in an act of impulsive charity as he bestows his cloak upon an impoverished nobleman. His haloed head acts as the central focus both in this particular composition and also within the design of the bay as a whole. On either side the landscape background divides to suggest the valley that once separated the city of Assisi—represented, with its wall and gateway, on the left—and the Collis Paradisi, upon which the church of San Francesco was built. Somewhat anachronistically, the basilica (which once had a spired tower) is shown on the right, so that St Francis stands in front of the great building which was to bear his name and to house his mortal remains. There is much in this landscape to remind us of the hill in Cavallini's mosaic, which is topped by a little town intended to represent Jerusalem. The character of

the design in the fresco, the manner in which the rocky striations of the hill are rendered, and the inclusion of a similar tree that grows from the edge of the slope and makes a pattern against the sky—all these features of the composition in the Upper Church suggest that the St Francis Master took Cavallini as his model. Of course a similar composition may already have existed at San Francesco a Ripa in Rome, although the specific allusion to Assisi is likely to have been an innovation. It is fascinating in itself, since it reflects a new adventure in art that was to preoccupy such masters as Giotto and Duccio—a concern for the *genius loci*, for the evocation of a specific building or town or landscape setting. The St Francis Master's attempt to represent Assisi is considerably more advanced than Cavallini's rather stylized mode of representing Jerusalem, even if it falls short of the extraordinary conviction of reality which the St Cecilia Master was able to lend to his glimpse of the piazza in the opening scene—a composition that may truly be described as the first modern street-scene in European art.

Elsewhere in the *Gift of the Mantle* the St Francis Master reveals his relationship to Cavallini: the powerful lighting, which falls consistently from one side, creating hard edges in the landscape forms and in the deeply chiselled draperies, must derive directly from Cavallini's example and perhaps also from that of the Isaac Master; the placing of the figures on a narrow foreground plane, leaving the 'middle distance' somewhat unresolved, and the boldly sculptural aspect of the figures themselves, almost giving the impression that they have been carved out of stone, are no less 'Cavallinesque' in character. Yet the St Francis Master tends to explore the possibilities of gesture much further, and to delight more in giving animation to his figures. Altogether he evinces a lively curiosity of eye, and attempts problems of naturalistic representation and of perspectival illusionism that go beyond Cavallini's explorations in his surviving works. Unlike the city of Jerusalem in Cavallini's *Adoration of the Magi*, the cluster of little dwellings that make up the *città santa* of Assisi in the *Gift of the Mantle* is represented satisfactorily from below eye-level, and the orthogonals, or perspective lines, of these buildings and of the church on the right incline inwards towards the centre of the composition: naturalistic perspective is in process of birth. As in the mosaics at Santa Maria in Trastevere, there is a general tendency in the St Francis Master's frescoes at Assisi to impose upon each composition an almost geometric symmetry. This is one of the features of the *St Francis* cycle that contrast with Giotto's method of design in the Arena Chapel. Nor, indeed, is the mind of Giotto to be discerned at Assisi either in the human types or in the conventions employed in the depiction of architecture and landscape. Further, the Assisi painters tend to retain a planar system of pictorial movement, where Giotto insists upon spatial composition.

Above all, perhaps, the virtues of the St Francis Master and his associates at Assisi are apparent in the clarity with which they expound, in the language of painting, the religious themes set forth in their principal literary source, the *Legenda maior* of St Bonaventura,

extracts from which are paraphrased in inscriptions below the frescoes. The compilation of the *Legenda maior* was due to a decision of the Franciscan Order made at the Chapter of Narbonne of 1260 (presided over by Bonaventura as Minister-General), when it was re-solved that all earlier accounts of St Francis should be destroyed and replaced by an official *Life* consonant with Franciscan orthodoxy. As mentioned earlier, the Friars Minor saw the coming of Francis as marking the inauguration of a new age, and Bonaventura's intention was not only to write a clear account of his life, emphasizing the sanction given to his ministry by the Church, but also to set forth its spiritual significance. Likewise the *Legend* at Assisi is more than a sequence of narratives: running through it there is a carefully woven theological pattern. There could be no better illustration of this fundamental element in the *St Francis* cycle than the group of three scenes in the third bay from the altar on the north wall (*Plate 41*).

The three episodes were conceived as a unified whole, enframed by a splendid invention of illusionistically rendered columns and corbels, through which we look at the sequence of narratives. This method of organization, which is common to all the bays, has its origins in Rome, and there are particularly close resemblances to the columniated framework of a tenth-century decoration at San Crisogono. The first of the three scenes shows the sanction-ing of the Franciscan Rule by Pope Innocent III; the second a vision of St Francis ascending in a fiery chariot like another Elijah; and the third a further vision, explained to a friar by an angel, of the throne in heaven reserved for St Francis among the thrones of angels. Upon the triad of scenes there has been imposed an all-embracing pattern of ascending and descend-ing movements, assisted by the use of perspective to establish firm direction-lines, as the spectator's eye is carried up from the humble Saint in the first scene to his glorification in the second, and thence in a downward direction in the closing narrative, where it comes to rest in a further representation of the Saint in a kneeling posture. The deliberate nature of this method of planar design can be judged from the emphasis given to the slanting lines of the thrones (the treatment of which is otherwise inexplicable) and the projecting roof of the chancel in the final fresco of the group.

What is being brought to our attention is not simply a series of episodes in the life of St Francis, but the meaning of that ideal of holy poverty and humility which was enshrined in the Franciscan Rule (the subject of the first of the three scenes), and which entitled the Saint, by his absolute obedience, to a place among the angels (the subject of the third scene). As Bonaventura had expressed it, it was by becoming nothing, according to the precepts of the Rule, that the truly humble would be 'exalted to that excellent glory from which the proud are cast down'. It is no less significant that in the central fresco Francis should be likened to Elijah, who in the presence of Elisha was taken up to heaven in a chariot of fire. In Christian thought and in medieval iconography the ascension of Elijah had always been seen as the Old Testament type of the Ascension of Christ; but now in the *Legend* at Assisi Elijah is

presented as the type of Francis himself—a daring comparison that has Bonaventura's authority behind it, for after telling the story which the fresco illustrates, Bonaventura comments thus upon the reaction of the Saint's companions:

> For truly they all with one accord understood, when they looked into each other's hearts, that although their holy father was absent in body he was present in spirit, and that through the operation of a supernatural miracle he was being shown to them by God transfigured in this way, radiant with heavenly brightness and on fire with heat, in a shining and fiery chariot, so that they, as Israelites indeed, might follow after him, since he had been made by God, like another Elijah, the chariot and horseman of spiritual men. Indeed, we must believe that He opened the eyes of these simple men in answer to the prayers of Francis himself, so that they should see the power of the majesty of God, Who had once opened the eyes of the young man so that he might see the mountain full of horses and chariots of fire round about Elisha.

In other frescoes of the cycle there are clear statements of the Franciscan insistence upon Francis's likeness, not merely to such Old Testament prophets as Elijah and Moses, but to Christ himself—an interpretation of Francis's special significance in the history of Christianity which again occurs in the *Legenda maior*, as also in other Franciscan writings. So, for example, one of the frescoes, representing the bearing home of the Saint's body to Assisi (*Plate 31*), borrows from the iconography of scenes of Christ's entry into Jerusalem a striking image—that of a boy climbing a tree to gather festive branches,—thus making by pictorial means the same implicit comparison with the Gospel story that is already embedded in Bonaventura's text. But perhaps the most perfect expression of this theme of Francis's likeness to Christ—of which his followers saw manifest confirmation in the miracle of his Stigmatization, whereby he had received the very wounds of the Crucified—is to be found in the bay on the south wall (*Plate 42*), which opens with the scene of the *Death and Ascension of St Francis*. Here the ascension image in the first of the three scenes, showing St Francis carried to heaven by angels, is directly related, in a compositional sense, to a crucifix represented on the rood-beam of a church in the third scene (the *Verification of the Truth of the Stigmata*).

That 'family of styles' to which the painters of the *Legend* adhered was ideally fitted to carry such overtones of meaning. In the example just cited, the somewhat rigid geometry of design, which by means of a simple horizontal zone in the upper reaches of the frescoes defines the celestial regions and separates heaven from earth, not only pleases by its symmetry but makes possible telling associations of religious imagery; and in the bay opposite, in which Francis's exaltation like a second Elijah is combined with its explanation—his possession of a surpassing humility,—the 'primitive' system of perspective itself contributes to the

expression of the deeper meaning that underlies the story of the heavenly chariot. A more 'advanced' style could easily have impoverished the painters' language. As so often happens in the history of the arts, the themes that preoccupied the age found in contemporary style the perfect medium for their expression.

It may be said that the common purpose shared by the painters of the *Legend* triumphed over their differences of style, which embrace marked variations in quality—some of the assistants' work (as for example in the figures of the friars in the *Sanctioning of the Rule*) being very inferior. These differences are most noticeable when we reach the later frescoes on the south wall, for the Master of the Obsequies and the St Cecilia Master share a delicacy and refinement absent from the earlier scenes by the St Francis Master and by the author of the *Miracle of the Spring* and other frescoes near the entrance. It would seem that two pairs of related painters dominate the whole enterprise. Thus the stylistic differences between the first pair—the St Francis Master and the author of the *Miracle of the Spring*—are far less radical than those that distinguish these painters from their two successors on the south wall, who bring the cycle to completion.

It is in the area of the entrance that the morphological resemblances to the figure style of Pacino di Bonaguida are most in evidence (although they also occur elsewhere in the cycle). Figures similar to the two friars in the foreground of the *Miracle of the Spring* often appear in Pacino's miniatures and panel-pictures, where we also find other figures with much the same proportioning as the rather squat, large-headed St Francis in the adjacent fresco of the *Sermon to the Birds*, as well as female figures that recall some of the women represented in the next scene, the *Death of the Knight of Celano*. Equally interesting is the exact correspondence between the landscape conventions found in the work of Pacino and those adopted in the *Miracle of the Spring*. Preserving the traditions of the early Trecento, Cennino Cennini, in his *Libro dell'arte*, was to recommend painters to take stones or rocks into their workshops and to use them as the basis for their representations of landscapes; and this practice accounts for the model-like aspect of many landscape backgrounds in early Italian painting in general. Nevertheless, each artist had his own way of looking at Nature, and the conventions employed by such painters as Giotto, the St Francis Master, Duccio, Simone Martini and the Lorenzetti are all quite distinctive and individual. So when we find in the *Miracle of the Spring* (*Plate 43*) and in the work of Pacino (*Plate 44*) precisely the same type of rocky hill or scarp, cleft in exactly the same manner into deeply cut, curving fissures, or variegated with patterned facets which have a fundamentally decorative function, it is hard to accept that such close similarities are merely fortuitous.

The whole question of Pacino's relationship to the Assisi cycle is more complex than it is possible to indicate here; but the fact that the stylistic connections are especially marked in one of his early panels, the *Tree of Life* in the Accademia in Florence (*Plate 83*), suggests the possibility that he was a member of the Assisi workshop towards the beginning of his career.

If this was so, then we know the name of at least one of the painters of the *Legend*. Such a reading of the problem would confirm the Florentine paternity, although not of course the Giottesque authorship, of at least some of the later stages of the decoration, since the St Cecilia Master also worked almost exclusively in Florence and the neighbourhood. At the same time, the Roman origins of the art of both Pacino and the St Cecilia Master can be deduced from their altarpieces; and the same inference can be drawn from the style of the St Francis Master and from the character of the *Legend* as a whole: the path from Rome to Assisi seems to lead on to Florence.

Nevertheless, it would not be surprising if local Umbrian painters were drawn into the great programme for the decoration of the basilica. Certainly, the closest affinities with the frescoes by the Master of the Obsequies are to be found in the large *Madonna with St Paul and St Benedict* (Plate 160) formerly at Montelabate, near Perugia, which bears the signature of the Umbrian painter Marino da Perugia. The miniaturist delicacy of Marino's style, the refinement of his drawing and the rich glow of his colour are all paralleled in the scenes relating to St Francis's obsequies on the south wall at Assisi. Their painter, it would appear, came to his task without much, if any, experience of the techniques of fresco, since he employed unusually small *intonaco* patches, at least to begin with—a method, admittedly, that would in any case have suited his interest in minute detail. In sheer beauty of workmanship and in richness of effect, his frescoes far surpass the earlier scenes in the cycle (that is to say, those still ascribed by most Italian scholars to Giotto), and reveal a consummate taste that has much in common with that of the St Cecilia Master, who worked alongside him and probably influenced the designs of his elegant compositions.

One distinctive feature of these scenes is the tendency to crowd a composition with figures. It is difficult to think that this aspect of the frescoes is entirely due to the requirements of iconography—to the need to be faithful to the stories that told of the vast throngs which flocked to Assisi to pay tribute to St Francis after his death. One reason for it is undoubtedly stylistic; for at this point in the cycle the figures are reduced in size, and given a more natural scale in relation to the buildings they inhabit. This interesting development is consummated in the final three frescoes, painted by the St Cecilia Master. We also find here a number of figures represented in a back view, as we never find on the north and east walls, with the sole but partial exception of a friar in the *Vision of the Chariot*, seen in a three-quarter back view but with his head in profile. Such explorations in the representation of the human figure already occur at Assisi in the work of the Isaac Master (notably in the scene of *Pentecost*); but we associate them particularly with the art of Giotto and with the frescoes in the Arena Chapel; and it may be inferred that by the time the decoration of the south wall at Assisi was under way the impact of Giotto's revolutionary style was making itself strongly felt. One example of Giotto's presumed influence is to be found in the splendid scene of *St Francis mourned by St Clare and her Companions* (Plate 31), in which the boy

climbing a tree (already mentioned in the context of the iconography of this fresco) recalls the similarly posed figure in *Christ's Entry into Jerusalem* in the Arena Chapel.

The Assisi fresco presents us with a scene of tender and moving pathos, not untouched by a gentle lyricism. The treatment of the architecture is as fine as anything in the *Legend*, and includes beautifully rendered sculptures of saints and angels, besides evincing an adventurous curiosity about effects of light and shade and even the depiction of cast shadows. It cannot be said that any of the frescoes by the St Francis Master approach the quality of this composition, which is as remarkable for its mastery of fluent drawing and refined colour as for its imposing design.

The *Legend* concludes, in the altar-bay on the south wall, with three posthumous miracles of St Francis. As we have seen, these frescoes, and the first of all—*St Francis honoured by a Simple Man of Assisi* on the north wall (*Plate 30*)—were executed by the St Cecilia Master. The latter fresco is typical of his art, which is notable for its concern with harmony of design as well as for its narrative charm. No less distinctive are his elegant, aristocratic figures, with their petite hands and feet and their graceful, studied movements and lively expressions. His style must have had its origins in the circle of Cavallini, and with all their elegance his figures possess a substantiality that can have been derived only from Cavallini's example; and they are finely modelled in light and shade. As a colourist, especially in the three final scenes at Assisi, he is equally a master, showing also a refined sensitivity to effects of pattern and texture. Moreover, the St Cecilia Master was the supreme exponent of fresco painting among the various authors of the cycle. Like Giotto himself, he avoided such technical faults of the St Francis Master as the use of white lead, which eventually turns black (with the consequence that much of the original detail on the north wall has been lost); and he worked with such assurance and rapidity that he often laid out his *intonaco* patches in extraordinarily large areas. In the final three scenes at Assisi—for example, in the *Liberation of Peter of Alifia from Prison*, where the setting is Rome, as is indicated by a wonderful representation of Trajan's Column, adorned with brilliantly drawn reliefs—he experiments more than in the opening scene (evidently anterior in date) with effects of light, which catches the edges of forms while others disappear into shade. Such adventures have already been noted in the frescoes by the Master of the Obsequies, and reflect the stylistic development which occurs within the *Legend*, as we pass from the Cavallinesque art of the St Francis Master to the more 'advanced' painters who completed the work. If the St Francis Master was Giotto, then Giotto was a primitive among the authors of the cycle. At all events this stylistic evolution carries us from the Roman world of Cavallini and his immediate heirs to the threshold of Trecento—and specifically Florentine—painting, which was to be dominated by the genius of Giotto, but which was ample enough to embrace many achievements distinct from his own.

Duccio and his followers in Siena

The revival of mural painting by Cavallini in Rome and its development by the masters of the following generation, notably in Tuscany, established the art of fresco as the medium in which the Italian genius, during the long period of artistic achievement that stretches from the age of Giotto to the age of Michelangelo, was to find its most characteristic expression. On the other hand no work in fresco attributable with certainty to Giotto's great Sienese contemporary Duccio di Buoninsegna has come down to us; but parts of the Biblical cycles at Assisi have sometimes been ascribed to him. It is of interest in this context that a group of figures in the *Crucifixion* (*Plate 46*) in Duccio's supreme masterpiece, the *Maestà* for Siena Cathedral, repeats a passage found in Cimabue's fresco of the *Crucifixion* at Assisi (*Plate 17*) —an apparent borrowing that might indicate Duccio's presence in Assisi at some time before the execution of the *Maestà* (*Plates 45–48, 50–52, 66*).

The *Maestà* was commissioned in October 1308 for the High Altar of Siena Cathedral and was completed by June 1311. In addition to the large-scale representation of the Virgin and Child, enthroned amid a company of angels and saints, which fills the entire central section of the front of the altarpiece, the whole *ensemble* as originally executed included, in the predella below, seven scenes from the early life of Christ, each of them flanked by figures of prophets who had foretold the incidents depicted, and above, within a sequence of seven pinnacles, scenes of the last days of the Virgin (culminating, probably, in a *Coronation of the Virgin*). The back of the altarpiece was given over to an extensive series of panels illustrating the life of Christ—the predella containing stories of his ministry, the large central area (behind the *Madonna enthroned in Majesty*) being filled with unusually numerous scenes of the Passion, and the pinnacles reserved for the glorious conclusion of Christ's redemptive work for mankind, seen in his Resurrection, his appearances to his disciples, his Ascension and the final drama of Pentecost. This is the earliest surviving altarpiece with predella panels, although a work painted a few years before by either Duccio or Cimabue, which is now lost, is known to have included a predella.

There can be little doubt that the intention of the Sienese authorities in commissioning an altarpiece of unprecedented splendour and complexity was to rival the potentialities of the monumental fresco cycle. It is no wonder that this masterpiece, which unfortunately can no longer be seen in its entirety, was carried by the rejoicing citizens and clergy of Siena in triumphal procession from the painter's workshop to its destined place in the cathedral, to the sound of pipes and drums. The occasion has been described for us by a contemporary

chronicler, who did not disguise his pride that Siena could boast an artistic achievement worthy of comparison with any other in Italy. The *Maestà* was commissioned to replace an earlier *Madonna*, to whose miraculous agency the Sienese had attributed their crushing victory over the Florentines at Montaperti. After the battle the Sienese authorities had in solemn rites placed their city under the eternal protection of the Virgin; and Duccio's *Maestà* was to be a crowning token of the city's devotion to the *Regina coeli*, who thus had also become Queen of Siena.

Duccio's art was compounded of many elements. It can be related to that of his countryman Guido da Siena, with whom he shared a profound debt to the Byzantine heritage. But he belonged to the emergent world of Italian Gothic, already manifested in Siena in the elaborate sculptural decorations by Giovanni Pisano on the façade of the cathedral; and, like Giotto, he was aware of developments in Rome, as his treatment of architectural motifs demonstrates most clearly. Yet beside Giotto he appears in some respects curiously archaic, until we remember that he belonged to an earlier generation and that the *Maestà* (although slightly later in date than Giotto's frescoes in the Arena Chapel) was the work of a man about fifty-five years old. Duccio takes his place in the history of Italian painting beside Cimabue rather than beside Giotto, save only that he lived long enough to come to terms, in his own fashion, with the preoccupations of the new age, and so to invest the traditional narratives with a humanity and intimacy of presentation loosely comparable with Giotto's ideals, although expressed in a quite different pictorial language.

The closeness of Duccio's world to that of Cimabue is apparent from the large *Rucellai Madonna* (*Plate 5*), which, as we have seen, was painted for a chapel in the church of Santa Maria Novella in Florence. Duccio's *Madonna* was commissioned by the Compagnia dei Laudesi di Maria Vergine in April 1285, and probably postdates Cimabue's slightly smaller *Madonna* for Santa Trinita (*Plate 13*) by a few years. (The name *Rucellai Madonna* merely derives from the fact that when, in the mid-fourteenth century, the chapel of the Laudesi was acquired by the Bardi family, the picture was removed from its original position over the altar and later found its way into the nearby Cappella Rucellai.) It is understandable that so imposing an altarpiece of this period, painted for a Florentine church, should have been assumed, by the fifteenth century, to be the work of the celebrated Cimabue; but there is no reason to doubt that the picture documented in 1285 as having been commissioned from Duccio is to be identified with the *Rucellai Madonna*.

These two great altarpieces by the leading masters of the Sienese and Florentine Schools of the late Dugento can be easily compared, since they now hang in the same room in the Uffizi. Beside Duccio, Cimabue seems austere and even rigid in his adherence to Byzantine conventions. Duccio does not seek to approach Cimabue's heroic ideal; and although in his modelling of the figures and in his concern to represent the Madonna's throne in perspective he shows a comparable interest in the rendering of form and space, he allows the sinuous

grace of his line, the charm of the silhouette, and the delicate harmonies of his palette to take precedence over Florentine monumentalism and *disegno*. The distinctive preoccupations of the two masters, who would probably have been in close contact at this time, are epitomized by the difference between Duccio's ethereal, floating angels and the more substantial angels and prophets of Cimabue. As Cecchi wrote of Duccio's ecstatic beings, 'it is the meeting of a beauty steeped in sentiment, like the impassioned beauty of a woman, with the sovereignty of the angel or the cherub, and creating together a sort of sexless idol'. The solemn angel-ministers of Cimabue's imagination are more coolly and, as it were, more objectively observed.

The contrast speaks eloquently of the divergent paths taken by the Florentine and Sienese Schools, notwithstanding the connections between them; and just as Cimabue can be related directly to Coppo and to the style of the later Baptistery mosaics, so the *Rucellai Madonna* reveals Duccio as more fundamentally the artistic heir of his countryman Guido da Siena (see *Plates 12, 25*). At the same time Duccio's connections with thirteenth-century Gothic must be stressed, and there is every reason to assume his familiarity with French Gothic illuminations and stained glass windows: even on this scale—as in the Siena *Maestà*—he preserves the exquisite values of the miniaturist. But the styles of both Duccio and Cimabue remain rooted, ultimately, in Byzantine traditions, and the individual panels of the *Maestà* show that Duccio was able to breathe fresh life into his subject-matter by infusing into Byzantine iconography a new spirit that is primarily Gothic in character.

The Santa Trinita and Rucellai *Madonnas* take their place in Dugento art as the supreme pictorial interpretations of that fervent devotion to the Blessed Virgin Mary which, partly under the influence of Franciscanism, reached its climax at this time. Each represents the Virgin in her exalted role as the *Regina coeli*, the Queen of Heaven enthroned among the angels. Yet the new emphasis upon the humanity of the Virgin, which has already been touched upon in relation to earlier works of the century, and which is particularly noticeable in Siena, a city that was now known officially as the *vetusta civitas virginis* (the ancient city of the Virgin), relates directly to the growing insistence upon her approachability as the media-trix between man and God. If the believer hesitated to approach the awesome throne of God Himself, he could still his fears in the presence of Christ's gentle Mother. As St Bernard urged in his *Sermon on the Nativity of the Virgin*, 'Perhaps you . . . fear the divine majesty in Him, for, though it was permitted that He should become man, yet He remained God. Do you want an advocate to plead with Him? Then turn to Mary . . . I tell you certainly that she will be heard because of the reverence due to her. The Son hears the prayer of His Mother, and the Father hears the prayer of His Son.' By the twelfth and thirteenth centuries the doctrine of the *necessary* mediation of the Virgin Mary had begun to crystallize, and St Bonaventura was to maintain that 'no one can enter heaven except by passing through Mary, the door of heaven'. Such ideas are contained in many of the theological and devo-

tional writings of the period, from the sermons of St Bernard to the *Speculum beatae Mariae* ascribed to Bonaventura.

At times the veneration of the Virgin becomes the vehicle for lyrical outpourings of particular intensity, whether in the popular poetry of the Middle Ages or in the prose of such writers as St Bernard and Albertus Magnus. As St Bernard, in his commentary on the Song of Songs, had amplified the ancient tradition which associated the fair bride addressed in the poem with Mary herself, so the *Mariale* of Albertus Magnus (an older contemporary of Duccio and Cimabue) expatiates likewise upon the Virgin's beauty: 'We say ... that just as our Lord Jesus Christ was beautiful in appearance above the sons of men, so the very Blessed Virgin was most lovely and beautiful amongst the daughters of men, and that she had the highest and most perfect degree of beauty possible in a mortal body, nature giving it to her always according to her age.'

There is no single painting that more comprehensively translates these conceptions into the language of art than Duccio's Siena *Maestà*, where the Madonna, at once regal and beautiful, enthroned as in a palace and courted by a retinue of angels and saints, yet gracious and compliant in aspect, seems literally to embody the sentiment expressed by St Bernard: 'No grace comes down to earth from heaven, save that which passes through the hands of Mary.' As the symbolic 'door of heaven', well might the Virgin Mary be presented thus to her devotees, on the front of the altarpiece, together with scenes from the infancy of her Son and from her last days, while the whole story of the Redemption, with its accent upon Christ's Passion, was reserved for the back of the vast, free-standing ensemble.

The organization of the thirty-four Passion scenes (*Plate 45*), which are still preserved in their entirety, is of considerable interest. They are disposed in four registers, the top two registers being separated from the lower two by a horizontal band. The total arrangement is basically symmetrical, but not entirely so. The *Crucifixion* (*Plate 46*), which is given pride of place as the climactic point in the divine drama, extends to the whole height of the two topmost registers, and occupies a central position between the group of Passion narratives leading to the *Procession to Calvary* and the final group which concludes with the appearances of the Risen Christ. The *Crucifixion* is twice the height of each of the neighbouring scenes and one-and-a-half times as wide. This distinctive format is balanced in the lowest two registers by the two central episodes, immediately below, representing *Christ at Gethsemane* and the *Kiss of Judas* (*Plate 66*), each of the same width as the *Crucifixion*. These paired scenes, the one below the other, combine therefore with the *Crucifixion* to form a kind of vertical shaft at the centre, and help to bind the upper and lower fields together.

Yet an apparent anomaly at once strikes the eye of the modern beholder, for we discover in the lower left-hand corner of the cycle one other composition, the *Entry into Jerusalem* (*Plate 48*), which, although having the same width as the small scenes, also extends to the height of two registers. It might seem at first sight that there was something haphazard

about the intrusion of this larger composition into the well-balanced ordering of the lowest registers, where otherwise harmoniously related interiors enclose on either side the central landscapes of the *Kiss of Judas* and *Christ at Gethsemane*. Then we notice that these last two narratives are followed immediately by two interior scenes—*St Peter's First Denial* and *Christ before Annas (Plate 50)*—which in fact form a single composition extending from the fourth to the third register: we look, indeed, into two storeys of the same building, and a stairway leads up from the lower room, where St Peter warms himself at the fire, to an upper room, where Christ is brought before Annas. This double scene corresponds, therefore, to the *Entry into Jerusalem*, and each scene acts as an introduction to the narratives set forth in a group of four smaller compositions. The effect is not one of symmetrical balance in the strict sense, but there are indications elsewhere in Trecento art that such concordances came naturally to the painters of the period.

It will be apparent from the foregoing that the narratives unfold from the lower left corner of the total field to the top right corner. Through the gateway in the *Entry into Jerusalem* we are led, as it were, into the drama of Christ's Passion, while the gateway in the *Walk to Emmaus (Plate 52)* leads us out. Chronologically, the narratives in the two bottom registers precede those in the two upper registers. The upward momentum of the narrative is epitomized in the final composition in the top right corner, the *Walk to Emmaus*, where the whole design contributes to a soaring movement across the picture-plane—a movement containing symbolic overtones that scarcely require elucidation. But within this general pattern Duccio introduced subtle variations according to the requirements of his narrative: the lower scene of two vertically paired episodes does not always depict an incident in the Gospel story antecedent to the upper scene; there is considerable flexibility, which allows even for simultaneity of dramatic action—as in the case of the paired scenes of *St Peter's First Denial* and *Christ before Annas*.

Still more remarkable, perhaps, is Duccio's concern with the *mise en scène*: the rooms represented in Christ's successive appearances before Annas, Caiaphas, Pilate and Herod are all quite distinctive, and it is clear, for instance, that the twisted columns of Pilate's palace are references to antiquity appropriate to the dwelling of a Roman procurator. In this context, it is difficult to think that the emphasis given to the *Entry into Jerusalem* had no special significance at the time. One of the most striking features of this composition is the resemblance of the representation of Jerusalem to the city of Siena itself. We may be reminded of the opening scene of the *St Francis* cycle at Assisi, with its vivid evocation of the Piazza Minerva *(Plate 30)*, which must have brought home to the Assisans the realities of their Saint's life and ministry and the glory that he had conferred upon their city: but in Duccio's picture a story from the Gospels themselves has been made into a present and abiding reality, as though to suggest that the people of Siena had as much choice in acclaiming or rejecting the Saviour as the populace of Jerusalem.

The means by which the rising pictorial movement in the *Walk to Emmaus* is effected brings home to us the futility of any approach to Trecento painting that seeks to form aesthetic judgments upon principles appropriate only to a different period. The walled gateway of the town and the path leading to it are treated in a manner that at first sight may seem naïve in comparison with the more 'advanced' solution of perspectival problems in other scenes on the *Maestà*, such as the *Christ before Annas*, where the upper room is effectively rendered in terms of a centralized interior. Yet an apparent discrepancy of this nature reminds us that perspective, as we understand it today, and as it was rediscovered by the masters of the fifteenth century, forms only one element of a painter's language; and evidently, for Duccio, symbolic values took precedence over merely representational aims. In this case both the architectural forms and those of the landscape establish that pictorial movement which ascends towards the gabled pinnacles of the altarpiece, reserved for the ultimate statement of Christ's triumph and glorification. The joyousness of the expectant crowd in the *Entry into Jerusalem* finds here its theological justification and fulfilment.

Duccio's gift for narrative can be seen at its most impressive in the tumultuous *Kiss of Judas (Plate 66)*, which differs from Giotto's interpretation of the same subject in the Arena Chapel *(Plate 65)* by its closer dependence upon Byzantine iconography. At the same time a comparison with the fresco ascribed to Torriti at Assisi *(Plate 28)* will show the extent to which Duccio revitalized the tradition by endowing the various actors in the clamorous scene with an individuality and a capacity for emotional response that may have owed much to the enactments of the Passion in the religious dramas of the period. Duccio's delight in crowding his compositions with figures distinguishes him no less markedly from Giotto, who prefers to condense the elements of his subject-matter into a minimum of meaningful images and forms. Duccio is more anecdotal, but no less supreme an exponent of dramatic action: where Giotto retains an almost classical reserve, and dignifies each scene by a measured prosody, Duccio allows his deeply felt emotions to dictate the structure of his compositions. It is perhaps significant that the three dominant trees in the background of the *Kiss of Judas* on the *Maestà*, serving the threefold function of drawing attention to the central figure of Christ, to that of St Peter, and to the spiritual gulf that separates the fleeing disciples from their Master, were discarded by Barna when he came to reinterpret Duccio's composition in his fresco at San Gimignano; for it was the emotional expressiveness of Duccio's figures that evidently impressed his followers most, if we exclude the inventiveness and beauty of his colour. Thus Pietro Lorenzetti, in his vault fresco of the *Entry into Jerusalem* in the Lower Church at Assisi *(Plate 49)*, attempted to rival the bustling energy of the crowd at the city gates as Duccio had rendered it, asserting the continuance in the Sienese School of values independent of those upheld by Giotto and his immediate pupils.

Duccio, besides being a guardian of older Byzantine traditions, was one of the pioneers of the new naturalism; and the panels of the *Maestà* are rich in closely observed details that

must have been studied from life. A fine example is the servant-girl who questions St Peter in the scene of his first denial of Christ (*Plate 50*), one hand resting upon the banister of the stairway—with her forefinger pointing towards St Peter—as she pauses momentarily from her daily chores. She is shown in a back view, and such figures in the work of Duccio bring the Sienese master's visual curiosity close to that of Giotto himself. There are other aspects of the *Maestà* that recall the art of Giotto as we know it from the Arena Chapel, notably the concern with unity of time and place, the scrupulous attention to the environment appropriate to a particular scene, and a deep interest in the characterization of individuals.

Yet neither his naturalism nor his skill as a narrator is ever permitted to detract from the spiritual and aesthetic ideality of his art. It is impossible to separate the various elements of his rich pictorial language, since they each form part of a coherent whole; and least of all can this be done in respect of the dual function of his radiant palette, which on the one hand reveals him as one of the most inventive masters of colour orchestration in the history of European painting, surpassed in this period only by his presumed pupil Simone Martini, and on the other appears always to have borrowed its tincture from a vision of eternal harmonies. And it is this latter function of Duccio's colour that gives such a scene as *The Three Maries at the Sepulchre* (*Plate 51*) its overwhelming power as a restatement of a subject already stereotyped by its rigid codification in Byzantine iconography: who could forget the splendour of the angel's white and yellow robes, or the resonant harmonies of the draperies which the three human figures draw around them as they approach the mystery of mysteries?

Duccio evidently commanded a large workshop, and three of his sons are known to have been among his assistants; other pupils, such as Mino and Masarello, are recorded in documents, but none of these painters can be definitely connected with any surviving work. There are, however, signed paintings by his cousin Segna di Bonaventura, an artist documented between 1298 and 1326, and by Ugolino di Neri, documented in 1319, both of whom faithfully continued the Ducciesque tradition, although developing it in diverse directions—the one forming a bridge between the style of Duccio and that of Simone Martini, and the other having certain affinities with Pietro Lorenzetti. Two *anonimi*, the Maestro di Badia a Isola and the Maestro di Città di Castello, typify the strictly conservative outlook reflected in so many paintings of Duccio's School. They take the names by which we know them from two impressive altarpieces of the *Madonna Enthroned*. The picture in the church of Badia a Isola (near Siena) combines some of the qualities of the *Rucellai Madonna* with an incisive clarity of drawing, which is especially marked in the throne with its Cosmatesque details; and the more ambitious picture at Città di Castello shows a deeper sympathy with Duccio's tender lyricism and an altogether finer feeling for spatial design and compositional harmony.

Segna and Ugolino are more important figures. Segna's major altarpiece, the signed

Madonna in Majesty in the Collegiata of Castiglion Fiorentino, demonstrates his early adherence to the formulae of his master, as do also his numerous small panels of the *Virgin and Child* (see *Plate 54*), in which he is at his most charming. Ugolino was a stronger personality, and the narrative scenes of his now dismantled polyptych for the High Altar of Santa Croce in Florence, which was probably executed in the 1320s and which was signed by him possess a vigour and intensity of expression almost worthy of Duccio himself. A good example is the *Crucifixion* now in a private collection (*Plate 53*). Indeed, the close iconographical dependence of these panels upon those of the *Maestà* suggests that the Santa Croce altarpiece was intended to provide Florence with a counterpart, as it were, of Duccio's celebrated masterpiece. The presence of this work in Santa Croce may well have provided a channel for Sienese influence upon Florentine painting. Duccio himself had died in 1318 or 1319, and it is a measure of Ugolino's reputation as perhaps the leading exponent of the great Sienese master's style that this important work should have been commissioned from him: the strength of his drawing and his understanding of the structure of the human figure, which were his principal contributions to the development of the Ducciesque manner, would undoubtedly have found favour among the Florentines. Duccio had already experienced the force of the innovations introduced by Giotto, which were increasingly to influence his own followers in Siena; but the Santa Croce polyptych witnesses nevertheless—and it is not alone in this—to the continuing vitality of the traditions that he had founded and transmitted to his pupils.

FOUR

Giotto

The early writers, from Boccaccio to Vasari, all recognized that with the advent of Giotto a new era had opened in the history of painting. As Ghiberti wrote in his *Second Commentary* (of about 1450), 'Cominciò l'arte della pittura a sormontare in Etruria in una villa allato alla città di Firenze, la quale si chiamava Vespignano' ('The art of painting began to arise in Tuscany in a village near the city of Florence, called Vespignano'). The village boy from Vespignano who was to become the supreme artist of his age was born, according to Vasari, in 1276. Perhaps Vasari read this date on Giotto's tomb. On the other hand, the fourteenth-century poet Antonio Pucci, who produced a somewhat inaccurate rhymed version of Giovanni Villani's *Chronicle*, states that when Giotto died in 1337 he was seventy years old: accordingly, although it is questionable whether Pucci is to be trusted on this matter, most modern historians have concluded from his evidence that Giotto must have been born some ten years before the date given by Vasari. The question is still an open one, and it is possible that neither Pucci nor Vasari was right. What we do know is that Giotto is first documented in Florence in 1301, and that the first securely datable work by him is the fresco cycle in the Arena Chapel at Padua, painted between 1303 and 1306 for its founder Enrico Scrovegni. But he must have established his reputation much earlier, and, as we shall see, there are grounds for believing that the principal surviving work from the pre-Paduan period is the great altarpiece for Old St Peter's in Rome, even though so early a dating for the altarpiece has been denied by the majority of students of Giotto and remains controversial.

It is possible, as Gioseffi has attempted to prove, with interesting arguments, that Giotto was himself the architect of the little chapel which Enrico Scrovegni had decided to build beside his magnificent palace at Padua, and which Giotto was to decorate with his peerless frescoes. The palace of the Scrovegni was destroyed in the nineteenth century; but the Arena Chapel—so named because of its position near an ancient Roman amphitheatre—remains as the *locus classicus* of Giotto's art, a place of pilgrimage for lovers of painting, displaying in a remarkable state of preservation the greatest and the most complete of his few surviving fresco cycles (*Plates 60, 61*, Fig. A). The scheme of the decorations is highly complex in content, and includes apparent allusions to the circumstances under which the chapel was founded and to religious ceremonies associated with an earlier church dedicated to the Virgin Annunciate which had stood on the same site, as well as introducing into the main Christ cycle a whole new iconography of theological parallelisms which clarify the meaning of each episode and its place within the larger theme of the redemptive work of Christ.

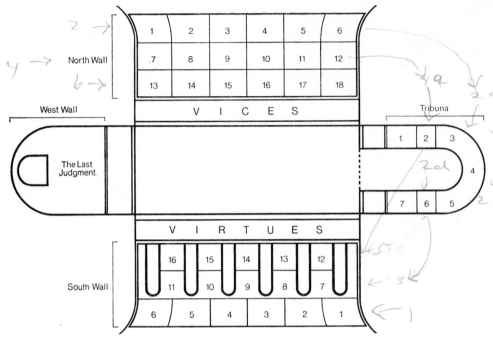

FIG. A *Diagram of the frescoes in the Arena Chapel, Padua*

NORTH WALL

1. Birth of the Virgin
2. Presentation of the Virgin
3. Wooers bringing the Rods
4. Wooers praying
5. Marriage of the Virgin
6. The Virgin's Return Home
7. Christ teaching in the Temple
8. Baptism of Christ
9. Marriage Feast at Cana
10. Raising of Lazarus
11. Christ's Entry into Jerusalem
12. Cleansing of the Temple
13. Procession to Calvary
14. Crucifixion
15. Pietà
16. Resurrection *and* Noli me tangere
17. Ascension
18. Pentecost

TRIBUNA

1. Perspective of chapel
2. Pact of Judas
3. The Angel of the Annunciation

4. The Debate in Heaven and God the Father sending the Archangel Gabriel
5. The Virgin of the Annunciation
6. Visitation
7. Perspective of chapel

SOUTH WALL

1. Expulsion of Joachim
2. Joachim's Return to the Sheepfold
3. Annunciation to Anne
4. Sacrifice of Joachim
5. Vision of Joachim
6. Meeting at the Golden Gate
7. Nativity
8. Adoration of the Magi
9. Presentation of Christ
10. Flight into Egypt
11. Massacre of the Innocents
12. Last Supper
13. Washing of the Feet
14. Kiss of Judas
15. Christ before Caiaphas
16. Mocking of Christ

The immense wealth of the Scrovegni family had been compiled by Enrico's father Reginaldo through the practice of usury, a sin that from the time of the early Fathers had been the subject of severe stricture on the part of the Church; and in the seventeenth Canto of the *Inferno* Dante was to single out Reginaldo Scrovegni as the arch-usurer who merited eternal damnation. In the Hell of the *Last Judgment* (*Plate 60*) on the entrance wall of the Arena Chapel, we find a group of usurers hung by their purse-strings—a passage that directly confronts the fresco on the *tribuna* representing the *Pact of Judas* (*Plate 61*), a scene of sordid monetary transaction. This unusual imagery lends support to the statement of a sixteenth-century historian of Padua, Bernardino Scardeone, that Enrico Scrovegni erected the chapel as an act of expiation (see *Plate 56*), in order to redeem his father's soul from the punishment of Purgatory (although, according to Dante, Reginaldo had already been consigned to Hell itself!); and it calls to mind the vivid word-pictures painted by Fra Filippo of Siena in his *Assempri*, a work of the late fourteenth century, when he came to condemn the sin of avarice. Describing, for instance, the death of a certain usurer, Fra Filippo tells how a multitude of fiends in human form, 'dark and terrible beyond all human imagining', carried off the lost soul 'with fury, and with tempest, and with inconceivable rage, biting and smiting and rending and tearing him'.

The new chapel was dedicated to the Virgin Mary, and it was consecrated in 1305 on the feast of the Annunciation (25 March). The church which Scrovegni's private chapel replaced had itself been named Santa Maria Annunziata, and since the later years of the thirteenth century there had been dramatic enactments on Lady Day, outside the church, of the story of the Annunciation. We can understand, therefore, the attention given in the Arena frescoes to the life and person of the Virgin, and above all the emphasis placed upon the *Annunciation* itself, which dominates the *tribuna* and immediately impresses itself upon the visitor as he enters the chapel (*Plate 61*).

Within Giotto's great poem of the Redemption, which unfolds in three registers along the side walls of the nave and on the arch of the *tribuna*, the Annunciation is conceived as the point of intersection, so to speak, of the horizontal movement of time and the vertical irrup-tion of Divine Providence into human history: that is to say, the historical sequence begins at the east (or altar) end of the top register on the south wall, which is devoted to the story of the Virgin's parents St Joachim and St Anne; having reached the west end of the chapel it continues towards the altar in the corresponding register of the north wall, containing episodes from the life of Mary and culminating in her return home after her betrothal to Joseph (*Plate 64*); we then pass at once to the *Annunciation* on the *tribuna* itself, but this momentous event not only follows in precisely the right place in terms of the historical narrative but is also related, compositionally and thematically, to a large fresco directly above, representing a subject rarely treated in art—the contention in Heaven leading to God's decision to take pity upon mankind and to send Gabriel to announce to Mary the

tidings of the Incarnation; a story told by St Bernard and repeated in the *Meditationes* of John de Caulibus, which no doubt was Giotto's actual source.

As we read in the *Meditationes*, it was the angels who first implored the Father to show mercy to fallen man and to deliver him by 'a saving remedy'. There then follows a long account of the debate between Mercy, supported by Peace, and Truth, supported by Justice. These allegorical figures, which reappear in other medieval texts, such as William Langland's *Piers Plowman* (of the late fourteenth century), and which were known as the Four Daughters of God, have their origin in a passage in Psalm 85: 'Mercy and Truth are met together; Righteousness and Peace have kissed each other.' In the *Meditationes*, Mercy and Truth are the sole protagonists throughout the debate, the other Virtues remaining silent. Mercy argues for man's need for rescue, Truth for the maintenance of the divine decree that through Adam's disobedience he and his race must die eternally. God answers: 'One says, "I perish if Adam does not die"; the other says, "I perish if he does not find mercy". Let death become good, and let both have what they ask.' The sending of the Son of God to die for mankind becomes the solution that satisfies the contending parties, and the Father summons Gabriel so that he may deliver his message to Mary: 'And Gabriel being called, He said, "Go, tell the daughter of Zion, Behold, thy King cometh unto thee".'

In Giotto's fresco we see two angelic figures standing before the Throne of Majesty— Mercy kneeling in supplication on the left, and on the right Truth standing with folded arms in an attitude suggestive of an unbending fixity of purpose. The enthroned figure of God the Father combines a regal with a humane aspect. This figure was painted on a panel set into the wall, possibly closing a niche from which a dove would be released during enactments of the Annunciation in the chapel. The inclusion in the Arena Chapel cycle of the poetic myth told at length in the *Meditationes* offers but one instance of the connection between the art of Giotto and that influential example of the devotional literature of the Middle Ages. But before we turn to a consideration of Giotto's pictorial language as it is expressed in the cycle as a whole, a little more must be said about the organization of the frescoes in relation to the structure of the chapel.

The nave is remarkable for the expanse of its plain wall-surfaces, suggesting that from the beginning it was the intention to cover them entirely with fresco decorations. No windows interrupt the north wall, and the nave is lit only by six narrow windows on the south wall and by a larger window high up on the entrance wall. This simplicity of design may well have been due to Giotto himself, and although we have no documentation of his employment as an architect until the last few years of his life, when he was put in charge of the building works at Santa Reparata and began the celebrated campanile of Florence Cathedral, it is more than possible that at the time of the planning of the Arena Chapel he was already in Padua, in the employment of the Franciscans, and that Enrico Scrovegni consulted him in the matter. Certainly the structure of the chapel was ideally suited to Giotto's

sublime conception, which expounds the theme of the Redemption and of the substitution of the Old Law by the New Covenant in clearly defined stages.

The harmonious unity of the whole decorative scheme is evident at once to the visitor as he enters the chapel and looks about him. God's plan for man's salvation, depicted on the *tribuna*, finds its consummation in the large fresco of the *Last Judgment* (the final event in human history according to the Christian scheme of things), which fills the entrance wall directly opposite. In between, the narratives of the story of Redemption carry around the side walls and the lower part of the *tribuna*, the ceiling being reserved for medallions representing *Christ Blessing* and the *Madonna and Child*, each surrounded by smaller roundels containing figures of prophets, and placed against an azure 'sky' studded with golden stars. In Byzantine decoration the images of the *Christ Pantocrator* and the *Regina coeli* would have been given a greater prominence, but in the Arena Chapel all the emphasis is placed upon the storied walls, one episode following upon another as in the sacred dramas of the period.

Yet the design of the ceiling is worthy of attention, since it clarifies the organization of the decorations as a whole. The expanse of the curving vault is divided by a broad decorative band into two fields, the one nearer the altar having at its centre the *Christ* medallion, and the other that representing the *Madonna*. This ornamental feature, which is filled with figures of saints framed by geometric motifs, extends downwards into the side walls, so creating a central point of focus within the narrative cycles. On the north wall, the frescoes of the *Pietà* and *Noli me tangere* are disposed on either side of this band, as unified compositions at the centre of the chapel, the second scene being conceived as the mirror-image of the first (*Plate 37*). Further ornamental borders separate the individual narrative scenes within the three registers. Since each register comprises six scenes, three in each row occupy the lower end of the chapel, and three the upper end. The north wall, accordingly, preserves the absolute symmetry of the ceiling, a symmetry that is also carried into the field beneath the narratives: here, directly below the ornamental borders, Giotto painted a series of figures of *Vices*, corresponding to a similar series of *Virtues* on the south wall. The *Virtues* and *Vices* were executed in monochrome, in imitation of sculpture, and they are particularly interesting on account of the novelty and originality of their iconography. The *Vices* take their appropriate place on the left (or *sinister*) wall, in the vicinity of the representation of Hell in the *Last Judgment*, and the *Virtues* on the right wall; and it is significant that in the *Virtues* series the female figure symbolic of *Hope*, who raises her arms in an eager attitude towards the heavens, is placed next to the Blessed in the *Last Judgment*, so that her gesture carries forward and upward into the awesome scene.

The organization of the frescoes in the two lower registers of the south wall differs from that on the north wall, for it was necessary to take account of the six windows that interrupt this central section of the wall area. The windows do not extend to the uppermost register, so that it was possible here to retain the same number of scenes as on the north wall—three

on each side of the decorative band spanning the vault. In each of the two lower registers, however, there was room for only five scenes, separated from each other by the four inner windows and enclosed by the two outer windows. The middle scenes in the two rows— the *Presentation of Christ in the Temple* and the *Kiss of Judas*—replace the main decorative band in providing the central focus, and the design of both frescoes concentrates upon an inward movement towards the exact centre of the wall. The presence of the windows did not affect the placing of the *Virtues*. It did, however, deprive the south wall of an interesting feature of the wall opposite, where the decorative borders separating the scenes of the Ministry and Passion of Christ (which occupy, respectively, the second and third registers) include tiny representations of Old Testament subjects that relate typologically to each succeeding incident from the Gospel story: such a system was impossible on the south wall, where the windows intervene in place of the decorative borders.

Nevertheless, the Biblical series as a whole embraces a much vaster programme of typological parallelisms. Throughout the New Testament cycle, a complex system of concordances was imposed upon the narratives by means of skilful associations between one scene and another. Attention has already been drawn to the compositional relationship between the *Pietà* and the *Noli me tangere* (Plate 37): here we pass from death to life, from despair to hope, a theme reinforced by the contrast between the barren tree that crowns the rocky hill in the *Pietà*, adding its stark tone to the lament for Christ's death, and the flowers and shrubs springing up before the feet of the Risen Lord in the *Noli me tangere*. More often, however, thematic overtones of this kind are introduced by correspondences between vertically paired scenes: thus the fresco directly above the *Noli me tangere* depicts the *Raising of Lazarus*, in which Christ already asserts his power over death, so that this scene becomes the prelude to his final victory over death by his Resurrection. To take two further examples, the pairing of the *Nativity* with the *Last Supper*, and the *Adoration of the Magi* with the *Washing of the Feet*, seems no less meaningful: just as the *Nativity* opens the story of Christ's infancy, so the *Last Supper* is the prelude to his Passion; moreover, the newly born Child in the *Nativity* is placed directly over the Christ of the *Last Supper*, suggesting a parallel between the Incarnation of the Godhead in man and the indwelling of the Body of Christ in the Eucharist. And as in the *Adoration* (Plate 55) the kings of the earth come, in their pomp, to kneel before the King of Heaven, so Christ, in the *Washing of the Feet*, kneels in humility before his disciples.

The narratives are grouped together within six 'cantos': the top register on the south wall is devoted to the story of the Virgin's parents; that on the north wall to the story of the Virgin herself, culminating in the *Annunciation* and the *Visitation* on the *tribuna*; the second register on the south wall to the Nativity and Infancy of Christ; the second on the north wall to the Ministry of Christ; the third on the south wall to the Betrayal and Trial of Christ (beginning with the *Pact of Judas* on the *tribuna*); and the third on the north wall to

the Passion, Death and Resurrection of Christ, together with the *Ascension* and *Pentecost*, which bring the solemn drama of the Redemption to its conclusion. It can be affirmed with confidence that no surviving mural decoration in the history of early Italian painting approaches the Arena Chapel cycle either in the riches of its content or in the perfection with which its various parts have been knitted into a unified whole. And yet this grand and complex design is but the framework for the manifestation of a new and profound language of pictorial expression, the vehicle for a sublime discourse which few even of Giotto's pupils and immediate followers fully understood.

Although less indebted than Duccio to the Byzantine heritage, Giotto still adapted its iconography to his own uses. While the Arena *Pietà*, for example, owes much to the tradition of the Byzantine *Lamentation*, the accepted conventions are remoulded entirely in a process of reassessment which seeks to assimilate the symbolic content of Byzantine art to the requirements of a new realism of presentation. In a word, this process can be defined as one of 'revisualization'. Like Giovanni Pisano in the sister art of sculpture, Giotto attempts to show in painting what a particular event in the Gospel story might have looked like; and it was appropriate that, of all sculptors, it was Giovanni Pisano who was commissioned to carve a marble *Madonna* for the altar of the Arena Chapel. This important aspect of Giotto's art brings him close in spirit to the author of the *Meditationes*, whose account of the lament over the dead Christ (an event not described in the Gospels) surely influenced Giotto's conception: 'The nail being extracted from the feet, Joseph descended, and all received the body, and placed it on the ground. Our Lady sustained the head and shoulders on her lap; the Magdalen the feet, next which she had formerly found such grace; others stood around, all making great lamentations—all weeping for Him as bitterly as for a first-born.'

On the other hand, the *Meditationes*, taken as a whole, indulges in a wealth of anecdotal and peripheral detail that belongs to a different order of the creative imagination from Giotto's selective genius. In Giotto's *Pietà* the dense, sculptural forms are compressed into the mould of what is virtually the equivalent of a painted bas-relief. There is no extraneous detail. The shrill lament of the angels is joined to the ineffable grief of the human actors by the stony hill which seems to bear down inexorably towards the head of the Saviour. The dead Christ is encircled by a ring of mourners, enclosed, as it were, in their sorrow. Never before in the art of painting was human emotion embedded thus within the very substance of plastic form. The only true precedent for Giotto's composition is the Isaac Master's fresco at Assisi (*Plate 36*); but now there is a new tightness in the design, a greater mastery in the representation of the figure, and a developed feeling for spatial harmonies, which is epitomized by the circle of mourners, some of whom crouch with their backs to the spectator, and who recall seated mourning figures in ancient funerary sculpture.

We receive from the Arena Chapel frescoes an impression of a mind and eye of insatiable curiosity, filled with a store of images culled from everyday observation, and yet controlled

by a disciplined and powerful intellect which is comparable in its austere idealism only with
that of Dante. Indeed, Dante's devotion to the Latin poets, and especially to Virgil, can be
paralleled in Giotto's art by all that it has in common with the classicizing tendencies of
High Gothic and with ancient sculpture itself. The *Annunciation* on the portal at Rheims and
Giotto's fresco of *The Virgin's Return Home* (*Plate 64*) may be seen as marking different
stages in a gradual process of assimilation, whereby the Gothic style absorbed something of
the spirit of the lost Graeco-Roman world. In Giotto's case, the direct influence of ancient
reliefs can be definitely established—a well-known instance being the derivation of the
figure of St John in the Arena *Pietà* from a Meleager relief.

It is difficult to believe that in *The Virgin's Return Home* the classic feeling for interval and
measure and the manner of treating the fall of the draperies were not equally affected by
Giotto's knowledge of ancient relief sculpture. The apparent extent of his acquaintance with
ancient art suggests indeed that early in life he visited Rome. At the same time we do not
forget that this lovely composition belongs wholly to the age of Dante—not so much the
Dante of the *Divina Commedia* as the young poet of the *Vita Nuova*,—and looking up at the
fresco we recall, perhaps, the beautiful sonnet on Beatrice which begins (in Rossetti's
translation):

> My Lady looks so gentle and so pure
> When yielding salutation by the way,
> That the tongue trembles and has nought to say,
> And the eyes which fain would see, may not endure:
> So still, amid the praise she hears secure,
> She walks with humbleness for her array;
> Seeming a creature sent from Heaven to stay
> On earth, and show a miracle made sure.
>
> (*Vita Nuova*, 26: *Tanto gentile*)

The fresco has a gentle, idyllic quality appropriate to its subject-matter, and it forms both a
fitting conclusion to the narratives of the Virgin's early life and a prelude to her solemn
acceptance of her divine role in history, as represented by the *Annunciation* and the *Visitation*
on the *tribuna* and the cycle of the Infancy of Christ on the south wall.

As we follow the narratives around the walls, we may note with what subtlety Giotto
suggests in his successive portrayals of the Virgin her awareness of the gradually deepening
shadow of the Cross, which reaches a crescendo in her imploring gesture in the *Procession to
Calvary*, as she vainly attempts to reach her Son through the throng, and in the final drama
of Golgotha. Even in the *Nativity* and the *Adoration of the Magi* her expression is already
grave with foreknowledge. It seems appropriate, in stressing Giotto's supreme gifts as a
master of dramatic narrative, to single out his characterization of the Virgin, to whom the

Arena Chapel was dedicated; but of course Giotto's human sympathies were so wide that we find comparable subtleties in his portrayals of all the principal *dramatis personae* of the great cycle. Even quite subsidiary figures can be no less remarkable as studies of individuals, such as the man with the sloping forehead and retreating chin who stands amidst the crowd surrounding Christ in the *Kiss of Judas* (*Plate 65*).

The stylistic contrast between this masterpiece and the fresco of the same subject at Assisi (*Plate 28*) tells us much about the innovatory character of Giotto's art—an art concerned as much with spatial and formal problems as with the intimate evocation of dramatic action and human response. We have already compared Giotto's fresco with Duccio's equally vivid but more diffusely narrative interpretation of the subject on the Siena *Maestà* (see p. 44), and here it is Giotto's concentration upon essentials and the economy of his means that are most impressive, resulting as they do in a compactness of design and a unity of conception that are unprecedented in Italian painting. The *Kiss of Judas* is probably the most dramatic of Giotto's compositions in the Arena Chapel. All the violence latent in the treachery of Judas, who, having made his pact with the high priest, is silently present at the Last Supper and its aftermath, the Washing of the Feet, bursts to the surface at this climactic, central point of the sequence of five scenes on the south wall. The drama is enhanced by the flaming torches, conveying an impression of night, although the sky is painted in the same deep azure which forms the background of all the narrative scenes on the nave walls, and which is even visible above the roofs of buildings in interior scenes, so contributing to the unity of the decoration.

At the still centre of the fresco Christ surrenders to his betrayer, whose cloak of yellow, a colour symbolic of evil, encloses him: here, indeed, Good and Evil meet in direct confrontation, the one personified by the ideal features given to Christ and the other by the almost simian distortion in Judas's face of the accepted canon of physiognomic proportioning. To this decisive moment of spiritual conflict all the principal movements of the design direct attention, and even the subsidiary themes of St Peter's severing of Malchus's ear and the high priest's anger as he witnesses the violent deed are handled in such a way that the gestures and attitudes of these figures force the spectator's eye inward towards the central drama of the betrayal.

This insistence upon the unity of the dramatic action distinguishes Giotto's composition both from the Assisi fresco and from Duccio's *Maestà* panel. The basic elements of Giotto's design are already present in the little scene on the Pistoia cross ascribed to Salerno di Coppo (*Plate 16*), where St Peter's gruesome deed is brought upon the central stage instead of forming, as at Assisi and in Duccio's picture, a separate incident on its own. The contrast with Duccio's interpretation of the subject is particularly instructive. Where Giotto concentrates his attention upon the dramatic encounter of his principal protagonists, Duccio places an equal emphasis upon the disciples' reactions, the violence of which is expressed by explosive movements outwards from the central group containing the figures of Christ,

Judas, the priests and the soldiers; St Peter, whose threefold denial of Christ is to be narrated by Duccio in succeeding episodes of the Passion cycle, turns his back on his Master as he strikes at Malchus, leading the spectator's eye to the left, while on the right the other disciples flee away in terror.

The disciples' defection at the moment of Christ's capture was frequently omitted from Byzantine and medieval representations of the subject, with inevitable loss to the full implications of the Gospel narratives. It was characteristic of Giotto that he should have indicated this aspect of the story by the simplest possible means. On the far left of the Arena Chapel fresco, partly cut off by the painted border, there can be seen the haloed head of a young man; a member of Judas's band, in a grey hood and cloak, pulls at his garment in order to stop his flight, but it slips from his shoulders, fluttering up behind St Peter's head before falling. This passage alludes to the young man described in St Mark's narrative of the Arrest, whom theologians have usually identified with the evangelist himself: 'And a certain young man followed with him, having a linen cloth cast about him, over his naked body: and they lay hold on him; but he left the linen cloth, and fled naked.' In conformity with the text Giotto includes a second youth, who attempts to grab him on the other side of St Peter. Once again, a subsidiary incident has been welded into the main mass of the design. Duccio's interpretation of his subject-matter is no less convincing than Giotto's and scarcely inferior to it, but the comparison emphasizes the wide differences between the means employed by the two painters: we might liken Duccio to a great novelist, and Giotto to a great dramatist.

It is very possible that the vividness of Giotto's reinterpretations of the Gospel stories owed much to the contemporary liturgical dramas, which are especially well documented in Padua in this period. The noble *Annunciation* in the Scrovegni Chapel may even have been intended to recall the dramatic presentations of the Archangel's visit to the Virgin Mary which were held at the Arena, and Giotto could himself have witnessed the splendid occasion on 25 March 1305, when the mystery of the Annunciation was enacted with particular pomp and ceremony. Other frescoes in the chapel, such as the *Nativity*, the *Adoration of the Magi* and the *Presentation of Christ in the Temple*, suggest the same possibility.

A comparison between the *Adoration of the Magi* (*Plate 55*) and the mosaic of the same subject at Santa Maria in Trastevere (*Plate 39*) will show the full extent of Giotto's advance beyond the point reached by Cavallini in naturalistic representation, and will clarify further the aesthetic foundations of his revolutionary art. The two compositions inevitably have in common a number of elements drawn from Byzantine iconography, and it may be noted, for instance, that the function given by Cavallini to the kneeling king of linking together the two groups of figures is retained in the Arena Chapel fresco. But the differences in the two masters' use of the tradition are more significant. In the mosaic the vertical shaft of the archway of the building on the right serves as a *caesura* separating the kneeling king from

the Virgin and Child; Giotto, however, breaks down this distinction between two compositional fields, and allows the king to approach close to the divine infant, although preserving the idea that the area containing the holy figures forms a kind of sacred precinct. Further, Cavallini's attempt to create a convincing space for the group of the Virgin and Child and St Joseph, to which his rendering of the building in an oblique view itself witnesses, results only in a partial solution of a problem which Giotto triumphantly masters: in the Arena fresco the compositional rhythms flow back and forth within the depths of the pictorial space rather than across the picture-plane, and the kneeling king turns inward in his act of homage.

The representation of the Virgin as being seated on a throne, a detail common to the two scenes, is found almost universally in Byzantine art. There is, besides, some evidence that in liturgical enactments of the Adoration, held on the feast of the Epiphany, the Virgin and Child were often represented by a picture. It was undoubtedly customary in Padua from the late thirteenth century to include in the Christmas vigil in the Cathedral a mime of the adoration of the shepherds in which clerics impersonating the shepherds knelt before a painting of the Madonna and Child. In Giotto's fresco the throne is set at an oblique angle, so that to the kneeling king the Virgin and Child would take on the aspect of a Byzantine *Nikopoia*. Whether Giotto intended such an allusion we cannot say; but we must undoubtedly attach some significance to another aspect of this passage in the fresco, and that is the prominent position accorded to St Joseph. Cavallini follows the accepted tradition in placing St Joseph behind the Virgin's throne, where he remains a figure set apart, communing within himself. Giotto, however, moves him to the Virgin's right hand, with the consequence that the three symmetrically disposed figures of St Joseph, the Virgin and the Christ Child make up a little family group, closely knit together. The tender intimacy of this beautiful conception speaks eloquently of the humanity of Giotto's art.

Giotto follows Cavallini in illuminating his figures from a single source of light, but his chiaroscuro takes on added depth and subtlety, giving his figures a more sculptural quality and assisting in nuances of modelling never attained in earlier painting, even by the Isaac Master. If Giotto's style was partly formed by an early training under Cavallini in Rome, or at least by close acquaintance with his works there, he would have come into contact at the same time with all those relics of the art of antiquity that still survived in the Holy City. The growing interest in Roman remains during the fourteenth century is exemplified by Petrarch's scholarly study of ancient medals, by his friend Cola di Rienzo's explanation of Roman monuments, and by the great collection of antiquities formed by Oliviero Forzetta. In Giotto's case, there are numerous passages in the Arena Chapel frescoes that indicate a deep knowledge of ancient sculpture, one example being the figure of an attendant holding the bridle of a dromedary in the *Adoration of the Magi*: the striking foreshortening of the head of this figure has suggested to more than one student of Giotto's art a

5

reminiscence of one of the celebrated Dioscuri of Montecavallo in Rome (works that were much admired by Petrarch). It may be added that a dromedary, or camel, similar to the delightful animal in the Arena fresco, occurs in a Roman relief that Giotto might have known. Iconographically, the dromedary was a symbol of humility, but Giotto has made of this passage a complex exercise in spatial relationships, while introducing at the same time a light and joyous note that enriches the composition.

Giotto executed numerous fresco decorations in almost every region of Italy—in Florence, Padua, Rimini, Milan and Naples, to mention only the cities (in addition to Assisi) referred to by early writers, while in Rome he was commissioned to design the mosaic of the *Navicella* (since entirely restored) for the atrium of Old St Peter's. Little now survives of these extensive works, and his development as a fresco painter after the period of his labours in the Arena Chapel is known to us only from the decorations in the Bardi and Peruzzi Chapels at Santa Croce (*Plates 58, 63, 125*), which are probably datable within the second decade of the century, although some of the works can be partly reconstructed.

Of the surviving panel-paintings, the most celebrated is the *Madonna* for Ognissanti (*Plate 14*), which is usually dated about 1310 but may be considerably earlier. The almost ponderous realism of this altarpiece has already been discussed in relation to the *Madonnas* of Duccio and Cimabue (*Plates 5 and 13*). Most of the other panels commissioned from Giotto, including the altarpiece for the Baroncelli Chapel at Santa Croce, seem to have been delegated to his assistants. The most problematic of them all is the great altarpiece (*Plate 73*) commissioned by Cardinal Stefaneschi for the High Altar of Old St Peter's. Most scholars have assumed that it is a late work executed by Giotto's shop, and affinities have been seen both with a *Madonna with Saints* at Bologna, datable after 1328, and with the *Franciscan Allegories* on the vault of the Lower Church at Assisi (*Plates 67, 69*). Recently, however, strong arguments have been advanced by Gardner for a date around 1299 or 1300. According to this view, the *Stefaneschi Altarpiece* was painted by Giotto, with the help of assistants, and is in fact the earliest datable work by Giotto to have come down to us. The arguments are complex, but the difficulties involved in the acceptance of an early date do not seem to me to be insurmountable. This important work, painted for the central shrine of Christendom, was probably connected with the Jubilee Year of 1300, when pilgrims from far and wide flocked to Rome; and it seems less likely that the altarpiece was commissioned after the departure of the papal court to Avignon in 1308. Indeed, during the long period in which the popes were resident at Avignon (from 1308 until 1377) we can scarcely point to any major works of art commissioned in Rome. A telling piece of evidence is the apparent reminiscence of the *St Peter Enthroned* on the altarpiece that occurs in a panel of *St Peter Enthroned* painted by the St Cecilia Master for San Simone in Florence, for this panel bears the date 1307. These conclusions make Giotto's authorship of any of the frescoes in the Upper Church at Assisi, which are so different in style, even more implausible.

The *Stefaneschi Altarpiece* takes the form of a triptych painted on both sides, and the elaborate Gothic framework which once enclosed it can be reconstructed from the representation of the painting in the hands of the donor—Cardinal Stefaneschi,—who offers the picture to the enthroned St Peter in the central back panel. The importance given to St Peter needs no comment in view of the destination of the picture; and his martyrdom and that of St Paul, the other of the two chief apostles, are accordingly the subjects of the two narrative panels which flank the *Enthroned Christ* on the front of the altarpiece. The scene of the *Crucifixion of St Peter* includes a representation of the famous pyramid of Cestius in Rome, and in this and other aspects of the design it follows the traditional iconography for the depiction of the subject; but Giotto injects into it a new realism, which is to be seen especially in the finely modelled figures of the witnesses to the apostle's ordeal, while the naked figure of St Peter himself suggests a keen study of anatomical structure. We shall return to this panel when we come to discuss the work of Giotto's followers in the Lower Church at Assisi; but attention may be drawn at this point to the high quality of the donor figures and especially to the portrait of Cardinal Stefaneschi in the central front panel, which is comparable in its skill with the portrait of Enrico Scrovegni in the Arena Chapel *Last Judgment* (Plate *56*).

The Bardi Chapel frescoes, devoted to the *Life of St Francis*, and now only partially preserved (see *Plate 125*), contrast strongly with the scenes of the *Legend* in the Upper Church at Assisi, and reflect many of the aesthetic preoccupations that are displayed in the Paduan cycle. The *Stigmatization of St Francis* painted over the entrance to the chapel (*Plate 63*) extends Giotto's spatial explorations in a startling use of violent *contrapposto* in the figure of the kneeling St Francis, which (as Panofsky has demonstrated) must have been derived from an antique prototype. The impression that this figure made upon later times is indicated by its virtual repetition in the scene of *St John on Patmos* in the *Très Riches Heures* of the Limbourg brothers and, I believe, in one of the figures of the Saved in another fifteenth-century work, Rogier van der Weyden's *Last Judgment* at Beaune. On the whole, however, the Bardi Chapel shows Giotto in a new phase of development, in which dramatic action tends to be muted by its containment within a more severely geometric ordering of design.

This change is especially noticeable in the Peruzzi Chapel, which seems to be later in date. This chapel contains two cycles, illustrating the lives of St John the Baptist and St John the Evangelist. In the *Ascension of St John the Evangelist* (Plate *58*), a fresco typical of the series— and one that Michelangelo was to study in his youth, making a careful drawing of two of the figures on the left—the scale of the architectural setting in relation to the figures is more imposing than in any of the frescoes in the Arena Chapel, and the structural features of the buildings now provide a kind of stasis that acts as a counterpoint to the movement of the figures, as well as enclosing them in clearly defined fields. The figures themselves assume a

new grandeur, and Michelangelo's interest in them is quite understandable, for he was studying at the same time Masaccio's frescoes in the Brancacci Chapel in Santa Maria del Carmine in Florence. The line that leads from Giotto to Masaccio and from Masaccio to Michelangelo and the Sistine ceiling is a direct one.

To the masters of the Renaissance Giotto's frescoes at Santa Croce must have seemed to be marvellous anticipations of their own ideals; and it was in the light of such works that Cennino Cennini, who was a pupil of Agnolo Gaddi, the son of Giotto's own pupil Taddeo Gaddi, declared in his *Libro dell'arte* that Giotto had 'translated the art of painting from Greek into Latin, and made it modern'—a reading of Giotto's place in the history of Italian painting that was confirmed by Ghiberti when he wrote in his *Commentarii* that Giotto had broken away from the *rozzezza dei Greci*, the 'roughness of the Byzantines'. Yet, as has been stressed, our recognition of Giotto's revolutionary significance for the artists of the Renaissance should not tempt us to see his achievement through Renaissance eyes. There was much that Giotto preserved from the Byzantine heritage, even when he reinterpreted it, but it tended to be submerged during the Renaissance by an increasing preoccupation with the material world of visual phenomena. Giotto appeared at a moment in history when it was possible for a supreme creative imagination to combine, without danger of conflict, a new sense of human values with the profound spirituality of the Middle Ages.

Giotto's followers
and Florentine contemporaries

While the Bardi and Peruzzi Chapels at Santa Croce tell us much, although far from every-thing, about Giotto's late style as a fresco painter, other decorations in the church by his contemporaries, direct pupils and remoter followers show the extent of his influence upon the course of Trecento painting. The frescoes that are probably nearest in date to those by Giotto are the two scenes of the *Martyrdom of St Lawrence and St Stephen* (see *Plate 57*) painted by Bernardo Daddi in the Pulci-Berardi Chapel, perhaps in the 1320s. Daddi's precise relationship to Giotto remains obscure: he would seem to have been his younger contem-porary, but not necessarily his pupil. As we shall see, his work combines Giottesque elements with closer affinities with the St Cecilia Master and the Sienese School.

At some time between 1327 and 1334 Giotto's pupil, assistant, and son-in-law, Taddeo Gaddi, decorated the Baroncelli Chapel at Santa Croce with an important series of frescoes of the *Life of the Virgin* (*Plate 86*). The altarpiece for the Baroncelli Chapel was signed by Giotto and was certainly not executed by Gaddi; and, since the altarpiece is part of the over-all design, Gardner has made the interesting suggestion that Giotto was himself responsible for the layout of the entire scheme. Another of Giotto's pupils, Maso di Banco, decorated the Bardi di Vernio Chapel in the 1330s with scenes from the life of St Silvester (*Plate 100*). Then, at some date before the middle of the century, a more independent follower of Giotto, the 'Master of the Fogg *Pietà*' (also known as 'Maestro di Figline'), painted an *Assumption of the Virgin* over the entrance to the Tosinghi Chapel. An interesting attempt has recently been made by Marchini to identify this painter with the documented Assisan master Giovanni di Bonino. (The frescoes inside the chapel, assigned by Ghiberti to Giotto, are now lost.)

All these works must have been overshadowed by the gigantic frescoes of the *Triumph of Death*, the *Last Judgment* and the *Inferno* painted by Orcagna in the south aisle. These frescoes are usually dated about 1360, but they may be somewhat earlier. Only small frag-ments (see *Plates 148, 149*) now survive; yet something of the impressiveness of the original decoration can be deduced from the frescoes devoted to the same subjects in the Campo-santo at Pisa (*Plates 150–153*). The final phase in the development of the Giottesque School, although already directed into channels somewhat remote from Giotto's own aims, is represented at Santa Croce by the scenes of the *Legend of the True Cross* (*Plate 62*) commis-sioned towards the end of the century from Agnolo Gaddi, the son of Taddeo, for a place of honour in the choir, as was appropriate in a church named after the Holy Cross.

Before looking at these works, only a few of which will concern us in the present chapter, we must turn again to that monument to Giotto's School, the Lower Church of San Francesco at Assisi; for here we see Giotto's influence at an earlier stage. Several of Giotto's pupils were at work in the Lower Church in the first decades of the fourteenth century; but, apart from the Master of the Fogg *Pietà*—the putative Giovanni di Bonino,—who may not have been his direct pupil, none has yet been identified by name, with the possible exception of Stefano Fiorentino and Puccio Capanna. Stefano was celebrated in his own day for his astonishing realism, on which account the Florentine historian Filippo Villani dubbed him 'Nature's ape', adding that he 'imitated Nature so effectively that in human bodies represented by him the arteries, veins, sinews and every most minute lineament are accurately disposed as by physicians: so much so that, as Giotto himself said, his pictures seemed only to lack breath and respiration.' But although Ghiberti recorded an unfinished work by Stefano at Assisi, it is far from certain that any of the surviving decorations there can be definitely ascribed to him. The same can be said of Puccio Capanna, who traditionally undertook extensive commissions at Assisi, where he is said to have settled.

Apart from a *Madonna* by the Master of the Fogg *Pietà* in the sacristy, the Giottesque decorations in the Lower Church fill the crossing above the High Altar, the right transept and the nearby Orsini and Magdalen Chapels. There are five main groups of frescoes; and it was clearly these extensive decorations that Ghiberti had in mind when—without implying that products of Giotto's shop were apodictic works by the master—he wrote that Giotto had painted 'almost all the lower part' of the basilica, and Vasari certainly assumed that this was what Ghiberti meant. (Vasari's attribution to Giotto of the *St Francis* cycle in the Upper Church rested upon a quite different tradition from Ghiberti's *Commentarii*.) And when we consider the strong possibility that Giotto planned, or helped to plan, the decorations in the Baroncelli Chapel painted by Taddeo Gaddi, it is not implausible to suggest that he was called to Assisi to advise on the work that was to be undertaken in the Lower Church by other pupils, two of whom, the St Nicholas Master and the painter of the Magdalen Chapel, can probably be identified among his assistants in the Arena Chapel at Padua. This hypothesis is given some support by a notarial document recently discovered in the municipal archives of Bevagna, a small town not far from Assisi—an entry in the register of the notary Giovanni Alberti, dated 4 January 1309. It attests that on that date a certain Jolo Juntarelli received back the sum of 50 lire in Cortona money from one Palmerino di Guido, in repayment of a loan previously granted to Palmerino and 'Giotto di Bondone of Florence'. Although not decisive, this document is at least a pointer to Giotto's possible presence in Assisi shortly before 1309; and the most likely date would seem to be 1307 or 1308.

These dates are suggestive, for 1307 and 1308 are, respectively, the dates of two panels by Giuliano da Rimini (*Plate 162*) and the so-called Cesi Master which, as Meiss has shown,

introduce motifs based upon the frescoes painted by the St Nicholas Master in the Orsini Chapel. These borrowings date the decorations there to around 1307 or slightly earlier; they cannot be very much earlier, especially since the Arena Chapel frescoes, on which the St Nicholas Master probably worked as an assistant, were completed about 1305 or 1306. Thus early was Giotto's *dolce stil nuovo* brought to Assisi by one of his most faithful pupils. The Orsini Chapel abuts on to the end of the right transept, and over the entrance to the chapel the same pupil painted an *Annunciation* (a traditional subject for a chapel entrance); thus at least part of the Giottesque decorations in the transept dates from 1307 or earlier.

As we stand by the High Altar looking into the right transept (*Plate 67*), we know at once that we are within the world of Giotto; we know, before we attempt to define the matter further, that the great series of frescoes on the walls and vaulting can be broadly classified as 'Giottesque', in the sense that in general they reflect many of Giotto's most fundamental preoccupations (as, for instance, the *St Francis* cycle in the Upper Church does not); and they also reflect, although in varying degrees, Giotto's characteristic ideal of the human figure and physiognomy. At the far end of the transept we see the Orsini Chapel, decorated with scenes from the *Life of St Nicholas*; to the right of the transept, with its main entrance leading from the nave, is the Magdalen Chapel, devoted to scenes from the *Life of Mary Magdalen*; behind us, in the left transept, are the great frescoes of the *Passion of Christ* by Pietro Lorenzetti (*Plate 121*) (and, beyond, another chapel built by the Orsini). Above us, in the crossing, directly over the High Altar, are the four *Franciscan Allegories* (*Plates 67, 69*). Next to these, in the right transept, are scenes of the *Infancy of Christ* (*Plate 72*), with a *Crucifixion* below (on the right wall), beside an older fresco by Cimabue—a *Madonna and Child with Angels and St Francis*, which was trimmed when the Giottesque decorations were added. The charming *Infancy* narratives rise up into the vaulting, across to the opposite wall, like Lorenzetti's frescoes in the left transept. Beyond them, immediately below the *Annunciation*, there is a representation, in two frescoes, of one of St Francis's posthumous miracles (*Plate 71*); and a further miracle scene, together with a fresco of *St Francis and Death*, decorates the left wall. These scenes relate stories about wonderful cures performed upon children, and are therefore appropriate neighbours to the *Infancy of Christ* narratives, to which the *Annunciation* is also related thematically.

The *Crucifixion* may seem at first sight to be out of place in this context, since the *Passion of Christ* was reserved for the left transept, where Pietro Lorenzetti was to paint another very large *Crucifixion* (*Plate 122*). In actuality the scheme adopted in the Lower Church followed a precedent established in the Upper Church, where two large *Crucifixions*, by Cimabue and his School (see *Plate 17*), already existed in the same relative positions in the two transepts. And originally an altar stood below each of these four paintings of the Crucifixion. This emphasis upon the Crucifixion, of which, it seems, the friars were always to be reminded, is to be explained in terms of Franciscan piety—in terms of the vivid recollection of

Francis's special devotion to the Cross of Christ, towards which, in the Giottesque fresco in the right transept (*Plate 79*), he lifts his stigmatized hands as he identifies himself with Christ's sufferings and redeeming death.

Already we begin to discern the coherence of the total decoration of the two transepts, with the *Allegories* at its centre, in the crossing. On either side of the *Allegories*, the *Infancy* narratives in the right transept and the *Passion* scenes in the left transept are balanced symmetrically. The *Passion* scenes are continued on the end wall (which is pierced by the entrance to the second Orsini Chapel); but even this extension of Lorenzetti's cycle is related to the frescoes in the other transept; for not only is the *Annunciation* on the end wall of the right transept the prelude to Christ's Incarnation and to his redemption of mankind by his Passion and death, but the two frescoes below tell the story of a child's death and subsequent resurrection through the merits of St Francis, just as, on the corresponding wall in the left transept, the sequel to the Crucifixion leads us in four scenes from Christ's death to his own triumphant Resurrection—that is to say, from the lower scenes of the *Deposition from the Cross* (*Plate 123*) and the *Entombment* to the upper scenes of the *Resurrection* and the *Descent into Limbo* (or the *Harrowing of Hell*) (see *Plate 121*).

As though to emphasize the concordance, and at the same time calling our attention to a more general stylistic indebtedness, Lorenzetti introduced into his *Deposition* a remarkable, and intensely expressive, motif which was evidently derived from the scene of the child's death in the right transept (*Plate 71*), where the heads of the grieving mother and her child are aligned, but in reverse positions. In Lorenzetti's fresco we discover the same tender juxtaposition in the heads of the Virgin and her dead Son. Who was the painter of genius who invented this expressive image? All that we know is that the miracle scenes were executed by some anonymous pupil of Giotto who was capable of developing, within the terms of his own looser, descriptive style, his master's increasing concern with spatial composition and sculptural form.

It is certain that Lorenzetti's fresco, which is to be assigned, probably, to the early 1320s, postdates the scene in the right transept. Technical examination of the frescoes in the Lower Church has revealed the sequence in which the principal groups of frescoes in the transepts and crossing were executed. In the area of the right transept where the borders on the vault adjoin the archway leading to the Orsini Chapel, the *intonaco* (or fresco surface) of the *Infancy* cycle overlaps that of the *Annunciation* painted over the archway. The *Infancy* scenes are therefore later in date than the *Annunciation*. It can likewise be shown that the *Franciscan Allegories* in the crossing postdate the *Infancy* cycle, and furthermore that the *Allegories* themselves were already in existence before Lorenzetti began work on the *Passion* cycle in the left transept. It would seem likely that the Giottesque frescoes in the right transept and in the Orsini Chapel, as well as those in the Magdalen Chapel, were all in being before the third decade of the century. And, as has been mentioned, one part of the entire decoration—

the *Annunciation* and the frescoes in the Orsini Chapel—had been executed by the year 1307.

If the decoration as a whole can be regarded as the work of members of Giotto's *bottega*, perhaps commissioned from Giotto and then contracted out to his pupils, it becomes possible to associate the vast enterprise with an important early reference to Giotto's activity in Assisi, which is contained in the *Compilatio chronologica* written by Riccobaldo da Ferrara: 'The works executed by him in the churches of the Friars Minor at Assisi, Rimini and Padua, and in the church of the Arena at Padua, testify to what he was in his art.' This passage was probably written in 1312 or 1313, and at the latest by 1317. Even if it antedates the completion of the frescoes, Riccobaldo's informant—especially if he was a member of the Franciscan Order, as is probable from the context—may well have known something about the total scheme of the new decoration, which was undoubtedly planned with great care. Such an interpretation of Riccobaldo's statement is consistent with what Ghiberti tells us; for Ghiberti is the first writer to *locate* the work undertaken by Giotto at Assisi, and he locates it in the Lower Church. It is also consistent with the Vasarian tradition, for Vasari identified the decorations mentioned by Ghiberti with the *Allegories* and the Giottesque frescoes in the right transept.

The earliest of the Giottesque frescoes at Assisi, the *Annunciation* and the scenes from the *Life of St Nicholas* in the Orsini Chapel, faithfully reflect Giotto's style in its Paduan phase, although the austere grandeur of the Arena Chapel cycle gives way to a more genial, narrative spirit. When Giuliano da Rimini copied some of the standing Saints in the Orsini Chapel, introducing them into his Urbania altarpiece of 1307 (*Plate 162*), he was responding to the noble realism of the new style and even to those reflections of the study of antique sculpture that are particularly evident in the classical drapery-style in the Orsini Chapel. Even more important and revealing is the impact made by the art of the St Nicholas Master upon Pietro Lorenzetti. Below his great *Crucifixion* in the left transept Lorenzetti painted a *Virgin and Child with St John the Evangelist and St Francis* (*Plate 75*). This splendid work, which the evening sunlight, passing through a window opposite, fires into glowing radiance, is not only a veritable *sacra conversazione* but a frescoed altarpiece. Its origin clearly lies in the magnificent fresco of the *Virgin and Child with St Nicholas and St Francis* (*Plate 74*) which the St Nicholas Master painted over the altar in the Orsini Chapel.

Instead of the traditional triptych on panel, the St Nicholas Master created a sequence of simulated niches, which seem to become one with the architectural fabric of the chapel. The illusionism, imitated by Lorenzetti in his own fresco, is enhanced by the manner in which St Nicholas and St Francis appear to be emerging from their niches as they express their devotion to the Virgin and the Christ Child, while the further illusion is created that the Christ Child is standing on a real marble ledge viewed from below. At a time when the strict party in the Order of Friars Minor was vehemently objecting to the splendour of the new Franciscan churches, and to the excessive expense laid out for paintings, statues, win-

dows, vestments and so forth, the avoidance of the cost of an altarpiece on panel may well have seemed prudent even to a patron less anxious to maintain the ideal of Holy Poverty. Successive General Chapters of the Order had issued directives against the use of costly ornaments and works of art, and they had been reaffirmed at the Chapter held at Assisi in 1304, probably not long before the decoration of the Orsini Chapel was begun. But the reason for such frescoed altarpieces (and there are others elsewhere in the Lower Church) is less important than the opportunity given to the painter to create a new kind of unity between fresco decoration and architecture. The thinking that lay behind the St Nicholas Master's innovation was worthy of the mind of Giotto himself; and the seeds of the noble illusionism of the Orsini Chapel altar-fresco are already present in the *Virtues* and *Vices*, imitative of sculpture, in the Arena Chapel—figures that refuse to remain still within their fictive niches.

The work of Giotto's pupils at Assisi, while reflecting aspects of his own development in the post-Paduan period, presents a variety of interpretations and adaptations of his style. For example, the author of the *Infancy* scenes tends to relax the dramatic tension characteristic of the corresponding subjects in the Arena Chapel, and to reduce their expressive intensity by introducing a wealth of incident and detail. If Giotto's sublimity of mind is not here, the cycle possesses virtues of its own: we can share in the more relaxed mood, and delight in an art that combines a superlative gift for narrative with a gentle lyricism. This was no mean painter, and the scenes abound in fresh observation, whether of human gestures and expressions or of architectural detail. Moreover, the recent recognition that the decorations in the right transept at Assisi belong to the first two decades of the fourteenth century throws new light upon the historical importance of those adventures in the treatment of perspective which are to be seen especially in the *Infancy* cycle. The masterly treatment of the interior in the *Presentation in the Temple* (*Plate 119*), where the orthogonals consistently converge towards the centre, can now be seen to antedate—by two decades or more—the similar solutions to such problems which we find in the famous Marian panels (*Plates 117, 118*) painted by the Lorenzetti in 1342 for Siena Cathedral.

The four *Franciscan Allegories* in the crossing reveal more than one hand. These compositions are symbolic representations of the three great Franciscan virtues of Poverty, Chastity and Obedience, together with a further representation of *St Francis in Glory*. The *Allegory of Obedience* (*Plate 69*) is perhaps the most interesting. Obedience, seated between Humility and two-visaged Prudence, places a yoke on the shoulders of a friar; one angel converses with a young couple; and another confronts a remarkable centaur (*Plate 70*)— the symbol of rebellious Pride. The attitude of this centaur is intriguing, for it is one of violent *contrapposto* as he looks backwards with one arm raised and his hand foreshortened. Since he is half man and half animal, this is one of the oddest examples of *contrapposto* one could expect to find anywhere; but, apart from that aspect of him, his pose recalls that of

St Francis in the scene of the *Stigmatization* (*Plate 63*) painted by Giotto over the entrance to the Bardi Chapel at Santa Croce: he seems almost like a hideous parody. Here too we find a reflection of Giotto's preoccupations in his later years. The representation of a hand as markedly foreshortened as this is attempted in the Arena Chapel only in two of the last frescoes to be executed; but in the later decorations at Santa Croce Giotto shows more than once a complete mastery of the problem.

We may now turn to the *Crucifixion* and to the scenes of the *Life of Mary Magdalen* in the nearby Magdalen Chapel, where the resemblances to Giotto's known style are still closer. Two of the Magdalen Chapel frescoes—the *Raising of Lazarus* (*Plate 68*) and the *Noli me tangere* (*Plate 77*)—are based on the famous compositions in the Arena Chapel. Yet there are considerable differences. Some of these differences can be explained in terms of the relative weakness of a pupil's style, but not all of them; others again relate to developments in Giotto's own style which we know something about. The compositions are more spacious than their counterparts in the Arena Chapel, recalling the frescoes in the Bardi and Peruzzi Chapels at Santa Croce, where we also find parallels with the ample figure-style. And, to revert to a question that we have just been considering, it is instructive, in front of the *Raising of Lazarus*, to examine the gesture of the bearded man who raises his hands in wonder. His twin in the Arena Chapel fresco (*Plate 37*) does likewise; but there is a difference: at Assisi the plane of the hands recedes much more sharply; and this change must have been very deliberate. The exploration of forms in space has been carried a stage further.

Another development in Giotto's later style is also reflected in the Magdalen Chapel. Whereas in the Arena Chapel important *personae* in a particular scene are often placed close to the edge of the picture, in the Magdalen Chapel—as also at Santa Croce—they tend to move inwards to occupy a more central position, with the consequence that there is a reduction in what might be termed the structural tension of the composition. A good example is provided by the *Noli me tangere* at Assisi, which is altogether a more relaxed narrative than the intense drama at Padua. In addition to the demands of stylistic change, there was an iconographical reason at Assisi for the more central role, and for the new dignity, now accorded to Mary Magdalen, for she is the titular saint of the chapel, and the frescoes are devoted to her life. The representations of the Magdalen in this scene and in the *Noli me tangere* are at the same time very similar in style, in the most fundamental sense, to comparable figures in the Arena Chapel cycle, such as the Magdalen in the *Noli me tangere* and the St Anne in the *Presentation of the Virgin in the Temple* (*Plate 59*). What is lacking at Assisi is the firmness of Giotto's pictorial construction; we are clearly in the presence, not of the master himself, but of a gifted pupil. In fact the same hand is detectable in a double-sided altarpiece which once stood over the High Altar of Florence Cathedral.

Yet the quality of the painting in the Magdalen Chapel rises at times to an extremely high level, and not least in the two donor portraits, the first showing Cardinal Pietro di Barro

with the Magdalen (*Plate 76*), and the second portraying Tebaldo Pontano with San Rufino, the martyr-bishop of Assisi. The cardinal had died in 1252, having evidently left money for the building of the chapel after his death; and Tebaldo Pontano, who was Bishop of Assisi from 1296 to 1329, would have commissioned the decorations. Since the panels by Giuliano da Rimini and the Cesi Master of 1307 and 1308 respectively betray a knowledge of the Orsini Chapel but not of the Magdalen Chapel, it can be assumed that the decorations in the Magdalen Chapel date from after 1308, as indeed their developed style would suggest. Certain similarities with the Peruzzi Chapel frescoes of Giotto (*Plate 58*) may indicate a date towards 1320, although a considerably earlier dating may be implicit in Riccobaldo's reference (probably about 1313) to frescoes by Giotto at Assisi.

The donor portraits descend in type from the profile representation of Enrico Scrovegni (*Plate 56*) in the Arena Chapel and also recall the style of the portraits of Cardinal Stefaneschi on the altarpiece for Old St Peter's (*Plate 73*). Yet the forms are ampler; and, as in the case of the frescoed altarpiece in the Orsini Chapel (*Plate 74*), the donors and their patron saints are not confined within the niches in which they kneel or stand. Mary Magdalen, a particularly imposing and beautiful figure, steps forward from her niche (and is thus displaced to the right), in order to allow the kneeling suppliant to take her hand. The conception is profoundly spatial and sculptural, while in physiognomic type the Magdalen is reminiscent of a number of figures in the Arena Chapel cycle; but the figure has a greater fullness and an enhanced softness, which are typical of Giotto's later works, such as the *Madonna* in the National Gallery of Art at Washington. It may be noted that the striking portrayal of Cardinal Pietro di Barro is a posthumous image; indeed, the cardinal had been dead for over half a century when this 'portrait' of him was painted.

Like the *Raising of Lazarus* and the *Noli me tangere* in the Magdalen Chapel, the stylistically related *Crucifixion* outside the chapel (*Plate 79*) depends basically upon the corresponding composition at Padua (*Plate 19*). Indeed it is easy to understand how such frescoes came to be ascribed to Giotto himself, for, although they were executed by pupils, their general conception was ultimately his. The iconography of the *Crucifixion* includes Franciscan elements necessarily absent from the fresco in the Arena Chapel, which in other respects also was not the only source for the composition. The workmanship varies from passages that are quite inferior to others that are of superlative quality. The beautiful figures of St John and the mourning woman standing behind him are quite masterly, and the quality of the painting is all the more obvious when we compare the figure immediately to the left, which suggests the handiwork of an assistant. The woman behind St John—one of the legendary Maries—flings her arms back in a familiar gesture of mourning which is found on ancient Meleager reliefs, and which Giotto had already adapted to his wonderful St John in the Arena Chapel *Pietà* (*Plate 37*). Giotto, however, gave his St John a stooping pose, whereas the figure in the Assisi fresco stands upright; and in this respect a more exact prototype for the Assisi

figure is to be found on the Stefaneschi altarpiece: it is the female figure in a rose-red garment who stands with arms outstretched on the left side of the *Martyrdom of St Peter* (*Plate 73*). Indeed, the Assisi figure is a development of the image on the altarpiece; and we may note, for instance, the new foreshortened treatment of the visible hand.

In the Lower Church we can trace the processes of stylistic evolution within Giotto's immediate circle, as his discoveries are exploited by his pupils. While these pupils do not quite touch the heights of his own achievement in the Arena Chapel and at Santa Croce, the beauty of the decorations as a whole reminds us that the history of art is not the history only of the contributions made by the great geniuses and innovators: every artist of quality has an honoured place in it. But a further question is raised. If the decoration of this part of the Lower Church was the work of Giotto's shop, he would presumably have sanctioned the designs, which may reflect his ideas much more extensively than has usually been allowed.

It is nevertheless vital in the study of this period, about which we still know far too little, to guard against the kind of simplification that ascribes every important development in early fourteenth-century Florentine painting to Giotto himself. In fact there were other currents that ran parallel, on the whole, to the direction of Giotto's art and which yet remained essentially distinct from it. The unknown authors of the *Altarpiece of St Cecilia*, the *Madonna* at Santa Maria Maddalena in Pian di Mugnone, the Santa Maria Novella crucifix and the *Madonna* at San Giorgio alla Costa in Florence (the last two of which have been wrongly assigned to Giotto by some critics), together with such documented personalities as Pacino di Bonaguida, Bernardo Daddi, Jacopo del Casentino and Buonamico Buffalmacco, all worked in Florence at the time that Giotto was creating his new style, but steered a largely ~~surviving crucifix must have been painted by 1301, when Deodato Orlandi made a virtual~~ independent course. Most, if not all, of these painters came under Giotto's influence in varying degrees, but without sacrificing their individuality, upholding as they did ideals somewhat different from his own.

The crucifix at Santa Maria Novella in Florence (*Plate 22*) has often been ascribed to Giotto on the basis of documents of 1312 and 1313 which refer to a large cross executed by him for the church. But there is contradictory evidence in the form of another document, now lost, which referred to Giotto's crucifix as having been finished in 1312, whereas the surviving crucifix must have been painted by 1301, when Deodato Orlandi made a virtual copy of it (*Plate 23*). It is difficult in any case to reconcile the style of the crucifix with that of Giotto's authenticated works, such as the crucifix which he painted for the Arena Chapel. The Master of the Santa Maria Novella Cross, as Offner called him, was undoubtedly a pioneer of the new realism, but despite its impressiveness the ponderous figure of the Crucified is lacking both in the subtlety of draughtsmanship and in the nobility of conception which we associate with the art of Giotto. Yet the striking naturalism of this figure, so powerfully suggestive of death, seems to have made a considerable impression upon painters

active in Florence and elsewhere in the years around 1300, as can be inferred, for example, not only from Deodato Orlandi's attempted emulation of it but also from other anonymous Florentine crucifixes which reflect its influence; and, as has often been pointed out, there is another apparent copy of it in the scene of the *Verification of the Stigmata* (*Plate 42*) in the *St Francis* cycle at Assisi, where a very similar cross is represented on the rood-beam of a church. In brief, the Santa Maria Novella crucifix takes its place within that independent stream of development in Florence which produced such painters as Pacino di Bonaguida and Jacopo del Casentino.

One of the dominant figures in this group of Florentine painters was the St Cecilia Master. The fact that his great *Altarpiece of St Cecilia* (*Plate 29*), now in the Uffizi, must have been painted before 1304 (when the church of Santa Cecilia in Florence was burnt down) is extremely significant; for it shows that his style was already mature before Giotto began work on his frescoes in the Arena Chapel: indeed, the *Stefaneschi Altarpiece* of Giotto and the *Altarpiece of St Cecilia* were probably executed at roughly the same time. So far from taking his place in the history of Trecento painting as a tardy follower of Giotto (as has sometimes been proposed), the St Cecilia Master was a pioneer. A consideration of his role in the painting of the *Legend of St Francis* at Assisi supports the same conclusion, since there is evidence that the cycle had been completed by 1307. Like the St Francis Master as Assisi, with whom he shows certain affinities, he would seem to have had a Roman training. His style as it is known to us from his works in Florence and Assisi is, indeed, anticipated in the fragments which have survived of two fresco cycles in Rome—a group of Old Testament scenes at Santa Cecilia in Trastevere, and a series of scenes from the *Life of St Catherine of Alexandria* formerly at Sant'Agnese and now in the Vatican. These frescoes may give a clue to his very early manner.

His art is all elegance and refinement, although his figures are strongly and subtly modelled and exist in a spatial world which is firmly constructed—notably by means of gracefully designed buildings which soar up above the figures and establish the principal divisions of a composition. His designs reflect an artist who is concerned with the geometry of pictorial composition—as deeply, in his own way, as a Piero della Francesca or a Vermeer. The scenes from the life of St Cecilia on the Uffizi panel demonstrate his feeling for design and his faultless taste: the somewhat aristocratic figures, with their frail, attenuated limbs and tiny hands, act out the story with a grave pathos, enframed by the characteristic architecture, which harmonizes with their lively movements. We enter a world remote indeed from that of Giotto—a world of sensitive narrative rather than heroic drama, but nevertheless a world of the imagination that holds us by the intensity of the feeling and by the skill of the composing. The exquisite colour-schemes of this subtle master are no less foreign to Giotto's bolder palette. Altogether he has more in common with Bernardo Daddi and with such Sienese masters as Simone Martini and Ambrogio Lorenzetti. The solemn expressiveness of

his style well fitted him to tell the story of a virgin martyr such as St Cecilia (not yet, by this date, the patroness of musicians), which is not precisely a tragedy, but a lesson in the merits of those virtues (including sexual abstinence in marriage) which according to the medieval mind were the pathway to heaven through glorious martyrdom. The St Cecilia Master's realistic figure-style was especially appropriate to the increasing demand for the vivid expression of such legends: his little figures are strongly characterized, and St Cecilia, her husband Valerian, and the prefect Almachius are all presented to us as individual people.

The same may be said of his masterly portrayal of Francis in the opening scene of the Assisi cycle (*Plate 30*)—not yet the ascetic saint but an elegant young man of the world, whose refined features correspond closely to early descriptions of him. The simple man of Assisi who lays his cloak at Francis's feet, and whose ingenuousness of mind was considered (as was common in medieval times) a sign of divine inspiration, is no less a 'character'; and the same interest in the individual is evident in the St Cecilia Master's other frescoes at Assisi. In the scene in which St Francis descends from heaven to heal a Spaniard named John of Lerida, who has been attacked in an ambush, the wounded man is given dark, aquiline features evidently intended to suggest his Spanish blood, and he, his sorrowing wife, and the burly physician, who has given his patient up in despair, are all beautifully portrayed as real people.

The realism of the St Cecilia Master could never be confused with that of Giotto. Just as it serves the purposes of exalted narrative rather than of sublime drama, it also exhibits a greater interest in exquisite detail and in gorgeous effects of pattern, as, for example, in the colourful treatment of the costumes and the angels' wings in the fresco we have just been considering. There is a decorativeness in the art of the St Cecilia Master which is generally absent from that of Giotto; and this is one of his most seductive qualities. A similar contrast is apparent when we compare his *Madonna* (*Plate 84*) at Santa Margherita a Montici, in a suburb of Florence, with Giotto's famous *Madonna* (*Plate 14*) for Ognissanti. Where the St Cecilia Master adds a new grace and approachability to the type of majestic image created by Cavallini, Giotto upholds a far sterner ideal, which may well have struck some of his contemporaries as less beautiful, just as, a century later, the Pisa *Madonna* by Masaccio (now in the National Gallery in London) may have seemed forbiddingly austere in comparison with pictures of the Virgin and Child by Fra Angelico and Gentile da Fabriano.

Giotto's supreme gifts lay rather in the direction of monumental fresco decoration; and while the *Stefaneschi Altarpiece* for St Peter's and the *Madonna* for Ognissanti were major commissions, he frequently left the execution of paintings on panel to his workshop; in any case there were many other painters who could be commissioned to produce the numerous altarpieces that were required. When, for example, the miraculous image of the Virgin at Orsanmichele was destroyed in the great fire of 1304, the picture commissioned

by the church authorities to replace it was very probably the large *Madonna enthroned with Angels* now at Pian di Mugnone, a work at once majestic in design and splendid in colour, and one that descends directly from the type of Madonna created by the St Cecilia Master. The evidence that this masterpiece of early Trecento painting—a work of unknown authorship—was executed for Orsanmichele is circumstantial; but if the hypothesis is correct the picture was in turn displaced by the famous *Madonna* painted by Bernardo Daddi in 1346–7 (*Plate 97*), which was to be enshrined in Orcagna's imposing tabernacle of 1359 (*Plate 96*).

The Orsanmichele *Madonna* possesses all the exquisiteness of Daddi's mature style: the daintiness of the angels around the throne, the delicacy of the colours, and the tender intimacy of sentiment expressed by the playful Christ Child are all characteristic of a development that turns increasingly away from the monumental to the precious. And it was Bernardo Daddi who was the master most perfectly fitted to meet the growing demand for small devotional pictures, whether in the form of a triptych, a diptych or even a single panel. These were frequently intended for private use and had the advantage of portability; and Daddi and his workshop produced them in large numbers. The earliest known example of this new kind of devotional picture was painted by Duccio; but it was Daddi who established its character in Tuscany as a whole, and the craftsmanship that he expended upon these jewel-like little panels must have greatly contributed to their popularity. Their Sienese origin reflects only one aspect of Daddi's general indebtedness to Duccio and his followers, whose concern with decorative and colouristic values he combined with a Florentine approach to form and design, deriving in part, it seems, from the St Cecilia Master and in part from Giotto.

Bernardo Daddi is first documented as an independent master in 1320, and his first signed picture, a triptych of the *Madonna and Child with St Matthew and St Nicholas*, originally at Ognissanti, bears the date 1328. There are several dated works of the 1330s. He is last mentioned in the year 1355; and if we are correct in assuming that he was born about 1290 his life spanned the great period in Florentine art which opened with the early works of Giotto and concluded with the emergence of Andrea di Cione, known as Orcagna, who became the dominant figure in the middle years of the century and one of the most potent influences upon the development of late Trecento style. Bernardo Daddi may be said to have formed a link between the two masters; for he understood something of the value of Giotto's treatment of form, and contributed also to the more decorative aspects of Orcagna's large pictorial repertoire.

It must have been at an early moment in his career that Daddi painted the frescoes in the Pulci-Berardi Chapel at Santa Croce; and the *Martyrdom of St Lawrence* (*Plate 57*) demonstrates what he learnt, and what he did not learn, from Giotto's example. The style of the architecture brings to mind the frescoes in the Peruzzi Chapel (*Plate 58*); and he seems to

be aware of an interesting device used there by Giotto, whereby the representation of architecture is apparently related to a viewpoint at the chapel entrance, which was originally closed off by an iron gate. An example in Daddi's fresco of the influence of Giotto's treatment of the human figure can be seen in the man carrying a basket of faggots on his shoulder: this figure recalls the servant bearing a bundle of clothes who stands at the foot of the stairs in the *Presentation of the Virgin* in the Arena Chapel (*Plate 59*). But although the figure is well enough modelled, we appreciate it in isolation; the various participants in the scene are not satisfactorily related to each other, either spatially or on a human level; and the composition takes on a somewhat disorderly character. It is questionable whether Daddi was wholly suited to the demands of monumental fresco painting. Certainly he seems to have been happier when working on a smaller scale; and the penchant for narrative shown in the Santa Croce frescoes was eminently capable of being developed in small panels, as in the predella scenes of the now mutilated altarpiece formerly at San Pancrazio and now in the Uffizi (*Plate 85*).

This elaborate polyptych, datable towards 1340, displays a richly cusped central panel of the *Madonna and Child adored by Angels*, flanked by six panels containing full-length figures of saints; further saints and prophets are represented at half-length in an upper row, while the predella is devoted to scenes from the lives of the Virgin and her parents, one of which —the panel of the *Marriage of the Virgin*—has been removed and is now in the Royal Collection. The altarpiece has suffered mutilation in other ways, and has lost its original Gothic pinnacles, the present rectangular frame being an ugly nineteenth-century addition. This ambitious work is one of Daddi's supreme masterpieces, and contains all his virtues. Above all, it reveals to the full the inventiveness of his luminous orchestrations of colour, ranging from deep scarlet—as in the carpet at the Virgin's feet, patterned in black and gold —to a variety of intense purples, blues and greens and softer lilacs and greys. There is an easeful mastery in the treatment of the figures, the lessons of Giotto having been assimilated to the fragility of Daddi's vision; and none of his many other interpretations of the subject of the Madonna and Child surpasses the gem-like composition in the central panel, where we may note, incidentally, the introduction of a vase of lilies before the Virgin's throne—a motif that was to be developed in paintings of the Madonna in the fifteenth century.

The scenes on the predella are among the most enchanting examples of narrative painting to be found anywhere in this period. The action of the angel who leans down in the *Meeting at the Golden Gate* (*Plate 87*) to join together the haloes of St Joachim and St Anne, reunited after their sad separation, would be unthinkable in the work of either Giotto or Taddeo Gaddi (*Plates 88, 89*), but nothing could be more typical of the innocent charm of Daddi's art.

Bernardo Daddi commanded a large workshop, and he had many imitators. Even the great Taddeo Gaddi, who basically had little in common with him, signed in 1334 a more

6

or less exact copy (now in Berlin) of an important triptych by Daddi (in the Bargello) executed in the previous year. (A similar panel, which has been ascribed to Maso, is also known.) Among lesser figures, Jacopo del Casentino, whose masterpiece is the *Altarpiece of San Miniato (Plate 78)*, painted for the church of San Miniato al Monte, seems to have originated, like Daddi himself, within the circle of the St Cecilia Master, and owed a considerable debt to the Sienese: eventually he fell completely under Daddi's spell. The *San Miniato Altarpiece* adheres to the type of the Florentine historiated dossal which was developed by the St Cecilia Master in his *Altarpiece of St Margaret* and which we saw in an earlier phase of evolution in the Magdalen Master's panel in the Accademia *(Plate 8)*. The cult-image of the saint, firmly enough modelled in its details, owes something to the example of Giotto but more to that of the St Cecilia Master: the large, impassive figure flattens out into an imposing silhouette and confronts us like the still effigy on a Gothic tomb. But Jacopo's most endearing qualities are to be found in the eight narratives of the Saint's legend. In the scene showing San Miniato miraculously vanquishing a leopard which has been unloosed upon him *(Plate 81)*, Jacopo's gifts for story-telling can be seen at their best; and while his debt to the St Cecilia Master is manifest in the general management of the design, in the simple geometry of the buildings and in the character of the figures, the composition is stamped with his own quiet, if slightly prosaic, charm.

The panels of the St Cecilia Master and such followers as Jacopo del Casentino and Bernardo Daddi have much in common with the art of the miniaturist, the virtues of which they preserved in an age dominated by the 'grand style' of Giotto and his pupils. But during this period the principal centre in Florence for the production of manuscript illuminations themselves was the workshop of Pacino di Bonaguida, a contemporary of Giotto documented between 1303 and 1330. The miniatures commissioned from Pacino included important series of illustrations to Dante's *Divine Comedy* and to Villani's *Chronicle*. Moreover, it was under Pacino that several other miniaturists active in Florence in the first half of the century appear to have received their training. Pacino was equally in demand as a painter of altarpieces and other panels, and it is around his signed polyptych of the *Crucifixion (Plate 80)* that the corpus of works attributable to him has been built up. Although he was not unreceptive to the influence of Giotto, he resembles the St Cecilia Master in remaining loyal to more ancient traditions. A Roman training may be presumed.

His early style is epitomized by the *Tree of Life (Plate 83)* in the Accademia, which can be dated provisionally within the first decade of the new century. This panel came from the Convent of the Poor Clares of Monticelli, one of the most ancient Franciscan foundations in Florence; and, like the fresco of the same subject painted by Taddeo Gaddi in the refectory of Santa Croce, it transcribes into pictorial terms the vision recounted by Bonaventura, in his *Lignum Vitae*, of the mystic Tree of Life mentioned in the Book of Revelation. The identification of the Tree of Life with the Cross of Christ explains the fact that in Pacino's

panel Christ is shown crucified upon the Tree, beneath which—as in the iconography of Crucifixion scenes—we see the skull of Adam. The small roundels among the branches of the Tree illustrate corresponding chapters in Bonaventura's treatise, in which the author meditates upon successive events in the story of Christ's redemptive work for mankind, each of the roundels representing one of the forty-eight fruits of the twelve-branched tree. Above, in the gable of the panel, Christ and the Virgin are enthroned in glory amid the company of heaven; seven narratives from Genesis, from the Creation of Adam to the Expulsion from Paradise, run along the bottom of the panel; and, immediately above the Genesis scenes, but on a larger scale, special prominence is given to figures of Moses and St Francis (on the left) and (on the right) St Clare and St John the Divine.

The entire work is finely composed, and its diverse parts are ingeniously related to each other. Despite its miniature-like quality, the forms are firmly modelled in light and shade, whereas in Pacino's illuminated manuscripts the treatment is generally more summary and more decorative. It is misguided to criticize the picture, as it has been criticized, on the grounds that the literary subject-matter did not lend itself to pictorial expression; for its contemporary value as an encouragement to pious meditation is matched by its sheer beauty of design, and the medallions are not only exquisitely composed in themselves but are informed by a tenderness of sentiment that is at once solemn in tone and pleasing in effect. The colours, and especially the blues, have darkened with time, but we can still appreciate Pacino's skill in handling his characteristically simple yet vivid palette, in which bright reds, yellows and whites play an important role: not here the flower-like delicacy of Bernardo Daddi, but a clarity of concordances and contrasts which sharpens the narrative.

The polyptych of the *Crucifixion with Saints Nicholas, Bartholomew, Florentius and Luke* (*Plate 80*) shows Pacino in a different aspect, and reflects his quiet response to the art of Giotto. The painting formerly stood on the High Altar of San Firenze. Unfortunately, the date inscribed on it has been partly defaced; in all probability, however, it originally read either 1311 or 1315, or possibly 1320, so that the polyptych can be placed with reasonable certainty within the years 1311–20. This is the earliest known example of a Crucifixion polyptych in Florentine painting. Such features as the crown of thorns worn by the Crucified and the twisted columns which separate the panels suggest Sienese influence. Of greater significance, however, is the contrast between the figure of Christ and the corresponding figure in the earlier panel of the *Tree of Life*: the Romanesque tradition for the representation of the Crucified Christ which is preserved in the *Tree of Life* has here been abandoned in favour of the new naturalism which first made its appearance in Florence in the large Crucifix of Santa Maria Novella (*Plate 22*).

Altogether the figures in the polyptych are more plastic in conception than those in the earlier work, as well as being larger in scale; and this quality, together with a new simplicity and a new restraint in the design of the central panel, must be due to Giotto's direct influence.

Yet the reticent gracefulness of the Virgin and of St John the Divine—and also, indeed, of the Crucified—conforms to another taste, and in this respect Pacino remains closer to the St Cecilia Master and to the author of the beautiful *Madonna* at San Giorgio alla Costa (a work frequently, but mistakenly, ascribed to the young Giotto). Moreover, Pacino's employment of light as a modelling agent is less thoroughgoing than Giotto's own practice, and the flow of light in the *Crucifixion* panel, although directed mainly from a single source to the left, is not entirely consistent. Comparisons with Giotto, however, should not be allowed to diminish Pacino's humbler but still important place in early Florentine painting, or to detract from the virtues of this masterpiece of his maturity.

Perhaps the finest of Pacino's miniatures are the scenes from the life of Christ and from the life of the Blessed Gherardo of Villamagna (a Franciscan tertiary), which are now in the Pierpont Morgan Library in New York. The scene of the *Flight into Egypt* (*Plate 44*), while more summary in execution than his panels and less firmly controlled, brings the subject to life in a manner consonant with the new demand for naturalism—so much so that there is something almost homely about Pacino's interpretation of the Gospel story.

Although it is difficult to compare a small manuscript illumination with a large-scale fresco, the spirit of the narrative is not far removed from that of the *Miracle of the Spring* (*Plate 43*) and other scenes of the *St Francis* cycle at Assisi. Stylistic connections between the Assisi frescoes and the *Tree of Life* have long been recognized, but the differences in medium and in scale have tended to disguise the extent of such affinities. Frequently Pacino's figure-types—as, for example, the St Francis in the *Tree of Life*—recall those found in the Assisi cycle; and similar echoes occur in the New York miniatures: we need only compare the man holding the ass's bridle in the *Flight into Egypt* with the friar standing on the very left in the *Miracle of the Spring*. Unlike the scenes in the *Tree of Life*, the *Flight into Egypt* preserves a miniaturist convention for the representation of trees; but otherwise the landscape is very like that in the Assisi fresco: indeed Pacino's general approach to the design of a landscape and his mode of representing particular landscape forms are virtually identical with those of the author of the fresco. Certain spatial ambiguities in the fresco are exaggerated in the miniature, where the workmanship suggests great rapidity, and even haste, of execution.

All in all, the links between Pacino's style and that of the *Legend of St Francis* at Assisi, and especially of the *Miracle of the Spring* and other scenes in the same area of the decoration, are incontrovertible; and they are far stronger than any affinities between the Assisi frescoes and the work of Giotto. They raise, as we have seen earlier (p. 31), the question of his possible connection with the Assisi workshop. This is not a question that can yet be answered with certainty, since the evidence is suggestive rather than conclusive, and there is a complete lack of relevant documentation. But, so far as the history of Florentine painting is concerned, Pacino's position is clear enough: his *bottega* was a busy one; his art was in

great demand and was evidently admired; yet he stands out in the age of Giotto by virtue of his resistance to Giottesque iconography and Giottesque methods of composition, and in this respect he must be regarded as the major candidate for the leadership of that independent current in Florentine painting of the early fourteenth century which Offner called the 'miniaturist tendency'.

Offner's term can lead to misunderstandings when it is used as a comprehensive stylistic definition, as is obvious from the case of the St Cecilia Master, who certainly belonged to this group of painters and who yet proved himself at Assisi to be a supreme master of monumental fresco painting. Or we might look outside Florence and take the example of Simone Martini, who developed a style no less independent of Giotto's ideals. We should scarcely be aware of the fullness of Simone's genius if none of his frescoes had survived and if we knew him only as the author of paintings on panels and as a miniaturist. Style is often affected by the nature of a particular commission, expanding or contracting according to the dimensions of the task while preserving its recognizable individuality. This is one of the factors that make it possible to postulate a Pacino or a Traini or even a Duccio as a fresco painter, on the basis of signed or documented works in other media. Even apart from such considerations, to perceive the existence of a 'miniaturist' tendency in Florentine painting of the age of Giotto is not to deny that the altarpieces of Pacino, the St Cecilia Master, Jacopo del Casentino and others contain elements deriving from Giotto himself. But it would be wise to adopt a broader terminology, lacking in specific associations with the art of the illuminator; the term 'decorative tendency' would perhaps be preferable.

Among the miniaturists who were directly indebted to Pacino, the most interesting is the Biadaiolo Illuminator, so called from a fascinating series of nine illustrations to a book written by Domenico Lenzi about 1340 and entitled *The Florentine Corn-Dealer (Il Biadaiolo fiorentino)*. As its title indicates, this work is concerned with the Florentine corn-market and its importance in the life of the city; and the illustrations are quite remarkable for the vividness of their evocation of the contemporary scene. The bustling figures, with their curiously crumpled features and eager expressions, are so full of life, and intimate such interest in each other, that the impression is given that at any moment we might overhear their conversation. In the scene of *The Poor of Siena being received in Florence (Plate 82)*, the artist gives us an astonishing view of the city, with the Palazzo Vecchio in the foreground and the Baptistery further back. Both in his treatment of form and in his grapplings with perspective, the Biadaiolo Illuminator is highly individual; and it is not merely his quick eye and his curiosity about the visible world that are so appealing: there is immense vigour in the sheer gusto with which he evidently responded to this secular commission (and which was less appropriate to his interpretations of traditional religious subjects). The long history of Italian manuscript illumination scarcely knows a more exciting master.

We must now return to Santa Croce and consider three of Giotto's immediate followers

who worked there—Taddeo Gaddi, Maso di Banco and the Master of the Fogg *Pietà*. Among these painters Taddeo Gaddi has a place of his own as Giotto's assistant for twenty-four years (as we are informed by Cennino Cennini). His style derives directly from his master's, and even something of the inventiveness and gaiety of his colour-schemes is traceable in Giotto's late work, so far as it is known to us. Yet in many respects—notwith-standing his long apprenticeship—Taddeo Gaddi was eventually to diverge from Giotto's ideals, drawing closer to those of Bernardo Daddi. He was the most powerful of Giotto's direct pupils, and he must be accounted one of the supreme masters working in the fourteenth century.

The greatest of Taddeo Gaddi's surviving works are the frescoes of the *Life of the Virgin* in the Baroncelli Chapel at Santa Croce (*Plates 86, 89, 91, 101*). The tomb of the Baroncelli family is set into the entrance wall, which was also decorated by Taddeo, and it bears the date February 1327 (Old Style; i.e. 1328, New Style).*

The frescoes in the Baroncelli Chapel occupy the left (or east) wall and the south wall, facing the entrance. The left wall (*Plate 86*) contains five compositions—the large double scene, in the lunette, of the *Expulsion of Joachim from the Temple* and *The Angel's Appearance to Joachim;* and below this, in two rows, four rectangular scenes: the *Meeting at the Golden Gate*, the *Birth of the Virgin*, the *Presentation of the Virgin in the Temple* and the *Marriage of the Virgin*. The twisted columns separating each pair of scenes in the two lower registers establish a central division, which is carried up into the fresco in the lunette by the tall columns of the temple portico, so that the separate incidents illustrated in this upper fresco, although represented together in a single composition, are in effect contained within distinct pictorial fields. The other wall is the only one pierced by a window, and six scenes are disposed above the window and at the sides. These scenes, carrying the narrative forward to the birth and infancy of Christ, are the *Annunciation*, the *Visitation*, the *Announcement to the Shepherds*, the *Nativity*, the *Journey of the Magi* and the *Adoration of the Magi* (or *Epiphany*). Despite the proliferation of detail, the individual forms are so bold, and the magisterial designs laid out with such clarity, that each story and incident can be read with the utmost ease.

In the Baroncelli Chapel we are not far from the world of Giotto's own frescoes at Santa Croce; but although the roots of Taddeo's aesthetic can be traced there, its fruits were subtly different; and the contrast with the earlier Giotto of the Arena Chapel becomes still more pronounced. The differences are partly accountable to the painter's response to the changing religious climate of his times and partly to the logic of stylistic development in itself. On the one hand, the Baroncelli Chapel decorations reflect a reaction against the intimate religious devotions encouraged most notably by the *Meditationes*, in favour of a more restrained and, as it must have seemed, a more reverent approach to the divine mysteries—a reaction that was to grow in strength as the century advanced, and which, in

* The Florentine year used to begin on Lady Day (25 March).

Taddeo Gaddi's day, was typified by the sermons and writings of his friend Fra Simone Fidati. On the other hand, Taddeo extended Giotto's realism in the direction of a meticulous concern with naturalism of detail. In this he was not alone; and his interest in illusionism belongs to a tendency already current in his times: the *trompe l'oeil* aumbries containing liturgical vessels which are painted below the scenes in the Baroncelli Chapel are remarkable examples of an impulse to match the retinal image with the painter's skill. Similar adventures in illusionism occur earlier in Pietro Lorenzetti's frescoes at Assisi. In respect of his most original contribution to the Giottesque style—his advanced explorations of effects of light—Taddeo Gaddi occupies a place of his own as one of the major innovators in the history of early Italian painting.

Taddeo Gaddi's adventures into the problem of depicting light were motivated by the need to evoke not simply the splendour of natural light, but the mystery of the supernatural light of heaven. In his treatment of natural light on the east wall of the Baroncelli Chapel he consistently modelled his forms as though they were real forms illuminated from the south window. On the south wall, when he came to depict the supernatural light which emanated from the angels and the strange star, his desire to convey a sense of mystery and miracle impelled him to make an unusual innovation of a purely technical character: in painting the famous scene of the *Announcement to the Shepherds* (*Plate 101*), he first darkened the wall by preparing his fresco with a brown ground, which is now clearly visible in large areas of the sky where the overpainting has peeled off. 'In this dusky environment', Meiss has observed, 'the yellow light of the angel becomes incandescent.' And the shining mountain reflects a heavenly radiance, as one of the shepherds shields his eyes from the blinding light. As Gardner has pointed out, the light is envisaged as glowing from behind the wall on which the fresco was painted, as though from the window itself.

The light is supernatural; but its expression is that of an artist with an exceptional interest in natural phenomena. We may well believe that it was on account of an unusually inquiring mind that Taddeo Gaddi suffered the unfortunate accident which befell him in the year 1339. As he was to explain in a pathetic letter to Fra Simone Fidati, a member of the Augustinian Order in Rome, he had seriously damaged his eyes by gazing at an eclipse of the sun. This fascinating letter has survived because it was preserved along with Fra Simone's long reply, in which the friar offered spiritual advice and admonished the painter for his impious curiosity, and it has, accordingly, come down to us together with Fra Simone's major theological works, the *Ordine della vita cristiana* of 1333 and the larger *De gestis* (begun in 1338). In 1333 Fra Simone had left his native Umbria in order to reside in Florence, proceeding some five years later to Rome. During his Florentine period, when he established himself as one of the famous preachers of his day, he and Taddeo Gaddi had become friends. It was evidently late in 1339, not long after his arrival in Rome, that Taddeo wrote to him from Florence, begging him for his prayers and for some word of consolation:

A bodily infirmity, which has come upon me suddenly in these days, compels me to weary your ears. For from days not long past I have suffered, and still suffer, from an unendurable infirmity of the eyes, which has been occasioned by my own folly. For while, this year, the sun was in eclipse I looked at the sun itself for a long period of time, and hence the infirmity to which I have just referred. For I constantly have clouds before my eyes which impede the vigour of my sight. Hence I can truly say with him who sang: 'Mine eyes fail with looking upward. O Lord, I am oppressed, be thou my surety. What shall I say, and what shall be my surety, since he himself has brought it to pass?' [Cf. Isaiah 38: 14–15.] ... I grieve because this infirmity hinders certain undertakings of mine, but I do not weep over what is most to be deplored—that this indisposition, which through the mediating power of Christ ought to restore and strengthen the sharpness of my inward eye, has rather, by virtue of its own frailty, darkened it completely, and has thus bent the backbone of my own inward man. For I am plunged into the deepest abyss of melancholy ... I am compelled to write for two reasons. First of all, it is to seek the support of your prayers. I therefore pray you to intercede with God immediately, that He may act mercifully towards me. Secondly, it is to obtain the solace of some exhortation from you. I therefore beseech you to be so good, if you can spare the time, as to send me a little note ...

Taddeo Gaddi's despair must have been accentuated by the difficulty he would now find in painting, which seems to be implied in his reference to the 'undertakings' that he was now prevented from pursuing. Sunk in melancholy, he derived no comfort from the reflection that he was the recipient of a divine chastisement intended to illumine the inner eye, while darkening the outer: his affliction had produced the opposite effect. But it is questionable whether he would have been much consoled by Fra Simone's condemnation of that very curiosity of eye which we recognize today as an aspect of his artistic genius, but which to the religious mind of those times seemed to be a symptom of sinful pride. 'You have suffered a total eclipse', Fra Simone wrote, 'because you looked at the failure of the sun's light not only rashly but with curiosity.' And he proceeded to admonish his friend with some severity:

Examine your conscience and address your heart, for justly has this penalty smitten you. For curiosity never leaves her author unavenged, so that the kind of pain with which you must be punished may make the point for you, since you presume to look so rashly upon what it is not permitted to desire ... Your eyes are weakened because you looked surmisingly into the heavens; yea, they are affected and darkened because you lifted your face with pride towards the heights, not towards your Creator and not to praise His majesty or the wonders He has made, but so that you might understand those things which there is no usefulness in knowing.

Fra Simone proceeds to set forth the example of St Paul and other men of God who endured blindness and yet came to see the truth all the more clearly; and he urges Taddeo Gaddi to resist his tendency towards melancholy. The letter is dated, 'Written in Rome on the first day of 1340'.

The precise date of Taddeo Gaddi's unhappy experience can be determined, for an annular eclipse of the sun occurred on 7 July 1339; it was visible in Florence, and is mentioned in Giovanni Villani's *Chronicle*. Taddeo Gaddi could also have observed an earlier eclipse which had taken place in May 1333; and it is tempting to infer that his inquisitiveness about such celestial demonstrations was but one aspect of a general curiosity of mind concerning natural phenomena, such as seems to be reflected especially in the brilliant light effects in the *Announcement to the Shepherds* in the Baroncelli Chapel. In this context, it is of considerable interest that an actual representation of an eclipse of the sun is to be found in the border of Orcagna's now fragmentary fresco of the *Triumph of Death* which once filled the south wall of the nave of Santa Croce (*Plate 148*). This little scene belongs to a sequence of representations of ominous signs that would precede the Second Coming of Christ and the Last Judgment; but its vivid realism suggests that it was based upon personal experience. Two men are seen staring up at the sun, which is obscured by the dark disc of the moon; both men shield their eyes with one hand; and, what is still more interesting in view of Taddeo Gaddi's troubles, a third figure (on the right) turns away from the spectacle in evident pain, with his hand raised to his right eye. We may recall the shepherd who shields his eyes from the light in Taddeo's fresco of the *Announcement to the Shepherds* or the similar gesture of one of the kings in the *Appearance of the Star to the Three Kings*. Such images bring home to us, as much as Fra Simone's reaction to Taddeo Gaddi's curiosity, the difference between our modern conception of the universe and the medieval world-view, which saw the skies as the very borders of heaven, and read in the motions of the planets, no less than in manifestations of the heavenly host, clear signs of the operation of the Divine Will.

Despite Taddeo Gaddi's confession to Fra Simone that he was unable to derive spiritual comfort from his chastisement by God, the Baroncelli Chapel frescoes communicate an intense religious feeling that is consonant with all we know about the spiritual climate of the middle decades of the century. The impression that a veil has been drawn aside from mysteries which are beyond normal experience is already conveyed on the east wall, where the double scene in the lunette, which introduces the narratives, sets the tone of the whole cycle: the tense postures and dramatic gestures of the figures express a grave awareness that the events in which they are partaking have a solemn import beyond their complete comprehension. The surprise of the shepherds at the angel's appearance—underlined by the startled reaction of the sheepdog, which strains upward, frozen by fear—focuses attention upon St Joachim's awed response to the divine message. The reverential restraint shown by husband and wife at their reunion in the following scene (*Plate 89*) belongs to the

same world of ideas. Where Giotto, in the Arena Chapel (*Plate 88*), had dwelt upon the loving intimacy of their embrace, Taddeo Gaddi was concerned with an ideal of purity and self-control which offers an insight into the spiritual mood of the 1330s; indeed, the fresco could have been used as an illustration to Fra Simone's own injunction that 'married couples must not indulge, whether seductively or playfully, in caresses, which put the fire of sensuality into their flesh'.

The symmetrical disposition of the motionless figures of St Joachim and St Anne and the device whereby their meeting haloes preserve the distance between them stress the theological significance of the event, which was directly associated in medieval thought with the unofficial doctrine of the Immaculate Conception; for it was believed not only that the Virgin Mary was conceived by St Anne without sin—as the 'second Eve' who was as perfect as Eve herself had been before the Fall—but also that St Anne had miraculously conceived her child at the moment when she was embraced by her husband as they met at the Golden Gate of Jerusalem. It is this striking imagery that must have inspired Bernardo Daddi's charming treatment of the subject in his San Pancrazio polyptych (*Plate 87*).

The same restraint characterizes the attitudes of Mary and Joseph in the final scene, the *Marriage of the Virgin* (see *Plate 86*), where St Joseph is not permitted to approach too closely to his young bride, and is barely distinguished from the crowd of disappointed suitors, while she herself stands on a higher level of the temple steps beside the High Priest. Such incidental details as the trumpeters on the left, the birds in the garden beyond, and the onlookers who peer down from a balcony on the right, while evidently intended to incorporate in the composition something of that sense of joyous occasion which Giotto, in the Arena Chapel, gave to his interpretation of the succeeding event in the apocryphal story— the *Virgin's Return Home* (*Plate 64*)—do not distract attention from the solemnity of the scene.

The preceding fresco, the *Presentation of the Virgin in the Temple* (*Plate 91*), makes an equally instructive comparison with Giotto's rendering of the same subject at Padua (*Plate 59*). In Giotto's imagination the story had taken on the aspect of a tender scene of maternal solicitude on the part of St Anne, and of benign sympathy on the part of the High Priest; and the miraculous circumstance which was central to it—the child's precocious ability to mount the fifteen steps of the Temple unaided—was in the process lost sight of. Taddeo Gaddi, on the other hand, draws attention to the miracle by creating around the Virgin a vast space, within which she stands isolated, as she looks back momentarily before ascending the long stairway to the waiting priests.

The figure of the Virgin has suffered from later restoration, but a fourteenth-century drawing in the Louvre, which has been thought to be Taddeo Gaddi's own preparatory study for the composition, and which, if not that, may at least be his authorized record of it, executed by a member of his shop, shows that she was originally represented in a

self-contained attitude, without particular gesture, and isolated all the more by virtue of her stillness. It may be concluded that the extraordinary architectural invention wherewith Gaddi conveyed an idea of the grandeur of the Temple, employing to new effect an oblique perspectival construction, had its origins less in naturalistic considerations in themselves than in the desire to do justice to the religious meaning of the subject; and the fresco evokes the sense of mystery attendant upon a miraculous occurrence in the life of the future Mother of God and Queen of Heaven, in the presence of which the solemn witnesses of the drama, forming a wide circle around the tiny but dignified figure, keep their distance. The sheer virtuosity of the artist's management of space made this fresco a composition that was long remembered, and about a century later Pol de Limbourg repeated it with remarkable accuracy in a famous illumination in the *Très Riches Heures du Duc de Berry*.

About the same time that he was working on the frescoes in the Baroncelli Chapel, Taddeo Gaddi was commissioned to decorate a cupboard in the sacristy at Santa Croce. This work, which is now in the Accademia (apart from one panel at Munich), comprises a lunette containing an *Ascension* and an *Annunciation*, twelve quatrefoil panels representing further scenes from the life of Christ and ten such panels devoted to the legend of St Francis. In the main, the Franciscan scenes are based partly upon the canon established in the Upper Church at Assisi and partly, and more profoundly, upon the frescoes by Giotto in the Bardi Chapel. Their origin in large-scale mural decoration is betrayed by the difficulty that Gaddi evidently experienced in fitting known compositions into the awkward quatrefoil format. Even so, several of the panels show considerable originality.

One notable example is the *Christmas Crib at Greccio* (Plate *92*), which departs radically from the Assisan iconography (Plate *93*). (The subject is omitted from Giotto's cycle at Santa Croce.) This is the story of the Christmas Mass which St Francis sang beside a crib, having brought there an ass and an ox, when a member of the congregation saw the Christ Child miraculously appear in the Saint's arms—a story that led eventually to the popularization of Christmas cribs throughout the Christian world. Taddeo Gaddi creates a characteristically lucid design, to which variety is given by the representation of the figures from different angles; and although he has obscured the important circumstance that St Francis (as we are told in the *Legenda maior*) was himself the celebrant, his refashioning of the tradition enabled him to isolate the figure of the Saint and to draw a meaningful parallel between the *Corpus Christi* of the Mass and the holy infant who graciously allows St Francis to embrace him in the flesh. The architectural divisions within the compact composition contribute to the expression of the same idea.

Taddeo Gaddi's reputation after Giotto's death in 1337 can be judged from a document of 1347 relating to a polyptych of the *Madonna and Child with Saints* (Plate *94*) for the church of San Giovanni Fuorcivitas at Pistoia. Before commissioning the altarpiece the church authorities drew up a list of *li migliori maestri di dipingiere che siano in Firenze per la tavola*

dell'opera di Sancto Giovanni ('the best masters of painting in Florence for the work of executing the picture for San Giovanni'), and they placed Taddeo Gaddi at the head of the list—before Stefano, Orcagna, Nardo di Cione and an assistant of Orcagna's named Francesco.

Taddeo Gaddi completed the altarpiece by 1353, in which year a final payment to him is recorded. No work better illustrates the change of direction taken by his style in his later years, when he came increasingly under the influence of the Sienese and seems to have been largely won over by the decorative manner of Bernardo Daddi. The otherworldly character of the altarpiece is epitomized by the central panel, where, as in Orcagna's *Strozzi Altarpiece* (*Plate 154*) of a few years later, prominence is given to an aureole of winged cherubim—disembodied spirits which now take the place of those substantial angels of early fourteenth-century tradition who stand around the Virgin's throne on terra firma.

This mystical interpretation of the Madonna theme can be regarded, nevertheless, as a natural development of that visionary element in Taddeo Gaddi's genius which found expression, in different terms, in the Baroncelli Chapel; and, as we shall see when we come to consider Orcagna and the late Trecento masters, the development that reached a climax in the Pistoia *Madonna* was seemingly bound up with religious and social forces at work in the second half of the century, which had already been anticipated by the attitudes exemplified by the sermons and writings of Fidati. On the scale of fresco painting, some of the qualities of the Pistoia *Madonna* are foreshadowed in the decorative splendour of Gaddi's *Tree of Life* in the former refectory of Santa Croce, datable towards 1340. The art of Taddeo Gaddi bridges two virtually distinct periods in the cultural and religious life of Florence: rooted in the traditions established by Giotto, it branches outwards in directions that on the one hand intimate the questionings of original genius and on the other manifest a sensitive response to a changing spiritual climate.

Less is known about the once mysterious Maso whom Ghiberti listed among Giotto's pupils, and who can now be identified definitely with Maso di Banco, a painter documented in Florence between 1343 and 1350. It is Ghiberti who informs us that Maso was the author of the frescoes in the Bardi di Vernio Chapel in the left transept of Santa Croce. The problem of his identity arose from the fact that Vasari confused under one name—'Tommaso [or Maso] di Stefano, called Giottino'—three different masters, the sculptor Tomaso di Stefano and the painters Giotto di Maestro Stefano, known as Giottino, and Maso (or Tomaso) di Banco. The beautiful *Pietà* from San Remigio (*Plate 95*) is often ascribed by modern authorities to Giottino, but there is no proof of the correctness of this attribution. The style of the panel has much in common with that of Maso's frescoes at Santa Croce. Although it preserves strong recollections of Giotto (the Giotto, indeed, of the Arena Chapel *Pietà*), the treatment is the reverse of dramatic, and the donors and saints participate in the lament over Christ's death on an ideal plane of mystical contemplation.

Maso's frescoes, on the other hand, belong to an earlier stage in the development of the Giottesque style, and probably date from the late 1330s. The chapel they adorn had been built about 1310 by the Bardi di Vernio, a branch of the wealthy banking family whose own chapel, decorated by Giotto with scenes from the life of St Francis, stands by the High Altar, next to that of their rivals the Peruzzi. Testimony to the family's importance and, in a more general sense, to the rising power of the laity during this period is provided by the elaborate Gothic tomb which is set into a niche on the north wall of the chapel. Its presence is quite unusual, for long custom had ordained that members of the middle classes should not be buried within a church but in niche tombs placed against the exterior walls. Another unusual feature of the Bardi di Vernio tomb is the inclusion of a fresco painted by Maso above the sarcophagus (*Plate 98*), in which the dead man—sometimes identified with Andrea dei Bardi, sometimes with Bettino dei Bardi—is represented as having risen from his tomb to kneel before his Maker: as two angels blow the last trump, Christ the Judge appears in the heavens, surrounded by four more angels bearing the instruments of the Passion. The fresco has been aptly likened by Eve Borsook to a private *Last Judgment*. Traditionally, donor portraits were given a reduced scale in relation to sacred figures, as, for example, in the case of the portrayals of Cardinal Stefaneschi in Giotto's altarpiece for St Peter's (*Plate 73*), but here Signor Bardi is as large as the members of the angelic host, as though to underline his assertive confidence in his ultimate entry into heaven.

The main decorations in the chapel, which also contains windows designed by Maso, consist of an extensive series of scenes illustrating the miracles of St Silvester, the fourth-century pope whom legend credited with the conversion and baptism of Constantine the Great, and whose name became inextricably associated with the so-called 'Donation of Constantine', whereby Silvester and his successors on the papal throne were supposedly granted spiritual and temporal dominion over western Europe as well as supremacy over the other patriarchates. This document was to be proved a forgery in Renaissance times; but St Silvester's connection with Constantine the Great provided sufficient justification in itself for his inclusion among the saints honoured in fresco cycles at Santa Croce (the church of Holy Cross); for according to the colourful story in the *Golden Legend*, the discovery of the True Cross had been made by the Emperor's mother, St Helena, and it was after a vision of the cross, which he had seen emblazoned against the sun, that Constantine had won his victory over Maxentius, so ensuring the triumph of Christianity in the West.

The most famous of Maso's frescoes is justly the scene in which Silvester quells a dragon whose foul breath has been killing off the population of Rome (*Plate 100*). Two incidents are shown: on the left, the saint binds the dragon's mouth; and on the right he restores to life two sorcerers who are among its victims. The *mise en scène* is as remarkable as the piazza, with its Roman temple, depicted in the first episode of the *St Francis* cycle at Assisi (*Plate 30*): Maso offers us a realistic representation of the Roman Forum, and conveys a vivid

impression of the havoc wrought by time upon age-old buildings, from whose cracked stonework grass, ferns and other plants have sprouted. There are no precedents for this historicism, for this 'picturesque' interpretation of the melancholy beauty of an ancient ruin. Pictorial space is here articulated in a new way. The figures are enclosed by the ruined buildings and the fallen masonry, and a sequence of overlapping planes—almost aligned with the picture-plane but subtly differentiated from it—creates a space that recedes in calculated stages. The very magnificence of this spacious environment contributes to the grandeur of the scene, and (although there are modern retouchings) the lucid and brilliant colours, enhanced by repeated notes of pure white, help to give clarity to each sharply defined form. No painter of the period shows a more cerebral approach to design; and as the eye passes from one passage in this marvellous composition to another we become aware that nothing has been left to chance: every detail takes its place as an essential element of the total design, and the architectural coulisses march together with the attitudes and gestures of the human actors. Maso's starting-point must have been the harmoniously ordered style of the Peruzzi Chapel (*Plate 58*) and presumably the lost frescoes of Giotto's later years, such as those formerly in Naples, where in the Castelnuovo there survive some fragments in Maso's style which suggest that he was Giotto's assistant there. Giotto's works in Naples had included a series of secular frescoes of *Famous Men*—a theme, it is of interest to note, that is taken up again in the windows designed by Maso for the Bardi di Vernio Chapel.

These frescoes by Giotto, which seem to have been largely destroyed in the fifteenth century, are recorded by Ghiberti. They were commissioned by King Robert for the 'sala degli uomini famosi' at his palace of Castelnuovo, and portrayed nine 'Worthies'—Solomon and Samson, from Jewish history, and the pagan heroes, Alexander, Hector, Aeneas, Achilles, Paris, Hercules and Julius Caesar. If these and other late works of Giotto had survived we should be in a better position to assess the nature of Maso's stylistic origins; but it seems evident enough from the decorations in the Bardi di Vernio Chapel that he was no mere imitator but a master of great originality who was able to exploit Giotto's discoveries in his own way, on the one hand extending Giotto's explorations of pictorial space, and on the other carrying design itself to a stage of refinement which brings to mind the geometrizing of Piero della Francesca.

Beside Maso, the so-called Master of the Fogg *Pietà*, or Maestro di Figline, seems almost eccentric in his bold independence of outlook. He must have been highly regarded in his own time, for he decorated, or helped to decorate, a chapel at Santa Croce—the Tosinghi Chapel to the left of the choir—and also painted the large crucifix which is still to be seen over the High Altar. The damaged *Assumption of the Virgin* over the entrance to the Tosinghi Chapel is all that remains of the fresco decorations for this chapel, which constituted a series of scenes of the life of the Virgin. Some stained glass by him also survives in a window above the *Assumption*. There are other windows by him in the Lower

Church at Assisi, and it has recently been proposed by Marchini that he is to be identified with Giovanni di Bonino, an artist previously known only as the designer of some stained glass windows in Orvieto Cathedral. This attractive hypothesis does not, however, amount to certain proof. Ghiberti—a usually reliable source—recorded the Tosinghi Chapel frescoes as being by Giotto. His statement does not, however, necessarily imply that Giotto was personally responsible for their execution. If he was not, the whole enterprise could have been a job entrusted to his workshop; in which case the Master of the Fogg *Pietà* may have been a member of the workshop and in that capacity would have painted the *Assumption* over the entrance and perhaps other decorations inside the chapel.

His *Madonna in Majesty* in the church at Figline, another *Madonna* at Assisi and the panel of the *Pietà* (*Plate 99*) in the Fogg Museum at Harvard are representative in their different ways of his austere vision, which has reminded some critics of that of Castagno. Indeed, like Castagno in the following century, the Master of the Fogg *Pietà* discovered for himself the value of the expressive outline; and it is this incisive linearism that most distinguishes him from Giotto's closest followers. Nor, apparently, did the logic of Giotto's new treatment of space have for him the importance that it had for his pupils Taddeo Gaddi and Maso.

The Fogg *Pietà* demonstrates that he had learnt from Giotto how to give his figures a convincing plasticity; and in its intensity of feeling and in its humanity the picture recalls both the celebrated fresco by Giotto in the Arena Chapel (*Plate 37*) and also the *Pietà* by the Isaac Master at Assisi (*Plate 36*). Yet the Master of the Fogg *Pietà* lacks Giotto's restraint; he is the great 'expressionist' of the early Trecento; and he borrows from Giotto's vocabulary only the rudiments of a unique, emotion-charged language, whereas Maso, for instance, builds on the foundations laid by his master an art of controlled rationality. A comparison between the art of the Fogg Master and that of Maso brings home to us the width of the horizon opened out by Giotto's innovatory genius; but the fact that Giotto's followers could pursue such divergent aims reminds us also of the limits of his direct influence over those who came after him.

Simone Martini
and his followers in Siena

Giotto's impact upon his Sienese contemporaries is evident as early as 1315, the date inscribed on Simone Martini's *Maestà* in the Palazzo Pubblico at Siena (*Plate 104*), a large fresco painted on the end wall of the Great Council Chamber. This is the most important painting to have been commissioned in Siena since the completion, some four years earlier, of Duccio's *Maestà* for the Cathedral. Simone, whose origins are obscure, must have been about thirty years old at the time. It is reasonable to suppose that he had received his training under Duccio himself. Indeed the type of Madonna (*Plates 5, 54*) evolved by Duccio and his pupils leads on directly to that of Simone's Santa Caterina polyptych of 1319 (*Plate 108*) and of the comparable polyptych in the Gardner Museum at Boston. In addition, as the fresco of the *Maestà* indicates, Simone must have been deeply impressed early in life by Giotto's novel treatment of space. The scheme of the medallions set into the broad decorative framing even suggests a reminiscence of Giotto's *Navicella* mosaic in the atrium of Old St Peter's—in which case a period of study in Rome can also be inferred.

The Giottesque elements in the *Maestà*—a work that in its tapestry-like decorativeness may seem at first sight quite remote from the principles proclaimed so uncompromisingly in the *Ognissanti Madonna* (*Plate 14*)—have been admirably defined by Oertel, who draws attention to the centralized system of perspective (epitomized in the frieze of foreshortened consoles which intervenes between the picture area and the frame), to the spatial treatment of the recessed throne, and to the identification of the source of light with the window of the Council Hall. In a more general sense, Simone derived from Giotto 'monumentality, rational order, and the new unifying vision': yet these elements were but the means to an amplification of the distinctive Sienese idiom as it had been shaped by Duccio before him, and which Simone remoulded in the Gothic spirit of his own times.

Whereas Giotto placed the representation of visual phenomena at the service of a searching interpretation of the human situation, so that in the *Ognissanti Madonna* the very world of heaven is made flesh, Simone dwelt upon the sheer beauty of visible things—a beauty that in the Siena *Maestà* seems to reflect the majesty of the Divine Artist. Above all else, Simone found this beauty in the radiance of colour, and he was unquestionably one of the most original and subtle colourists in the history of western painting. The rhythmic grace of his line is attuned to the same ideal. In the work of Simone Martini the epic character of Giotto's art is ultimately rejected in favour of an intensely personal lyricism; the monumental gives way to the melodious; grave austerity to chaste delight.

This characterization of Simone's genius is not meant to imply that he lacked Giotto's seriousness of purpose, nor that he was incapable of the profound expression of human emotion that informs the art of his great Florentine contemporary. The dispersed panels of the famous *Polyptych of the Passion*, of which the *Procession to Calvary* (*Plate 102*) in the Louvre is among the most memorable, would alone be sufficient to contradict any such ideas, however much his brilliant effects of colour and pattern may even here dazzle the sight. And if the *Maestà* overwhelmed the citizenry of Siena by its splendour, its more fundamental purpose was to act as a solemn reminder of the virtues of wise and humane government. Two verses adorn the steps below the Virgin's throne, declaring her concern, as Queen of Siena, that the qualities of wisdom and justice should be held in honour by its citizens and rulers. The verses begin: 'The angelic flowers, the roses and lilies with which the celestial meadowland is adorned do not delight me more than good counsel. But I see some who for their own ends despise me and lead my country astray.' The inscription constitutes a heartfelt appeal to Siena's divine protectress to send down the blessings of peace upon a city torn by internecine strife.

The message is underlined in Simone's composition by the prominence given in the foreground to the four patron saints of Siena (Vittorio, Crescenzio, Savino and Ansano), who kneel in intercession before the throne of grace, together with two angels, who offer flowers to the Virgin as in the verses quoted. Other saints crowd around behind them, the twelve Apostles forming the row at the back. Some of the saints support the splendid canopy—its border lined with civic coats of arms—which spreads out above the assembly. The composition is all the more impressive on account of the scale of the figures, which are well over life-size. The Virgin's throne is an elaborate Gothic structure with soaring pinnacles, somewhat in the form of a gabled polyptych; it is richly gilt and exquisitely tooled, and, despite the damaged condition of the fresco, the gold still blazes against the deep blue background of sky. The more delicate blue of the Virgin's gown, itself embroidered with gold, strikes a gentler note, and in turn is differentiated from that of the cushion on which she is seated: already in this central passage the variety and subtlety of Simone's colour combinations make themselves felt. No less characteristic of the master's quest for pictorial harmonies are the contrived patterns into which the Virgin's robes have arranged themselves, matching the soft curves of her pliant form.

In 1317 Simone was summoned to Naples by King Robert of Anjou, who knighted him, granted him an annual pension of fifty ounces of gold, and commissioned him to paint a large votive picture (*Plate 105*) commemorating the canonization in the same year of his brother Louis of Anjou, bishop of Toulouse. On his election to the bishopric (in 1296) the unworldly Louis had renounced the throne of Naples in favour of his brother; as a member of the Order of Friars Minor he was to become one of the most revered of Franciscan saints: hence the prominence given to his image in many fresco decorations in Franciscan churches,

7

such as those by Giotto in the Bardi Chapel at Santa Croce and Simone Martini's own cycle devoted to the *Life of St Martin* in the Montefiore Chapel at Assisi (*Plates 106, 107*), which has a close stylistic connection with the *St Louis* altarpiece. The ugly accusations directed against King Robert, to the effect that he had usurped his brother's throne, may well have had a bearing upon the nature of the commission that he now gave to Simone Martini; for in the central panel the enthroned St Louis is shown in the unequivocal act of placing his earthly crown upon the head of his brother, who kneels humbly at his feet, while he himself is crowned by angels with a more splendid crown of sanctity. The picture is signed SYMON DE SENIS ME PINXIT.

The crimson-robed figure of St Louis is placed against a gold background which is finely tooled; naturalistic effects of light and shade are reduced to the minimum; forms flatten out to boldly defined silhouettes; the effect of an ideal, rather than a real, space is enhanced by the frame, its broad blue border being decorated with fleurs-de-lis. The impression made upon Simone's contemporaries by the stately figure of the saint and by that of his regal brother must have been dazzling, for their garments were originally studded with jewels and precious stones. In every sense this is courtly art at its most refined, and the picture shows how quickly Simone Martini responded to the modes current in the Angevin domains, where French tastes and customs prevailed. The effects of his saturation in the culture of the Neapolitan court were to be permanent, and in turn the works that he executed towards the end of his life at Avignon—the temporary seat of the Papacy for most of the century—were to make a deep impression upon painting in France. The portraits of the enthroned St Louis and the kneeling king themselves anticipate the style of the later French illuminators, and one thinks especially, perhaps, of the famous dedication miniature in the Hague Bible, the work of Jean Bondol. The two heads in Simone's panel present a telling contrast: the one beautiful in its repose and in its purity of aspect, as though it were lit from within, and rendered frontally according to the tradition for the depiction of cult-images; the other less ideal, more powerfully characterized, and shown in profile like Giotto's portrait of Enrico Scrovegni (*Plate 56*).

Comparisons with Giotto suggest themselves again when we turn to the five predella panels, illustrating incidents from the saint's life; for all the scenes are grouped together spatially in relation to a focal point at the centre, bringing to mind the system used by Giotto in the Arena Chapel—most notably in the five frescoes in the third register of the south wall. In the central panel, accordingly, representing *St Louis serving the Poor*, the orthogonals of the architecture recede to a central axis, towards which those in the flanking scenes are likewise directed inwards. Some of the buildings, such as the little house, with its upper storey, represented in the final scene (*The Saint appearing to a Devotee, and the Saint raising a Dead Child*), bring to mind, somewhat unexpectedly, the simplified *aediculae* of the St Cecilia Master (*Plate 29*), the petite daintiness of whose figures is also paralleled here.

The affinities are curious but interesting, especially in view of the presence in the preceding panel—the *Obsequies of St Louis* (*Plate 103*)—of what must be a direct borrowing from the *Legend of St Francis* at Assisi: at the centre of his composition Simone introduced two singing friars—striking figures which are almost exact copies of two of the four similar friars in the *Christmas Crib at Greccio* (*Plate 93*). Simone was to repeat this motif, with variations, when he came to paint the fresco of the *Obsequies of St Martin* in the Montefiore Chapel (*Plate 107*). The vivid naturalism of the Assisi master's rendering of these figures in the *Christmas Crib at Greccio* evidently made a strong impression upon a number of painters of the period. In Simone's case, such a borrowing raises the question whether he visited Assisi before his summons to Naples; in which event, he could, conceivably, have been called to San Francesco before 1317, with a view to the planning, if not to the execution, of the decorations in the Montefiore Chapel in the Lower Church.

These and other stylistic connections between the *St Louis* picture and the frescoes in the Montefiore Chapel indicate a probable date for the *St Martin* cycle not too far distant from the year 1317, although in the past the frescoes have been variously assigned to the periods 1317–20, 1322–6, the late 1320s, and the middle or late 1330s, while according to one radical but implausible view they were begun as early as 1312, the date of a document stating that Cardinal Gentile da Montefiore had bequeathed some money for the embellishment of the chapel. The chapel itself is small, but the effect of the whole is extremely rich, for the frescoes combine with the lovely, rainbow-hued windows of stained glass and the pavement and wainscoting—inlaid with coral and white marble—to create a decorative unity of complex beauty; and the colours in the frescoes shift with the play of the iridescent lights of the windows.

The story of St Martin is told in ten scenes, five on each of the side walls. Three pairs of tall windows, with frescoed figures of saints in the embrasures, fill the back of the chapel and provide the imagined source of light for all the narratives. Opposite the windows, over the interior arch of the entrance, the donor, Cardinal Gentile da Montefiore, who is buried in the Lower Church, is represented within a Gothic tabernacle in the act of offering himself to the protection of St Martin, whom he revered as the patron of his cardinalate. The interior of the entrance arch is decorated with standing saints, including St Francis, St Clare and St Louis of Toulouse. The five frescoes on each side wall are arranged in three registers, the lower two rows each containing two scenes, and the upper register one scene painted on the vault. As in Duccio's *Maestà*, the narrative unfolds from the lowest tier to the uppermost, and this sequence corresponds to a spiritual ascent, from the saint's life in the world to his ministry and miracles and thence to his death and obsequies. Save in the votive fresco of *Cardinal Gentile da Montefiore and St Martin*, where the treatment is bolder (perhaps to allow for the great height of the fresco from the floor), every passage in the decoration seems to have been executed by Simone and his assistants in tiny, 'Cézannesque' brushstrokes.

The Montefiore Chapel is Simone Martini's masterpiece. He was never to surpass, certainly in any surviving work, either the consummate beauty or the dreamy charm of this colourful evocation of chivalric legend. The courtly style of the *St Louis* panel, imbued with qualities that are essentially French in character, is here exploited on a grand scale; and Simone has moved a long way from the Ducciesque manner of his *Maestà* of 1315.

All Simone's finest qualities come together in what must have been one of the last narratives to be painted, *St Martin renouncing the Sword* (*Plate 106*). The story is taken from the *Golden Legend*, and it tells how St Martin, an officer of the Roman imperial guard, having accepted his vocation as a soldier of Christ, explains to the Emperor Julian on the eve of a battle against the German barbarians that he cannot take active part in it. On being accused of cowardice, St Martin declares that he will confront the opposing army with a cross, which in the fresco he holds in his left hand as he turns away from the Emperor towards the enemy encampment. The Emperor had announced his intention of rewarding his troops, and behind him an official can be seen dropping gold coins into the hand of a soldier. In a contrasting gesture, the Emperor, taken aback by St Martin's temerity, points his sceptre at the saint, giving him a long look as though more in surprise than in anger.

The tents of the two armies, separated by a gorge, through which there flows a narrow stream, perhaps intended to represent the Rhine, combine with the slopes of a central mountain to form a decorative backdrop, against which the elegant figures, with their costly attire and richly emblazoned accoutrements, enact a graceful *tableau*. The realization of deep space is only a secondary consideration, and Simone accords to the distant soldiery in the barbarian camp much the same scale as that given to the Emperor's retinue: yet the effect is one of spacious airiness, such as we find again in the *Equestrian Portrait of Guidoriccio da Fogliano* in the Palazzo Pubblico at Siena (*Plate 111*). It is, however, the ornamental decorativeness and pageantry and the blazing colour of the Assisi fresco that live in the memory. The lavish use of gold adds to the chromatic splendour, and is common to all the scenes; the borders of the frescoes are themselves embellished with gold, which was also used in the now defaced inscriptions below.

At the same time the decorative unity of the chapel is enhanced both by the consistent employment of a single light source and by a co-ordinated system of perspective in the main block of four scenes on each wall, which is related to a 'viewing position' at the centre of the chapel. As in the *St Louis* panel, Simone Martini demonstrates in the Montefiore Chapel his attentive study of the method of Giotto; but nowhere are we more conscious of his apparently deliberate refusal to apply that method to the same ends. It is not merely that Giotto's art is concerned largely with form and space, and Simone's with linear grace and sumptuous surface-values, nor that for Giotto colour was the adjunct, as it were, to the expression of plasticity, but for Simone the very language of sensuous delight: the separate

roads followed by the two masters lead to equally different worlds of the imagination—so much so that the figures that people the *St Martin* series seem to belong to a culture far removed from the *ethos* of Giotto's cycles at Padua and Florence. The physiognomic types are themselves quite distinctive, and Simone dismisses the *sfumato* of Cavallini and Giotto in his preference for a linearism almost oriental in character, compounded of elements derived both from Byzantine tradition and from French Gothic. The lack of deep shadows enhances the luminous quality of his forms, which he was able to model by changes of colour and variations in colour saturation.

The decorations in the Montefiore Chapel can be assigned provisionally to the early 1320s. They cannot be much earlier, for their stylistic character is very different from that of the *Maestà* of 1315, so that a considerable period of development in the interval seems to be implied, and it is arguable that the great polyptych of the *Madonna and Child with Saints* (*Plate 108*) painted in 1319 for the Dominican church of Santa Caterina in Pisa (which is Simone's largest altarpiece) shows a less advanced style. The master is documented in Siena on a number of occasions from 1321 onwards, and in 1321 he undertook the restoration of his *Maestà* of 1315. In 1322 he was paid for certain unspecified works, which would appear to have been of an extensive nature, in the loggia and the Chapel of the Council of Nine in the Palazzo Pubblico. For at least part of the year 1324 he was certainly present in his native city, since it was then that he married the daughter of the Sienese painter Memmo di Filippuccio, who has recently been credited by Previtali with the figures of saints on the *sott'arco* of the Upper Church at Assisi, and whose son Lippo Memmi was to assist Simone Martini in the painting of the famous *Annunciation* (*Plate 110*) now in the Uffizi. In 1325 Simone is mentioned as the author of a work for the Palazzo del Capitano del Popolo; he is again recorded in Siena in 1326, and in 1327 he was paid for another lost work. In 1328 he executed the fresco of *Guidoriccio da Fogliano* in the Great Council Chamber in the Palazzo Pubblico; and in the following year he was employed once more on work for the Chapel of the Council of Nine, where he painted two figures of angels (since lost).

At Assisi, in addition to the frescoes in the Montefiore Chapel, Simone Martini painted a series of half-length figures of saints in the right transept of the Lower Church. If, as has been suggested earlier, Simone made a visit to Assisi just before his departure for Naples in 1317, these figures might conceivably have been painted then; and although there is little to distinguish their style from that of the Montefiore Chapel, the generally bolder treatment of form in the chapel would be consistent with a later date. A further fresco in the same transept, representing the *Virgin and Child with two Crowned Saints*, suggests the workmanship of one of the assistants who helped in the painting of the *St Martin* cycle.

These works pale into insignificance beside the one other surviving masterpiece of Simone Martini's activity as a fresco painter (apart from the ruined decorations at Avignon), the *Equestrian Portrait of Guidoriccio da Fogliano* (*Plate 111*), which decorates the wall of the

Great Council Chamber opposite the *Maestà*. The fresco bears the date 1328, the year in which the famous *condottiere* led the Sienese forces to victory over the Ghibelline general Castruccio Castracane, so liberating the towns of Montemassi and Sassoforte, which are represented, respectively, on the left and towards the centre of the panoramic landscape.

In the foreground of this bare and dry landscape, which lies silent and devoid of human habitation, the *condottiere* rides in solitary triumph, his profiled form and his mount fashioned almost like a paper cut-out. The subject-matter, but not the style, brings to mind ancient sculpture and, above all, the equestrian statue of Marcus Aurelius on the Capitol in Rome, a work well known to the Middle Ages; but the treatment is fanciful and emblematic, and if this is a true portrait its memorability is accountable less to any quality of realism in the presentation than to Simone's extraordinary power of creating an image which immediately impresses itself upon the mind, so that even its details remain unforgettable. The nearest comparison that could be made with Giotto would lead us to a figure of a rider in the little monochrome scene under the *Justitia* in the Arena Chapel (*Plate 109*). The contrast between the conceptions of the two masters is startling, and once again we are reminded, not simply of essential distinctions between the Sienese and the Florentine genius, but more generally of the complexity of the artistic currents of the early Trecento: where Giotto anticipates the heroic classicism of Masaccio, Simone Martini leads on to the fine embroidery of the International Style, especially as it was to be interpreted, in Masaccio's time, by Gentile da Fabriano.

The stylistic development represented by the passage from the Assisi frescoes to the *Guidoriccio* is carried a stage further in the *Annunciation* of 1333 (*Plate 110*), and it attains its consummation in a panel in the Walker Art Gallery, Liverpool, representing the rare subject of the return of the young Jesus to his parents after his debate with the Elders in the Temple, a work painted in 1342 during the master's Avignon period (*Plate 112*). The *Annunciation*, now in the Uffizi, was commissioned for Siena Cathedral, and Simone was aided in its execution by Lippo Memmi. Indeed it was signed by both painters: SYMON MARTINI ET LIPPUS MEMMI DE SENIS ME PINXERUNT ANNO DOMINI MCCCXXXIII. The extent of Lippo's participation has been much debated. Full account has to be taken of medieval workshop practice, wherein the control exercised by the *capomaestro* of the *bottega* was often such as to make it extremely difficult to distinguish one hand from another, especially where a passage entrusted to an assistant was reworked by the master himself. Nevertheless it seems almost certain that in addition to purely decorative work and gilding, Lippo Memmi was largely responsible for the lateral figures of St Ansano and the presumed St Maxima (St Ansano's godmother), as well as for the medallions in the richly tooled pinnacles. These attributions are in accord with Lippo's style as it is known from his independent works, such as his version of Simone's *Maestà*, painted in 1317 for the Town Hall at San

Gimignano, his *Virgin and Child* at Santa Maria dei Servi in Siena, and especially the *Madonna di Misericordia* for Orvieto Cathedral (now in the Opera del Duomo).

The central panel of the *Annunciation* in the Uffizi altarpiece is imbued with all the lyricism of Simone's genius, and the lateral figures of saints are mere prose beside it. The poetic imagination that engendered it could only have been Simone's. The props of naturalism have largely been discarded, and the background of pure gold dissolves space itself in the radiance of celestial light. To Simone's contemporaries it might well have seemed that the artist was endowed with the gift of attaining to a vision of heavenly mysteries denied to the sight of ordinary men. One recalls the famous sonnet by his friend Petrarch, for whom he had painted a portrait—evidently a miniature—of the poet's beloved Laura:

> Ma certo il mio Simon fu in paradiso
> onde questa gentil Donna si parte;
> ivi la vide, e la ritrasse in carte,
> per far fede qua giù del suo bel viso.
> L'opra fu ben di quelle che nel cielo
> si ponno imaginar, non qui tra noi,
> ove le membra fanno a l'alma velo . . .
>
> (Per mirar)

But certainly my Simon was in Paradise, whence comes this noble lady; there he saw her and portrayed her on paper, to attest down here to her lovely face. The work is one of those which can be imagined only in Heaven, not here among us, where the body is a veil to the soul . . .

Petrarch's Lyric Poems, trans. and ed. Robert M. Durling, 1976.

Petrarch, no doubt, would have appreciated the spirituality of the Siena *Annunciation*, to judge from his strictures in his *De remediis utriusque fortunae* upon the more obviously beguiling enchantments of the art of painting—in the words of Thomas Twyne's sixteenth-century translation, that 'delight in the pencil colours', and in 'the price, and cunning, and variety, and curious dispersing', which together with the lifelike portrayal of human beings please and distract the outer eye. ('Pencil' originally meant 'brush'.)

The portrait of Laura has not survived. Petrarch himself lost, but later recovered, a copy of Servius's *Commentary on Virgil*, for which he then asked Simone Martini to paint a frontis-piece (*Plate 113*). This delicate miniature combines a representation of the poet, who reclines under a tree, quill-pen in hand, in an attitude suggesting inspiration, with allusions to his three great works—the *Aeneid*, symbolized by the armed figure of Aeneas himself, to whom Servius gives a glimpse of the poet by drawing aside an equally symbolic veil; the *Georgics*, indicated by a peasant pruning a tree; and the *Eclogues*, represented by a shepherd milking

one of his sheep. We know that Simone painted the frontispiece after Petrarch's recovery of the manuscript in 1340. By this date Simone had settled at the papal court, now exiled at Avignon, where he was to die in 1344, full of honours, and whither Petrarch had preceded him; and the Virgil frontispiece and the panel of the *Return of the Young Christ to his Parents* at Liverpool (*Plate 112*) reflect Simone's renewed response to the values of French painting. The Liverpool picture might almost be a manuscript illumination, and its brilliant harmonies of colour—ranging from bright scarlet to subtle purples and blues—are matched by an enhanced decorativeness of intention. On the other hand, we still recognize in this intensely felt drama of family relationships, in which the troubled incomprehension of St Joseph, the more serene invitation extended by the Virgin to her Son for an explanation of his absence, and the gentle authority of the young Christ are so sensitively conveyed, the humane art of the creator of the Antwerp *Polyptych of the Passion* and of the *St Martin* cycle at Assisi.

One can but regret the more the loss of Simone Martini's monumental works at Avignon, of which only traces now remain. These include a group of frescoes in the portico of the Cathedral of Notre-Dame des Doms, and it is just possible to make out a *Virgin and Child* in the lunette over the entrance, flanked by two figures of angels, one of whom presents the unknown donor (perhaps Cardinal Stefaneschi). Above this fresco, in the architrave of the doorway, other ruined decorations can be discerned; but the *Virgin and Child* has a greater significance, for here we meet for the first time the type of the 'Madonna of Humility', seated upon a cushion placed on the ground. This theme, emphasizing the humanity and condescension of the *Regina coeli*, was to have a profound meaning for the succeeding age, and there is every reason to assume that it first made its appearance in the gentle art of Simone Martini. (The motif occurs earlier, of course, in Nativity scenes.)

A number of Simone's Sienese followers also worked at Avignon, which during the enforced exile of the Papacy had become a busy centre of artistic activity, attracting painters from Italy, France and Catalonia. Among these artists, Lippo Memmi seems to have stayed only a short time, and his *Madonna* for the Franciscan church was executed in collaboration with his brother Federico di Memmo. The anonymous Master of the St George Codex, who illuminated a life of St George (now in the Vatican) which had been composed by Cardinal Stefaneschi, may well have been working on the codex in Avignon, since the scene of *St George and the Dragon* derives from a fresco painted by Simone Martini for the Cathedral, which although lost is known to us from a seventeenth-century drawing. These miniatures mark a further stage in the stylistic development that leads from the art of Simone Martini to the emergence of the International Style towards the end of the century. In his panels, such as the *Noli me tangere* in the Bargello in Florence, the Master of the St George Codex reduces Simonesque formulae to the terms of an essentially miniaturist style, in which the forms of Nature are woven into delicate patterns.

Several Italian artists are mentioned in documents referring to the decoration of the

Palace of the Popes, which had been erected in the 1330s by Benedict XII and enlarged by his successor Clement VI. It was Clement VI who commissioned from Matteo Giovanetti da Viterbo a series of frescoes in the Cappella di San Giovanni, datable about 1343, and a further series for the Sala della Grande Udienza about ten years later. These decorations survive only in part, but the *Prophets* on the vault of the Sala della Grande Udienza are no less representative than the work of the Master of the St George Codex of the progression towards the courtly graces of International Gothic. The style of these figures, drawn in rippling outlines and modelled in luminous colours, while deriving from Simone Martini, comes close in spirit to the art of André Beauneveu and the Franco-Flemish illuminators.

Simone's own importance in this development has already been stressed. Although the northern exponents of International Gothic, such as the Limbourg brothers, derived motifs from Giotto and Taddeo Gaddi, the influence of the Sienese School, headed by Simone Martini, was more profound in a stylistic sense; and it is of interest in this context to note that the *Polyptych of the Passion* (all the panels of which have a French provenance) was almost certainly painted for Cardinal Napoleone Orsini during Simone's stay at the Avignon court. Strong echoes of the panel of the *Procession to Calvary* (*Plate 102*) are found in one of the miniatures by the Limbourg brothers in the *Très Riches Heures du Duc de Berry*, and this is only one among many examples of Simone Martini's extensive influence, both in Italy and beyond. It is scarcely surprising that a century after his death, as we learn from Ghiberti, he was still regarded as the greatest of the Sienese masters.

Pietro and Ambrogio Lorenzetti

The only Sienese contemporaries of Simone Martini whose achievements are comparable with his own and with those of Giotto were the brothers Pietro and Ambrogio Lorenzetti: indeed, Vasari held that Pietro, who seems to have been the elder brother, followed Giotto's manner with such excellence that he even surpassed him. Both the Lorenzetti were undoubtedly indebted to Giotto, and evidence of Ambrogio's early connections with Florence is supplied by a number of documents from 1321 to 1327, in which year he matriculated in the artists' guild of Medici e Speciali; his presence in Florence on a later occasion—between 1332 and 1334—is also established. Furthermore, Ambrogio's first known work, the famous *Madonna and Child* of 1319, was painted for a church near Florence, Sant' Angelo in Vico l'Abate.

Although he may have been born as early as the 1280s, Pietro's first datable painting was executed a year after the Vico l'Abate panel: this is the signed polyptych (*Plate 115*) commissioned in 1320 by Guido Tarlati, the bishop of Arezzo, for the high altar of the city's parish church. Here also an intimate acquaintance with the art of Giotto can be presumed, for despite the decorativeness of the whole, the figures have a weight and substance which indicate that early in his career Pietro Lorenzetti was no less interested than his brother in Giotto's discoveries. At the same time, the work of the Lorenzetti was to be one of the principal channels through which Florentine painters became receptive to Sienese traditions. Such reciprocal influences must account in part for some of the remarkably similar tendencies to be seen in Sienese and Florentine painting as the century advances towards that overwhelming catastrophe, the Black Death of 1348. Since Pietro is last recorded in 1344, and Ambrogio in 1347, the two brothers may themselves have been victims of the plague. At all events, the end of their known activity, which embraced important fresco decorations as well as altarpieces, coincided approximately with the close of the heroic age of Trecento painting in Tuscany. The view that radical changes in the cultural and artistic climate followed in the wake of the Black Death will concern us later.

The Arezzo altarpiece indicates that Pietro Lorenzetti's stylistic roots lay in the art of Duccio. But by 1320 his modernity of outlook is evident from his sensitive understanding of Giotto's aims. Yet in temperament Pietro Lorenzetti seems quite unlike Giotto, showing much closer affinities with Giovanni Pisano, whose sculptural decorations on the façade of Siena Cathedral, executed towards the end of the thirteenth century, he would have known from boyhood. The representation of the Virgin and Child in the central panel of the

Arezzo altarpiece strongly recalls the emotion-charged Madonnas of the great Pisan sculptor, such as the half-length statue in the Camposanto (*Plate 116*). There is a grave expressiveness in Pietro's interpretations of the Madonna theme which contrasts with the gentler vision of his brother. Yet this contrast should not tempt us to make facile simplifications: both painters were concerned in such pictures with the tender relationship between Mother and Son, but in Pietro's case the tragic implications of the Incarnation are more strongly intimated. In other features of the Arezzo altarpiece, and above all in the elaborate structure of the polyptych, which recalls that of Duccio's large altarpiece in the Siena Pinacoteca, echoes of the older Sienese tradition linger. But among the subsidiary figures of saints, the originally conceived St Luke, turning to gaze upward at the scene of the *Annunciation* (which he alone among the Evangelists describes for us), may well have been inspired by the active half-length figures designed by Giovanni Pisano for the exterior of Siena Cathedral—all of them associated with the Virgin and with the prophecies concerning her divine destiny.

Pietro's style developed in the 1320s and 1330s in the direction of a marked austerity of design and a curious rigidity in the treatment of the figure, as is apparent from the *Madonna and Child with Saints Nicholas and Anthony Abbot* (*Plate 114*), completed in 1329 for the Carmelite Church at Siena and now in the Pinacoteca, and from the panels of a dismembered polyptych of 1332, also in the Pinacoteca in Siena. The aulic regality and remoteness of the Carmelite *Madonna*, emphasized by the insistent spaces of the composition, which increase the sense of her aloofness, appear strangely reminiscent of the frescoed *Madonna* in the sacristy of the Lower Church at Assisi, an early work by the Master of the Fogg *Pietà* (or Maestro di Figline). These similarities are surely not fortuitous, and hint at a dating before 1329 for Pietro Lorenzetti's visit to Assisi to paint the great *Passion* cycle (*Plate 121*) in the left transept of the Lower Church.

Although the date of the Assisi frescoes remains controversial, the older view that they belong to the last period of Lorenzetti's life has become less and less acceptable to modern criticism, and a date around 1320 now seems far more plausible. As we have seen, the frescoes fill the left transept and complete a vast programme of decoration undertaken in the right transept and in the crossing by pupils of Giotto. Lorenzetti's *Passion* scenes—together with a *Stigmatization of St Francis*, a subject that directly alludes to Francis's sharing of Christ's Passion—form, essentially, the counterpart in the left transept of the narratives of the *Infancy of Christ* in the right transept (*Plates 72, 119*). As we have also seen, the lovely altar-fresco by Lorenzetti of the *Virgin and Child with St Francis and St John the Evangelist* (*Plate 75*) continues the tradition established by the St Nicholas Master in his own frescoed altarpiece in the Orsini Chapel (*Plate 74*). Yet another fresco of this type, a *Virgin and Child with St John the Baptist and St Francis*, was painted by Lorenzetti over the altar of the Chapel of St John the Baptist, built by Cardinal Napoleone Orsini, which leads off from the far

end of the left transept; this fresco in the second Orsini Chapel also had the function of an altarpiece.

The recent cleaning of the *Passion* scenes has restored them to all their former glory; and the vault frescoes in particular, which modern criticism has sometimes strangely belittled, have been revealed as compositions of dazzling splendour and power. The *Last Supper* (*Plate 129*) is extremely inventive, and the hexagonal construction given to the upper room at Jerusalem has no known precedent in Italian painting. The walls facing the spectator have been indicated by four piers composed of clustered columns, each supporting a statue of a winged *putto*, so that we seem to look through a richly decorated loggia. The magnificence of this setting is enhanced by the attention accorded to the Cosmati-work and other ornamental details of the whole symmetrical structure and by the glowing colours of the draperies of the figures.

It is a night scene, and the dark blue sky is scattered with stars, which in the narrow strip at the right edge of the composition carry down to floor level, so contributing to the impression that this is indeed an 'upper room' and, more significantly, to our awareness of an interfusion between the earthly and the heavenly worlds. To the left, a crescent moon appears over a realistically rendered kitchen abutting on to the main apartment. Within the kitchen, by a blazing fire, a servant is scouring out a dish to offer scraps to a dog, while a cat drowses nearby. The realism of this delightful genre passage, which provides a telling contrast to the sacred scene of the Last Supper, and which is particularly notable for its light-effects (the fire itself being the source of light), anticipates the down-to-earth naturalism beloved of the northern masters of the International Style, such as the Limbourg brothers, Broederlam, and Campin.

The treatment of perspective in the main scene demonstrates Pietro's profound interest in problems that were not to be mastered until the following century, but which nevertheless came near to complete solution in his altarpiece of the *Birth of the Virgin* (*Plate 117*), painted in 1342 for Siena Cathedral, and still nearer in Ambrogio's *Presentation of Christ in the Temple* (*Plate 118*) of the same year. The Assisi fresco reflects no less clearly the influence of Giotto, especially in the way in which the draperies of the seated disciples tightly define the forms of their bodies; and there is a hint here that Lorenzetti may have studied with interest the work of the Isaac Master, whose *Pentecost* in the Upper Church at Assisi includes figures seen from the back and treated in a comparable manner. Lorenzetti's disciples, however, burn with an inner intensity foreign to the spirit of Giotto's art, and it is not only the rapacious Judas who would be unthinkable in the Arena Chapel cycle.

The same quality distinguishes Lorenzetti's interpretation of the *Entry into Jerusalem* (*Plate 49*) from the scene by Duccio on the *Maestà* (*Plate 48*). The nervous excitement that fills this bustling composition reaches a crescendo in the enormous *Crucifixion* on the lower curve of the arch (*Plate 122*), a composition that Pietro repeated with variations in the

evidently later fresco in San Francesco at Siena, painted about 1331. But the greatest and most moving of all the *Passion* narratives is unquestionably the *Deposition* on the end wall, by the entrance to the Chapel of St John the Baptist (*Plate 123*). Although Pietro Lorenzetti undoubtedly responded to Giotto's volumetric treatment of form and was influenced by him in other ways, no work by him declares more openly the ultimate independence of his genius. Everything contributes to the stark expression of the agony of Golgotha, which is alleviated only by the tenderness of the Virgin's embrace, as the awkward, twisted body of her Son is lowered from the Cross so that his pathetically inverted head meets her own in a wonderfully evocative image of the union of hopeless love and departed life—an image, as we have seen, already found in one of the scenes of the miracles of St Francis in the right transept, but here imbued with a new power. Damage to the ladder leading up to the cross-beam scarcely affects the noble dignity and compression of the fundamentally pyramidal design, from which all extraneous detail has been excluded in the effort of a great master, who here approaches the expressiveness of Grünewald, to lay bare upon the wall an emotion that stretches the resources of painting to the limit.

Pietro Lorenzetti's late style is represented especially by the fresco of the *Crucifixion* at San Francesco in Siena; by the beautiful *Virgin and Child enthroned with Angels* of 1340 (now in the Uffizi), a work painted for the Franciscan church at Pistoia, in which vibrant colour harmonies blend with the intense blue of the Virgin's draperies, demonstrating Pietro's astounding originality as a colourist; and by the panel of the *Birth of the Virgin* which has already been mentioned.

This last work may reflect the composition of one of the lost frescoes devoted to the life of the Virgin which once decorated the façade of the Ospedale della Scala in Siena, a joint enterprise commissioned from the Lorenzetti brothers in 1335. Although Ghiberti ascribed the fresco to Ambrogio, an interesting feature of Pietro's inferred adaptation of the composition to the requirements of an altar-painting on panel—the cohesion established between the frame and the interior space of the painting itself—already occurs on a more limited scale in the *Annunciation* on his Arezzo polyptych of 1320 (*Plate 115*). In the *Birth of the Virgin* the slender columns of the frame, supporting Gothic pinnacles, are seen to be applied to the actual walls of St Anne's bedchamber and to those of the smaller room on the left, where the anxious Joachim receives the news of his daughter's birth. The pinnacles of the frame are likewise conceived as part and parcel of the imposing architectural ensemble, which is crowned by star-studded vaults reminiscent of a church interior. When we consider Ambrogio's adventurous abandonment of comparable framing elements in his *Presentation* of the same year, our minds leap forward to Mantegna and the Renaissance masters to discover a similar concern with a total and ordered unity of this kind.

It would seem that the two brothers, however distinct in genius, remained in close touch with one another. The delicacy of sentiment expressed in Pietro's panel has often been

attributed to Ambrogio's example. Certainly Ambrogio exhibits in all his known works a serenity and gentleness that his brother rarely shows. Even Ambrogio's early *Madonna* of Vico l'Abate, although somewhat stiff and 'hieratic' in the rigid frontality of the Virgin's attitude, conveys a warmth of feeling that is evident especially in the charming Christ Child, wriggling his toes as only an infant does, as he gazes in love at his grave-faced Mother, as though to lighten the burden of her future sorrows. This tenderness of feeling is developed further in Ambrogio's later Madonnas, as in the *Madonna del Latte* of about 1330, in the great *Maestà* of Massa Marittima of the 1330s, and in the lovely panels from an altarpiece for Santa Petronilla in Siena (*Plate 120*), which are of comparable date.

In such pictures Ambrogio dwells with affection upon the theme of maternal and filial love, sometimes (as in all these works) bringing the heads of Virgin and Child close together in the most intimate communion. In the Santa Petronilla triptych the saints represented in the side panels, Mary Magdalen and Dorothy of Caesarea, offer their tributes in the same gentle, poetic spirit. Mary Magdalen holds in her hand the alabaster box of ointment with which, in the Gospel story, the Magdalen (or, rather, an unnamed woman whom later tradition identified with her) anointed the Lord's feet, while at her breast she wears a 'Veronica image' of Christ's features, in allusion to her presence at the Crucifixion. The flowers in St Dorothy's lap, from which she has made a posy as an offering to the Christ Child, allude to the legend of her promise to a sceptical lawyer, who had attended her trial, that after her martyrdom she would send him fruits and flowers from Paradise, a promise whose miraculous fulfilment led to his conversion.

Ambrogio's lyricism is too elusive to lend itself to probing analysis; but the pictorial language that communicates it is a blend of linear grace and subtle nuances of radiant and yet exquisite colour, in which serene blues, blue-greys and delicate rose-reds are orchestrated with deeper and stronger notes. His forms are soft and pliant, and his designs generally more harmonious than those of his brother, as we can see from the perfection of that absolute masterpiece among his panel-paintings, the *Presentation of Christ in the Temple* (*Plate 118*), commissioned for Siena Cathedral at the same time as Pietro's *Birth of the Virgin*. The marvellous unity of this composition, the influence of which can be traced in many later paintings, both in Italy and in northern Europe, is due in great measure to Ambrogio's triumphant solution of the complex perspectival problems that he set himself; for it seems evident that the lofty interior of the Temple, which is topped by an exterior view of its tower, was his starting-point. It is the sumptuously beautiful courtway of this building—the orthogonals of its tiled floor almost meeting at the single vanishing-point of later Albertian theory—that establishes the disposition of the figures of Mary and her two attendants, the aged Simeon, St Joseph (on the far left), the prophetess Anna (holding her customary scroll, inscribed with the text in St Luke which tells of her sudden appearance upon the scene, as a witness, like Simeon, to the coming redemption of Israel), and, at the centre,

the High Priest, who stands behind the altar and holds the sacrificial doves brought by St Joseph.

Ambrogio here remoulded the various elements of the traditional iconography (the history of which shows numerous variants) to bring together all the essential features of the story in harmonious unity; and he added several individual touches. The representation of the exterior of the Temple was not unprecedented, but the manner in which, in Ambrogio's composition, it crowns the majestic interior may call to mind no less a masterpiece of harmonious design than Raphael's *Sposalizio*; nor is the blending of Romanesque and Gothic forms in the architectural detail any less skilful. The statues of Moses and David surmounting the gracile columns refer respectively to the Mosaic ordinance regarding the purification of child-bearing women and to Christ's royal descent from the House of David. At the top of the panel, in the spandrels of the Gothic arch, half-length figures of Moses and Malachi display scrolls containing texts which refer prophetically to Christ's sacrifice and to the day when 'the Lord whom ye seek shall suddenly come to his Temple'. Ambrogio must have been required to place some emphasis (as indeed was usual in Trecento paintings of this subject) upon the symbolic significance of the Redeemer's presentation in the Temple, with its sacrificial implications. The panel also alludes to the Purification of the Virgin, which in medieval times was reinterpreted as only a nominal ceremony; for, as Jacopo da Voragine insisted, the Virgin had had no need of purification in the accepted sense, but had submitted to the Law 'to give an example of humility . . ., to put a term to the Jewish purification . . ., to mark the beginning of the Christian purification', and finally, and above all else, 'to teach us to purify ourselves throughout our whole life.' The subject of the picture has an intimate connection with the liturgy for the feast of Candlemas, which celebrates the Virgin's purity. We can see from this the importance of the commission given to Ambrogio, for this large panel was destined for an honoured place in the Cathedral of the *vetusta civitas virginis*.

As a fresco painter, Ambrogio Lorenzetti is chiefly known for his vast compositions illustrating *Good and Bad Government* in the Palazzo Pubblico in Siena (*Plates 126–128, 130, 131*). These were painted in 1338 and 1339. Among his late works there also survive the remains of a cycle in the Oratory of San Galgano at Montesiepi, which includes a remarkable *Annunciation* (*Plates 132, 133*). But an earlier series of mural decorations from his hand must be mentioned first. These are the Franciscan narratives painted in a chapel of San Francesco at Siena, of which only two scenes—*St Louis of Toulouse before Boniface VIII* and the *Martyrdom of the Franciscans in Ceuta*—have been preserved. The traditional date for the cycle, 1331, is extremely doubtful, a period in the middle 1320s being more probable. In this case the frescoes would have followed almost immediately upon Ambrogio's first recorded stay in Florence—an hypothesis that would account for his apparently sudden awareness of Giotto's cycle in the Bardi Chapel at Santa Croce (*Plate 125*).

Giotto's influence is particularly noticeable in the fresco of *St Louis before Boniface VIII* (*Plate 124*), which recalls in its composition the *Appearance of St Francis at Arles* and the *Confirmation of the Franciscan Rule* in the Bardi Chapel. The latter fresco may also have influenced the representation of the same incident from St Louis's life on the predella of Simone Martini's Angevin altarpiece (*Plate 105*): if that was the case, then the frescoes by Giotto in the Bardi Chapel must be dated before 1317. Damage to Ambrogio's fresco has imposed on it a deceptive linearism, but we can still appreciate the consummate skill with which the artist has ordered his design and the superb mastery of his treatment of airy space. St Louis, we may recall, had abdicated in favour of his brother Robert of Anjou, shortly afterwards taking his vows in the presence of the Pope. With a nice dramatic touch, Ambrogio included in his composition a strongly characterized portrayal of Robert of Anjou: the king wears his brother's discarded crown, and his frowning mien conveys his perplexity as he ponders the solemn rite of renunciation.

The enormous frescoes of *Good and Bad Government* in the Palazzo Pubblico occupy three walls of the Sala de' Nove—the council room of the 'Nine' who formed the oligarchic government of the Sienese republic. These decorations reflect, to a supreme degree, Ambrogio Lorenzetti's intellectual power; and they testify also to the anxiety of the city authorities to preserve hard-won liberties in a time of political uncertainty and potential unrest. As far as is known, the scheme of decoration had no exact precedent, although a fresco of a similar subject by Giotto, symbolizing the Commune, was once to be seen in the Palazzo del Podestà in Florence. The didactic symbolism of these elaborate allegories, while being concerned with the community at large—the labourers, for example, and the trades-men—is directed principally at the rulers of the republic, most of them members of the middle classes. The various admonitory verses that accompany the murals, mostly in the form of *tituli* below the scenes, are composed in Italian rather than in Latin.

On the end wall, opposite the windows that look on to the countryside below Siena, Lorenzetti was asked to paint a complex *Allegory of Good Government* (*Plate 126*). Leading on from this fresco, on the right-hand wall, there stretches the extensive panorama illustrat-ing the *Effects of Good Government in the Town and in the Country*, with the town-scene in the left half of the composition (*Plates 128, 130*) and the celebrated landscape in the right (*Plate 131*). Opposite, on the left wall, a now ruined fresco combines an *Allegory of Tyranny* with a representation of *Bad Government* (again showing city and country scenes). The programme was inspired both by Aristotelian and by Thomist ideas, as has recently been demonstrated. The frescoes also contain interesting quotations from the art of antiquity: the personification of Peace, for example, in the *Allegory* on the end wall, was inspired by a figure on a Roman sarcophagus now housed in the Palazzo Pubblico itself, while the nude figure of Security, flying protectively over the peaceful countryside in the fresco on the right wall, derives from an ancient *Victory* which is also preserved in Siena.

Although the reclining figure of Peace occupies the centre of the crowded *Allegory* on the end wall, the fresco is dominated by the gigantic figure of the Common Good (or the Siena Commune), seated to the right upon a throne which he shares with Peace, Prudence and Fortitude (on the left) and Magnanimity, Temperance and Justice (on the right). Above his head there fly winged figures symbolizing Charity, at the centre, and Faith and Hope on either side. His counterpart at the other extremity of the composition is the female figure of Distributive and Commutative Justice, also enthroned, and attended above by the winged Wisdom (*Plate 127*). The scales held by Wisdom support a pair of winged figures symbolic of the distributive and commutative aspects of Justice according to the Thomist-Aristotelian theory of Law: the first of these figures beheads a man and rewards another with a crown; the second bestows money on one man and arms another. Concord, another female figure, is seated at her feet. Below these allegorical figures, there stretches a long procession of Sienese citizens, bound together by a cord which is proffered by Distributive and Commutative Justice and held out to them by Concord. This symbolic cord leads to the enthroned representative of the Common Good. The essential meaning is clear: as the procession moves from left to right, the citizens of Siena make their choice, united in their pledge to serve the Common Good.

Yet the chief glory of the Sala de' Nove is the panoramic representation of the *Effects of Good Government* on the right wall. Here Lorenzetti was free to give full rein to his imagination and to a gift for landscape painting unparalleled among the masters of the early Trecento. The city on the left is Siena itself, with its cathedral and Porta Romana, and it comprises a whole assemblage of buildings of different kinds, including a school, a shoe-shop and an inn, as well as a house that is just being constructed, all bustling with appropriate activity. Happy youths and maidens dance in a street; farmers with their herds enter the city from the fertile fields. Elsewhere horsemen ride out into the country, leading us to an enchanting prospect of valleys and rolling hills, where small towns, hamlets and farms nestle in the security of peace. While the gentry indulge in falconry, peasants gather in the harvest or tend the vineyards. Contentment reigns in this ideal country, over which there flies the protective figure of Security, displaying a scroll which declares that everyone may walk without fear under the rule of law; but she also holds up a warning, in the form of a figurine of an evil-doer hanged on a gallows. At the same time, the verses below the fresco direct the rulers of Siena to take notice of all the benefits that come to their subjects from wise government, and to observe their own responsibilities; a warning still more interesting than Security's grim reminder, for here it is not the humbler citizenry but the civic government itself that is being addressed in the plainest terms.

Given their didactic function, the decorations, however intriguing to the historian, would constitute a mere document of their time if the practical motives of those who devised the whole intricate scheme had not provided an opportunity for a unique artistic adventure;

8

for in the broad panorama of the *Effects of Good Government* Ambrogio Lorenzetti dis-
covered for himself the way to a new branch of painting—pure landscape. Whether he
recognized the momentousness of his discovery we shall never know; in any event, the
lesson was not, apparently, learnt at the time, and none of his contemporaries or followers
attempted to explore his discoveries further.

Finally among Ambrogio's frescoes we must consider, however briefly, the poetic and
iconographically fascinating *Annunciation* painted (evidently in the mid-1330s) for the
Oratory of San Galgano at Montesiepi (*Plate 132*). Recently, when the fresco was detached
from the wall, there was discovered beneath it a splendid *sinopia* (*Plate 133*) which confirmed
the indications in the fresco itself that the figure of the Virgin had been repainted *a secco*.
According to Ambrogio's original conception—as the *sinopia* drawing reveals—the Virgin
was shown shrinking away in terror at Gabriel's approach, and clinging for support to
a column. The repainting was evidently thought necessary, probably only a few years
after the fresco had been completed, in order to give the Virgin a more conventional aspect,
and the painter called in to undertake this task (perhaps Pietro Lorenzetti) depicted her in a
traditional posture with her hands folded at her breast and her head bowed towards the
Archangel. Ambrogio had been inspired by a passage in Dante (*Paradiso*, XXXII, 112), in
which the poet says that Gabriel appeared to the Virgin bearing a palm, the symbol of
his victorious redemption of mankind; and so the Virgin's terror, as expressed in the *sinopia*
must allude to her awareness not simply of Christ's Incarnation but also of his destined
sacrifice upon the Cross. Very possibly, objections were raised by the Cistercians, who owned
the chapel containing the fresco, to an image of the Virgin that would have seemed to be
lacking in dignity: it was regarded, no doubt, as all too human. In a wider sense, this startling
invention stands at the close of a chapter in the history of early Italian painting.

The humanizing process that had begun in the late thirteenth century, and which was
taken up by Giotto and his circle, here reaches an entirely logical conclusion. But this
development was shortly to give way to a general reaction in favour of a transcendentalism
that sought, as it were, to restore the divine image and, in reasserting the authority of the
Church, to ensure that the gaze of humanity remained fixed upon heavenly things.

Late Trecento painting in Tuscany

The middle years of the fourteenth century can be described as a period of reassessement in the history of Tuscan painting. While such followers of Pietro and Ambrogio Lorenzetti as Niccolò di Ser Sozzo Tegliacci, Lippo Vanni and the so-called Ovile Master (probably the documented Bartolommeo Bulgarini) continued more or less faithfully in the Lorenzettian traditions, a marked difference in style is apparent in the work of the younger Sienese painters—among whom Bartolo di Fredi, Andrea Vanni, Paolo di Giovanni Fei and Taddeo di Bartolo lived on into the early years of the fifteenth century. A similar change is re-flected in the work of Florentine artists of the new generation, the most important of whom was the sculptor-painter Andrea di Cione, known as Orcagna (or 'Archangel'). As Meiss has demonstrated, much of the painting of the second half of the century shows a reaction against the realistic manner of Giotto and his followers; iconography often hardens into hieratic and ritualistic imagery; and, instead of the humanity and intimacy characteristic of the treatment of religious themes in early Trecento painting, there is a tendency for sacred figures to respond to each other with a certain reserve and to maintain their distance from the spectator. These developments went hand in hand with a recovery of some of the forgotten values of the Dugento.

Meiss has associated these tendencies with the climate of crisis and despair engendered by the catastrophes of the 1340s—such disasters as the outbreak of bubonic plague in 1348 which we know as the Black Death, a universal calamity which is nowhere more graphically described for us than in the opening pages of Boccaccio's *Decameron*; the economic collapse which began with the failure of the great banking houses of Florence and Siena, most notably those of the Peruzzi in 1343 and the Bardi two years later; and the period of political uncertainty and revolution which followed, making for instability and lack of confidence. On the one hand political strife and the breakdown of government in many parts of Italy tightened the grip of the Church, and on the other the devastation wrought by the plague left in its wake not only widespread misery and chaos but also a general sense of guilt (which touched both Petrarch and Boccaccio)—a frantic resolve to make atonement for the sins that must have called down from heaven so terrible a visitation, and, accompany-ing this impulse towards spiritual renewal, an increased tendency (although scarcely univer-sal) to try to escape from the world and self into a life of mystical contemplation.

Nevertheless, at least one aspect of Meiss's magisterial interpretation presents a difficulty. The findings of recent scholarship make it impossible to accept any longer a dating after

1348 for the Camposanto *Triumph of Death* (*Plates 150–153*): as Polzer has established, the frescoes were painted long before the Black Death. There are also arguments in favour of a date considerably earlier than that usually accepted for Orcagna's interpretation of the same subject at Santa Croce (*Plates 148, 149*). Orcagna's frescoes have usually been placed in the 1350s or 1360s, but it has lately been proposed by Boskovits, with persuasive reasons based upon a searching reassessment of the stylistic evidence, that a date around 1345 is far more probable. It is tempting to support Bokovits's conclusions by a further speculation: the little scene of the eclipse (*Plate 148*), which has been discussed earlier in relation to the eclipse of 1339 observed by Taddeo Gaddi, suggests a vivid, personal recollection; and if this was indeed the case we may postulate a date as close as possible to the year 1339. This is not by any means a conventional art-historical argument; but in the study of a period in which documentation is scanty, and in which precise dates are often difficult to determine, circumstantial evidence of various kinds can sometimes provide hints that support conclusions reached by more established methods.

Brief mention may here be made of a further problem. The plague of 1348 was preceded in 1340 by an outbreak of sickness (not, apparently, bubonic plague) which killed more than fifteen thousand people in Florence alone; and it might seem that this earlier calamity, rather than the plague of 1348, could account for the sudden interest in the theme of the Triumph of Death. However, the total evidence now points to a date in the 1330s for the Camposanto frescoes, so that the grim theme would already have become the subject of painting before the year 1340. Further inquiry might conceivably alter our picture of things; but at present any attempt to link the epidemic of 1340 with the Triumph of Death theme requires more substantial evidence than has yet been produced.

The foregoing objections to Meiss's argument do not seriously affect the general validity of his analysis of the period, with all its insights into late Trecento style and iconography. But there is other evidence to indicate that the conditions for that dark mood after 1348 which he has so brilliantly illuminated were being created much earlier in the century. For example, some of the qualities most characteristic of late Trecento painting are already present, as Meiss himself was the first to recognize, in the frescoes by Taddeo Gaddi in the Baroncelli Chapel.

More generally, it is too often taken for granted that the period before the Black Death was much more a time of prosperity and social well-being than it was in fact. In the first half of the fourteenth century Italy groaned under the weight of one disaster after another; and Giovanni Villani drew particular attention in his *Chronicle* to the sufferings of Florence from the early years of the century. He mentions, for example, the divisions between the White and Black parties and the banishment of the Whites, 'with all the consequences and indeed the ruin that followed from this'; the great fire which swept through the city in 1304; the siege of Florence undertaken in 1312 by the Emperor Henry VII of

Luxembourg, whose troops ravaged the countryside; the defeat of the Guelphs at Monte-catini in 1315, one consequence of which was the institution of a repressive system of police control over the city; the defeat of the Florentines at Altopascio in 1325, at the hands of Castruccio Castracane, lord of Lucca, resulting not only in the fall of Pisa and Pistoia, but also in the siege of Florence itself, which in desperation had consigned itself to the tyrannical rule of Charles of Calabria (the threat to Florence being removed only by Castruccio's death three years later); a famine in 1329; the incursions of the Emperor Louis IV and King John of Bohemia; in 1333 a catastrophic flood in Florence and Pisa, which caused wide-spread havoc and destruction and much loss of life; another, less serious flood in the follow-ing year; an outbreak of smallpox in 1335 from which over two thousand children died; serious economic troubles in 1339, resulting in the raising of food prices beyond the reach of most of the populace, who were consequently threatened with starvation; and in 1340 the terrible sickness which killed a great part of the population of Florence, and which was followed by famine and the gradual collapse of the economy. 'Evil followed evil', Villani wrote, adding that the afflictions of the people were such that 'in many cases the living envied the dead'.

The tone of these pages in Villani's *Chronicle* is apocalyptic; and running through his historical account there are periodic references to portents in the heavens—unusual con-junctions of planets, appearances of comets, and not least the spectacular eclipses of 1333 and 1339,—all of which were regarded with awe and with fear of the dire consequences which they might presage. The eclipse of 1333, for example, was observed to have immedi-ately preceded the great flood—or the *gran diluvio* as it was called—of the same year. A disaster of this magnitude was inevitably interpreted as a divine punishment for the sins of the populace; and the citizenry flocked to the churches to pray, to make confession, and to plead for God's mercy. The flood was associated in people's minds with the idea of Judg-ment; and Villani himself recalled Christ's words about the Last Days, with their allusion to the Deluge of old: 'As were the days of Noah, so shall be the coming of the Son of man.' It was in the same spirit that his brother Matteo, when he sat down to continue the *Chronicle* after the Black Death, of which Giovanni had been one of the victims, accepted the plague as a punishment well deserved: 'My mind is stupefied as it approaches the task of recording the sentence that divine justice mercifully delivered upon men, who deserve, because they have been corrupted by sin, a last judgment.' It was a natural reaction for men of the time; but the vast scale and unprecedented horror of the Black Death should not let us forget that much the same response was made to earlier catastrophes, such as the flood of 1333, of which Giovanni Villani had written:

And I . . . am of the opinion concerning this flood that because of our outrageous sins God sent this judgment . . ., and that then God gave us His gift of mercy in not letting

us all perish—for the devastation lasted a short time—in response to the prayers of the holy and devout people dwelling in our city and round about, and to the extensive acts of almsgiving undertaken by the people of Florence. And therefore, dearest brethren and fellow-citizens, those who are living now and those still unborn, whoever reads and understands must have very great reason to correct his faults and to abandon his vices and sins out of the fear of God and because of His warnings to us.

Yet the flood was for Villani but the latest and perhaps the most severe of 'numerous chastisements and warnings from God', beginning early in the century, which were no less real because those who suffered them could not foresee that still greater trials lay ahead, whether in the form of economic disaster or of irresistible pestilence.

Caution must therefore be exercised in attempting to account for the stylistic character of works of art produced in the middle and later years of the century by adducing a particular circumstance in the life of Florence or other cities, such as the plague of 1348. Nevertheless, this is not to deny that the cumulative effect of such events must be taken into consideration, especially since it is difficult not to associate them directly with the spiritual climate of the period, with its obsession with guilt and its insistence upon the need for penance and alms-giving as a means of averting the divine wrath. The religious mood of the second half of the century is epitomized by such figures as Jacopo Passavanti, prior of the Dominican church of Santa Maria Novella in Florence, and St Catherine of Siena, a Dominican tertiary. Both placed special weight upon the urgent need for penitence, which indeed is the subject of Passavanti's *Mirror of True Penitence*, a work embodying the ideas that he set forth in his sermons at Santa Maria Novella. Passavanti's emphasis upon the punishments awaiting sinners in hell has been likened by Meiss to the prominence given to representations of hell and to the torments of lost souls in paintings of the Last Judgment and the Harrowing of Hell in this period; and there is justice in his comparison between Passavanti and Orcagna.

It cannot be denied that the mood of much of the painting produced in this period presents a contrast to the spirit of early Trecento art as a whole. It is interesting in this context to note a criticism of Giotto which is to be found in a famous Commentary on Dante written in the 1370s by Benvenuto da Imola. Benvenuto observed that Giotto had made 'great errors in his paintings'; and it would seem less probable that this learned disciple of Boccaccio was indulging in a purely aesthetic criticism than that he was passing judgment upon the spiritual content of Giotto's art. If this reading is correct, the intimate embrace of St Joachim and St Anne in the Arena Chapel fresco (*Plate 88*) could be cited as an example of Giotto's humanizing style which might well have earned such strictures. As we have observed, the representation of the same subject by Taddeo Gaddi in the Baroncelli Chapel (*Plate 89*) already departs significantly from Giotto's composition, substituting a more formal image of reunion. In 1365 Giovanni da Milano painted this subject in the

Rinuccini Chapel at Santa Croce (*Plate 90*) and interpreted it in a still graver, even melancholy spirit, so that the meeting of the two saints takes on a solemn, ritualistic character. As Meiss has put it, 'the joyless Joachim and Anna are separated still further, bodily and in spirit'. No less significant a feature of the fresco is the emphasis given to the centrally placed angel, who announces to Joachim the glad tidings that his wife is to bear him a child; for here the landscape divides, to open out upon a heavenly vision. We may recall that Ambrogio Lorenzetti's image of the terrified Virgin in the Montesiepi *Annunciation* (*Plate 133*), painted at a much earlier date, must also have been considered an 'error': certainly it was felt necessary to correct it.

Among the transitional works of the mid-century, in which we can trace the continuation of the process of change outlined above, the great fresco cycle by Barna da Siena in the Collegiata at San Gimignano (*Plates 134–136*) must be given pride of place. Little is known

FIG. B *Plan of Barna da Siena's Christ Cycle in the Collegiata, San Gimignano*

 1. Annunciation
 2. Adoration of the Shepherds
 3. Adoration of the Magi
 4. Presentation in the Temple
 5. Massacre of the Innocents
 6. Flight into Egypt
 7. Christ among the Doctors
 8. Baptism of Christ
 9. Calling of St Peter
 10. Miracle at Cana
 11. Transfiguration
 12. Raising of Lazarus
 13. Christ's entry into Jerusalem (two fields)

 14. Last Supper
 15. Pact of Judas
 16. Agony in the Garden
 17. Kiss of Judas
 18. Christ before Pilate
 19. Flagellation
 20. Mocking of Christ
 21. Procession to Calvary
 22. Crucifixion
 23. Entombment
 24. Resurrection
 25. Descent into Limbo
 26. Ascension

about Barna, although he is mentioned by Ghiberti as one of the principal Sienese masters. Vasari records a tradition that as the frescoes were nearing completion Barna suffered a fatal fall from the scaffolding, so that the work had to be finished by his nephew Giovanni d'Asciano. The upper frescoes, in the lunettes, which would have been painted first, show the hand of an assistant who could have been Giovanni d'Asciano. What can be concluded with certainty, from the style of the frescoes, is that Barna's origins lay in the traditions of Duccio and Simone Martini. The San Gimignano cycle may be regarded as a reinterpretation, on a monumental scale, of the Passion narratives on Duccio's *Maestà*, while there is much in Barna's treatment of the human figure and physiognomy that recalls the art of Simone, whose brilliant colour and meticulous fresco technique must also have profoundly impressed him.

The San Gimignano frescoes are usually dated about 1350–5. They occupy the right aisle of the Collegiata, extending in three registers along six windowless bays (see *Fig. B*). As in the Arena Chapel, the programme of decoration, which numbers twenty-six scenes, embraces a complex of typological concordances that cannot be explained away by any theory of chance associations. A case in point is the vertical alignment of the *Massacre of the Innocents*, in the lunette of the fifth bay, with the *Crucifixion*. The increased scale given to the *Crucifixion*, which alone among the scenes fills both registers of its bay (*Plate 134*), must derive from Duccio's *Maestà* (*Plate 45*). The lunettes were reserved for six stories of the infancy of Christ, beginning with the *Annunciation* and continuing leftwards to the *Flight into Egypt*. The large *Crucifixion* being conceived as the climactic point of the cycle, the narratives resume to its right in the second register (that is to say, in the fourth bay) with the scene of *Christ among the Doctors*, and unfold from left to right to the *Entry into Jerusalem*, represented in two fields in the first bay (*Plate 135*). The sequence descends at this point to the third register, where it continues leftwards from the *Last Supper* in the first bay to the *Procession to Calvary* in the fourth bay, and thence to the *Crucifixion*. The four final scenes in the sixth bay, devoted to the events after Christ's death, are so disposed that the *Entombment* and the *Descent into Limbo* take their place, meaningfully, below the *Resurrection* and *Ascension*: here the rising movement also echoes Duccio's narratives on the *Maestà*, although the intention is more complex, for the *Flight into Egypt* in the lunette, representing Christ's divinely ordained escape from death at the time of the massacre of the Holy Innocents, complements the theme of his liberation from the bondage of death, which is the subject of the *Resurrection* and *Ascension*. Many other parallelisms of a like nature are to be found in the cycle, which, like the *Christ* cycle in the Arena Chapel at Padua, cannot therefore be read merely as a narrative sequence: the theological overtones produced by the association of one scene with another give added depth of meaning to the whole.

Every interpretation of the Passion must be tragic in tone, but no previous work of the Trecento conveys such desolation of the spirit as this deeply moving cycle. In the *Crucifixion*

the swooning Virgin and the attendant figures of the other Maries and St John the Divine are removed far from Christ's Cross, and only the angelic host comforts the Redeemer in his last hour. His loneliness is presented as the inexorable consequence of the evil immanent in a brutalized world, which is manifested not only in the grim actions of the soldiery in this terrifying composition, but also in the stark horror of the *Massacre of the Innocents* in the lunette.

The same atmosphere of sheer evil haunts the *Pact of Judas (Plate 136)*. This is a design of extraordinary inventiveness. The placid symmetry of the building (representing the Temple) acts as a foil to the compact, arching form into which the conspiratorial group of Judas and the priests has been compressed, their heads converging as the sinister transaction is consummated. The priest who pays out to the betrayer his thirty pieces of silver moves directly into the central space, but since Judas stands to the right, with the High Priest in between, there is a curious effect of displacement, contributing to a feeling of unease. The conspirators' awareness of their own guilt is effectively conveyed by their huddled whisperings and shifty glances.

If the scheme of the San Gimignano decorations recalls that of the Arena Chapel, their content could scarcely be more dissimilar; and it is to Pietro Lorenzetti's cycle at Assisi that we must turn to discover the closest anticipations in Trecento painting of Barna's tragic vision. Yet even here important distinctions are to be drawn; for whereas Lorenzetti remained within the mainstream of the realistic, Giottesque tradition, Barna took from that tradition what suited his purpose and discarded everything that did not. His greater independence is seen in the very freedom with which he composes, as in the splayed designs of the *Massacre of the Innocents* and the *Crucifixion*, in which rhythmic planar movements, often of great beauty, take precedence over spatial considerations. The strange twists that he gives to accepted iconographical patterns betoken the same originality of mind. At San Gimignano, therefore, we become aware of a deliberate revision of Trecento canons, and in this respect Barna, despite the ultimate independence of his genius, reflects tendencies in Tuscan painting that are peculiarly characteristic of artists working in the middle years of the century and later.

The Old Testament cycle completed in 1367 in the left aisle of the Collegiata of San Gimignano exhibits a disturbance of style which might also be related to the troubles and upheavals of the time (which included a fresh outbreak of the plague in 1363). But qualitatively these frescoes—the work of Bartolo di Fredi, a prolific Sienese master who controlled a large *bottega* and formed an association first with Andrea Vanni and later with Luca di Tommè—cannot compare with those of Barna, and their literalism and concern with detail indicate a somewhat pedestrian mind. At the same time, to look back from Bartolo's late *Presentation of Christ in the Temple* in the Louvre (*Plate 137*), datable about 1390, to Ambrogio Lorenzetti's treatment of this subject in his panel of 1342 (*Plate 118*) is to become aware of

the ritualistic emphasis increasingly demanded by Church patronage in the second half of the century: how else could we explain the unusual prominence given by Bartolo to the High Priest, who dominates the scene? Such iconographical departures from Lorenzetti's composition, one of the famous works of the century, are accompanied by a weakened grip upon reality, and only lip-service is paid to the spatial discoveries of the early Trecento masters.

Yet at his best Bartolo di Fredi possesses a charm of his own, as in the panel of the *Adoration of the Magi* (*Plate 138*) in the Siena Pinacoteca, in which a wealth of detail and a vivacious medley of attractive colours allow the eye to wander pleasurably over the surface of the rather disorderly composition; and there are agreeably unexpected touches, such as the distant view of a city which is recognizably Siena. Moreover, credit must be given here for a certain inventiveness; for many features of the design, including the procession of the Magi and their retinue over the hills, with their horses and camels and prancing dogs, reappear in the Strozzi altarpiece of Gentile da Fabriano, of the 1420s, and in an altarpiece of comparable date by Lorenzo Monaco. The panel by Bartolo now in the Pinacoteca takes, indeed, an honoured place in the contribution made by the Sienese School to the development of the International Style in fifteenth-century Italy.

Bartolo's partner Andrea Vanni was prominent in the public affairs of Siena, and was sent on diplomatic missions to Avignon in 1372 and to Naples in 1384. His sympathetic response to the life and teachings of St Catherine of Siena is reflected in a fresco in San Domenico at Siena (*Plate 139*), in which she is represented with a devotee at her feet, long before her canonization. St Catherine (Caterina Benincasa), who was born in 1347, was not only one of the great mystics of Christian history but one of the most forceful and influential personalities of late fourteenth-century Italy. Her exaltation of Christian love in all its purity, which runs through her *Libro della divina dottrina*, her fervent belief in the possibility of the soul's union with God on this earth, and her experiences of ecstatic communion with Christ were by no means the product of the mind of a simple visionary: there was another side to her nature—that practical concern for the welfare of the Church that led her to engage in reformist activities in Rome, to urge the return of the Pope from Avignon, and to encourage a new crusade against the Infidels.

In Andrea's fresco St Catherine is shown with the marks of the wounds of Christ in her hands: the sacred stigmata were imprinted upon her hands, feet and side after a prolonged and rapturous contemplation of a crucifix, and we are reminded immediately of the story of St Francis and the miraculous crucifix of San Damiano. On another occasion, as she was praying in front of Giotto's *Navicella* at St Peter's, St Catherine experienced the sensation that the ship represented in the mosaic—a symbol of the Church in troublous waters—was pressing down upon her shoulders, crushing her with its weight so that she fell to the floor, permanently paralysed in her lower limbs. There could be no more striking instances than

these of the continued power of the visual image over the religious mind of the late Middle Ages; nor are the life and influence of St Catherine of Siena less interesting to the art historian for the insight that they offer into the mystical impulses of the period. Is it coincidence that the art that was inspired by such profound longings took on a character appropriate to its spiritual message? Certainly in Andrea's fresco the naturalistic preoccupations of the previous age are conspicuous by their absence.

This work, inevitably, gives us only a partial glimpse of an artistic personality of considerable interest. Andrea Vanni's finest surviving altarpiece is unquestionably the signed triptych in the Corcoran Gallery in Washington, evidently from the period of his visit to Naples in 1384, which comprises a *Crucifixion* flanked by scenes of *Christ at Gethsemane* and the *Descent into Limbo*. The intense emotionalism of the *Crucifixion*, which is imbued with a deep mystical fervour, contrasts strangely with the more formal treatment of the subject in Andrea's triptych of about 1390 in the Siena Pinacoteca (*Plate 142*), where almost all attempt to evoke the drama of Golgotha is discarded in preference for a formal and static rendering of holy contemplation. The figure of Christ is oddly reduced in size in relation to those of the Virgin, the Beloved Disciple and Mary Magdalen, who might almost be performing their devotions before a crucifix, while the Prophets in the side panels are larger again, contributing thereby to the unreality of the whole—unreality in the sense of a lack of interest in narrative expression—but at the same time drawing the attention of the devout to the divine plan for man's salvation which had been foretold by the prophets.

Much the same disturbance of earlier modes occurs in the work of Paolo di Giovanni Fei, who is documented from 1372 to 1410, and whose style has many points of resemblance to those of Bartolo di Fredi and Andrea Vanni. In Paolo's large, elaborate triptych of the *Birth of the Virgin* in the Siena Pinacoteca (*Plate 141*), the origin of the central composition in Pietro Lorenzetti's panel of 1342 (*Plate 117*) is quite evident; but the attempt, some fifty years later, to amplify Lorenzetti's conception results in overcrowding and spatial confusion; and, as in Andrea Vanni's *Crucifixion* triptych, the lateral figures, representing four saints at full-length, again assume a grandiose scale which would have been unthinkable in the art of the Lorenzetti. That the predisposition to detail and overcrowding in this picture is no unusual feature of Sienese painting of the late Trecento will already have become evident to the reader; and at the turn of the century the same impulse, combined with startling effects of perspective and foreshortening, characterizes the monumental frescoes of Taddeo di Bartolo (not, *pace* Vasari, the son of Bartolo di Fredi), who is documented from 1386 until 1422, the year of his death.

Although he was active in many parts of Italy, including Genoa, Perugia and Volterra, Taddeo di Bartolo's most important works were painted in Tuscany—notably the two Marian cycles in the sacristy of San Francesco at Pisa (executed with the help of assistants in 1397) and in the Chapel of the Virgin in the Palazzo Pubblico at Siena (painted in 1406–7),

together with a later group of frescoes in an antechapel of the Palazzo Pubblico, representing *Civic Virtues* and *Famous Men.* This last series brings us to the years 1413–14, but despite their date and their classical subject-matter they belong stylistically to the art of the late Trecento rather than to that of the early Renaissance. Nevertheless, as Rubinstein has shown, the subject-matter of the frescoes seems to have been inspired by such early Florentine humanists as Leonardo Bruni and Coluccio Salutati, who, in opposition to the medieval belief that Florence had been founded by Caesar, argued from their reading of Cicero and Sallust that the city owed its origins to republican rather than to imperial Rome. This was a view that strongly appealed to all who saw the Florentine republic as the defender of civic liberties against tyranny (such as that of the Visconti), and it was one that could also be applied to Siena. Indeed Taddeo di Bartolo's decorations in the Palazzo Pubblico complement, in humanist terms, Lorenzetti's frescoes of *Good and Bad Government* in the Sala de' Nove, with their insistence upon service to the common good as the foundation of just government.

We must now turn to that new class of subject which, on the analogy of one of the themes of Petrarch's *Trionfi,* we know as the 'Triumph of Death'. Only a few fragments now survive of the large representation of this subject painted by Orcagna on the right wall of the nave of Santa Croce in Florence (see *Plates 148, 149*); but the composition is known from Bartolo di Fredi's version of it (also in fresco) at Lucignano. The Santa Croce decoration combined the *Triumph of Death* with a *Last Judgment* and an *Inferno,* and the whole awe-inspiring scheme must have made an overwhelming impression upon the Florentines as they entered the church. Orcagna's origins are obscure; but, as Boskovits has shown, his frescoes at Santa Croce have points of resemblance to the work of Maso, whose pupil he may have been. Their style seems undoubtedly to be less advanced than that of the *Strozzi Altarpiece* of 1357 (*Plate 154*), the most important of the surviving panel-paintings by this great master. The Santa Croce frescoes have an intimate connection with the vast *Triumph of Death* formerly on the south wall of the Camposanto at Pisa (the burial-ground of the city), which they probably postdate; and one of the texts that accompany the *Triumph of Death* at Pisa—a pathetic invocation to Death—supplies in its complete form a damaged inscription in the composition by Orcagna: 'Since prosperity has left us, Death, the medicine for all pains, come now to give us our last supper.'

The Pisa *Triumph of Death* and the frescoes related to it (*Plates 150–153*) have aroused a great deal of controversy about their authorship; but it will be preferable, before we examine this question, to consider some of the main features of these famous decorations. The frescoes have now been detached from the wall, during restoration work necessitated by wartime damage; and in the process some marvellous *sinopia* drawings were discovered under the *intonaco,* which add to our knowledge of the working methods of the master and his assistants, who employed *buon fresco* built up in large *intonaco* patches. The

Triumph of Death originally occupied the east end of the south wall, and was followed on the same wall by three further scenes—the *Last Judgment*, the *Inferno* and the *Legends of the Anchorites*. The iconography is novel, as is apparent at once when we compare the *Last Judgment* and *Inferno* with Giotto's *Last Judgment* in the Arena Chapel (see *Plate 60*). Hell has been enlarged to terrifying proportions and made into a scene on its own, with a horrible Satan at its centre; the figure of Satan is itself larger than the corresponding figure of St Michael in the *Last Judgment*; and the attitude of the regal Christ (represented in a mandorla alongside the Virgin) expresses only condemnation, whereas in the Arena Chapel he lowers one hand in rejection of the damned but extends the other in a gesture of welcome to the saved. The Virgin, it is true, looks down towards the condemned souls with gentler mien— for in popular devotion her protection was often invoked against the divine anger,—but the greater emphasis is placed upon the wrath of God, as represented by the severe Christ, and upon the everlasting punishment awaiting sinners.

It is understandable that the Pisa frescoes, although now known to antedate the Black Death, should have seemed to allude to the terrible plague of 1348. The group of high-born women and young men in the right-hand corner of the *Triumph of Death* (*Plate 153*) might almost be the fair maidens and their *amorosi* who tell, turn about, the famous stories in the *Decameron*, immured in a place of refuge far from the plague-ridden streets of Florence, or going off together 'through the gardens, talking of pleasant matters, weaving garlands of different leaves, and singing love-songs'. In the fresco black-winged Death—a female figure with a scythe—hovers ominously over the secluded garden. The doom of these carefree music-makers is certain; but their minds and hearts are full of worldly distractions.

The contrast between the thoughtless pleasures of this enchanting group and the sudden fate that awaits them is underlined by two *amorini*—derived from antique prototypes—who fly in attendance upon one dreamy couple, drawing our attention to the theme of earthly love cut short, and of the bloom of youth that is shed, while the aged and the maimed (represented further to the left) are incomprehensibly spared, although they themselves reach up towards the figure of Death begging for deliverance. In the corresponding area on the left side of the composition, a cavalcade of noblemen and their consorts rides out on a hawking expedition (*Plate 151*), to be confronted by three coffins containing putrefying corpses—an adaptation of the medieval allegory of the Encounter of the Three Living and the Three Dead. The message—that what the dead now are the living will themselves become—could not have been more powerfully conveyed; for the realism is startling, and the members of the hawking party are wonderfully characterized as individual human beings.

Across the central and right-hand field of sky, angels and demons fight for possession of the saved souls; but to the left, in a quiet corner of hilly landscape, hermits engage in their peaceful labours and meditations. This theme of holy living and preparation for holy dying is expanded in the fresco of the *Legends of the Anchorites*, which follows the *Inferno*,

and which was probably inspired by the *Vite dei Santi Padri* written by the Dominican preacher Domenico Cavalca of Pisa. Here the visitor to the Camposanto was reminded of the ultimate purpose of man's brief sojourn in the world, and there was set before his eyes an *exemplum* which opposed to the ephemeral consolations of worldly pleasures the Christian ideal of renunciation, meditation and prayer.

Until recently there were two main theories about the authorship of these frescoes and others painted on the east wall, where originally there was a New Testament cycle, only part of which survives. On the whole, scholars were divided as to whether the decorations were painted by the Pisan artist Francesco Traini, who is first documented in 1321, or whether they are attributable to some Emilian master influenced, perhaps, by Traini and Vitale da Bologna. Their attribution to Traini is due principally to their stylistic affinities with his signed altarpiece of *St Dominic and Scenes from his Life* (Plate 147), painted in 1345 for the church of Santa Caterina in Pisa. A new solution, however, has lately been proposed by Bellosi, who ascribes the frescoes to the mysterious Buonamico, called Buffalmacco, a Florentine master of the early fourteenth century whose amusing exploits feature in the *novelle* of Boccaccio and Sacchetti. (There is no evidence that the sobriquet Buffalmacco was used in the artist's lifetime.) Ghiberti says that Buonamico painted 'very many works' in the Camposanto, together with another group of frescoes in Pisa—an Old Testament cycle 'and many legends of the virgins' at San Paolo a Ripa d'Arno. (Apart from two standing *Saints* on one of the pillars of the nave, nothing now remains of this decoration.) According to this theory, Traini would have been Buffalmacco's associate in the Camposanto, and Bellosi draws comparisons between some of his figures in the *St Dominic* altarpiece and not dissimilar figures in the gigantic *Crucifixion* (Plate 144) on the east wall.

There can be no doubt about the stylistic similarities between the *St Dominic* panel and this group of frescoes in the Camposanto: on the other hand, they are not so decisive as to have convinced every student of the problem that they imply a common authorship; and, while there are difficulties inherent in the Buffalmacco hypothesis, the tradition handed down by Ghiberti (as I have long felt) cannot be lightly dismissed: indeed, the only other works in the Camposanto that Buffalmacco could have painted would be some lost decorations formerly on the west wall. Ghiberti also says that Buffalmacco painted a *Life of St James* in the Cappella Spini in the Badia at Settimo, but these decorations are now in such a ruinous condition that stylistic judgment is difficult. Nevertheless, there are striking similarities between the Camposanto decorations and a fragmentary fresco of the *Madonna and Child with Saints*, together with a *Christ as the Man of Sorrows* (Plate 146), in the Cathedral at Arezzo, which may be identical with part of a decoration documented as the work of Buonamico. If it could be established that this fresco does indeed belong to the decorations undoubtedly painted by Buonamico at Arezzo, and if it were clearer that there is no stylistic incompatibility between the Settimo frescoes on the one hand and the Arezzo and Pisa

frescoes on the other, the case for Buffalmacco would be still stronger. As it is, Bellosi's theory is of considerable interest, because it attempts not only to solve the problem of the Camposanto *Triumph of Death*, but also to fill in one of the most puzzling gaps in our knowledge of early Trecento painting; for Buonamico was renowned in his day as one of the greatest of Florentine masters, who in Ghiberti's opinion 'surpassed all other painters when he put his mind to his work'. He was no invention of Boccaccio's or Sacchetti's: he was probably the *Bonamichus magistri Martini* recorded in the Florentine guild of Medici e Speciali in the year 1320; and a connection with Pisa is established by a document of 1336, recording an accusation of breach of contract against *Bonamicus pictor* for his failure to undertake some unspecified work for the city (not, however, the most positive of documents). A further document, of 1341, refers to the frescoes by him in Arezzo Cathedral, evidently dating from a much earlier period. And no less important is Ghiberti's attribution to Buonamico of the frescoes at Settimo, which an inscription dates in the year 1315.

The Cappella Spini in the Badia (or parish church) at Settimo, near Florence, is a small chapel of simple construction; the wall at the back, near the entrance, contains the only window. The other three walls and the ceiling were once entirely covered with frescoes. The ceiling is divided into two cross-vaults, on one of which the artist represented the *Four Evangelists*, shown in the act of composing their Gospels, and on the other some half-length figures of *Prophets*, with scrolls in their hands. The best preserved of the wall frescoes, representing the *Martyrdom of St James*, contains a group of soldiers holding lances and a standard, against a steep hill, from which there grows a solitary tree (*Plate 145*). The entire surface of the decoration has been affected by damp caused by the repeated flooding of the chapel by the nearby Arno, and little of it survives but a cloudy patchwork of red pigment, with touches of black and ochre here and there. The impression created by the whole is nevertheless of a work of immense solemnity and heroic dignity, combining the new accent which the fourteenth century placed upon the perceptions of the senses with something of the older spirituality of the Dugento. The recent removal of the *intonaco* has revealed *sinopia* drawings which show remarkable inventiveness in the rendering of architectural perspective. Occasionally there are passages in these fragmentary frescoes that bring the Camposanto decorations to mind: the group of soldiers just mentioned is a case in point, for the riders, with their lances, in the Pisa *Crucifixion* (*Plate 144*) are very similar in conception.

The *Crucifixion* has suffered from a good deal of repainting, like the other surviving scenes in the New Testament cycle; and the original quality of the fresco can best be judged from the *sinopie*, which reveal a draughtsman of no mean order (*Plate 143*). There are certain features of the composition, such as the anguished figure of the Crucified, which recall not so much Traini or the painters of the Emilian School, as that independent Florentine tradition which developed side by side with that of Giotto and his pupils; and one thinks particularly of the Da Filicaia cross, the work of an anonymous Florentine of the early

fourteenth century who may be said to have developed to a new level of heightened express-
iveness the idiom of the crucifix of Santa Maria Novella (*Plate 22*). But further inquiry is
necessary in order to test the validity of such comparisons; and there are a number of other
panel-paintings of the period that may throw further light upon the authorship of the
Camposanto frescoes and which, when fully studied, may help to clarify the whole problem
of Buonamico Buffalmacco.

Few doubts now exist about the authorship of most of the other frescoes in the total
scheme of decoration in the Camposanto, which represents a vast enterprise extending into
the fifteenth century, and which, before the fire of 1944, unfolded upon the south and north
walls in two registers (the large scale of the *Triumph of Death* series being given up, except
in the case of the first scene on the north wall, which occupies two registers [see *Fig. C*]).
As we have seen, the *Triumph of Death* and its associated scenes opened the narrative sequence
on the south wall. An *Assumption of the Virgin*, now lost, which the Anonimo Magliabechiano
(writing in the early sixteenth century) ascribed to Stefano Fiorentino, originally stood over
a doorway immediately to the right of the *Legends of the Anchorites*. There then followed
three short cycles, each comprising six scenes. The first of these, devoted to the *Life of St
Ranierus*, the patron saint of Pisa, was begun in the 1370s by Andrea Bonaiuti, who painted
the three scenes in the upper register; it was completed between 1384 and 1386 by Antonio
Veneziano. The second cycle, the *Legends of Saints Ephesus and Potitus*, telling the story of two
Pisan martyrs who suffered, respectively, under the Emperors Diocletian and Antoninus,
was frescoed about 1390 by Spinello Aretino. The third and last cycle on the south wall, the
Story of Job, dates from a considerably earlier period, but it has been much repainted. These
frescoes were already in a ruined condition when Vasari saw them in the mid-sixteenth
century; but his attribution of the cycle to Taddeo Gaddi (who also worked, in the early
1340s, in San Francesco at Pisa) is confirmed by the style and quality of the remaining
sinopie.

The whole of the north wall of the Camposanto was reserved for an extensive Old
Testament series, containing twenty-nine scenes, in addition to a *Coronation of the Virgin*
opposite the lost *Assumption* on the south wall; but only the first few scenes of the cycle
belong to our period, the remainder having been executed in the second half of the fifteenth
century by Benozzo Gozzoli. The first four frescoes are documented as having been painted
in 1390 by Piero di Puccio, a painter and mosaicist active chiefly in Orvieto. The most
interesting of them is the large fresco that served as a prelude to the narratives from the
Book of Genesis. This shows a gigantic figure of the Creator holding in his hands a sche-
matic representation of the Universe rendered according to the Ptolemaic-Aristotelian
system, with the Earth at the hub of a series of concentric circles containing the elements of
water, air and fire, the sky and zodiac, and finally the cherub-thronged heavens.

It will be apparent from the list of artists called in to decorate the Camposanto that most

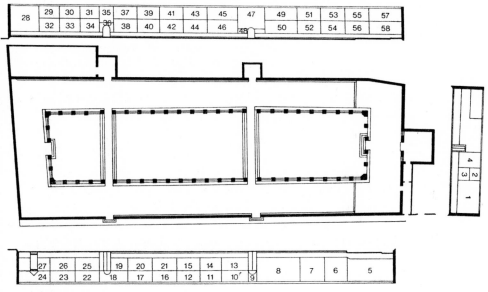

NORTH WALL

| 28 | 29 | 30 | 31 | 35 | 37 | 39 | 41 | 43 | 45 | 47 | | 49 | 51 | 53 | 55 | 57 |
| | 32 | 33 | 34 | 36 | 38 | 40 | 42 | 44 | 46 | 48 | | 50 | 52 | 54 | 56 | 58 |

| 27 | 26 | 25 | | 19 | 20 | 21 | 15 | 14 | 13 | | | | | | |
| 24 | 23 | 22 | 18 | 17 | 16 | 12 | 11 | 10 | 9 | 8 | 7 | 6 | 5 |

SOUTH WALL

FIG. C *Plan of the Camposanto, Pisa*

MASTER OF THE TRIUMPH OF DEATH
AND ASSOCIATES

1. Crucifixion
2. Resurrection of Christ
3. Incredulity of St Thomas
4. Ascension
5. Triumph of Death
6. Last Judgment
7. Inferno
8. Stories of the Anchorites

STEFANO?

9. Assumption (*lost*)

ANDREA BONAIUTI

10–12. St Ranierus cycle

ANTONIO VENEZIANO

13–15. St Ranierus cycle

SPINELLO ARETINO

16–21. Legends of SS. Ephesus and Potitus

TADDEO GADDI

22–27. Story of Job

PIERO DI PUCCIO

28. Theological Cosmography
29–31. Old Testament cycle
47. Coronation of the Virgin
 (*repainted by Taddeo di Bartolo*)

BENOZZO GOZZOLI
(*fifteenth century*)

32–46, 48–58. Old Testament cycle

of them were Florentines either by origin or by training. Among those who were not Florentines, Antonio Veneziano left his native Venice as a young man to become a pupil of Taddeo Gaddi in Florence; and by 1374 he is recorded as a member of the Florentine artists' guild. Spinello Aretino, after an early period in Arezzo, was also active in Florence, where he came increasingly under the influence of Orcagna and his brothers Nardo and Jacopo di Cione. Subsequently Spinello was to take a leading part in the Giottesque revival which marked the closing years of the fourteenth century. Although the remains of Taddeo Gaddi's decorations in the Camposanto add little to our knowledge of him, the frescoes

9

executed there by Andrea Bonaiuti, Antonio Veneziano and Spinello Aretino all represent important, late developments in their art which crown their careers. These we may best approach by retracing our steps to Florence, both to consider their earlier work and to pick up the threads of that process of stylistic change around the middle of the century within which the art of Andrea di Cione, known as Orcagna, occupies a central place.

Orcagna practised as a painter and mosaicist, as an architect and as a sculptor. Appointed architect of the Duomo in Florence in 1357, he played a part in the decisive resolutions of 1366 which were to give the main structure of the Cathedral its present form—recorded shortly afterwards in an imaginative view of the exterior in Andrea Bonaiuti's famous fresco at Santa Maria Novella (*Plate 158*). In his capacity as a sculptor, Orcagna erected the great Tabernacle in Orsanmichele (*Plate 96*), which was designed to house, within its front arch, the famous *Madonna* by Bernardo Daddi (*Plate 97*). This magnificent structure, topped by a peculiarly shaped dome, which no doubt reflects contemporary projects for the Cathedral, is lavishly adorned with sculptural decoration and enriched by coloured marble and inlaid mosaic. The Tabernacle is embellished with reliefs of scenes from the *Life of the Virgin*, which reach their climax in the large *Death and Assumption of the Virgin*: this scene occupies the rear archway and therefore forms the sculptural counterpart of Daddi's picture. Although the *Dormition* scene below and the other reliefs are treated, on the whole, in a conventionally naturalistic style, Orcagna's conception of the Virgin's Assumption into Heaven has much of that quality of otherworldly 'transcendentalism' which is so notable a feature of his major surviving painting, the signed altarpiece (*Plate 154*) commissioned in 1354 for the Strozzi Chapel at Santa Maria Novella and completed three years later.

Within the period in which Orcagna was working on his altarpiece for the Strozzi Chapel his elder brother Nardo di Cione, a lesser master, would have been decorating the chapel with his frescoes of the *Last Judgment*, the *Inferno* and *Paradise*. There is a certain parallel here with the Baroncelli Chapel at Santa Croce, where the altarpiece was commissioned from Giotto and the frescoes from his pupil Taddeo Gaddi.

Orcagna's *Strozzi Altarpiece* and Nardo's frescoes are both interesting documents of the changed tastes of the middle years of the century. As in the *Stefaneschi Altarpiece* by Giotto (*Plate 73*), Christ is represented in the central field of Orcagna's painting. Such representations of the majestic, adult Christ are rare in this period, although a slightly later example by Giovanni da Milano seems to confirm the importance of Giotto's conception to the later development of the subject. But in the *Strozzi Altarpiece*, notwithstanding the realism evinced in the three predella scenes and in the figures of saints in the side panels, the Redeemer is presented as a virtually disembodied being who exists in no definable space. Crowned as the King of Heaven and surrounded by cherubim, he stares out of the heavens, while with his left hand he consigns the keys to St Peter (who is attended by the Baptist) and with his right hand receives the *Summa*, the greatest theological work of the Middle Ages, which is

proffered by its author, St Thomas Aquinas, who is himself presented by the Virgin. It is a symbolic act, intended to demonstrate the authority of Thomist doctrine as well as to restate the older theme of the authority of the Church, as represented by St Peter.

Christ, enthroned in his majesty, makes no response to the intent glances of Aquinas and Peter. The Christ of the *Stefaneschi Altarpiece* is an equally regal figure, although he wears no crown; but Giotto placed him upon a substantial throne, which seems to belong as much to the earthly world as the lateral scenes of the martyrdom of St Peter and St Paul. In Orcagna's altarpiece, despite the substantiality of the figures, pictorial space as Giotto and his pupils understood it has been replaced by an evocation of the infinite and of the numinous which recalls the spirituality of the Dugento masters, and which is enhanced by the splendour of emblazoned scarlets and lavish gold-leaf ornamentation. A similar contrast is to be found between the non-naturalistic treatment of space in the oddly throneless *Madonna* by Nardo di Cione now belonging to the New York Historical Society and its clear definition in Giotto's *Madonna* for Ognissanti.

Few other works attributable to Orcagna have survived. Some busts of prophets on the vaulting of the choir of Santa Maria Novella, datable about 1349–50, are the only remains of a large decoration which was replaced in the late fifteenth century by the well-known frescoes by Ghirlandaio. Like a damaged *Annunciation* painted for SS. Remigio e Romeo, which bears a signature and seemingly the date 1346, these figures give us some indication of Orcagna's early style and confirm his presumed origins in the circle or workshop of Maso di Banco. Later on he came under the spell of the gracious Bernardo Daddi. The panel of *St Matthew and Scenes from his Life* in the Uffizi (*Plate 155*), begun by Orcagna in 1367 for Santa Maria Nuova but completed after his death shortly afterwards by his brother Jacopo di Cione, the third member of this distinguished family of painters, offers us some insight into the master's late manner. Here, in the central cult-image of the Evangelist, the rigid formality of the *Strozzi Altarpiece* is preserved.

Nardo di Cione's frescoes in the Strozzi Chapel, comprising a *Last Judgment* on the end wall and a *Paradise* and an *Inferno* on the windowless walls on either side, reflect the tendency towards two-dimensional design apparent in Orcagna's own work; but the style is more delicate than that of his brother and also more diffuse. It is difficult to discover any marked unity of conception in the Strozzi Chapel frescoes, which despite their awesome subject-matter possess a curious decorativeness. The *Inferno* is of particular interest, since Dante's system of the nine circles of Hell, each reserved for the punishment of a specific sin, is followed with some accuracy and with much descriptive power. An earlier *Passion* cycle by Nardo in the Giochi-Bastari Chapel in the Badia of Florence, which has come down to us only in part, can be dated provisionally around 1350. These frescoes are at once more dramatic and more poetic in feeling than the Strozzi Chapel decorations, and combine much of the force of Maso with something of the delicacy of colour of Giovanni da Milano,

the Lombard painter whose lyrical cycle in the Rinuccini Chapel at Santa Croce has been mentioned earlier (see *Plate 90*).

Giovanni da Milano, an influential figure, had settled in Florence in 1350. He too reflects in his work that rediscovery of the values held dear in the thirteenth century which, since Meiss's fundamental study of the period immediately following the Black Death, has been accepted as one of its most interesting characteristics. In Giovanni del Biondo's *Altarpiece of St John the Baptist*, the triumphant Baptist in the central panel tramples underfoot his executioner, King Herod; and similar images occur in two other paintings by this master. The symbolism derives from older medieval traditions: in the age of Giotto, it has been argued, such disrespect for the human body and individual personality would have been unthinkable. In the same manner the author of the *Glory of St Thomas Aquinas* at Santa Caterina at Pisa (traditionally ascribed to Traini) represented the Spanish Muslim philosopher Averroës, the Aristotelian scholar whose advocacy of the primacy of reason over faith lent itself by the early fourteenth century to heretical interpretations of Christianity, being trampled underfoot by the 'Seraphic Doctor'.

By far the most famous, and in many ways the most impressive, of all the major pictorial responses to the demand for didactic allegory in these years is the grandiose series of frescoes executed by Andrea Bonaiuti between 1365 and 1368 in the chapter-house, or 'Spanish Chapel', at Santa Maria Novella. The chapter-house had been erected soon after the tragic year of 1348 by a layman, Buonamico di Lapo Guidalotti, whose wife had been a victim of the plague; and it was the same patron who commissioned the decorations, perhaps devising the programme with the aid of his friend Jacopo Passavanti, the renowned Dominican preacher who was prior of Santa Maria Novella in the 1350s. The frescoes were intended to reassert the authority of the Church at a time of apostasy and confusion, to proclaim the true message of Salvation as mediated by the Church, and to glorify the work of the Dominican Order. In one of the frescoes, *The Apotheosis of St Thomas Aquinas*, heresy, in the persons of Averroës, Sabellius and Arius, is again shown at the feet of St Thomas Aquinas, before whom the miserable figures cower in acknowledgment of their errors.

As we enter the chapter-house we are confronted by a gigantic *Crucifixion*, which dominates the archway leading to the Guidalotti Chapel (behind the altar), this being the climactic point of a Christological cycle which extends into the vaulting. The entrance wall, directly opposite, is given over to six scenes from the *Legend of St Peter Martyr*, the thirteenth-century Dominican. The left wall is devoted to the *Apotheosis of St Thomas Aquinas*, whose doctrines had been officially adopted by the Dominicans in 1378, and the right wall to a *Triumph of the Church (Plate 158)*, the most celebrated of all the frescoes in the Spanish Chapel. Here the Church is symbolized by a representation (alluded to earlier) of Florence Cathedral, shown with a dome prophetic of Brunelleschi's famous masterpiece. In front of the cathedral the Pope and other representatives of the Church, both clerics and laymen,

are seated in a long row, almost like external statues. In the foreground, and further back, the black and white *domini canes* ('the hounds of God', a punning reference to the Dominicans) round up some lost sheep which are being attacked by wolves, just as the members of the Dominican Order, in their black and white habits, are seen preaching and ministering to the people, and guiding them—as we follow the rambling composition—to the Gates of Paradise. Above, in the heavens, the Redeemer, reminiscent not merely of the severe Christ of Orcagna's *Strozzi Altarpiece* but even of some Byzantine *Pantocrator*, is enthroned in a circular glory, alone in his majesty amidst the worshipping ranks of the angelic hosts.

The frescoes owe much, no doubt, to the example of the panoramic landscapes of Ambrogio Lorenzetti; but the loose, decorative compositions stand closer on the whole to Nardo's murals in the Strozzi Chapel. They contain a wealth of naturalistic detail, but this is placed at the service of an 'anti-realism', an adaptation of all the available devices of the painter's art to the requirements of a didactic programme: in the home, in Florence, of the Order of Preaching Friars, Andrea Bonaiuti produced a supreme example of a painted sermon. To see him in a slightly different light, one must return to the Camposanto at Pisa and to his three now ruined frescoes in the *St Ranierus* cycle, which was to be completed after his death by Antonio Veneziano. Here the ornamental effect of the Spanish Chapel decorations gives way to a more realistic manner, in which problems of perspective are satisfactorily solved and a genuine attempt is made to define space, even if the designs remain somewhat confused and overcrowded.

The art of Antonio Veneziano is very different. The *Death and Funeral of St Ranierus*, as it existed before the fire of 1944 (*Plate 156*), combined Sienese descriptiveness with a return to Giottesque principles, not least in the treatment of the human figure. In the background the painter introduced impressive renderings of some of the principal buildings of Pisa, including the Duomo and the famous campanile (already leaning). The vivid naturalism of this fresco is typical of a gradual reassessment, towards the end of the century, of Giotto's art, which culminates in the late style of Spinello Aretino and Gherardo Starnina.

This process might have been expected to manifest itself unequivocally in the art of Agnolo Gaddi, the son of Giotto's pupil Taddeo Gaddi and the teacher of Cennino Cennini. But just as Cennini's *Libro dell'arte* shows only a limited understanding of Giotto's aims, so Agnolo's frescoes of the *Legend of the True Cross* (*Plate 62*) in the choir of Santa Croce, although founded upon Giottesque principles, which in the realization of deeply recessed space they even extend, are so overlaid with descriptive detail that it is less easy to relate them to Giotto than to think ahead to Lorenzo Monaco, Gentile da Fabriano and other masters of the International Style. There was scarcely a finer draughtsman in this period than Agnolo Gaddi, nor a more charming colourist, and the fact that the Santa Croce frescoes belong to a transitional period and cannot be neatly categorized should not blind us to their beauty nor, for that matter, to the artist's sheer ingenuity as a storyteller. The

delicacy of his colours and the rhythmic grace of his line were, indeed, to provide the basic vocabulary of the supreme painter of the closing years of the fourteenth century and the early years of the fifteenth—his pupil Lorenzo Monaco, who takes his true place, however, in the history of Renaissance rather than Trecento painting.

Another pupil, Spinello Aretino, shows in his early work the influence both of Orcagna and of the Sienese, but his vigorous and prolific genius always retained a powerful individuality, and unlike most of his contemporaries he seems to have been impatient of the more decorative aspects of the painting of his times. The frescoes of the *Life of St Benedict* at San Miniato al Monte (*Plate 157*), probably completed in 1387, almost repel by their harsh expressiveness; but in their sculptural forms and assured manipulation of space, and perhaps above all in their concern with organic design, they anticipate Masaccio. Like Masaccio after him, Spinello must have made a close study of the work of Giotto, to whose art he increasingly turned for inspiration, as is evident already from his frescoes in the Camposanto (although there is nothing in Giotto's known work comparable with the tumultuous battle-scene in the fresco depicting St Ephesus's victory over the pagans). The influence of Giotto becomes still more apparent in the cycle of the *Life of Alexander III* in the Palazzo Pubblico in Siena, which he executed with the aid of his son Parri Spinelli in the years 1407–8. The scene of *Barbarossa at the Feet of the Pope*, for example, brings to mind Giotto's frescoes in the Bardi Chapel, although certain Lorenzettian elements are also in evidence.

A parallel development, in terms of a more refined style and sensibility, can be seen in the few remnants that survive of the work of Gherardo Starnina, a Florentine pupil of Antonio Veneziano who, according to Vasari, was born in 1354 and who is last recorded in 1409. Starnina is known to have worked in collaboration with Agnolo Gaddi at Empoli and also to have visited Spain between 1398 and 1401, when he undertook commissions in Toledo and Valencia, so becoming one of the channels of Italian influence upon Spanish art. In Starnina's case, however, attributional problems abound. The famous panel of the *Anchorites in the Thebaid* in the Uffizi, with its wonderful landscape, has been plausibly ascribed to him, but despite their fragmentary state greater importance attaches to the remains of a fresco cycle at Santa Maria del Carmine, datable between 1393 and 1410 and therefore immediately antecedent to the great works undertaken there by Masolino and Masaccio in the second decade of the century.

This cycle was painted in the Chapel of St Jerome, and the compositions devoted to the *Death and Obsequies of St Jerome* are known to us from engravings. A noble *St Benedict* (*Plate 140*) reveals Starnina as an essentially Gothic master who yet heralded the new style of the Quattrocento: the sensitivity shown in the delineation of the features is combined with great power of modelling; and, despite the late dating, one has the curious impression of being in the presence of an artist so close in spirit to Giotto that he might almost have been one of his pupils. In this sense, perhaps even more than Spinello, Starnina anticipates the

Giottesque revival shortly to be undertaken in the Carmine by the young Masaccio. And so, with the close of the fourteenth century and the dawn of a new age, we seem to have come full circle: the tide unleashed by Giotto's revolutionary art swept, at first, almost all before it, until in mid-century it receded in the face of a general spiritual reaction, only to turn back again into the mainstream of Renaissance painting.

Trecento painting outside Tuscany

The chief glory of Trecento painting is the flowering of the Tuscan schools, and especially those of Florence and Siena. Even Rome, which had produced in Pietro Cavallini a master of exceptional importance, suffered a decline as an artistic centre as the century advanced, largely because of the exile of the papal court at Avignon; and the last period of the activity of Cavallini and his pupils is to be traced not in Rome, but in Naples, where in the church of Santa Maria Donna Regina there are to be found the largest surviving fresco decorations of Cavallini's school. These were painted in the second decade of the century. It cannot, however, be said that this work, which includes a fine *Last Judgment*, compares in quality with the frescoes executed by Cavallini himself at Santa Cecilia in Trastevere in Rome (*Plate 33*), although certain figures, such as that of Christ, are very beautiful. As we have noted, Giotto and Simone Martini had also worked at Naples, and frescoes by their pupils are still to be seen there. The most important of these are the Giottesque vault decorations in Santa Maria Incoronata, representing the *Triumph of the Church* and the *Seven Sacraments*.

Despite the masterpieces left by Roman, Florentine and Sienese painters at San Francesco in Assisi, the local Umbrian School of the fourteenth century produced few artists of note; but Meo di Guido da Siena, who is recorded as a citizen of Perugia by 1319, and Marino da Perugia, whose splendid *Madonna with Saints* (*Plate 160*) has been mentioned earlier, are both interesting painters, deserving of greater attention than they have generally received in recent literature. Both have affinities with Duccio, but they were clearly aware of the new developments which were making their mark in Assisi. Meo and his followers executed a number of frescoes in the region; but Meo's gifts were perhaps best suited to less ambitious works, and his Madonnas (see *Plate 159*) reveal him as an exquisite minor master whose quiet but subtle art combines an unforgettable tenderness of feeling with technical skill of considerable refinement. Moreover, his interest in chiaroscuro and in the play of light makes him more than a merely conservative painter, and he may have learnt much from the new developments reflected in the decorations in the Upper Church at Assisi. As has been suggested earlier, the same may be said of Marino, whose style shows a number of affinities with that of the Master of the Obsequies (*Plates 31, 42*). It would not in fact be surprising if there were close connections between the Assisi workshop and the leading painters of Perugia.

The history of painting in Emilia and the Romagna is far more complex and presents a very different pattern of development, which was undoubtedly affected by Giotto's presence

in Rimini in the early years of the century. There had already appeared such painters as Neri da Rimini, first documented in 1292, and Giuliano da Rimini, the author of the signed polyptych of 1307 now at Boston (*Plate 162*) which, on account of its reflections of the *St Francis* frescoes in the Upper Church at Assisi and of the decorations in the Orsini Chapel in the Lower Church, helps to date both cycles. The style of Neri da Rimini must have owed much to the example of the great school of Bolognese miniaturists to which Dante alludes in a famous passage in the *Purgatorio* (XI, 79ff.). The adventurous naturalism of Neri's late illuminations, such as the *Crucifixion* (*Plate 161*) in a Gospel Commentary of the 1320s, already reflects that passionate spirit which is so characteristic of the Riminese and Bolognese Schools, and which adapts an essentially Giottesque idiom to intensely expressive purposes.

Giotto's early impact upon painting in Rimini is reflected above all in the Boston panel by Giuliano da Rimini which came from a Franciscan chapel at Urbania, in the work of Giovanni da Rimini, and in the fresco of the *Last Judgment* (*Plate 163*), of unknown authorship, executed for Sant'Agostino in Rimini but now housed in the Palazzo dell'Arengo. The Boston altarpiece includes a full-length figure of St Clare which must have been copied (although in reverse) from the almost identical figure represented in the Orsini Chapel in the Lower Church at Assisi. Other parts of the panel show a similar dependence upon the Assisi frescoes. This evidence that Giuliano visited Assisi is supported by the fact that the eight standing saints depicted on the panel are enclosed in niches framed by twisted columns—an apparent reminiscence of the decoration of the *sott'arco* in the Upper Church. The picture is essentially linear in style, and the effect is one of a certain flatness and decorativeness, to which the sumptuous colour contributes. Yet we also detect in the figures, and particularly in the standing saints, some attempt to come to terms with Giotto's sculptural treatment of form—as mediated, evidently, by the St Nicholas Master, that gifted pupil of Giotto,—and the folds of St Clare's habit, for instance, are carefully rendered in depth in a fundamentally Giottesque manner. The saints represented in the upper corners— Francis and Mary Magdalen—are given special prominence, and St Francis is shown in the act of receiving the sacred stigmata at La Verna, the design of the figure being based upon the representation of the Saint in the *Stigmatization* scene in the Upper Church at Assisi.

A fragmentary and partly repainted fresco of the *Crucifixion* in the Museo Civico at Forlì (originally in the Convent of San Pellegrino) can be ascribed with reasonable certainty to Giuliano. The composition reveals an intensity of feeling only hinted at in some of the figures in the Boston panel (such as the forcefully characterized John the Baptist). But the major Riminese fresco decoration of the very early years of the century is the now damaged cycle of the *Life of the Virgin* which occupies two walls of the Cappella del Campanile at Sant'Agostino in Rimini. The most famous of the scenes, the *Presentation of Christ in the Temple* (*Plate 164*), is remarkable for the harmonious balance of its design, in the realization of which the nobly conceived forms of the architecture play a decisive part. The volumetric

treatment of the figures would scarcely have been possible without the example of Giotto; but the elegant architecture calls to mind the St Cecilia Master's frescoes at Assisi. The pinnacles of the building are decorated with beautiful statues of angels. This important cycle has lately been ascribed by Volpe (with good reason) to Giovanni da Rimini, who is known chiefly from a signed and dated crucifix painted for San Francesco at Mercatello. The date on the crucifix used to be read as 1345, but the correct date seems to be 1309. This date provides valuable evidence in support of the view that Giotto's recorded visit to Rimini, where he painted some unspecified and now lost work in the Franciscan church (which we now know, since Alberti's remodelling of the building for Sigismondo Malatesta, as the Tempio Malatestiano), took place very early in the fourteenth century, if not earlier; for the Mercatello cross clearly derives from a crucifix in the Tempio Malatestiano which, although attributable to a Riminese follower of Giotto, is so profoundly Giottesque in style that it has often been ascribed to the master himself, and which demonstrates beyond dispute Giotto's immediate impact upon the Riminese School.

The powerful modelling of the figures in the Palazzo dell'Arengo *Last Judgment* (*Plate 163*) must derive from the example of Giotto and perhaps also from that of the Isaac Master; and it is possible that this impressive work, which once decorated the triumphal arch of Sant'Agostino, was painted within the first decade of the century, although a considerably later dating has also been proposed. Its author remains unidentified. A group of rather chaotically designed frescoes in the choir of Sant'Agostino, with scenes from the *Life of St John the Evangelist*, includes a beautiful *Madonna Enthroned*, scintillating with gold and azure, which has certain affinities with the *Madonna* by the St Nicholas Master at Assisi; but this now incomplete cycle would appear to belong to a much later period than the other decorations commissioned for the church.

The fervid 'expressionism' that from time to time bursts to the surface in Riminese and Bolognese painting of the Trecento found its major exponent in Pietro da Rimini, whose crucifix in the Chiesa dei Morti at Urbania is signed and dated 1333. The emotive quality of the sinuous figure of the Crucified in this work is repeated in a quite extraordinary, even lyrical interpretation of the *Crucifixion* in the former Convent of Santa Chiara at Ravenna (*Plate 165*), which belongs to a New Testament cycle attributable to Pietro. The *Crucifixion* occupies the upper areas of a wall pierced by a recessed arch, over which the foot of the cross is represented as hanging—a device that contributes to the impression that the Crucified Christ is suspended in space. At the same time his height from the ground is emphasized by the increased scale given to the mourning figures below—the Holy Women on the left, and St John the Divine and Longinus (together with other soldiers) on the right. A panel of the *Deposition* in the Louvre (*Plate 166*) is equally expressive of powerful emotion and touched by the same poetry and pathos. The tenderly conceived image of the meeting heads of the Virgin and the dead Saviour might have been suggested by Pietro Lorenzetti's

great fresco at Assisi (*Plate 123*); and the resemblance between the vault frescoes of the *Doctors of the Church* formerly at Santa Chiara in Ravenna (now in the Museo Nazionale) and their counterparts in the Upper Church at Assisi suggests the possibility that Pietro da Rimini visited Assisi at some point in his career. Nevertheless the pictorial language of the Riminese master remains quite distinctive, and he must be accorded a place among the most gifted artists of the early fourteenth century. His origins, however, are still obscure, and the view that a series of beautiful and elegantly coloured frescoes, somewhat archaic in style, in the refectory of the Abbey Church of Pomposa are early works by Pietro, datable about 1317, seems no longer tenable.

These decorations have also been connected with Giovanni Baronzio, another of the few Riminese painters whose names are known to us. Unquestionably there are resemblances, for instance, between the design and treatment of the Pomposa *Last Supper*, with its circular table, and the representation of this subject on Baronzio's well-known polyptych at Urbino (*Plate 168*), a work signed *Iohannes Barontius* and inscribed with the date 1345. The Urbino polyptych is probably the most important altarpiece of the Riminese School; elaborate in construction, it comprises a highly original *Madonna and Child adored by Angels* at the centre, flanked by full-length figures of St Louis of Toulouse and St Francis, and, at the extremities, paired scenes of the *Adoration of the Magi* and the *Presentation of Christ in the Temple* (on the left) and the *Last Supper* and the *Kiss of Judas* (on the right). The curiously designed central pinnacle, containing a *Crucifixion*, dwarfs the simple triangular gables on either side, which decrease in scale from the centre. The innermost gables contain busts of saints, and the outer gables an *Angel of the Annunciation* and a *Virgin Annunciate*. There is much in the iconography that is unusual, from the representation of the Virgin in the *Adoration* as a 'Madonna of Humility', seated upon the ground, to the informality of the central composition, in which Mary sits to one side of her throne, while the Christ Child, shown in a standing posture, appears to be about to clamber up to her lap. The charming inventiveness and individual fancy exhibited in the Urbino altarpiece mark out Baronzio as one of the most original geniuses of the period. Few other works, unfortunately, can be ascribed with any degree of certainty to this intriguing master, although it is not altogether impossible that the *Johannes* who signed the crucifix of Mercatello was the young Baronzio himself.

A huge fresco decoration in San Nicola at Tolentino was formerly ascribed by several scholars to Baronzio, and by others to Pietro da Rimini; but although the affinities with the style of Baronzio in particular seem clear enough, the resemblances could be explained by influence, and the rather loose designs and relaxed, anecdotal character of several of the scenes suggest a quite different hand. The frescoes embrace a New Testament cycle, a series illustrating the *Life of St Nicholas of Tolentino*, and representations of the *Doctors of the Church* on the vault. The joyous passage in the *Nativity* showing the angel's announcement to the shepherds of the birth of Christ is characteristic of the lively naturalism of the decorations

as a whole. The scholar's study represented in the *Education of the Saint* in the *St Nicholas* cycle (*Plate 167*) even anticipates those remarkable, and almost Flemish, interiors in the series of forty portraits of eminent Dominicans executed in 1352 by Tomaso da Modena (*Plate 169*) in the Capitolo dei Domenicani at Treviso.

Bologna, celebrated from the time of Dante for its manuscript illuminators, was one of the great centres of learning in medieval Europe, and its university had attained the peak of its reputation by the fourteenth century. The cultivation of the classics led to a demand for illustrations to such authors as Lucan and Seneca, in addition to traditional religious subject-matter; but the variety of Bolognese illumination in the Trecento is not confined to its content: it resides also in its experimental nature and in the richness of imagination shown by artists who were both receptive to outside influence, including that of Giotto, and inventive in their own right. The Franco Bolognese who according to Dante (*Purgatorio* xi, 83) surpassed Oderisi da Gubbio, just as Giotto had surpassed Cimabue, cannot now be identified; but a later master, Niccolò di Giacomo, who was active from 1351 until after the end of the century, brings together in his extensive *oeuvre* many of the outstanding qualities of the Bolognese School of illumination, from its delight in brilliant colour to its novelty of design and vivacity of drawing. A typical example of his work is a representation of *The Virtues and the Arts* in a manuscript now in the Ambrosiana in Milan.

Yet it was in Lombardy, at the very end of the century, that the most astonishing development in manuscript illumination occurred. Its central figure, Giovanni dei Grassi, worked as an architect and sculptor for that laborious and long-drawn-out enterprise, the building of Milan Cathedral, and was also commissioned to design stained glass windows. A manuscript of a treatise on the 'Usage of Milan Cathedral' has some superb drawings attributable to him. Even more interesting are his studies of human figures and, above all, of birds and animals in a sketchbook preserved in the Bergamo Library; they are not only beautiful in themselves but anticipate the graceful naturalism of detail which we associate especially with the International Style.

Another aspect of the art of Giovanni dei Grassi and his Lombard contemporaries—its courtly elegance—is summed up in the charming illustrations to a manuscript of the romance of *Lancelot du Lac*—itself typical of the chivalric themes popularized by artists working for the Visconti Court in Milan.

Apart from the illuminators, Vitale da Bologna, or 'Vitale of the Madonnas', as he was known in his lifetime, was the outstanding Bolognese painter of the early and middle years of the Trecento. Vitale is recorded as an independent master in 1330, when he executed some work for San Francesco at Bologna; and he is known to have died not later than July 1361. His artistic personality has been reconstructed largely on the basis of the so-called *Madonna dei Denti* at Bologna, signed and dated 1345, and of a smaller *Madonna* in the Vatican Gallery, which is also signed. A group of frescoes painted for the church of Santa Maria at

Mezzaratta are more remotely authenticated by a signature recorded in the seventeenth century although no longer visible. Some frescoes in the Cathedral at Udine, probably executed in 1348, are also documented as the work of Vitale, and some at least of the decorations in the Abbey Church at Pomposa are likewise autograph. Four panels from Santo Stefano illustrating the *Life of St Anthony* probably once belonged to an altarpiece of *St Anthony Abbot with Scenes from his Life* traditionally ascribed to Vitale. Another panel probably from his hand, the beautiful *Adoration of the Magi* in Edinburgh, has much in common with the *St Anthony Abbot* series, but lacks its dramatic intensity.

Vitale is in many ways an enigmatic master. The destruction of his earliest works has made it difficult to form a clear idea of his origins; but Sienese influence, combined perhaps with that of Emilian illuminations, seems to be at work in the *Madonna dei Denti*, and some contact with the art of Simone Martini may be presumed. There are also undoubted connections between Vitale and the Pisan School, headed by Traini. Of Giotto's influence there is relatively little trace. In the fresco of the *Obsequies of St Nicholas* in the Cathedral at Udine (*Plate 171*) there are hints of Vitale's study of the frescoes in the Bardi Chapel at Santa Croce in Florence (see *Plate 125*); but in its approximation to a Giottesque resolution of spatial problems this composition is somewhat exceptional in Vitale's *oeuvre*, and has the air of an exercise which held only a momentary fascination for his restless and independent genius. The habitual ambiguity of his conception of pictorial space can be observed most clearly in the *St Anthony* panels (*Plate 170*), with their strange combination of realism and fantasy—what Coletti called 'a kind of magical realism'.

The much damaged Marian scenes executed for Santa Maria at Mezzaratta probably antedate the *Madonna dei Denti*. In the famous emotion-charged *Nativity* (*Plate 172*) now in the Pinacoteca in Bologna, the serenity of the Virgin with her Child (at the centre of the composition) is almost swamped by the flurry around her created by the ecstatic angels, who twist and turn in their rapture, while the tortuous posture of St Joseph, as he pours out water from a jug into the holy infant's bath, although conceivably explicable as a derivation from some antique model, communicates a zeal that might seem excessive in the context of so humble an act. But Vitale's art is full of such surprises, and much the same vigour of expression and unconventionality of design are found again in the *St Anthony* panels.

A similar independence of vision characterizes the frescoes executed from the year 1351 by Vitale and his pupils in the nave of the Abbey Church at Pomposa. These extensive decorations are dominated by a *Christ in Majesty*, the work of Vitale himself, which fills the upper spaces of the apse wall, and by a large *Last Judgment* on the west wall. The Biblical cycle painted in two registers on both sides of the nave, above its imposing Romanesque arches, must have been executed in the main by assistants, but it contains novel compositional and iconographical features. In the *Entry into Jerusalem*, for example, the traditional motif of the boys gathering branches from the trees is infused with a new life, one boy being

shown in the act of leaning down from the top of a tree to assist another to climb up. Such naturalistic touches are given an intense vitality, but in comparison with Giotto's frescoes at Padua or with Pietro Lorenzetti's at Assisi the cycle is loosely organized as a narrative or dramatic sequence, although it is highly decorative in effect.

In his apse fresco at Pomposa Vitale seems deliberately to have reverted to an archaizing style, as though (like Cavallini before him) he had been entrusted with the task of renewing an earlier decoration. The unsurpassed splendour of the art of the Byzantine mosaicists, which could be seen by Emilian artists in many churches in the region, may in itself have contributed to a certain conservatism, such as we find, for instance, in the solemn, icon-like Madonnas of Barnaba da Modena, of which a signed panel of 1369 is representative (*Plate 173*). This sensitive minor master, who was active from 1362 to 1383, also shares with Vitale da Bologna a sympathetic appreciation of the Sienese, although his forms have a substance and a density of chiaroscuro that bring him into line with the general tendency in Emilian painting of the late Trecento towards an often prosy but sometimes charming naturalism of detail.

The leading exponent of this manner, Tomaso da Modena, was born about 1325 and died before 1379. Around 1360 he was commissioned to paint two *Madonnas* for the Emperor Charles IV's palace at Karlstein, outside Prague, and the resemblances between his style and that of Master Theodoric of Prague, the Emperor's court painter, indicates Tomaso's importance as a channel of Italian influence upon northern European art. Like other Emilian painters of the period, Tomaso da Modena was clearly drawn to the Sienese, and Simonesque and Lorenzettian features are to be found in his work, notably in the design of the Karlstein *Madonnas*, with their touching intimacy of feeling, and to some extent in a series of frescoes of the *Life of St Ursula* painted for the church of Santa Margherita at Treviso (now in the Museo Civico). The sadly damaged scene of the *Leave-taking of St Ursula* (*Plate 179*) contains delightful glimpses of contemporary life, and the whole subject is treated in an informal, secular spirit. The decorative splendour of these frescoes, which seem to belong to Tomaso's final period, has understandably suggested comparisons with High Renaissance painting in Venice, and, as Oertel has expressed it, 'the voluptuous female types are like a Trecento preparation for the figures of Palma Vecchio and Sebastiano del Piombo'.

No less remarkable are Tomaso's frescoes in the chapter-house of San Niccolò at Treviso, representing forty Dominicans distinguished by their piety or learning (*Plate 169*). This astonishing series, painted in 1352, again brings to mind the work of Renaissance artists, for they anticipate the Flemish-inspired fresco of *St Jerome* executed by Ghirlandaio for Ognissanti in Florence and other fifteenth- or sixteenth-century representations of scholars in their studies. Variety is given to the series by the different actions and postures of the figures —some of whom read studiously, while others meditate or sharpen their quill-pens,—and Tomaso's psychological approach to his subject-matter is that of a born portrait-painter.

It will be useful at this point to touch briefly upon an important aspect of the history of northern Italy in the fourteenth century—the rise in the Romagna and in Lombardy of the great *signori,* such as the Scaligeri in Verona, the Visconti in Milan and the Carrara in Padua, who ruled as virtual dictators and vied with each other for hegemony over the northern territories. Owing, indeed, to the ascendancy of the Scaligeri in the 1330s, and in particular to their occupation of Padua and their further claims to Bologna, the republics of Florence and Venice joined forces in a war against Verona, which was successfully concluded in the year 1339. One consequence of these events was that Venice, hitherto preoccupied with its eastern territories and trade, became less isolated from the rest of Italy, although to Petrarch the Venetian Republic still seemed a *mundus alter*—'a world apart'. There can be little doubt that the revival of painting in Venice, which can virtually be ascribed to the achievement of one artist of exceptional genius—Paolo Veneziano, or 'Maestro Paolo',—was stimulated by closer contacts with Florence and also with the humanistic culture of Padua.

Paolo Veneziano held the office of Painter to the Venetian Republic, which employed him on several major commissions, including the painting of the famous *Pala d'Oro* in St Mark's, in collaboration with his sons Giovannino and Luca. Whether he was also responsible for the direction of the work of executing the mosaics in the Baptistery is less certain. Paolo's known career extends from the 1330s to 1358, the date inscribed on the *Coronation of the Virgin* in the Frick Collection in New York, in the painting of which he was assisted by Giovannino. Another member of the family, Marco, is mentioned in a contemporary document as Paolo's brother, but the attempt that has been made to identify him with the author of the somewhat archaic *Coronation* in Washington (dated 1324) is merely speculative. The first secure date relating to Paolo Veneziano is 1333; for it was in that year that he signed a panel of the *Dormition of the Virgin* at Vicenza. (Another work ascribed to Paolo—the painted cover for the tomb of St Leo Bembo, formerly at San Sebastiano in Venice but now in the parish church at Vodnjan—once bore a suspect date, 1321, which probably refers not to the year of its execution but to some religious event, such as the erection of the chapel in which the panel stood, or of the altar associated with it.) Other works datable by inscriptions include the great *Madonna* in the Crespi Collection, Milan (*Plate 176*), painted in 1340, the cover panels for the *Pala d'Oro* (*Plate 177*), completed in 1345, and the particularly splendid *Madonna* of 1347 at Carpineta a Cesena.

Paolo Veneziano's awareness of the art of Giotto is apparent already in the polyptych of the *Dormition of the Virgin* in the Vicenza Museum: nevertheless, the painter's debt to his Byzantine heritage is at this stage much more apparent; and it is only with the Crespi *Madonna* of seven years later that he reveals a true understanding of the implications of Giotto's discoveries, which is shown by his firmer modelling of the figure throughout—not least in the delightful, white-robed angels who kneel on either side of the Virgin (suggesting

comparisons with Giotto's *Ognissanti Madonna*) and in the more realistic treatment of light. Yet, like Simone Martini, Paolo Veneziano refused to follow Giotto all the way; and his art is more comparable with that of the Sienese master in its delight in colour, in gorgeous effects of pattern, and in the enchantments of sinuous linear rhythms. And where—as in the crucifix at San Samuele in Venice—we may detect a direct indebtedness to a Giottesque prototype (in this case the Tempio Malatestiano crucifix at Rimini) the Venetian master preserves intact his own delicate vision, upholding an aesthetic ideal that has much in common with the art of the miniaturist. He was not a supreme innovator, and in consequence no master of the fourteenth century is more in danger of being underestimated by the proponents of a historical method which implicitly assumes that revolutionary developments necessarily produce works of art superior to those of a more conservative stamp.

In October 1339, shortly before his death, the Doge of Venice, Francesco Dandolo, one of the most enlightened rulers in the history of fourteenth-century Italy, made a will in which he asked to be buried in a dignified, but not ostentatious, tomb in the Frari Church (the Franciscan church of Venice). The monument, as originally set up in the chapter-house, enclosed a painting by Paolo Veneziano of the *Madonna and Child*, within a simple lunette flanked in the spandrels by angels. The Doge and his wife are shown with their patron saints, St Francis of Assisi and St Elizabeth of Hungary, who present them to the Virgin and the Christ Child (*Plate 174*). The base of the tomb shows a relief of the *Dormition of the Virgin*, once brightly polychromed, which has been ascribed, hypothetically, to the workshop of Marco and Paolo Veneziano (although the style seems hard to reconcile with this proposition): certainly it is possible that one or both of these masters were responsible for the design of the entire monument. The votive picture in the lunette is redolent of the qualities that give Paolo Veneziano a supreme place among the Venetian painters of the Trecento. The rich orchestrations of colour have a warmth and splendour that distinguish them from the more delicate harmonies of the Sienese masters: indeed, it is scarcely fanciful to regard Paolo's palette as prophetic of the colouristic values which we associate with Venetian painting of the Renaissance. At the same time there is a strongly Byzantine flavour about the design, with its flat gold background, against which the outer figures, together with those of the angels who hold up a cloth of gold behind the Virgin's throne, are disposed in strict symmetry—St Francis and St Elizabeth enclosing the whole by their stooping postures, which are aligned with the curve of the lunette. The symmetry is broken at the centre, where the Virgin turns in a rhythmic movement towards Elisabetta Dandolo, while the Christ Child faces the other way as he gives the Doge his blessing. The Doge himself, attired in his scarlet robes of state, his head erect, is finely characterized. The drawing of his sensitive profile comes as something of a surprise; for elsewhere in Paolo's art—even in the lively narratives on the cover for the *Pala d'Oro*—there is only rarely a hint of this modernity of approach to the rendering of an individual personality.

The paintings for the *Pala d'Oro* were executed during the dogate of Andrea Dandolo (a kinsman of Francesco), who was noted for his learning and for his promotion of humanistic studies. The painted cover had the function of protecting the gold and enamel altarpiece (the *Pala d'Oro*), which is still kept on the High Altar of St Mark's. The panels, which have been removed to the museum of the basilica, comprise, beneath figures of Christ and the Virgin and five saints, a sequence of narratives of the story of St Mark, the patron saint of the republic, whose body, according to legend, was carried by sea to Venice (*Plate 177*)—an incident that furnished Paolo Veneziano with the material for one of his most delightful flights of poetic fantasy and, if Muraro is right, for a learned allusion to classical antiquity. As Muraro has written of this panel, 'The scene of the boat in the storm, which more than any of the others tends to resolve the problem of integrating the figures into their surroundings, acquires a particular significance in that it seems to provide a foretaste of the glorious history of Venetian landscape painting yet to come. The painting offers, among other things, interesting evidence of Maestro Paolo's culture.' Muraro draws attention to Theocritus's reference, in his *Hylas*, to the rocky isles of the Symplegades and their danger to the Argonauts on their voyage towards the Pontus Euxinus. According to Theocritus, the seafarers were saved from shipwreck by the intervention of the gods. Muraro adds: 'Maestro Paolo and his patrons, friends of Petrarch and imbued with humanistic culture, evidently knew the legend well, and here we see it adapted to the episode of St Mark.'

Surprising though it may appear, Paolo Veneziano's greatness has only in recent years received proper recognition; and Lorenzo Veneziano—a painter of the following generation —was usually considered the more important master. Lorenzo, however, can now be seen as an artist of similar ideals who owed much to the older master's example. Like Paolo he was a splendid colourist and an engaging storyteller. Elements deriving from Byzantine mosaics survive in his work, but the character of his art becomes increasingly Gothic. The development represented by the passage from his *Mystical Marriage of St Catherine* of 1359, in the Accademia in Venice, to his last known painting, the *Virgin and Child with a Rose* of 1372, in the Louvre (*Plate 175*), demonstrates his concern to apply his developing understanding of plastic form and his increasing interest in spatial representation to the tradition established in Venice by Maestro Paolo and his School.

Yet it was not Venice but nearby Padua that was to become the focus for the most exciting explorations in late Trecento painting in northern Italy. And it was a Paduan, Guariento di Arpo, who was summoned to Venice, in October 1365, to execute for Doge Marco Cornaro the most important decoration commissioned for the republic in this period—the large and sadly ruined fresco of the *Coronation of the Virgin* in the Palazzo Ducale. This work belongs to Guariento's final period, and shows a classic restraint which contrasts with the more Gothic qualities of his earlier style, such as are found, for example, in the now detached panels representing the *Regina coeli* and the ranks of the heavenly hosts which once adorned the Cappella

10

Carrarese in Padua. Between these panels and the fresco at Venice we may place, in all probability, the decorations in the choir of the Eremitani church at Padua representing scenes from the lives of St Philip, St James and St Augustine, together with a *Last Judgment* (now destroyed) and, below the narratives, the famous allegories of the *Four Ages of Man* (painted in grisaille). Iconographically this latter sequence has considerable interest. In accordance with the tenets of medieval astrology, each stage in life is associated with a personification of one of the planets, placed between a male and a female figure typifying one of the 'four ages of man': thus Infancy is represented by the Moon, Youth by Venus, Middle Life (*Virilità*) by Mars, and Old Age by the melancholy Saturn.

The narrative scenes reveal the beginnings of a new attempt to solve perspectival problems, which is also detectable in a series of panels devoted to the *Life of St Sebastian* in the Biblioteca Capitolare in Padua. These pictures, one of which bears the date 1367, are the work of the contemporary Paduan master Niccolò Semitecolo; and both Guariento and Semitecolo can be regarded as precursors of the great Altichiero, whose mastery of such problems is epitomized by his superb handling of often complex architectural structures. Guariento's fresco of the *Vision of St Augustine* (*Plate 178*) in the Eremitani shows how successfully he was able to render an interior in deep recession and to place his figures convincingly within it, both in terms of space and in terms of scale. That such explorations are to be directly connected with a general revival of the Giottesque tradition is confirmed by Guariento's plastic modelling of his figures: indeed his close study of the art of Giotto is demonstrated by his signed crucifix at Bassano, which shows a complete grasp of Giotto's intentions in his own crucifix for the Arena Chapel.

These developments must have been encouraged by the arrival in Padua around the year 1370 of the Florentine painter Giusto de' Menabuoi, whose masterpiece is the extensive series of fresco decorations of about a decade later, which cover the interior of the Baptistery of Padua Cathedral (*Plate 182*). In the *Last Supper* the manner in which the table thrusts into the recesses of the room sets one thinking ahead to the dramatic manipulations of space that are so typical of the overwhelming expressiveness of Tintoretto. Yet in one respect the Baptistery frescoes are peculiarly conservative, even archaizing. We have only to look up at the circular vault (*Plate 183*), at whose eye a gigantic half-length figure of Christ raises his hand in blessing, amidst concentric rows of angels and saints, to recognize the origin of the scheme in Byzantine mosaic decorations; and even the Virgin, who is given special prominence below the Christ, raises her hands in the traditional gesture of a Byzantine *Maria-orans*.

Giusto's concern with illusionism and relief elsewhere in these impressive decorations is matched by a genuine dramatic sense, the force of which is only weakened by his delight in crowding his compositions with figures. But if this is a failing it can nevertheless produce effects that startle by their novelty, such as the phalanx of haloed disciples in the *Kiss of*

Judas, which recedes through the throng of soldiers—a veritable army—and suggests a solidarity of purpose that goes beyond any literal rendering of the Gospel narrative.

Giusto would have been engaged on this enormous decoration at about the same time that the Veronese painter Altichiero was working in the Santo. In 1379 Altichiero was paid for his work in the Cappella di San Giacomo—now Cappella di San Felice—in the basilica. This consisted chiefly of a large *Crucifixion* on the end wall and a *Life of St James*, of which the early scenes show signs of the workmanship of an assistant. This assistant may or may not be identifiable with the mysterious Avanzo, whose name has for a long time been associated with that of Altichiero but whose role in the history of Paduan painting has been exaggerated by optimistic attributions.

Owing to the division of the wall into three columniated bays, the *Crucifixion* in the Cappella di San Felice had virtually to take the form of a triptych. But Altichiero triumphed over the difficulty both by creating a unified space across the three bays and by allowing the principal incidents depicted in the side frescoes—the lament of the Holy Women on the left, and the soldiers dicing for Christ's garments on the right—to assume a new importance as dramatic subjects in their own right, as well as contributing to the tragic theme of the central composition. In the scene on the right (*Plate 180*), a horseman pauses to watch the soldiers' heedless game, while some bystanders look on and converse among themselves. It is all so human, and in the humanity lies the art; for these peripheral witnesses to events of whose significance they have no true understanding become the representatives of all heedless men. Meanwhile, the preoccupied soldiers seem to be unaware even of the sepulchre which awaits Christ's deposition from the Cross, and which recalls to us his ultimate triumph through his resurrection from the dead. In the Cappella di San Felice Altichiero proves himself to be an artist superior both to Guariento and to Giusto de' Menabuoi. His command of drawing is astonishing, and his figures anticipate Masaccio's.

Altichiero's later decorations in the Oratory of St George, which he completed in 1384, are still more remarkable. They show in a marked degree the influence of the frescoes in the Arena Chapel, where Altichiero must have made a searching study of Giotto's powerful treatment of form. Corroboration of a general renewal of interest in Giotto, about half a century after his death, seems to be supplied by a letter written in 1396 by the Paduan humanist Pier Paolo Vergerio, who in criticizing Seneca's view that literary style should be modelled on the best qualities of several authors, and arguing instead that Cicero alone is the ideal to be followed, adds that the writer 'should do what the painters of our own age do, who though they may look with attention at famous paintings by other artists, yet follow the models of Giotto alone'. The force of this reference to Giotto is weakened if it is no more than a conventional allusion, in the humanist tradition, to the most celebrated painter associated with the revival of the arts in Italy; but it is still striking that Vergerio's statement precisely matches our stylistic deductions, most notably in the case of Altichiero.

The frescoes in the Oratory of St George include a *Coronation of the Virgin* and a *Crucifixion* on the altar wall; an *Annunciation* and four scenes of the *Infancy of Christ* on the entrance wall; and on the side walls scenes from the legends of St George, St Lucy and St Catherine. The *Death of St Lucy* (Plate *181*) is perhaps the masterpiece of the whole series, and the loss of a large portion of the *intonaco* in the upper right corner hardly affects our appreciation of the firm structure and ordered harmony of the design. The imposing church may be compared with the building in Guariento's *Vision of St Augustine*: the development that has taken place in the interval brings us closer still to the world of Masaccio. Indeed it might even be argued that Altichiero was in advance of Masaccio in his mastery of the problem of giving his representations of buildings a convincing scale in relation to his figures.

Berenson, in a famous passage, wrote of Masaccio: 'Giotto born again, starting where death had cut short his advance, instantly making his own all that had been gained during his absence, and profiting by the new conditions, the new demands—imagine such an avatar, and you will understand Masaccio.' The Florentine Renaissance did undoubtedly revive and continue the process that had been begun by Giotto (or should we not rather say, by Cavallini, Giotto and the Isaac Master?). Yet it is evident that the matter is more complex than such a statement implies; for on the one hand some of the main characteristics of Renaissance painting were already manifesting themselves in the closing years of the fourteenth century in the work of such artists as Altichiero, Spinello and Starnina, while on the other hand the origins of the International Style, which we recognize as so fundamental to the aesthetic preoccupations of Uccello, Fra Angelico, Benozzo Gozzoli and other Renaissance masters, are to be sought ultimately not in the Giottesque revolution but in the Sienese School of the early Trecento, and especially in the art of Simone Martini.

Once that has been said, it cannot be emphasized too strongly that no chapter of art history shows us more clearly than that treated in this book the futility of that 'proleptic historicism' which in dwelling too exclusively on 'influences' and 'progressiveness' seeks to justify the achievements of a particular master or school by its impact upon succeeding generations. The first painter to be discussed in Vasari's *Lives* was Cimabue: now the fact that Cimabue's influence was by no means as extensive as that of Cavallini or Giotto is ultimately irrelevant to a true appreciation of his genius. Vasari himself, by his theory of progressive development from Cimabue to Michelangelo, helped to promote the idea that the early Italian masters were mere 'primitives' who crudely anticipated the greater achievements of Renaissance art. Prejudice is destructive of the human spirit, and its cold hand can reach out with its malign touch to the glories of past ages. Let us consider: if the taste of the seventeenth and eighteenth centuries had not given further support to Vasari's view of the artists of the Dugento and Trecento as the unsophisticated pioneers of greater developments to come, countless works of the period that are now lost to us would have been preserved with all the reverence due to them, revealing splendours at which we can now only guess.

SELECT BIBLIOGRAPHY

I GENERAL

F. Antal, *Florentine Painting and its Social Background*, London, 1948.

B. Berenson, *Italian Painters of the Renaissance*, London, 1968.

F. Bologna, *La pittura italiana delle origini*, Dresden and Rome, 1962.

F. Bologna, *I Pittori alla corte angioina di Napoli, 1266–1414*, Rome, 1969.

E. Borsook, *The Mural Painters of Tuscany*, London, 1960.

M. Boskovits, *Pittura fiorentina alla vigilia del Rinascimento, 1370–1400*, Florence, 1975.

E. Carli, *Italian Primitives: Panel Painting of the Twelfth and Thirteenth Centuries*, New York, n.d.

E. Carli, *Pittura pisana del Trecento*, 2 vols., Milan, 1961.

E. Cecchi, *The Sienese Painters of the Trecento*, trans. L. Penlock, London, 1931.

B. Cole, *Giotto and Florentine Painting, 1280–1375*, New York, 1976.

L. Coletti, *I Primitivi*, 3 vols., Novara, 1941–7.

J. A. Crowe and G. B. Cavalcaselle, *A History of Painting in Italy*, 2nd ed., ed. L. Douglas, 6 vols., London, 1903–14.

E. T. DeWald, *Italian Painting, 1200–1600*, New York, 1961.

E. B. Garrison, *Italian Romanesque Panel Painting: An Illustrated Index*, Florence, 1949.

F. Hartt, *A History of Italian Renaissance Art*, London, 1970.

M. Meiss, *Painting in Florence and Siena after the Black Death: The Arts, Religion and Society in the Mid-Fourteenth Century*, Princeton, 1951; New York, 1964.

M. Meiss, *The Great Age of Fresco: Discoveries, Recoveries and Survivals*, London, 1970.

O. Morisani, *Pittura del Trecento in Napoli*, Naples, 1947.

W. Oakeshott, *The Mosaics of Rome*, Greenwich, 1967.

R. Oertel, *Early Italian Painting to 1400*, London, 1968.

R. Offner, *A Critical and Historical Corpus of Florentine Painting*, Berlin and New York, 1930—.

R. Offner, *Studies in Florentine Painting*, New York, 1927; introduction by B. Cole, New York, 1972.

E. Panofsky, *Renaissance and Renascences in Western Art*, Stockholm, 1960.

G. Previtali, *La fortuna dei primitivi*, Turin, 1964.

C. L. Ragghianti, *Pittura del Dugento a Firenze*, Florence, 1955.

E. Sandberg-Vavalà, *Uffizi Studies: The Development of the Florentine School of Painting*, Florence, 1948.

E. Sandberg-Vavalà, *Sienese Studies: The Development of the School of Painting of Siena*, Florence, 1953.

E. Sandberg-Vavalà, *La croce dipinta italiana e l'iconografia della Passione*, Verona, 1929.

G. Sinibaldi and G. Brunetti, *Pittura italiana del duecento e trecento: Catalogo della Mostra Giottesca di Firenze del 1937*, Florence, 1943.

P. Toesca, *Florentine Painting of the Trecento*, Florence and Paris, 1929.

P. Toesca, *Storia dell'arte italiana, I: Il Medioevo*, Turin, 1927.

P. Toesca, *Storia dell'arte italiana, II: Il Trecento*, Turin, 1951.

R. Van Marle, *The Development of the Italian Schools of Painting*, The Hague, 1923–38.

A. Venturi, *Storia dell'arte italiana*, 18 vols., Milan, 1901–40.

C. Volpe, *La Pittura riminese del Trecento*, Milan, 1965.

J. White, *The Birth and Rebirth of Pictorial Space*, London, 1957; 2nd ed., 1967.

J. White, *Art and Architecture in Italy, 1250 to 1400*, Harmondsworth, 1966.

The Great Age of Fresco: Giotto to

142

The Dawn of Italian Painting

Pontormo (exhibition catalogue), Metropolitan Museum of Art, New York, 1968; *Frescoes from Florence* (catalogue of the London showing of the exhibition), Arts Council of Great Britain, 1969.

II SOURCES
S. L. Alpers, '*Ekphrasis* and aesthetic attitudes in Vasari's *Lives*', *Journal of The Warburg and Courtauld Institutes*, XXIII, 1960, 190ff.

M. Baxandall, *Giotto and the Orators: Humanist observers of painting in Italy and the discovery of pictorial composition, 1350–1450*, Oxford, 1971.

Pseudo-Bonaventura, *Meditations on the Life of Christ: An Illustrated Manuscript of the Fourteenth Century*, ed. I. Ragusi and R. B. Green, Princeton, 1961.

Cennino Cennini, *The Craftsman's Handbook*, trans. D. V. Thompson, London, 1933.

Cennino Cennini, *Il libro dell'arte*, ed. D. V. Thompson, New Haven, 1932.

L. Ghiberti, *I Commentarii*, ed. J. von Schlosser, Berlin, 1912.

G. Kaftal, *Iconography of the Saints in Tuscan Painting*, Florence, 1952.

G. Kaftal, *Iconography of the Saints in the Central and South Italian Schools of Painting*, Florence, 1965.

P. Murray, *An Index of Attributions made in Tuscan Sources before Vasari*, Florence, 1959.

G. Vasari, *The Lives of the Painters, Sculptors and Architects*, trans. A. M. Hinds, London, 1927.

G. Vasari, *The Lives of the Most Eminent Painters, Sculptors and Architects*, trans. G. du D. De Vere, 10 vols., London, 1912–15.

G. Vasari, *Le Vite de' Più Eccellenti Pittori, Scultori et Architettori*, ed.

G. Milanesi, 9 vols., Florence, 1878–85.

The Golden Legend of Jacobus de Voragine, ed. G. Ryan and H. Ripperger, London and New York, 1941.

III TECHNIQUE
E. Borsook, *The Mural Painters of Tuscany*, London, 1960.

Cennino Cennini, *The Craftsman's Handbook*, trans. D. V. Thompson, London, 1933.

U. Procacci, *Sinopie e affreschi*, Milan, 1961.

D. V. Thompson, *The Materials of Medieval Painting*, London, 1956.

L. Tintori and M. Meiss, *The Painting of the Life of St Francis in Assisi, with Notes on the Arena Chapel*, New York, 1962; rev. ed., 1967.

IV INDIVIDUAL ARTISTS
(Anonymous masters appear at the end)

Altichiero
G. L. Mellini, *Altichiero e Jacopo Avanzi*, Milan, 1965.

R. Simon, 'Altichiero versus Avanzo', *Papers of the British School at Rome*, XLV, New Series, XXXII, 1977.

Antonio Veneziano
M. Boskovits, *Pittura fiorentina alla vigilia del Rinascimento, 1370–1400*, Florence, 1975.

R. Offner, *Studies in;Florentine Painting*, New York, 1927.

P. Sanpaolesi, Mario Bucci and Licia Bertolini, *Camposanto Monumentale di Pisa: Affreschi e Sinopie*, Pisa, 1960.

Barna da Siena
E. Borsook, *The Mural Painters of Tuscany*, London, 1960.

S. L. Faison, 'Barna and Bartolo di Fredi', *Art Bulletin*, XIV, 1932, 285ff.

Giovanni Baronzio
C. Volpe, *La pittura riminese del Trecento*, Milan 1965.

Bonaventura Berlinghieri
E. B. Garrison, 'Towards a new history of early Lucchese painting', *Art Bulletin*, XXXIII, 1951, 11ff.

Andrea Bonaiuti
E. Borsook, *The Mural Painters of Tuscany*, London, 1960.

M. Boskovits, *Pittura fiorentina alla vigilia del Rinascimento, 1370–1400*, Florence, 1975.

J. Wood Brown, *The Dominican Church of Santa Maria Novella*, Edinburgh, 1902.

Buffalmacco (Buonamico)
L. Bellosi, *Buffalmacco e il Trionfo della Morte*, Turin, 1974.

P. P. Donati, 'Proposta per Buffalmacco', *Commentari*, XVIII, 1967, 290ff.

R. Offner, *Corpus*, Section III, vol. I, 1931, 41ff.

Jacopo del Casentino
R. Offner, *Corpus*, Section III, vol. II, parts I and II, 1930.

Pietro Cavallini
J. Gardner, 'S. Paolo fuori le mura, Nicholas III and Pietro Cavallini', *Zeitschrift für Kunstgeschichte*, XXXIV, 1971, 240ff.

J. Gardner, 'Pope Nicholas IV and the decoration of Santa Maria Maggiore', *Zeitschrift für Kunstgeschichte*, XXXVI, 1973, 1ff.

P. Hetherington, 'The Mosaics of Pietro Cavallini in Santa Maria in Trastevere', *Journal of the Warburg and Courtauld Institutes*, XXXIII, 1970, 84ff.

G. Matthiae, *Pietro Cavallini*, Rome, 1972.

W. Paeseler, 'Cavallini e Giotto: Aspetti cronologici', in *Giotto: e il suo tempo*, Rome, 1971, pp. 35ff.

E. Sindona, *Pietro Cavallini*, Milan, 1958.

J. White, 'Cavallini and the Lost Frescoes in S. Paolo', *Journal of the Warburg and Courtauld Institutes*, XIX, 1956, 84ff.

Cimabue (Cenni di Pepi)
E. Battisti, *Cimabue*, London, 1967.
A. Nicholson, *Cimabue*, Princeton, 1932.
J. H. Stubblebine, 'Cimabue and Duccio in Santa Maria Novella', *Pantheon*, XXXI, 1973, 15ff.
J. White, *Art and Architecture in Italy, 1250 to 1400*, Harmondsworth, 1966.

Coppo di Marcovaldo
G. Coor, 'Coppo di Marcovaldo: his art in relation to the art of his times', *Marsyas*, V, 1949, 1ff.
G. Coor-Achenbach, 'A visual basis for the documents relating to Coppo di Marcovaldo and his son Salerno', *Art Bulletin*, XXVIII, 1946, 233ff.
C. L. Ragghianti, *Pittura del Dugento a Firenze*, Florence, 1955.

Bernardo Daddi
R. Offner, *Corpus*, Section III, vol. III, 1930; vol. VIII, 1958.

Deodato Orlandi
E. B. Garrison, *Italian Romanesque Panel Painting*, Florence, 1949.

Duccio
C. Brandi, *Duccio*, Florence, 1951.
G. Cattaneo and E. Baccheschi, *L'opera completa di Duccio*, Milan, 1972.
J. H. Stubblebine, 'Cimabue and Duccio in Santa Maria Novella', *Pantheon*, XXXI, 1973, 15ff.
C. Weigelt, *Duccio di Buoninsegna*, 2 vols., Leipzig, 1911.
J. White, 'Measurement, Design and Carpentry in Duccio's *Maestà*', I, *Art Bulletin*, LV, 1973, 334ff; II, *ibid.*, 547ff.
J. White, 'Carpentry and Design in Duccio's Workshop', *Journal*

of the Warburg and Courtauld Institutes, XXXVI, 1973, 92ff.

Agnolo Gaddi
M. Boskovits, *Pittura fiorentina alla vigilia del Rinascimento, 1370–1400*, Florence, 1975.
M. Boskovits, 'Some Early Works of Agnolo Gaddi', *Burlington Magazine*, CX, 1968, 208ff.
B. Cole, *Agnolo Gaddi*, Oxford, 1977.
R. Salvini, *L'arte di Agnolo Gaddi*, Florence, 1936.

Taddeo Gaddi
P. Donati, *Taddeo Gaddi*, Florence 1966.
J. Gardner, 'The Decoration of the Baroncelli Chapel in Santa Croce', *Zeitschrift für Kunstgeschichte*, XXXIV, 1971, 89ff.
M. Meiss, *Painting in Florence and Siena after the Black Death*, Princeton, 1951; New York, 1964.
G. Sinibaldi and G. Brunetti, *Pittura italiana del Duecento e Trecento*, Florence, 1943.
A. Smart, 'Taddeo Gaddi, Orcagna, and the Eclipses of 1333 and 1339', in *Studies in Late Medieval and Renaissance Painting in Honor of Millard Meiss*, ed. I. Lavin and J. Plummer, New York, 1977.

Giotto
M. Alpatoff, 'The Parallelism of Giotto's Paduan Frescoes', *Art Bulletin*, XXIX, 1947, 149ff; reprinted in J. H. Stubblebine, *Giotto: The Arena Chapel Frescoes*, London, 1969, pp. 156ff., and in L. Schneider (ed.), *Giotto in Perspective*, Englewood Cliffs, N.J., 1974, pp. 109ff.
C. Bellinati, 'La Cappella di Giotto all'Arena e le miniature dell' antifonario "Giottesco" della Cattedrale', in *Da Giotto a Mantegna* (exhibition catalogue), Milan, 1974.

A. Bertini, 'Per la conoscenza dei medaglioni che accompagnano le storie della vita di Gesù nella Cappella degli Scrovegni', in *Giotto e il suo tempo*, Rome, 1971, pp. 143ff.
L. Bongiorno, 'The Theme of the Old and the New Law in the Arena Chapel', *Art Bulletin*, XLX, 1968, 11ff.
E. Borsook and L. Tintori, *Giotto: The Peruzzi Chapel*, New York, 1965.
H. M. Davis, 'Gravity in the Paintings of Giotto', in *Giotto e il suo tempo*, Rome, 1971, pp. 367ff.
J. Gardner, 'The Stefaneschi altarpiece: a reconsideration', *Journal of the Warburg and Courtauld Institutes*, XXXVII, 1974, 57ff.
C. Gilbert, 'The Sequence of Execution in the Arena Chapel', in *Essays in Honor of Walter Friedlaender*, New York, 1965.
C. Gilbert, 'The Fresco by Giotto in Milan', *Arte Lombarda*, XLVII–XLVIII, 1977, 31ff.
D. Gioseffi, *Giotto architetto*, Milan, 1963.
Giotto e il suo tempo: Atti del Congresso Internazionale per la celebrazione del VII Centenario della nascita di Giotto, Rome, 1971.
C. Gnudi, *Giotto*, Milan, 1958.
C. Gnudi, 'Il passo di Riccobaldo relativo a Giotto e la problema della sua autenticità', in *Studies in the History of Art dedicated to William E. Suida*, London, 1959, pp. 26ff.
M. Gosebruch, *Giotto und die Entwicklung des neuzeitlichen Kunstbewusstseins*, Cologne, 1962.
G. Marchini, 'Gli affreschi perduti di Giotto in una cappella di S. Croce', *Rivista d'Arte*, XX, 1938, 215ff.
A. Martindale and E. Baccheschi, *The Complete Paintings of Giotto*, London, 1969.

M. Meiss, *Giotto and Assisi*, New York, 1960.

A. Moschetti, *La Cappella degli Scrovegni*, Florence, 1904.

P. Murray, 'Notes on Some Early Giotto Sources', *Journal of the Warburg and Courtauld Institutes*, XVI, 1953, 58ff.

R. Offner, 'Giotto, Non-Giotto', I, *Burlington Magazine*, LXXIV, 1939, 259ff.; II, *ibid.*, LXXV, 1939, 96ff.; reprinted in J. H. Stubblebine, *Giotto: The Arena Chapel Frescoes*, London, 1969, pp. 135ff., and in L. Schneider (ed.), *Giotto in Perspective*, Englewood Cliffs, N.J., 1974, 86ff.

G. Previtali, *Giotto e la sua bottega*, Milan, 1967.

U. Procacci, 'La tavola di Giotto sull'altar maggiore della chiesa della Badia fiorentina', in *Scritti di Storia dell'arte in onore di Mario Salmi*, II, Rome, 1962, 9ff.

F. Rintelen, *Giotto und die Giotto-Apokryphen*, Leipzig, 1912; 1923.

R. Salvini, *Giotto, bibliografia*, Rome, 1938; C. De Benedictis, *Giotto, bibliografia*, vol. II, Rome, 1973.

R. Salvini, *All the Paintings of Giotto*, 2 vols., New York, 1963.

U. Schlegel, 'Zum Bildprogramm der Arena-Kapelle', *Zeitschrift für Kunstgeschichte*, XX, 1957, 125ff.; reprinted in English translation, 'On the Picture Program of the Arena Chapel', in J. H. Stubblebine, *Giotto: The Arena Chapel Frescoes*, London, 1969, pp. 182ff.

L. Schneider (ed.), *Giotto in Perspective*, Englewood Cliffs, N.J., 1974.

P. Selvatico, *Sulla Cappellina degli Scrovegni nell'arena di Padova e sui freschi di Giotto in essa dipinti*, Padua, 1836.

D. C. Shorr, 'The Role of the Virgin in Giotto's *Last Judgment*', *Art Bulletin*, XXXVIII, 1956, 207ff.;

reprinted in J. H. Stubblebine, *Giotto: The Arena Chapel Frescoes*, London, 1969, pp. 169ff.

O. Sirén, *Giotto and Some of his Followers*, trans. F. Schenck, Cambridge, Mass., 1917.

A. Smart, *The Assisi Problem and the Art of Giotto: A Study of the Legend of St Francis in the Upper Church of San Francesco, Assisi*, Oxford, 1971.

J. H. Stubblebine, *Giotto: The Arena Chapel Frescoes*, London, 1969.

A. Telpaz, 'Some Antique Motifs in Trecento Art', *Art Bulletin*, XLVI, 1964, 372ff.

L. Tintori and M. Meiss, *The Painting of the Life of St Francis in Assisi with Notes on the Arena Chapel*, New York, 1962; rev. ed., 1967.

P. Toesca, *Giotto*, Turin, 1941.

J. White, 'Giotto's use of architecture in *The Expulsion of Joachim* and *The Entry into Jerusalem* at Padua', *Burlington Magazine*, CXV, 1973, 439ff.

Giovanni da Milano

M. Boskovits, *Giovanni da Milano*, Florence, 1966.

M. Gregori, *Giovanni da Milano alla Cappella Rinuccini*, Milan, 1965.

A. M. Marabotti, *Giovanni da Milano*, Florence, 1950.

Giovanni da Rimini

C. Volpe, *La pittura riminese del Trecento*, Milan, 1965.

Giovanni del Biondo

M. Boskovits, *Pittura fiorentina alla vigilia del Rinascimento, 1370–1400*, Florence, 1975.

R. Offner and K. Steinweg, *Corpus*, Section IV, vols. IV and V, 1967, 1969.

Giuliano da Rimini

P. Hendy, *The Isabella Stewart Gardner Museum: Catalogue of the*

Exhibited Paintings and Drawings, Boston, 1931, pp. 175ff.

M. Meiss, *Giotto and Assisi*, New York, 1960.

C. Volpe, *La pittura riminese del Trecento*, Milan, 1965.

J. White, 'The Date of "The Legend of St Francis" at Assisi', *Burlington Magazine*, XCVIII, 1956, 344ff.

Giusto de' Menabuoi

S. Bettini, *Giusto de' Menabuoi e l'arte del Trecento*, Padua, 1944.

S. Bettini, *Le pittura di Giusto de' Menabuoi nel Battistero del Duomo di Padova*, Venice, 1960.

Guariento

F. Flores d'Arcais, *Guariento*, Venice, 1965.

R. Pallucchini, *La Pittura veneziana del Trecento*, Venice, 1964.

Guido da Siena

R. Offner, 'Guido da Siena and A.D. 1221', *Gazette des Beaux-Arts*, XXXVII, 1950, 61ff.

J. H. Stubblebine, *Guido da Siena*, Princeton, 1965.

Ambrogio Lorenzetti

E. Borsook, *Ambrogio Lorenzetti*, Florence, 1966.

E. Borsook, *The Mural Painters of Tuscany*, London, 1960.

C. Brandi, 'Chiarimenti sul Buon Governo di Ambrogio Lorenzetti', *Bollettino d'arte*, XL, 1955, 119ff.

G. Rowley, *Ambrogio Lorenzetti*, Princeton, 1958.

N. Rubinstein, 'Political Ideas in Sienese Art: The Frescoes by Ambrogio Lorenzetti and Taddeo di Bartolo in the Palazzo Pubblico', *Journal of the Warburg and Courtauld Institutes*, XXI, 1958, 179ff.

G. Sinibaldi, *I Lorenzetti*, Siena, 1933.

The Great Age of Fresco: Giotto to Pontormo (exhibition catalogue),

Metropolitan Museum of Art, New York, 1968; *Frescoes from Florence* (exhibition catalogue for the London showing), Arts Council of Great Britain, London, 1969.

Pietro Lorenzetti

E. Cecchi, *Pietro Lorenzetti*, Milan, 1930.

E. T. DeWald, *Pietro Lorenzetti*, Cambridge, Mass., 1930.

H. B. Maginnis, 'Assisi Revisited: Notes on Recent Observations', *Burlington Magazine*, cxvii, 1975, 511ff.

H. B. Maginnis, 'The Passion Cycle in the Lower Church of San Francesco, Assisi: the technical evidence', *Zeitschrift für Kunstgeschichte*, xxxix, 1976, 193ff.

R. Simon, 'Towards a Relative Chronology of the Frescoes in the Lower Church of San Francesco at Assisi', *Burlington Magazine*, cxviii, 1976, 361ff.

G. Sinibaldi, *I Lorenzetti*, Florence, 1933.

Lorenzo Veneziano

R. Pallucchini, *La pittura veneziana del Trecento*, Venice, 1964.

Marino da Perugia

U. Gnoli, *Pittori e Miniatori nell' Umbria*, Spoleto, 1923.

A. Smart, *The Assisi Problem and the Art of Giotto*, Oxford, 1971.

Simone Martini

A. Blunt, 'Simone Martini at the Hôtel de Sully', *Burlington Magazine*, cvi, 1964, 129.

E. Borsook, *The Mural Painters of Tuscany*, London, 1960.

M. Boskovits, 'A Dismembered Polyptych: Lippo Vanni and Simone Martini', *Burlington Magazine*, cxvi, 1974, 367ff.

G. Contini and M. Gozzoli, *L'opera completa di Simone Martini*, Milan, 1970.

G. Paccagnini, *Simone Martini*, London, 1957.

J. Rowlands, 'The Date of Simone Martini's Arrival in Avignon', *Burlington Magazine*, cvii, 1965, 25f.

J. Rowlands, 'Simone Martini & Petrarch: A Virgilian Episode', *Apollo*, lxxxi, 1965, 264ff.

C. Volpe, *Simone Martini e la pittura senese*, Milan, 1965.

Maso di Banco

F. Bologna, *Novità su Giotto*, Turin, 1969.

E. Borsook, *The Mural Painters of Tuscany*, London, 1960.

M. Meiss, *The Great Age of Fresco: Discoveries, Recoveries and Survivals*, London, 1970.

P. Toesca, *Gli Affreschi della Cappella di S. Silvestro in S. Croce*, Florence, 1944.

Nardo di Cione

R. Offner, *Corpus*, Section IV, vol. II, 1960.

H. Gronau, *A. Orcagna und Nardo di Cione*, Berlin, 1937.

Orcagna (Andrea di Cione)

M. Boskovits, 'Orcagna in 1957 —and in Other Times', *Burlington Magazine*, cxiii, 1971, 239ff.

H. Gronau, *A. Orcagna und Nardo di Cione*, Berlin, 1937.

M. Meiss, *Painting in Florence and Siena after the Black Death*, Princeton, 1951; New York, 1964.

R. Offner, *Corpus*, Section IV, vol. I, 1962.

K. Steinweg, *A. Orcagna*, Strasburg, 1929.

Pacino di Bonaguida

R. Offner, *Corpus*, Section III, vol. II, 1930; and Section III, vol. VI, 1956.

A. Smart, *The Assisi Problem and the Art of Giotto*, Oxford, 1971.

Paolo Veneziano

M. Muraro, *Paolo da Venezia*, Philadelphia, 1970.

R. Pallucchini, *Pittura veneziana del Trecento*, Venice, 1964.

Pietro da Rimini

L. Coletti, *I Primitivi*, III (*I Padani*), Novara, 1947.

C. Volpe, *La pittura riminese del Trecento*, Milan, 1965.

Filippo Rusuti

J. Gardner, 'Pope Nicholas IV and the decoration of Santa Maria Maggiore', *Zeitschrift für Kunstgeschichte*, xxxvi, 1973, 1ff.

J. Wilpert, *Römische Mosaiken und Malerei*, 4 vols., Freiburg, 1916.

Spinello Aretino

M. Boskovits, *Pittura fiorentina alla vigilia del Rinascimento, 1370–1400*, Florence, 1975.

G. Gombosi, *Spinello Aretino*, Budapest, 1960.

P. Sanpaolesi, Mario Bucci and Licia Bertolini, *Camposanto Monumentale di Pisa: Affreschi e Sinopie*, Pisa, 1960.

Tomaso da Modena

L. Coletti, *Tommaso da Modena*, Bologna, 1933.

Iacopo Torriti

J. Gardner, 'Pope Nicholas IV and the decoration of Santa Maria Maggiore', *Zeitschrift für Kunstgeschichte*, xxxvi, 1973, 1ff.

Francesco Traini

L. Bellosi, *Buffalmacco e il Trionfo della Morte*, Turin, 1974.

M. Meiss, 'The Problem of Francesco Traini', *Art Bulletin*, xv, 1933, 97ff.

M. Meiss, *Painting in Florence and Siena after the Black Death*, Princeton, 1951; New York, 1964.

M. Meiss, 'Notable Disturbances in the Classification of Tuscan Trecento Paintings', *Burlington Magazine*, cxiii, 1971, 178ff.

J. Polzer, 'Aristotle, Mohammed and Nicholas V in Hell', *Art Bulletin*, xlvi, 1964, 457ff.

P. Sanpaolesi, Mario Bucci and Licia Bertolini, *Camposanto Monumentale di Pisa: Affreschi e Sinopie*, Pisa, 1960.

Vitale da Bologna
C. Gnudi, *Vitale da Bologna*, Bologna, 1962.

Bardi St Francis Master
C. L. Ragghianti, *Pittura del Duecento a Firenze*, Florence, 1955.

Giotto's School
(LOWER CHURCH, ASSISI)
C. Gnudi, *Giotto*, Milan, 1958.
M. Gosebruch, 'Gli Affreschi di Giotto nel braccio destro del transetto e nelle "Vele" centrali della Chiesa Inferiore di San Francesco', in *Giotto e i Giotteschi in Assisi*, intro. by G. Palumbo Rome, 1969.
B. Kleinschmidt, *Die Basilika San Francesco in Assisi*, Berlin, 1915–28.
H. B. J. Maginnis, 'Assisi Revisited: Notes on recent observations', *Burlington Magazine*, CXVII, 1975, 511ff.
V. Martinelli, 'Un documento per Giotto ad Assisi', *Storia dell' Arte*, 1973, 193ff.
M. Meiss, *Giotto and Assisi*, New York, 1960.
E. Pagliani, 'Note su restauri degli affreschi Giotteschi nella Chiesa Inferiore di San Francesco', in *Giotto e i Giotteschi in Assisi*, intro. by G. Palumbo, Rome, 1969.
G. Previtali, *Giotto e la sua bottega*, Milan, 1967.
G. Previtali, 'Le Cappelle di S. Nicola e di S. Maria Maddalena nella Chiesa Inferiore di San Francesco', in *Giotto e i Giotteschi*

in *Assisi*, intro. by G. Palumbo, Rome, 1969.
R. Simon, 'Towards a Relative Chronology of the Frescoes in the Lower Church of San Francesco at Assisi', *Burlington Magazine*, CXVIII, 1976, 361ff.

Isaac Master
C. Brandi, 'Sulla cronologia degli affreschi della Chiesa Superiore di Assisi', in *Giotto e il suo tempo*, Rome, 1971.
F. J. Mather, Jr., *The Isaac Master*, Princeton, 1932.
M. Meiss, *Giotto and Assisi*, New York, 1960.
A. Smart, *The Assisi Problem and the Art of Giotto*, Oxford, 1971.
A. Smart, 'Some Unpublished Copies of Frescoes at Assisi', *Apollo*, XCIX, 1974, 228ff.
I. Toesca, 'Una croce dipinta romana'. *Bollettino d'arte*, LI, 1966, 27ff.

Magdalen Master
C. L. Ragghianti, *Pittura del Dugento a Firenze*, Florence, 1955.
G. Sinibaldi and G. Brunetti, *Pittura italiana del duecento e trecento*, Florence, 1943.

Master of the Fogg Pietà
(Maestro di Figline)
(Giovanni di Bonino?)
Giuseppe Marchini, 'Il giottesco Giovanni di Bonino', in *Giotto e il suo tempo*, Rome, 1971, pp. 67ff.
R. Offner, *Corpus*, Section III, vol. VI, 1956.
C. Volpe, 'Ristudiando il maestro di Figline', *Paragone*, 277, 1973, 3ff.

Master of the Santa Maria Novella Cross
R. Offner, *Corpus*, Section III, vol. VI, 1956.

Master of the Camposanto 'Triumph of Death'
See under BUFFALMACCO and FRANCESCO TRAINI.

St Cecilia Master
C. De Benedictis, 'Nuove proposte per il Maestro della Santa Cecilia', *Antichità Viva*, XI, 4, 1972, 3ff.
R. Offner, *Corpus*, Section III, vol. I, 1931.
G. Sinibaldi and G. Brunetti, *Pittura italiana del duecento e trecento*, Florence, 1943.
A. Smart, *The Assisi Problem and the Art of Giotto*, Oxford, 1971.

St Francis Master
(UPPER CHURCH, ASSISI)
M. Meiss, *Giotto and Assisi*, New York, 1960.
R. Offner, 'Giotto, Non-Giotto', *Burlington Magazine*, LXXIV, 1939, 259ff.; LXXV, 1939, 86ff. Reprinted in J. H. Stubblebine, *Giotto: The Arena Chapel Frescoes*, London, 1969, and in L. Schneider (ed.), *Giotto in Perspective*, Englewood Cliffs, N.J. 1974.
A. Schmarsow, *Kompositionsgetesze der Franziskuslegende in der Oberkirche zu Assisi*, Leipzig, 1918.
A. Smart, *The Assisi Problem and the Art of Giotto*, Oxford, 1971.
L. Tintori and M. Meiss, *The Painting of the Life of St Francis in Assisi*, New York, 1962; rev. ed., 1967.
J. White, *Art and Architecture in Italy, 1250 to 1400*, Harmondsworth, 1966.
J. White, 'The Date of the "Legend of St Francis" at Assisi', *Burlington Magazine*, XCVIII, 1956, 344ff.
See also under GIOTTO.

INDEX

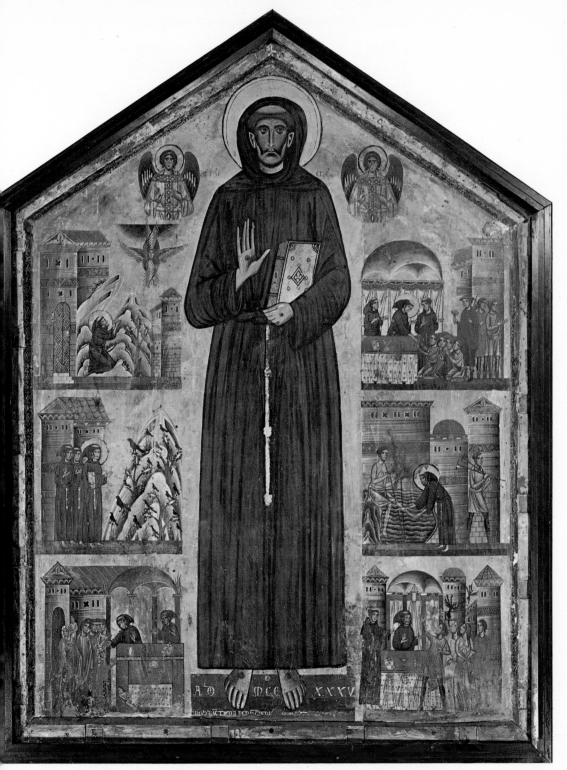

1. BONAVENTURA BERLINGHIERI: *St Francis Altarpiece*. 1235. Pescia, San Francesco

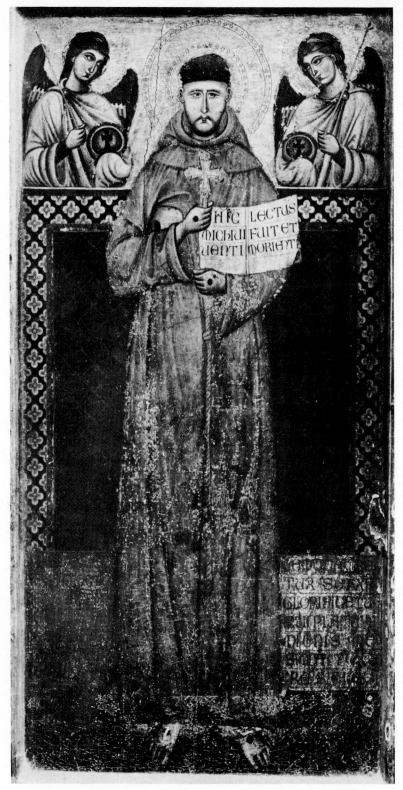

2. MASTER OF ST FRANCIS: *St Francis*. Assisi, Santa Maria degli Angeli

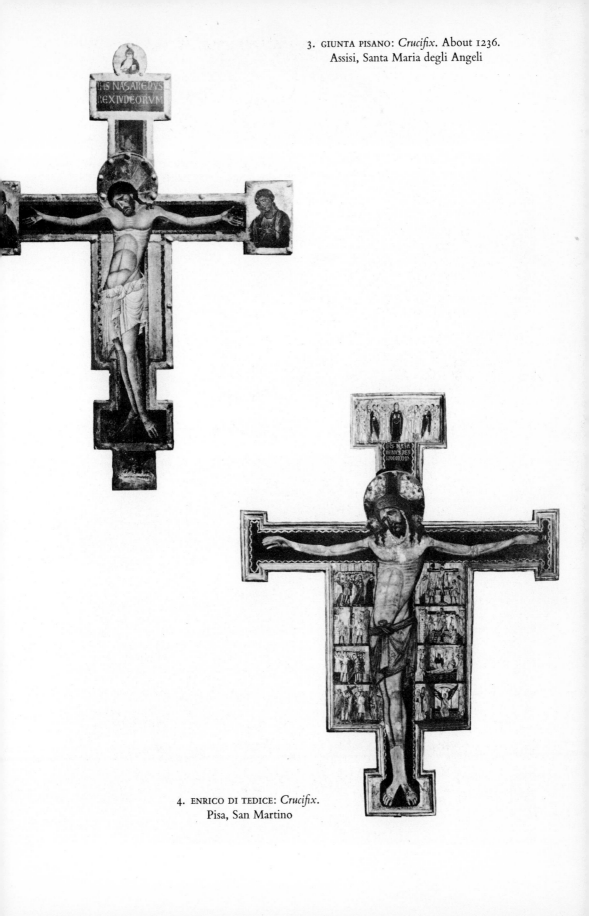

3. GIUNTA PISANO: *Crucifix*. About 1236.
Assisi, Santa Maria degli Angeli

4. ENRICO DI TEDICE: *Crucifix*.
Pisa, San Martino

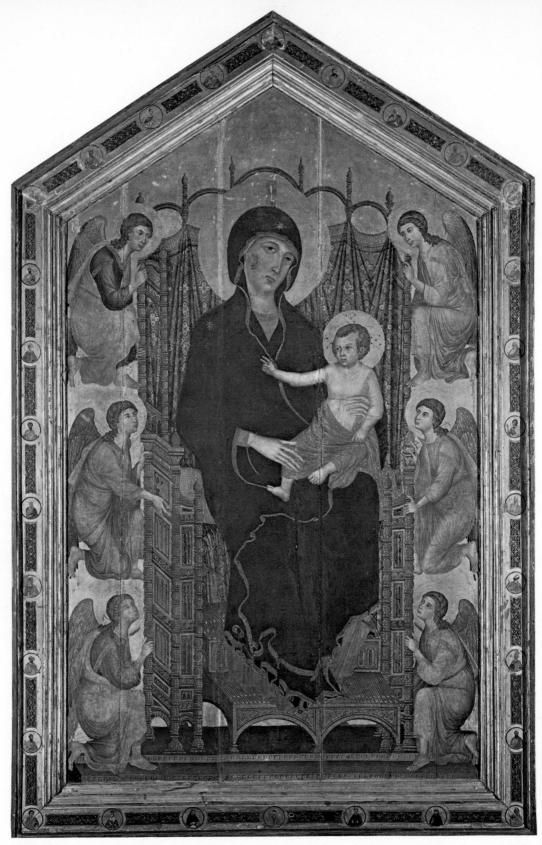

5. DUCCIO: *Rucellai Madonna*. Commissioned 1285. Florence, Uffizi

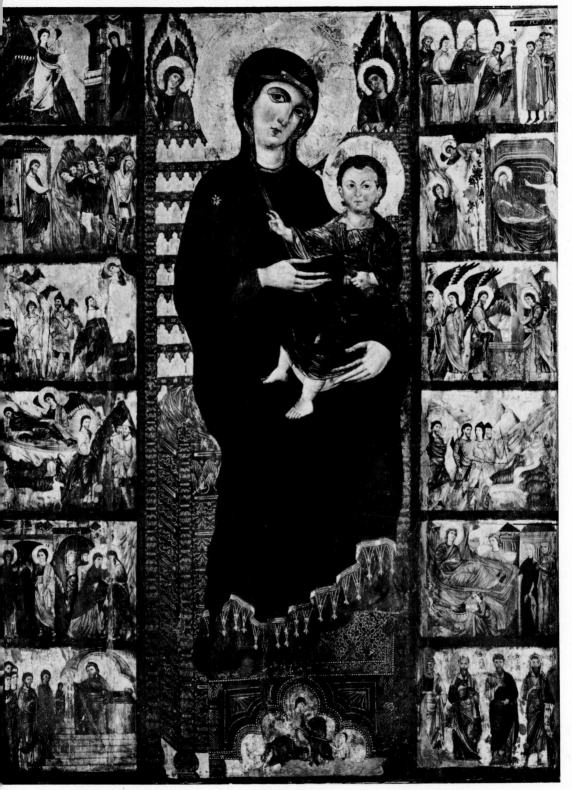

6. RANIERO DI UGOLINO (?): *Madonna and Child with Scenes from the Lives of the Virgin and her Parents.*
Pisa, Museo

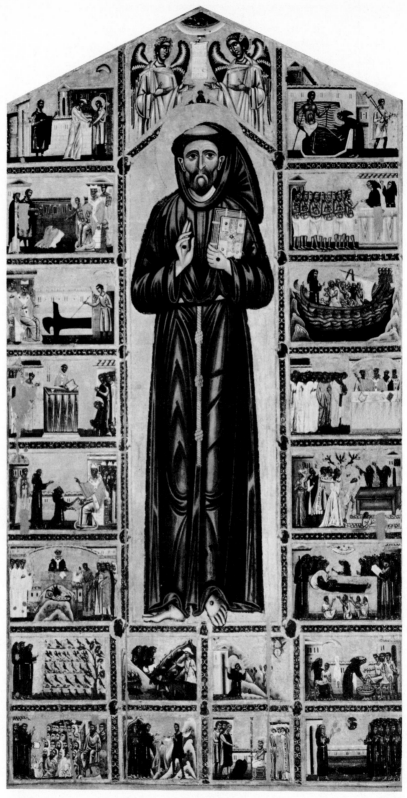

7. BARDI ST FRANCIS MASTER: *St Francis Altarpiece*. Florence, Santa Croce, Bardi Chapel

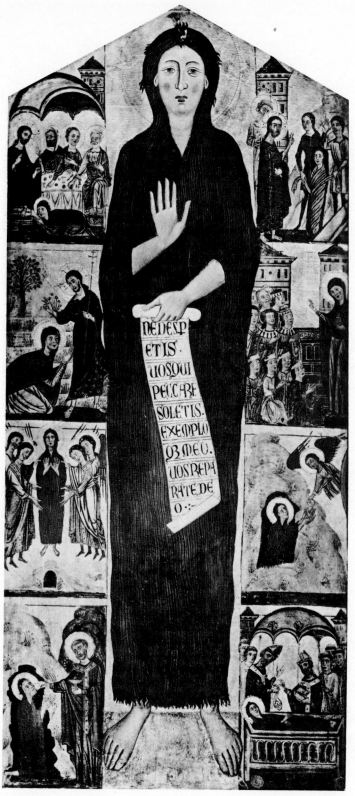

The scroll reads:

NE DESP
ETIS.
UOS QUI
PECCARE
SOLETIS.
EXEMPLO
OB MEO.
UOS REPA
RATE DE
O

8. MAGDALEN MASTER: *St Mary Magdalen and Scenes from her Life*. Florence, Accademia

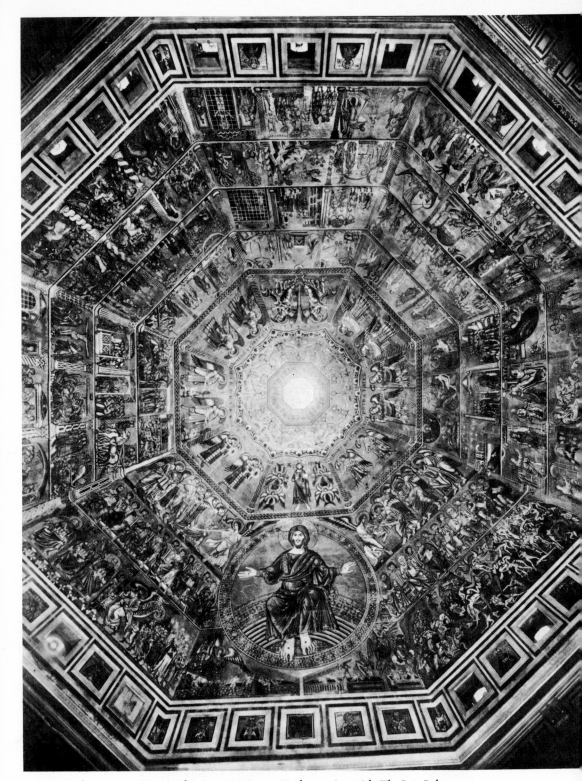

9. Florence, Baptistery. Vault mosaics, with *The Last Judgment*

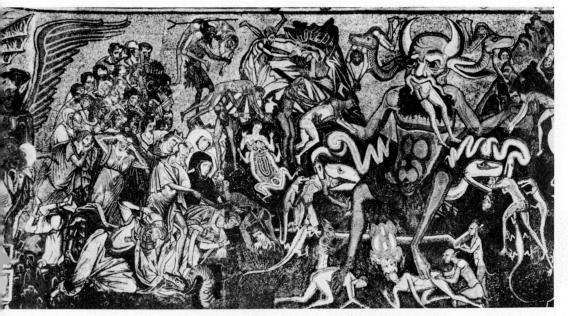

10. *The Damned.* Detail of *The Last Judgment* (Plate 9)

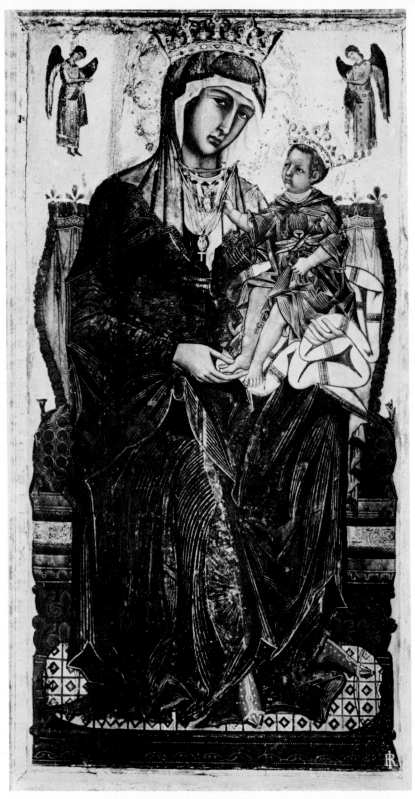

11. COPPO DI MARCOVALDO: *Madonna and Child Enthroned* ('*Madonna del Bordone*'). 1261.
Siena, Santa Maria dei Servi

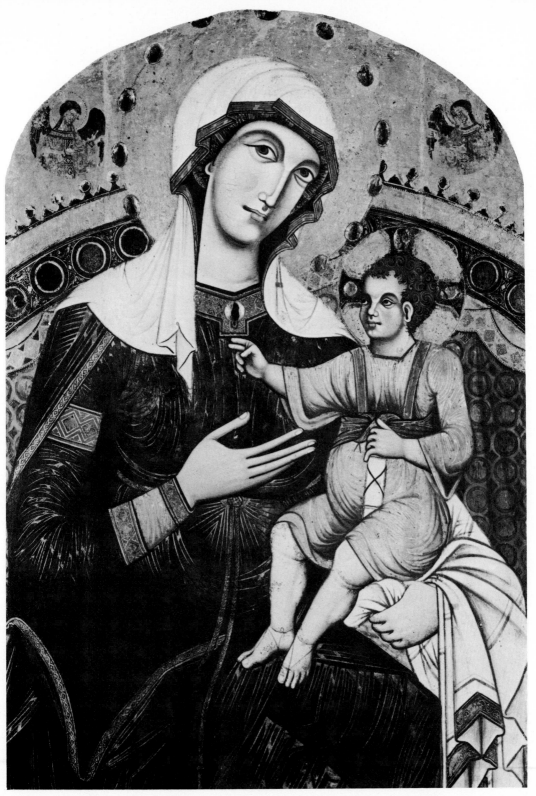

12. GUIDO DA SIENA: *Madonna and Child Enthroned* (cut down). 1262. Siena, Pinacoteca

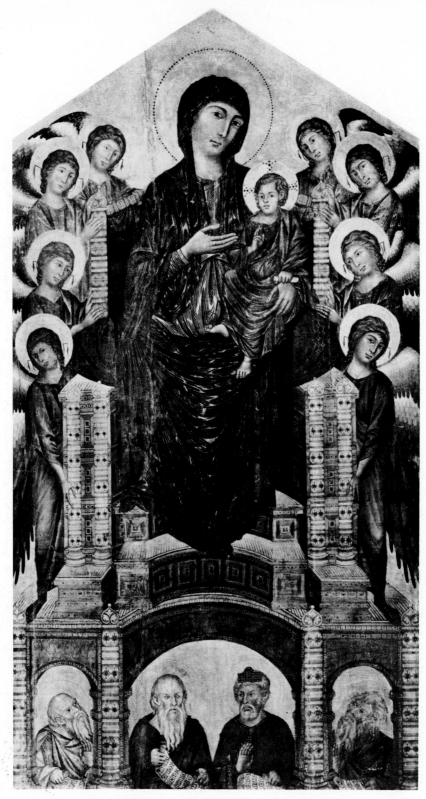

13. CIMABUE: *Santa Trinita Madonna*. Florence, Uffizi

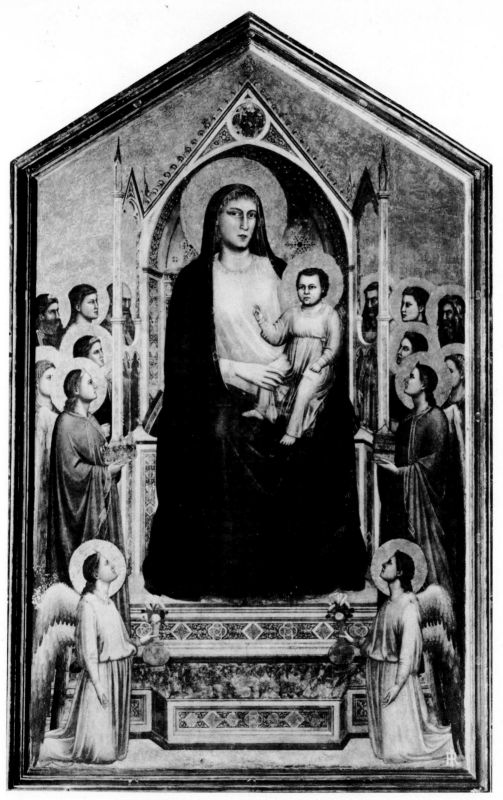

14. GIOTTO: *Ognissanti Madonna*. Florence, Uffizi

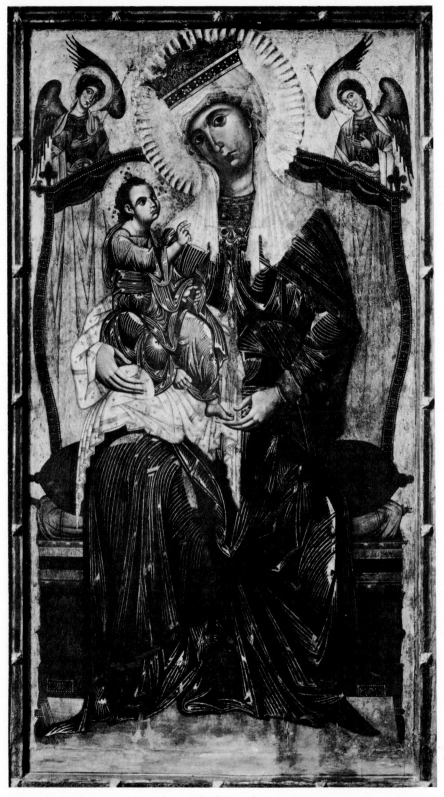

15. COPPO DI MARCOVALDO: *Madonna and Child Enthroned*. Orvieto, Santa Maria dei Servi

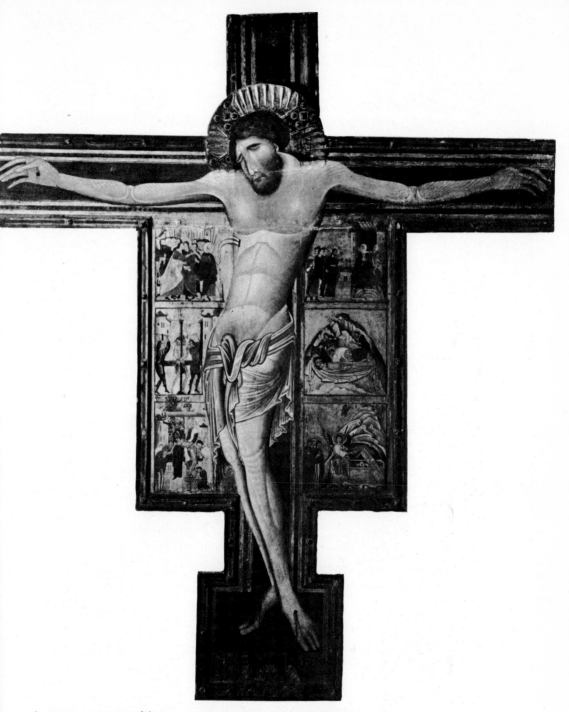

16. SALERNO DI COPPO (?) or COPPO DI MARCOVALDO AND SALERNO DI COPPO (?): *Crucifix*. 1274-5.
Pistoia, Cathedral

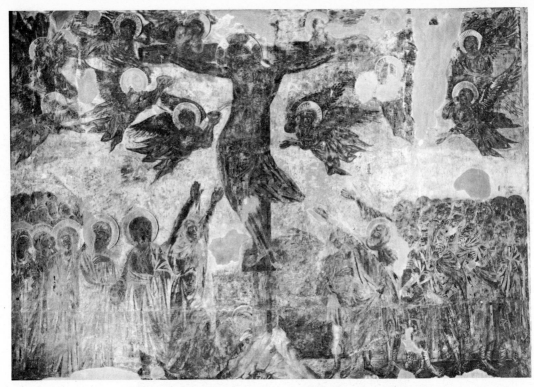

17. CIMABUE: *The Crucifixion*. Assisi, San Francesco, Upper Church

18. MASTER OF ST FRANCIS: *The Crucifixion*. Assisi, San Francesco, Lower Church

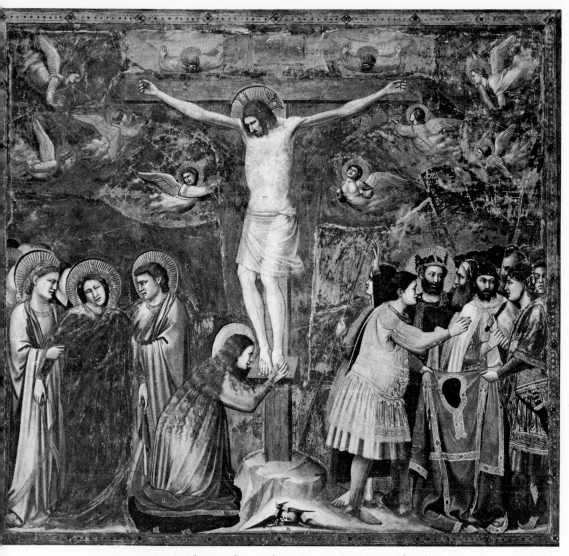

19. GIOTTO: *The Crucifixion*. About 1305. Padua, Arena Chapel

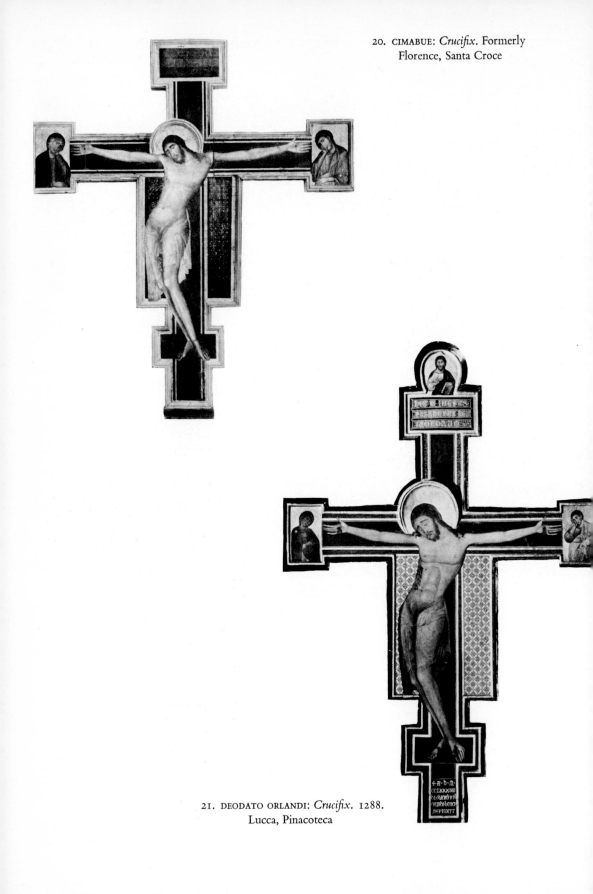

20. CIMABUE: *Crucifix*. Formerly
Florence, Santa Croce

21. DEODATO ORLANDI: *Crucifix*. 1288.
Lucca, Pinacoteca

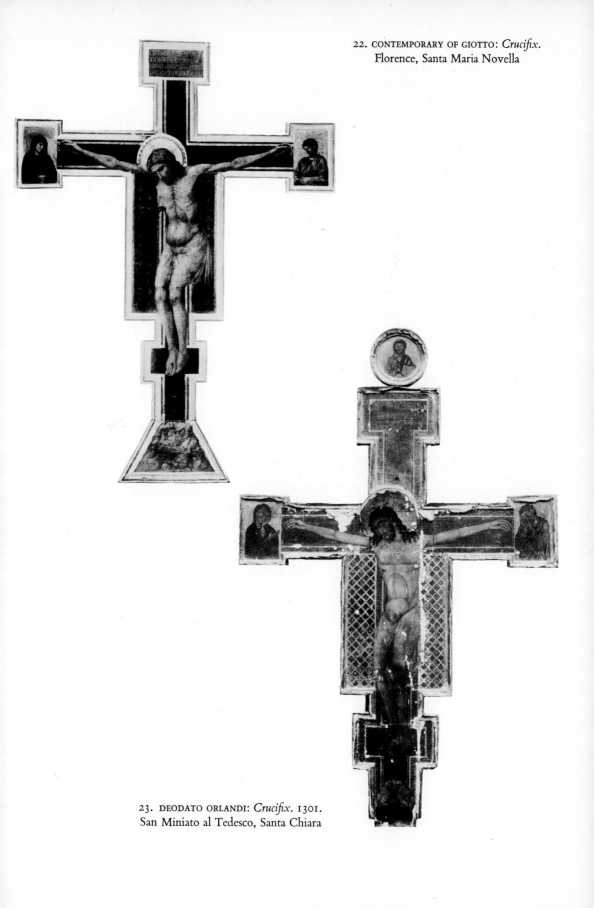

22. CONTEMPORARY OF GIOTTO: *Crucifix*.
Florence, Santa Maria Novella

23. DEODATO ORLANDI: *Crucifix*. 1301.
San Miniato al Tedesco, Santa Chiara

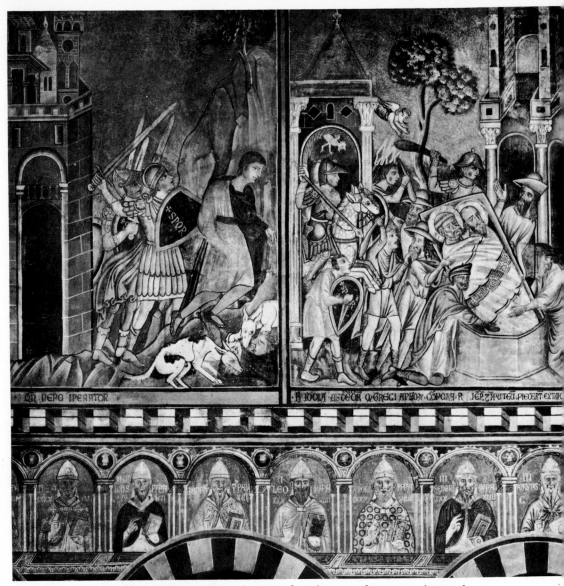

24. DEODATO ORLANDI (?): *Scenes from the Lives of St Peter and St Paul.*
Pisa, San Piero a Grado

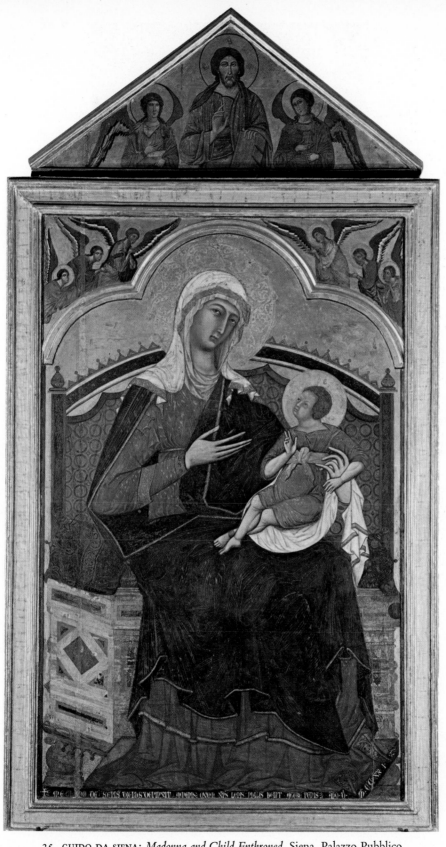

25. GUIDO DA SIENA: *Madonna and Child Enthroned*. Siena, Palazzo Pubblico

26. ARNOLFO DI CAMBIO: *Tabernacle*. 1285. Rome, San Paolo fuori le Mura

27. G. P. PANNINI: *The Visit of the Cardinal of York to San Paolo fuori le Mura*. 1741.
Formerly Collection of the Duke of Leeds

28. JACOPO TORRITI (?): *The Kiss of Judas*. Assisi, San Francesco, Upper Church

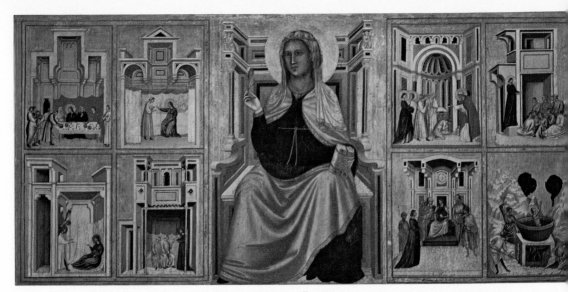

29. ST CECILIA MASTER: *Altarpiece of St Cecilia*. Not later than 1304. Florence, Uffizi

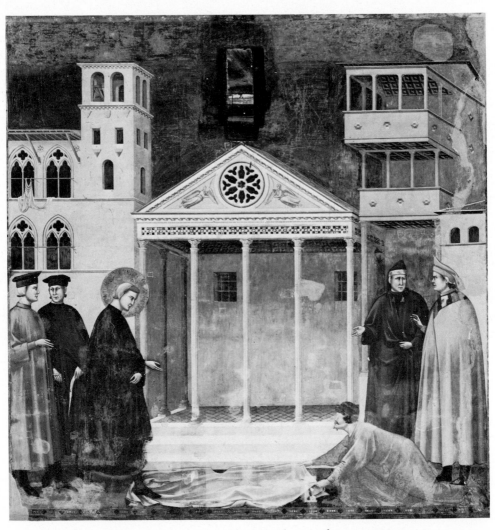

30. ST CECILIA MASTER: *St Francis honoured by a Simple Man of Assisi*. Assisi, San Francesco,
Upper Church

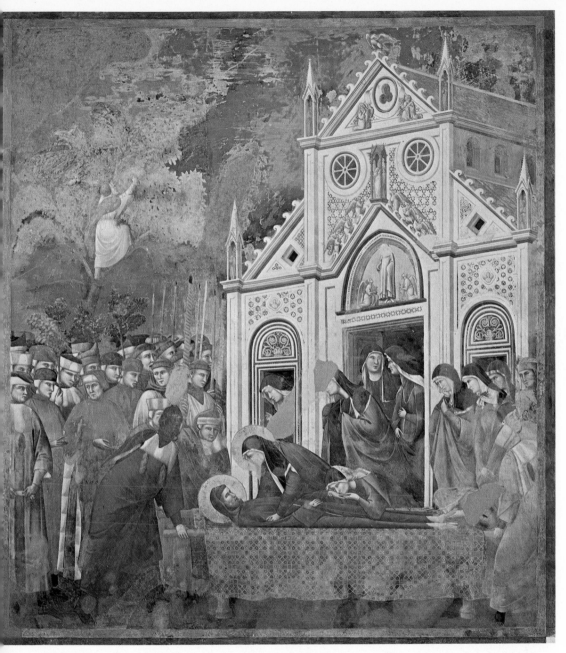

31. MASTER OF THE OBSEQUIES OF ST FRANCIS: *St Francis mourned by St Clare*. Assisi, San Francesco,
Upper Church

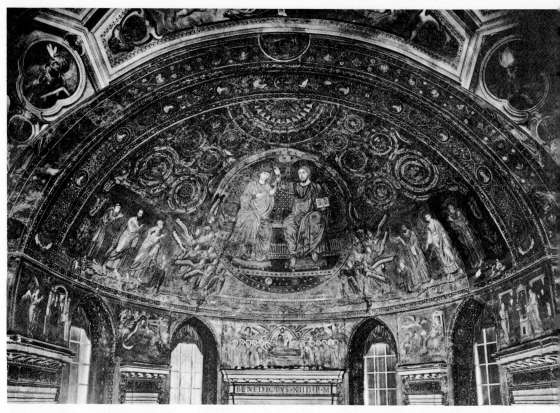

32. JACOPO TORRITI: *The Coronation of the Virgin and Scenes from her Life*. Rome, Santa Maria Maggiore

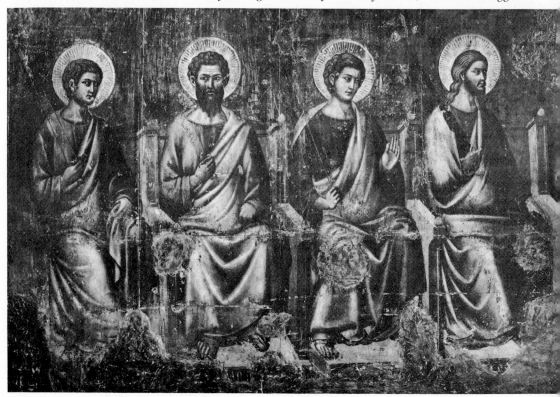

33. PIETRO CAVALLINI: *Apostles*. Detail of *The Last Judgment*. Rome, Santa Cecilia in Trastevere

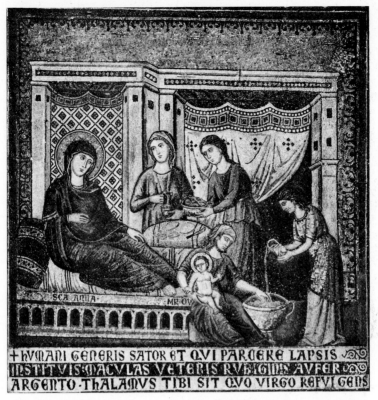

34. PIETRO CAVALLINI: *The Birth of the Virgin*.
Rome, Santa Maria in Trastevere

35. ISAAC MASTER: *The Rejection of Esau*.
Assisi, San Francesco, Upper Church

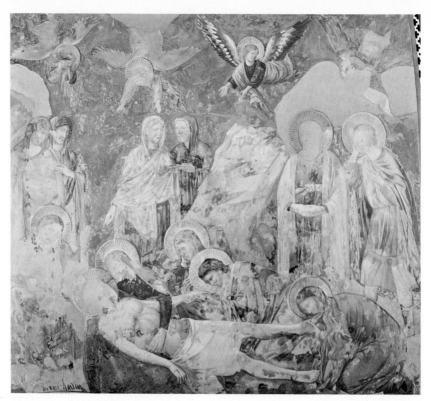

36. ISAAC MASTER: *Lamentation over the Dead Christ*. Assisi, San Francesco, Upper Church. Watercolour copy by Eduard Kaiser, 1876. On permanent loan to the University of Leeds

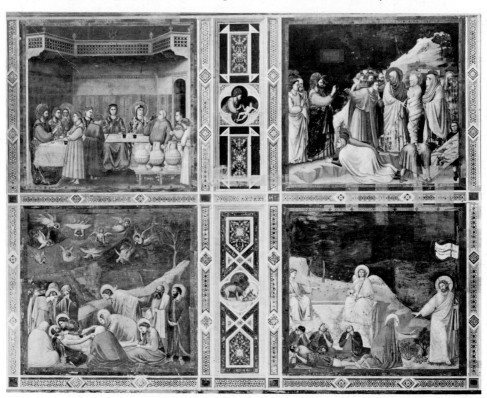

37. GIOTTO: *The Marriage at Cana, The Raising of Lazarus, Pietà, Noli me tangere*. About 1305. Padua, Arena Chapel

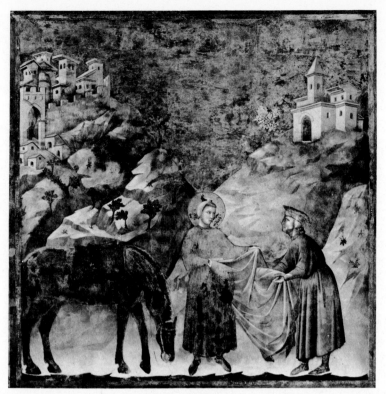

38. ST FRANCIS MASTER: *The Gift of the Mantle*. Assisi, San Francesco, Upper Church

GENTIBVS IGNOTVS STELLA DVCE NOSCITVR INFANS

39. PIETRO CAVALLINI: *The Adoration of the Magi*. Rome, Santa Maria in Trastevere

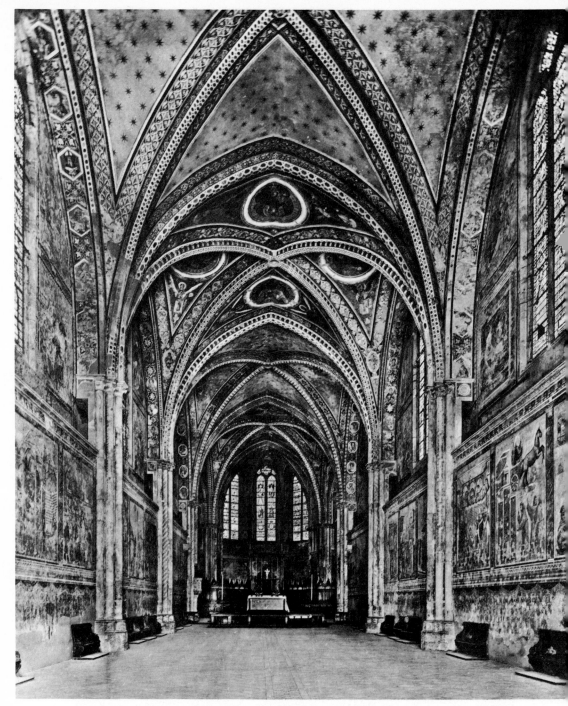

40. Assisi, San Francesco, Upper Church. View of the nave, with frescoes of *The Legend of St Francis* and, above, Old and New Testament cycles

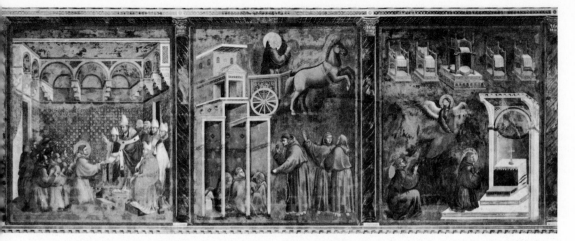

41. ST FRANCIS MASTER: *The Sanctioning of the Rule, The Vision of the Chariot, The Vision of the Thrones.*
Assisi, San Francesco, Upper Church

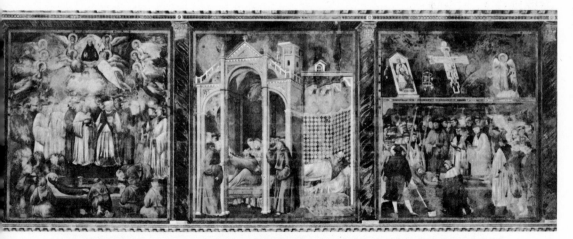

42. MASTER OF THE OBSEQUIES OF ST FRANCIS: *The Death and Ascension of St Francis, The Vision of the Ascension of St Francis, The Verification of the Stigmata.* Assisi, San Francesco, Upper Church

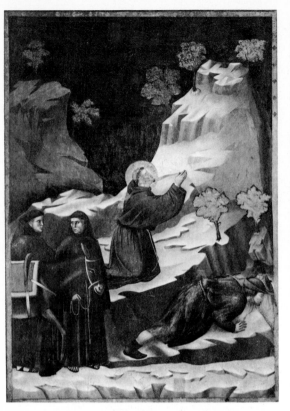

43. ST FRANCIS MASTER: *The Miracle of the Spring.*
Assisi, San Francesco, Upper Church

44. PACINO DI BONAGUIDA: *The Flight into Egypt.*
New York, Pierpont Morgan Library

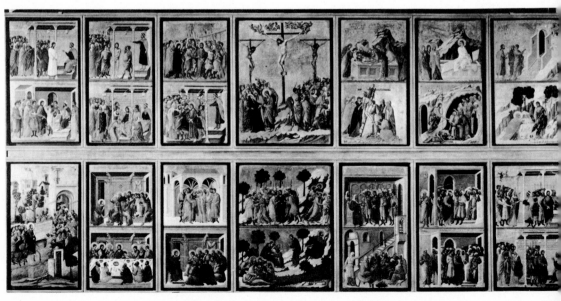

45. DUCCIO: *Maestà* (back). 1308–11. Siena, Museo dell'Opera del Duomo

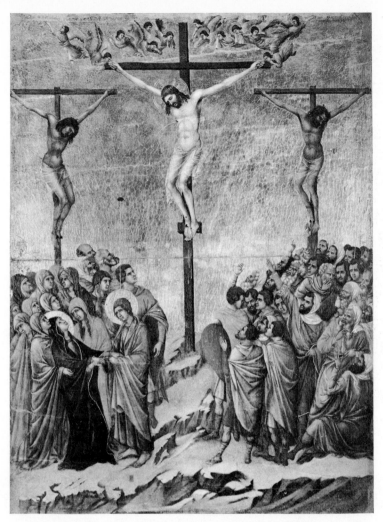

46. DUCCIO: *The Crucifixion.* Detail of the *Maestà* (Plate 45)

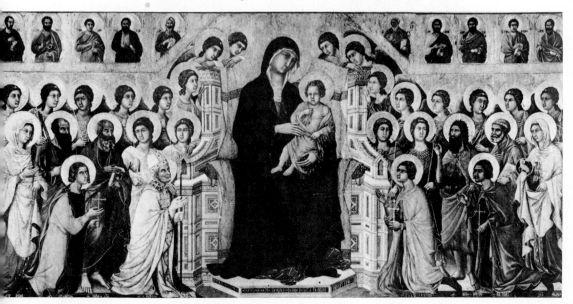

47. DUCCIO: *Maestà* (front). 1308–11. Siena, Museo dell'Opera del Duomo

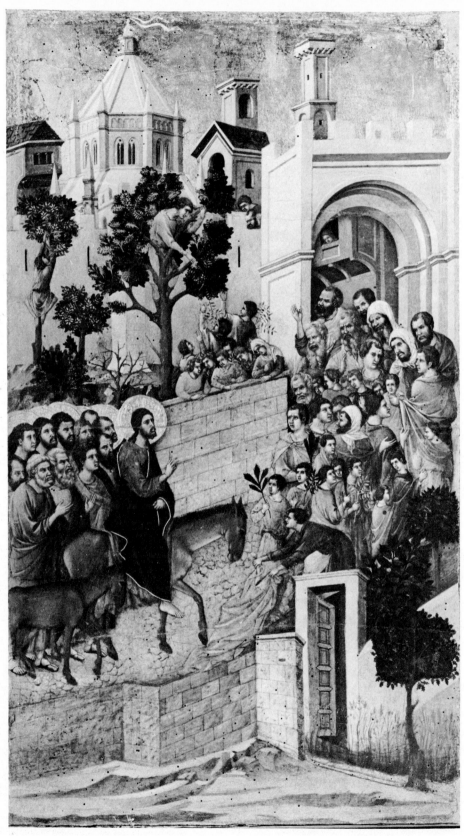

48. DUCCIO: *Christ's Entry into Jerusalem*. Detail of the *Maestà* (Plate 45)

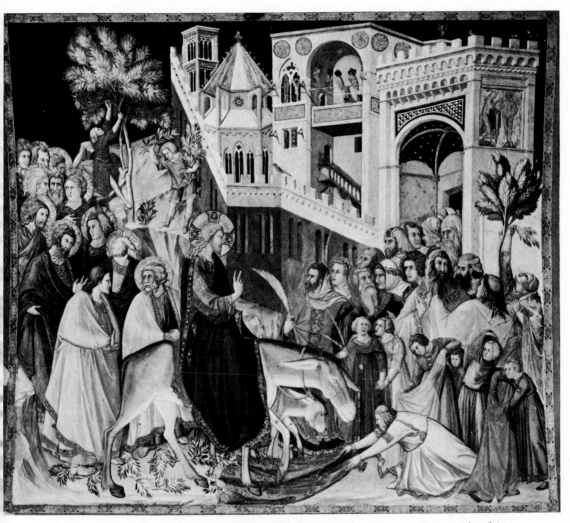

49. PIETRO LORENZETTI: *Christ's Entry into Jerusalem*. Assisi, San Francesco, Lower Church

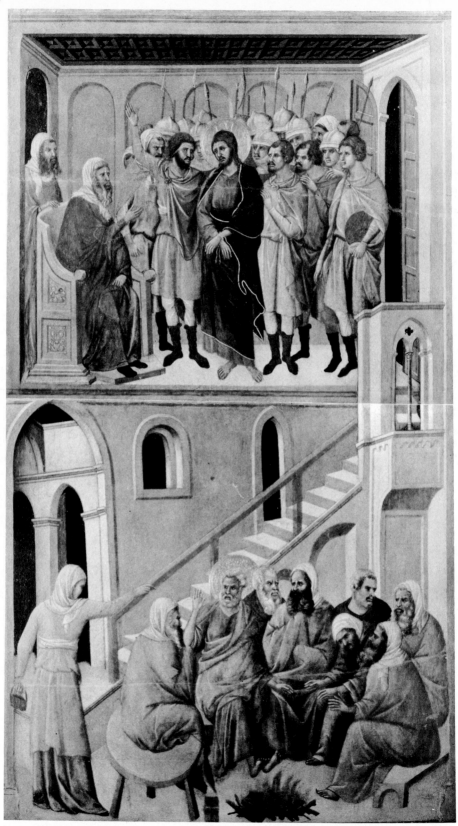

50. DUCCIO: *St Peter's First Denial* and *Christ before Annas*. Detail of the *Maestà* (Plate 45)

51. DUCCIO: *The Three Maries at the Sepulchre*. Detail of the *Maestà* (Plate 45)

52. DUCCIO: *The Walk to Emmaus*. Detail of the *Maestà* (Plate 45)

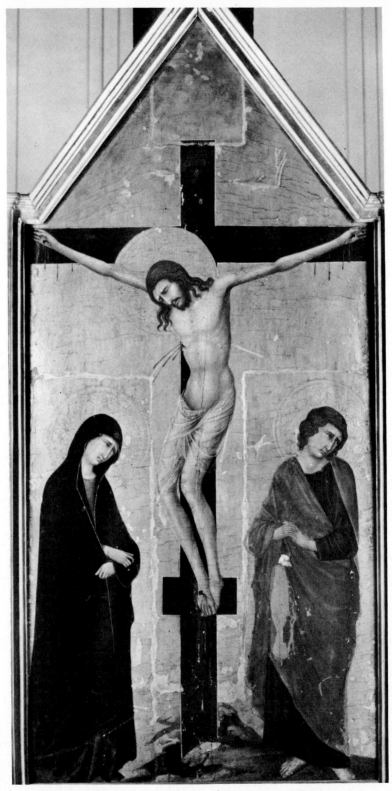

53. UGOLINO DI NERI: *The Crucifixion*. Private Collection

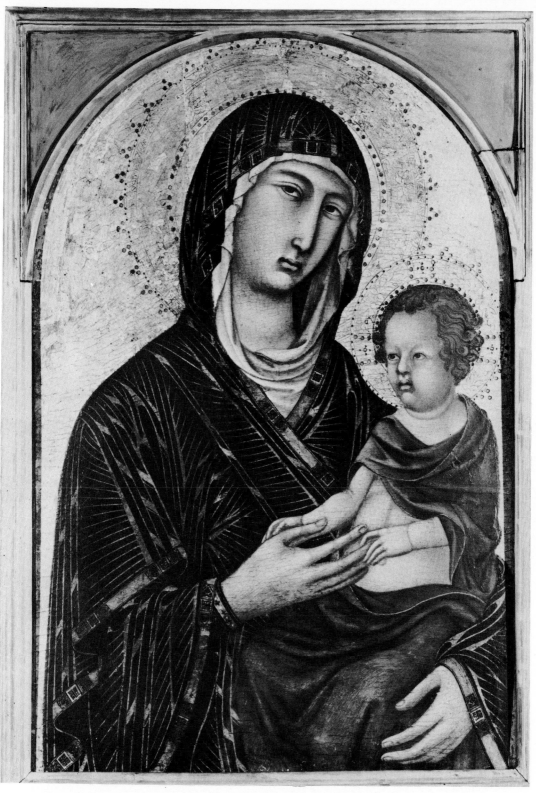

54. SEGNA DI BONAVENTURA: *Madonna and Child*. Locko Park, Captain P. J. B. Drury-Lowe

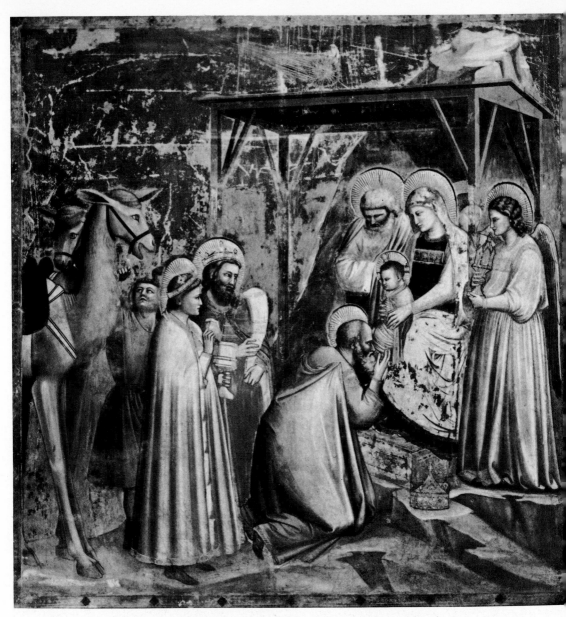

55. GIOTTO: *The Adoration of the Magi*. Padua, Arena Chapel

56. GIOTTO: *Enrico Scrovegni offering his Chapel to the Virgin*. Detail of *The Last Judgment*. Padua, Arena Chapel

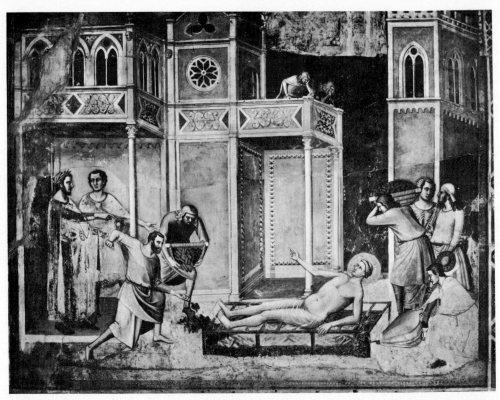

57. BERNARDO DADDI: *The Martyrdom of St Lawrence*. Florence, Santa Croce, Pulci-Berardi Chapel

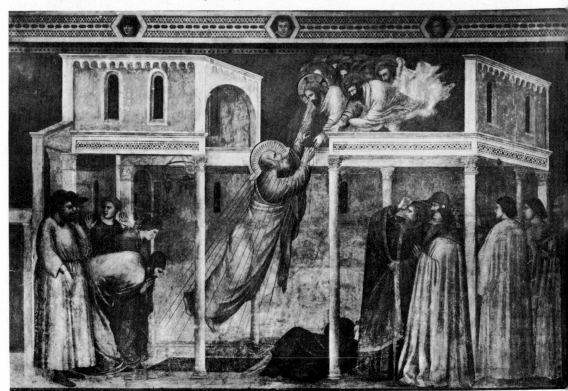

58. GIOTTO: *The Ascension of St John the Evangelist*. Florence, Santa Croce, Peruzzi Chapel

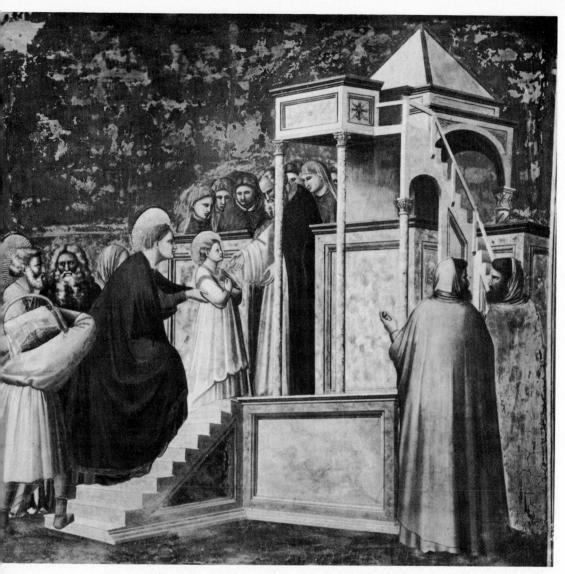

59. GIOTTO: *The Presentation of the Virgin in the Temple*. Padua, Arena Chapel

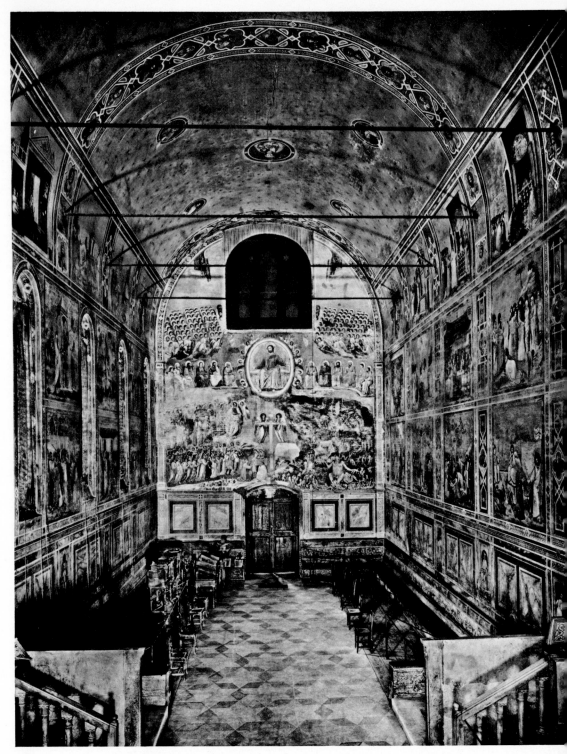

60. Padua, Arena Chapel (looking west). Frescoes by Giotto. About 1303–6

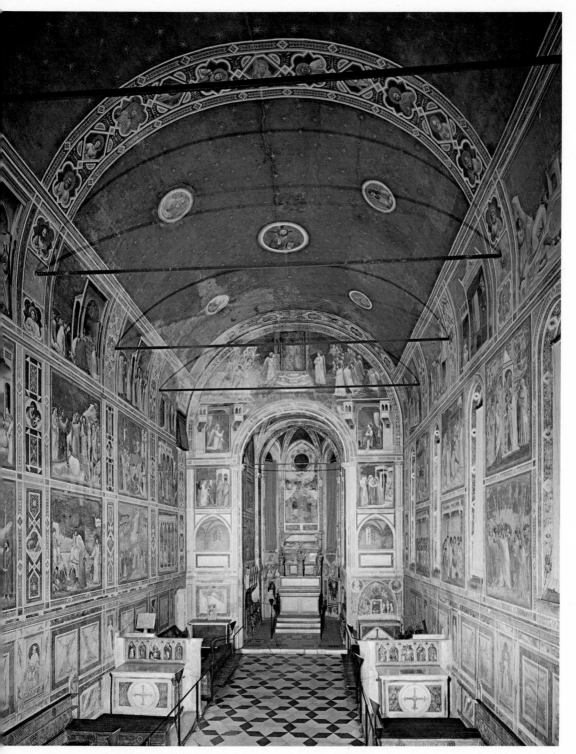

61. Padua, Arena Chapel (looking east). Frescoes by Giotto. About 1303–6

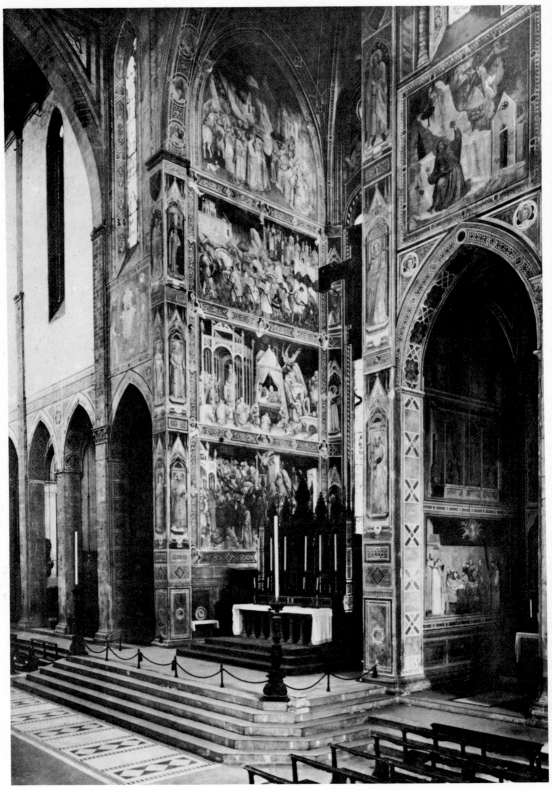

62. Florence, Santa Croce. View of the choir, with frescoes of *The Legend of the True Cross* by Agnolo Gaddi. On the right, above the entrance to the Bardi Chapel, is Giotto's *Stigmatization of St Francis*

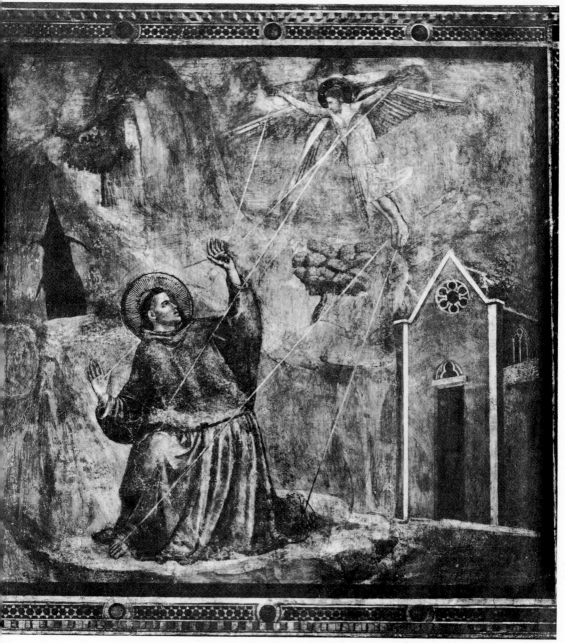

63. GIOTTO: *The Stigmatization of St Francis*. Florence, Santa Croce

64. GIOTTO: *The Virgin's Return Home*. Padua, Arena Chapel

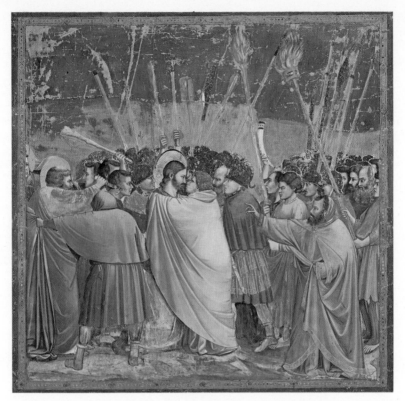

65. GIOTTO: *The Kiss of Judas*. Padua, Arena Chapel

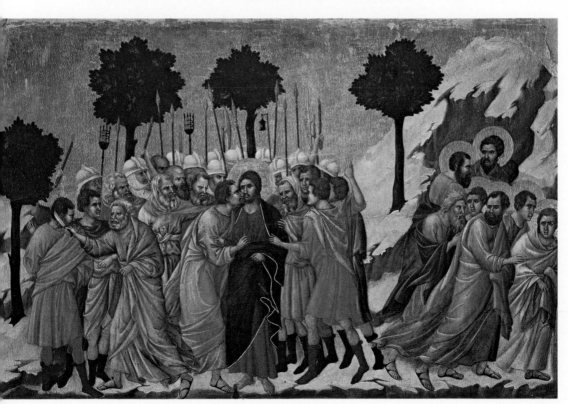

66. DUCCIO: *The Kiss of Judas*. Detail of the *Maestà* (Plate 45)

67. Assisi, San Francesco, Lower Church. Right transept with *The Franciscan Allegories*, *The Infancy of Christ* and other frescoes of the School of Giotto; to the right the Magdalen Chapel (School of Giotto)

68. FOLLOWER OF GIOTTO: *The Raising of Lazarus*. Assisi, San Francesco, Lower Church, Magdalen Chapel

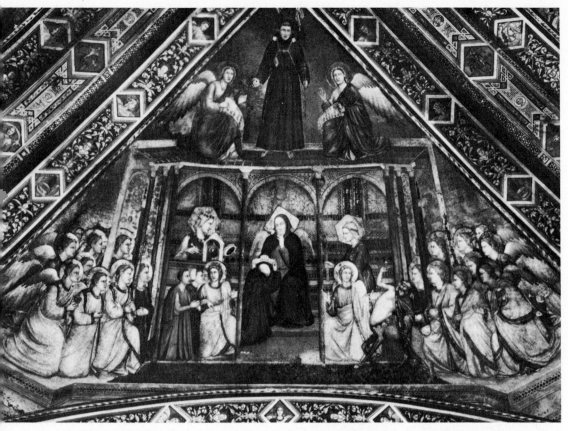

69. FOLLOWER OF GIOTTO: *The Allegory of Obedience*. Assisi, San Francesco, Lower Church

70. FOLLOWER OF GIOTTO: *Centaur*.
Detail of Plate 69

71. FOLLOWER OF GIOTTO: *The Miracle of the Child of Suessa*.
Assisi, San Francesco, Lower Church

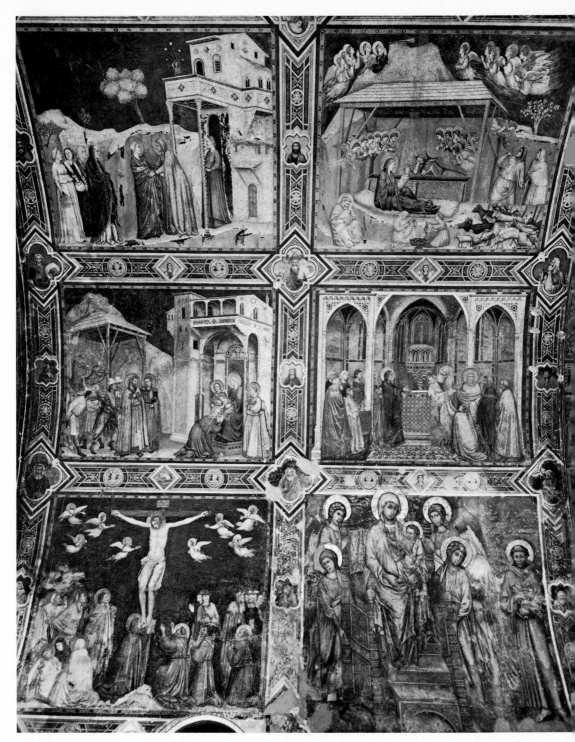

72. FOLLOWER OF GIOTTO: *Scenes from the Infancy of Christ* (see also Plate 119). Below: *The Crucifixion* (see Plate 79) and *Madonna and Child with Angels and St Francis* (Cimabue). Assisi, San Francesco, Lower Church

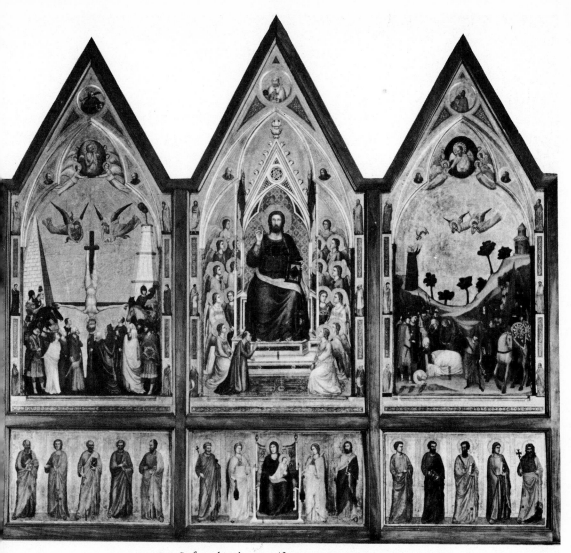

73. GIOTTO: *Stefaneschi Altarpiece* (front). Rome, Vatican Museum

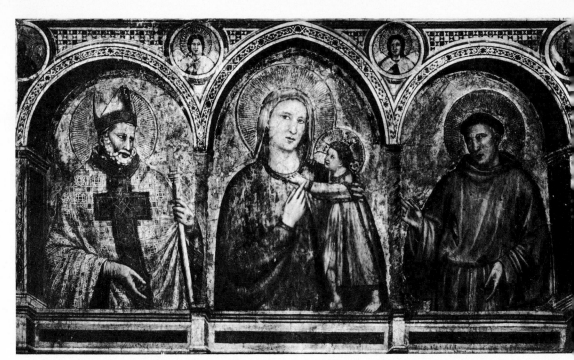

74. ST NICHOLAS MASTER: *Madonna and Child with St Nicholas and St Francis.* Before 1308. Assisi,
San Francesco, Lower Church, Orsini Chapel

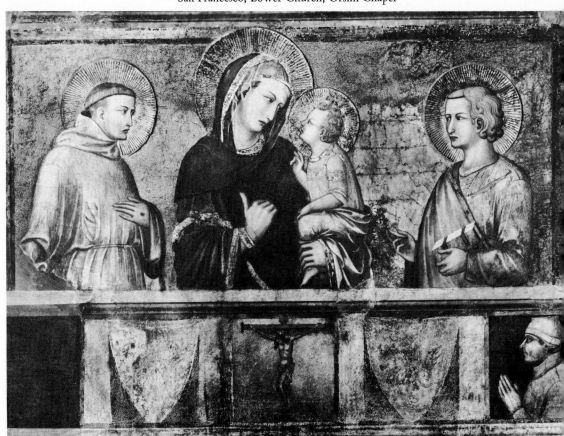

75. PIETRO LORENZETTI: *Madonna and Child with St John the Evangelist and St Francis.* Assisi,
San Francesco, Lower Church. See also Plate 121

76. FOLLOWER OF GIOTTO: *The Magdalen and Donor.* Assisi, San Francesco, Lower Church,
Magdalen Chapel

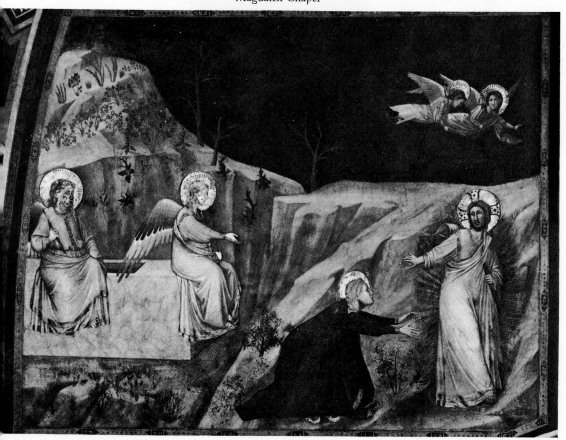

77. FOLLOWER OF GIOTTO: *Noli me tangere.* Assisi, San Francesco, Lower Church, Magdalen Chapel

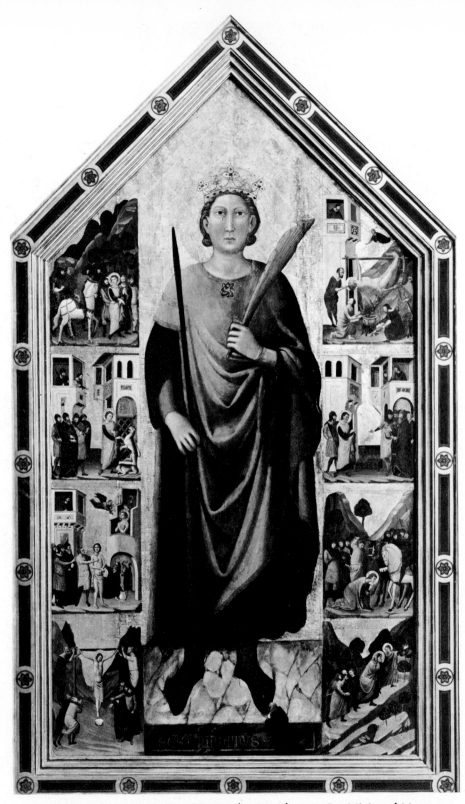

78. JACOPO DEL CASENTINO: *San Miniato Altarpiece*. Florence, San Miniato al Monte

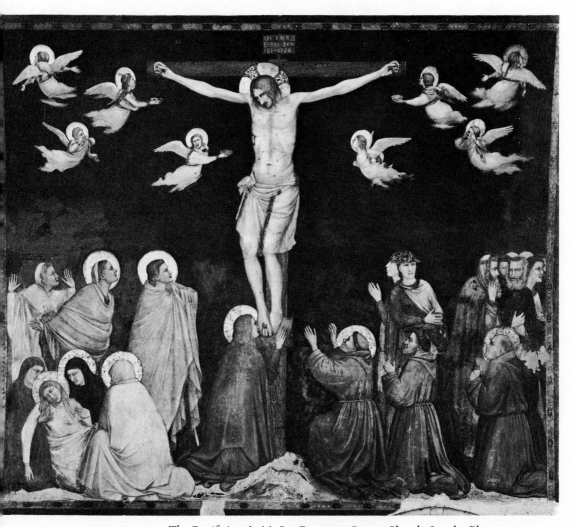

79. FOLLOWER OF GIOTTO: *The Crucifixion*. Assisi, San Francesco, Lower Church. See also Plate 72

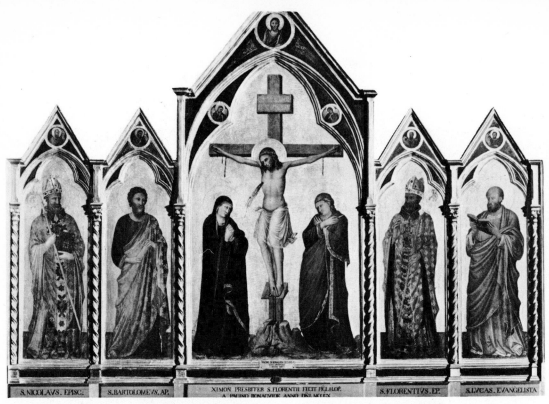

80. PACINO DI BONAGUIDA: *Crucifixion Polyptych*. Florence, Accademia

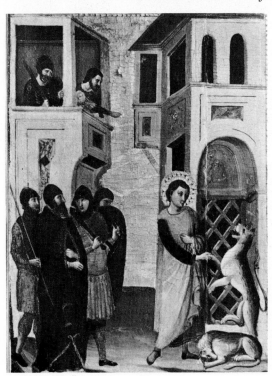

81. JACOPO DEL CASENTINO: *San Miniato and the Leopard.*
Detail of Plate 78

82. THE BIADAIOLO ILLUMINATOR: *The Poor of Siena being received in Florence*. Florence, Biblioteca Laurenziana

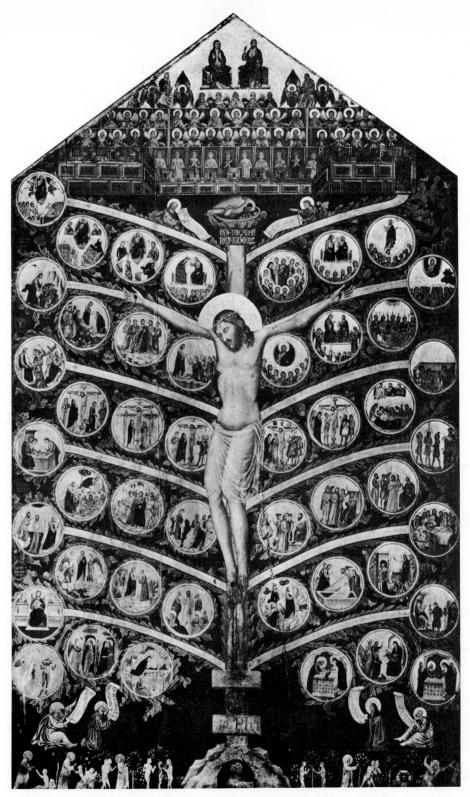

83. PACINO DI BONAGUIDA: *The Tree of Life*. Florence, Accademia

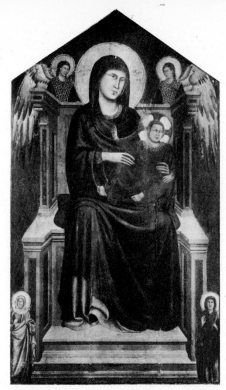

84. ST CECILIA MASTER: *Madonna and Child*.
Florence, Santa Margherita a Montici

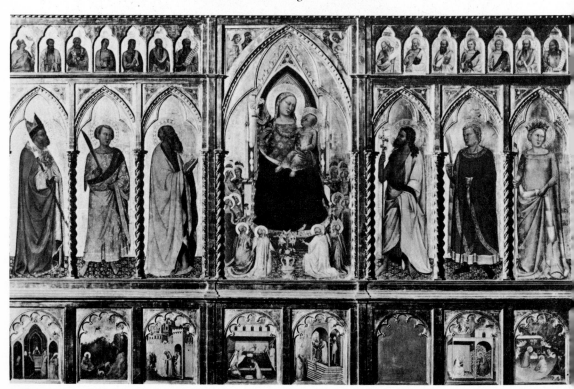

85. BERNARDO DADDI: *Polyptych*. About 1340. Florence, Uffizi

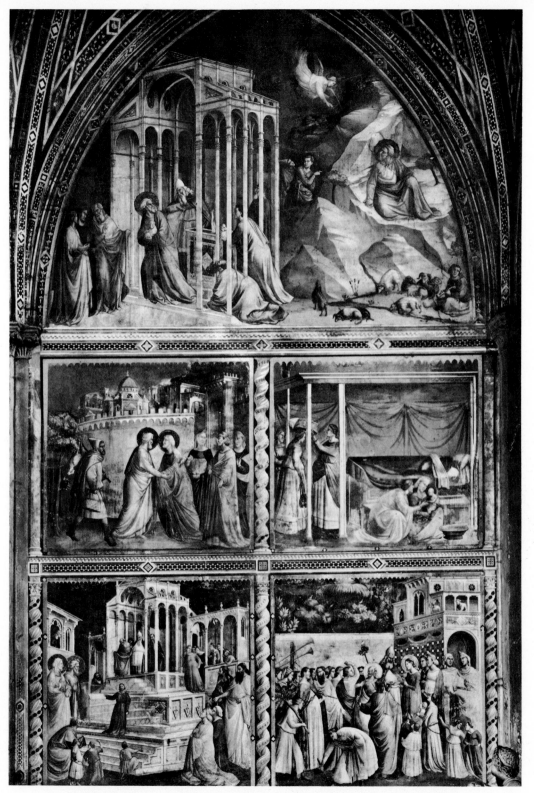

86. TADDEO GADDI: *Scenes from the Life of the Virgin*. Florence, Santa Croce, Baroncelli Chapel

87. BERNARDO DADDI: *The Meeting of St Joachim and St Anne at the Golden Gate.*
Detail of Plate 85

88. GIOTTO: *The Meeting of St Joachim and St Anne at the Golden Gate.* Padua, Arena Chapel

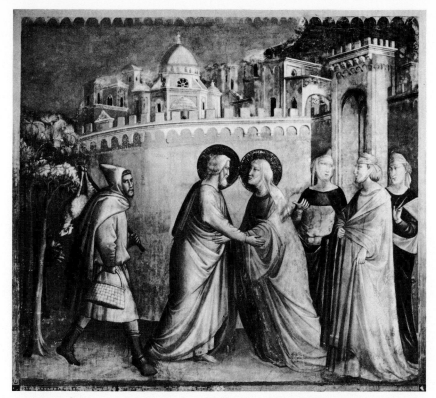

89. TADDEO GADDI: *The Meeting of St Joachim and St Anne at the Golden Gate.*
Detail of Plate 86

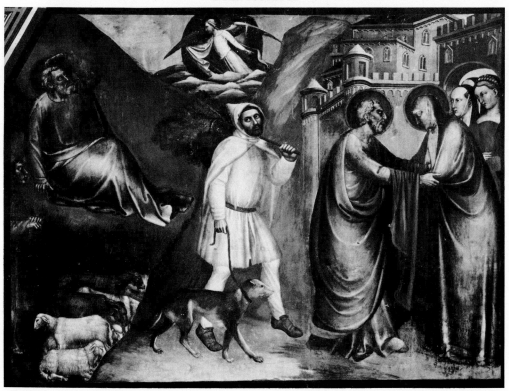

90. GIOVANNI DA MILANO: *The Meeting of St Joachim and St Anne at the Golden Gate.* 1365.
Florence, Santa Croce, Rinuccini Chapel

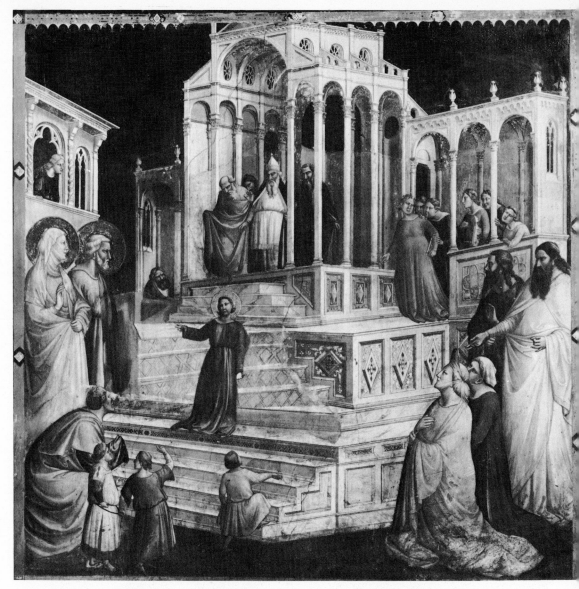

91. TADDEO GADDI: *The Presentation of the Virgin in the Temple*. Detail of Plate 86

92. TADDEO GADDI: *The Christmas Crib at Greccio. Armadio* panel. Florence, Accademia

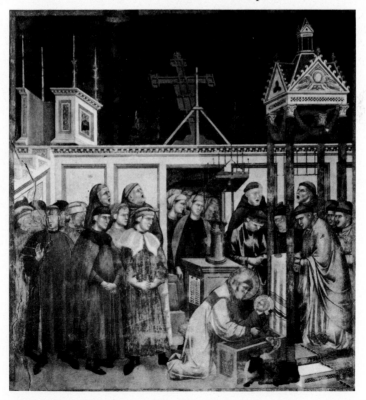

93. ST FRANCIS MASTER: *The Christmas Crib at Greccio*. Assisi, San Francesco, Upper Church

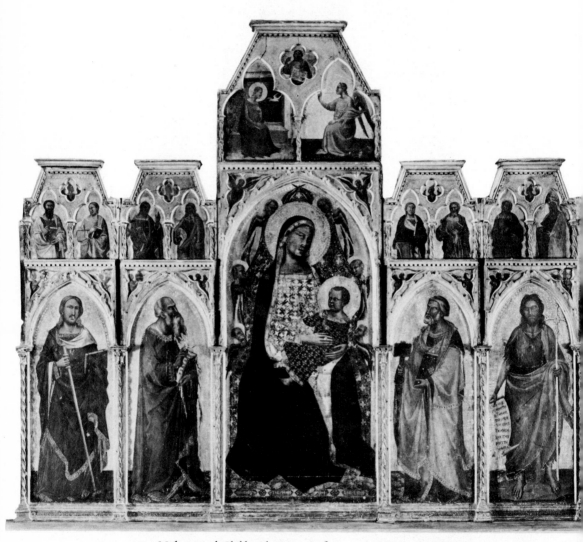

94. TADDEO GADDI: *Madonna and Child with Saints.* Before 1354. Pistoia, San Giovanni Fuorcivitas

95. GIOTTINO (?): *Pietà* from San Remigio. Florence, Uffizi

96. ORCAGNA: *Tabernacle*, with relief of *The Assumption of the Virgin*. Completed 1359. Florence, Orsanmichele

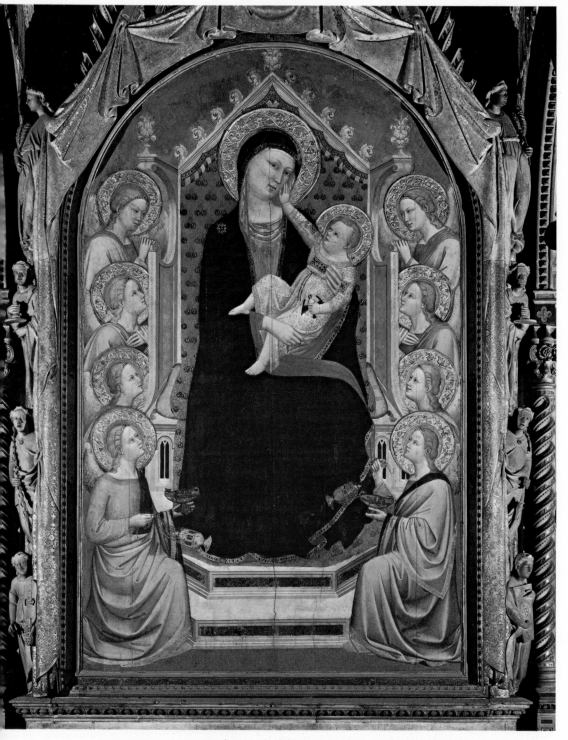

97. BERNARDO DADDI: *Madonna and Child.* 1346–7. Florence, Orsanmichele

98. MASO DI BANCO: *The Donor and the Last Trump*. Florence, Santa Croce, Bardi di Vernio Chapel

99. MASTER OF THE FOGG PIETÀ (GIOVANNI DI BONINO?): *Pietà*. Cambridge, Mass., Fogg Art Museum

100. MASO DI BANCO: *St Silvester quelling the Dragon*. Florence, Santa Croce,
Bardi di Vernio Chapel

101. TADDEO GADDI: *The Announcement to the Shepherds*. Florence, Santa Croce,
Baroncelli Chapel

102. SIMONE MARTINI: *The Procession to Calvary*. Panel from the *Polyptych of the Passion*. Paris, Louvre

103. SIMONE MARTINI: *The Obsequies of St Louis*. Detail of Plate 105

104. SIMONE MARTINI: *Maestà*. 1317. Siena, Palazzo Pubblico

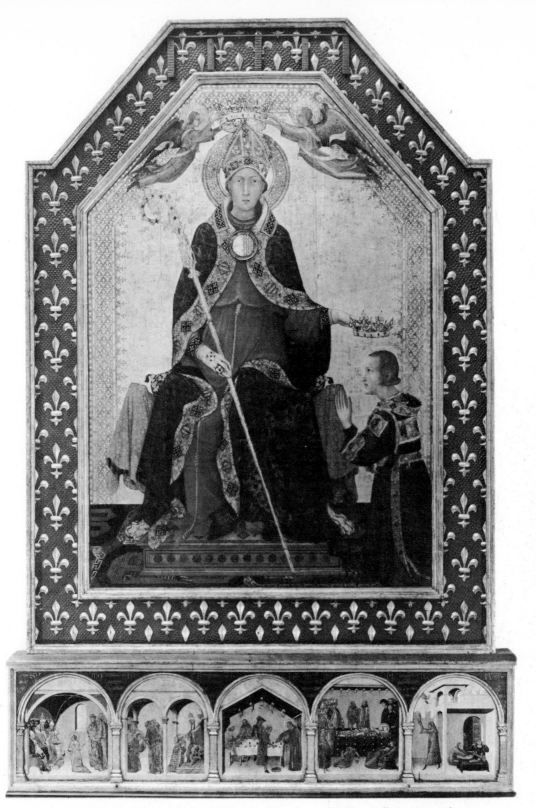

105. SIMONE MARTINI: *St Louis Altarpiece*. About 1317. Naples, Galleria Nazionale

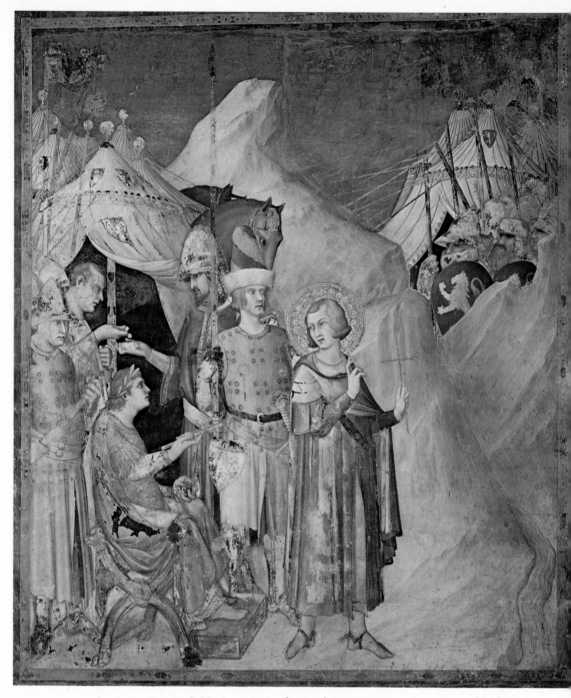

106. SIMONE MARTINI: *St Martin renouncing the Sword*. Assisi, San Francesco, Lower Church, Montefiore Chapel

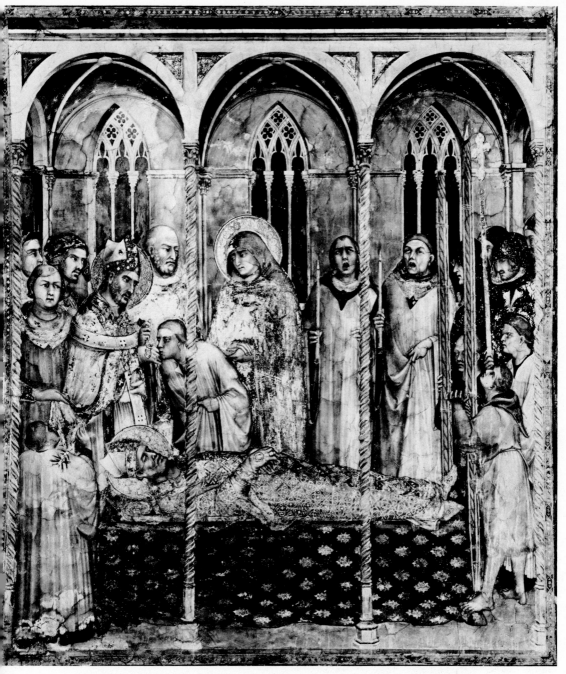

107. SIMONE MARTINI: *The Obsequies of St Martin*. Assisi, San Francesco, Lower Church, Montefiore Chapel

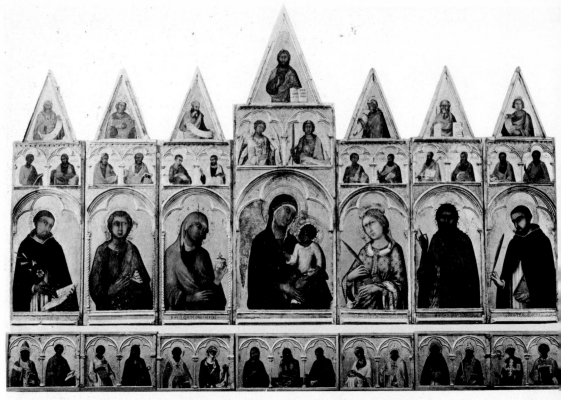

108. SIMONE MARTINI: *Polyptych*. 1319. Pisa, Santa Caterina

109. GIOTTO: *Rider*. Detail of scene below the Virtue *Justitia*. Padua, Arena Chapel

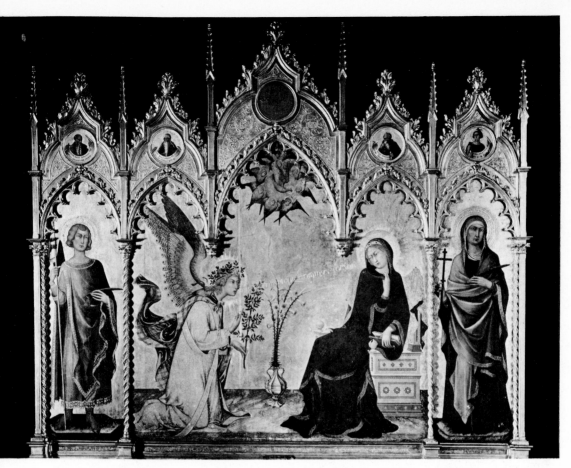

110. SIMONE MARTINI AND LIPPO MEMMI: *The Annunciation*. 1333. Florence, Uffizi

111. SIMONE MARTINI: *Equestrian Portrait of Guidoriccio da Fogliano*. 1328. Siena, Palazzo Pubblico

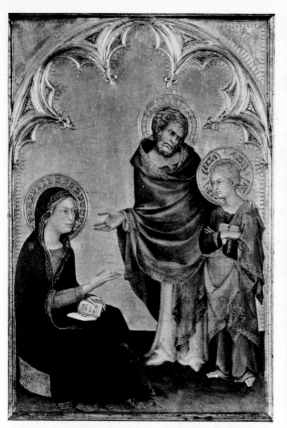

112. SIMONE MARTINI: *The Return of the Young Christ to his Parents*. Liverpool, Walker Art Gallery

113. SIMONE MARTINI: *Virgil Frontispiece*. Milan, Biblioteca Ambrosiana

114. PIETRO LORENZETTI: *Madonna and Child with St Nicholas and St Anthony Abbot.* 1329.
Siena, Pinacoteca

115. PIETRO LORENZETTI: *Polyptych*. 1320. Arezzo, Pieve di Santa Maria

116. GIOVANNI PISANO: *Virgin and Child*. From 1284. Pisa, Camposanto

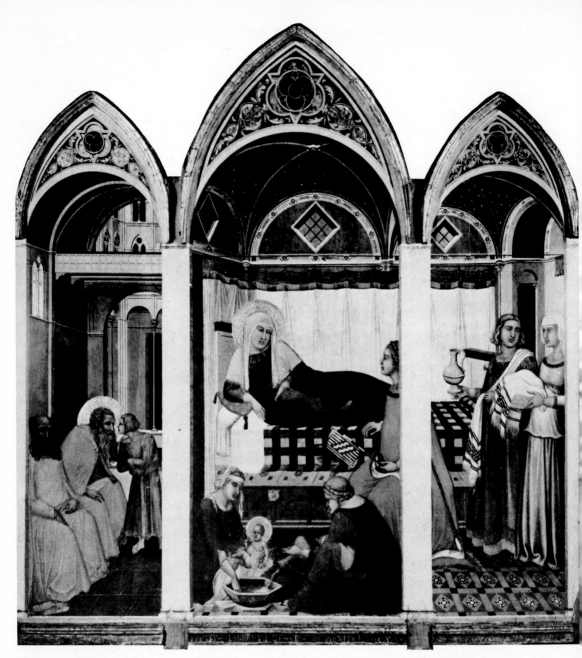

117. PIETRO LORENZETTI: *The Birth of the Virgin*. 1342. Siena, Museo dell'Opera del Duomo

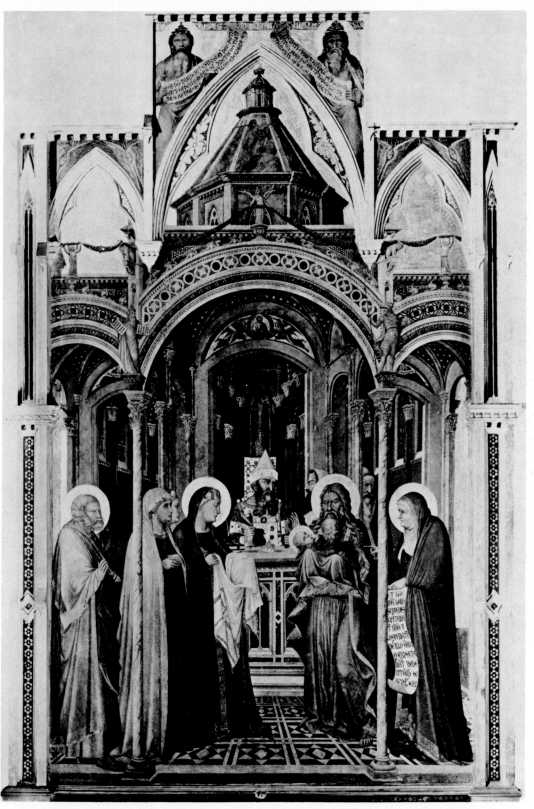

118. AMBROGIO LORENZETTI: *The Presentation of Christ in the Temple.* 1342. Florence, Uffizi

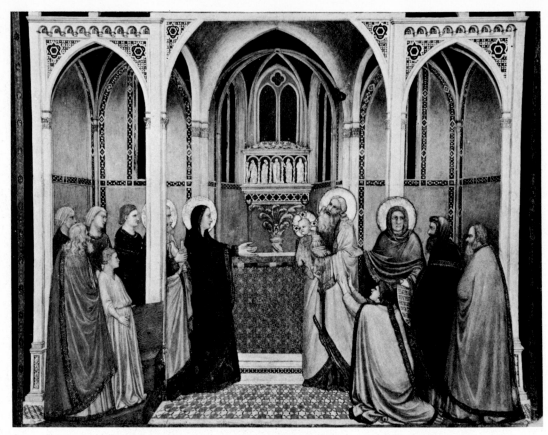

119. FOLLOWER OF GIOTTO: *The Presentation of Christ in the Temple*. Assisi, San Francesco,
Lower Church. See also Plate 72

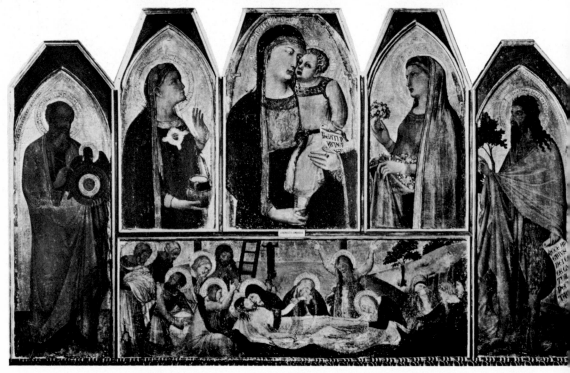

120. AMBROGIO LORENZETTI: *Madonna and Child with St Mary Magdalen and St Dorothy*. Siena, Pinacoteca

121. PIETRO LORENZETTI AND SHOP: Frescoes of *The Passion of Christ*, with, below *The Crucifixion*, a frescoed *Madonna* (see Plate 75). Assisi, San Francesco, Lower Church

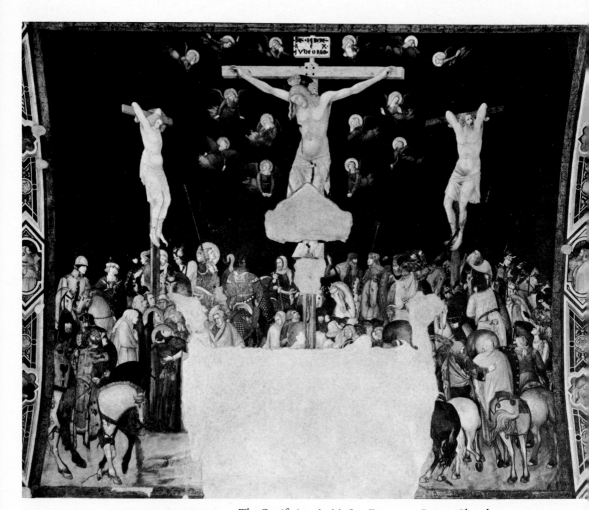

122. PIETRO LORENZETTI: *The Crucifixion*. Assisi, San Francesco, Lower Church

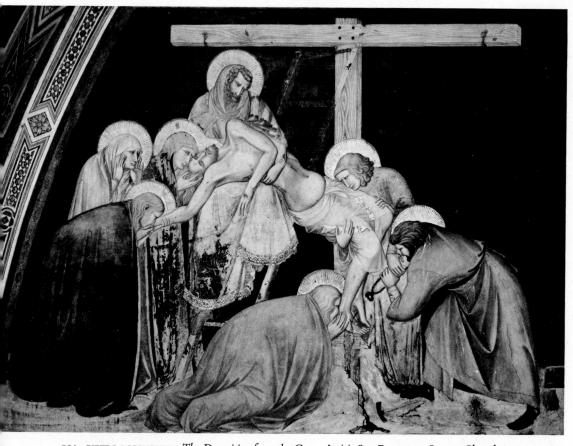

123. PIETRO LORENZETTI: *The Deposition from the Cross*. Assisi, San Francesco, Lower Church

124. AMBROGIO LORENZETTI: *St Louis before Boniface VIII*. Siena, San Francesco

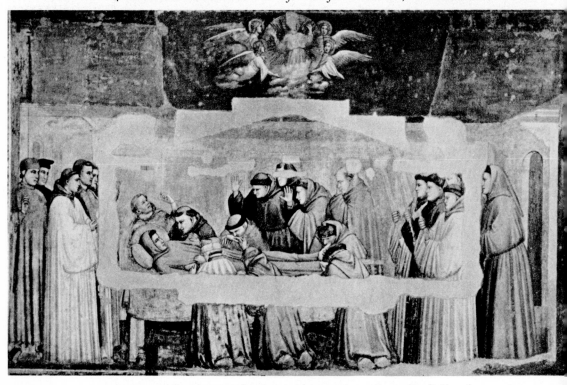

125. GIOTTO: *The Obsequies of St Francis*. Florence, Santa Croce, Bardi Chapel

126. AMBROGIO LORENZETTI: *The Allegory of Good Government* and *The Effects of Good Government*.
1338–9. Siena, Palazzo Pubblico, Sala de' Nove

127. AMBROGIO LORENZETTI: *Distributive and Commutative Justice*. Detail of Plate 126

128. AMBROGIO LORENZETTI: *The Effects of Good Government: the City*. Siena,
Palazzo Pubblico, Sala de' Nove

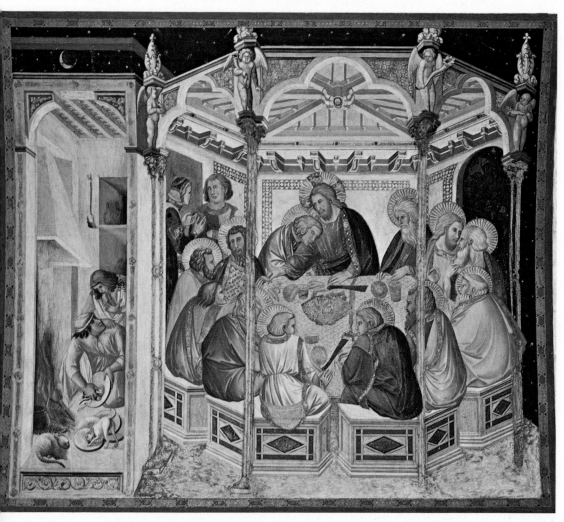

129. PIETRO LORENZETTI: *The Last Supper*. Assisi, San Francesco, Lower Church

130. AMBROGIO LORENZETTI: Detail of *The Effects of Good Government: the City* (Plate 128)

131. AMBROGIO LORENZETTI: Detail of *The Effects of Good Government: the Country*. Siena,
Palazzo Pubblico, Sala de' Nove

132. AMBROGIO AND PIETRO (?) LORENZETTI: *The Virgin*.
Detail of *The Annunciation*. Montesiepi,
Oratory of San Galgano

133. AMBROGIO LORENZETTI: *Sinopia* of the Virgin from
the Montesiepi *Annunciation* (Plate 132)

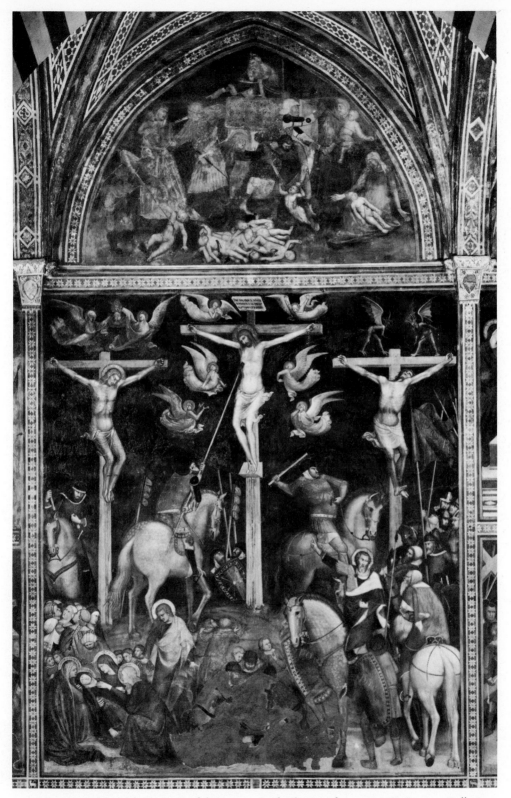

134. BARNA DA SIENA: *The Massacre of the Innocents* and *The Crucifixion*. San Gimignano, Collegiata

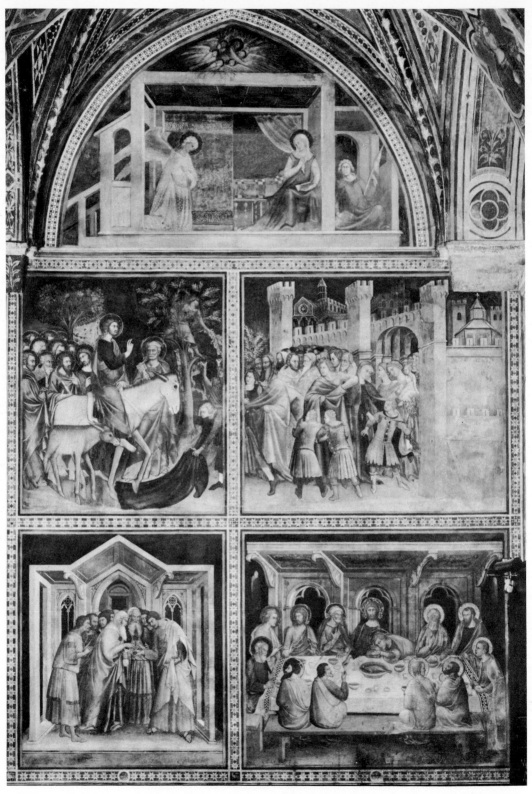

135. BARNA DA SIENA: *The Annunciation, Christ's Entry into Jerusalem* (two fields), *The Pact of Judas, The Last Supper.* San Gimignano, Collegiata

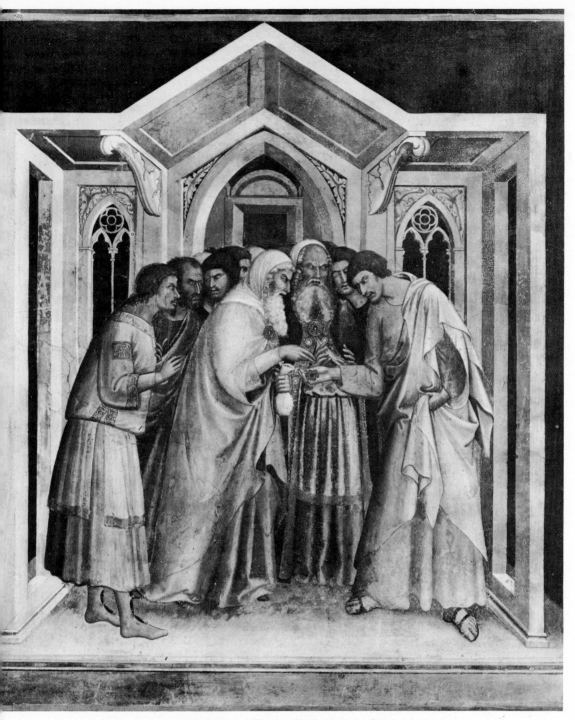

136. BARNA DA SIENA: *The Pact of Judas*. Detail of Plate 135

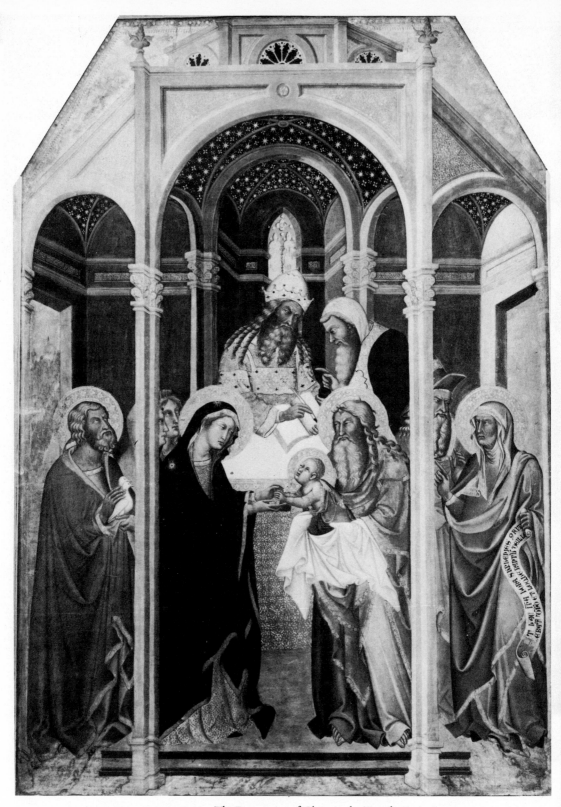

137. BARTOLO DI FREDI: *The Presentation of Christ in the Temple*. Paris, Louvre

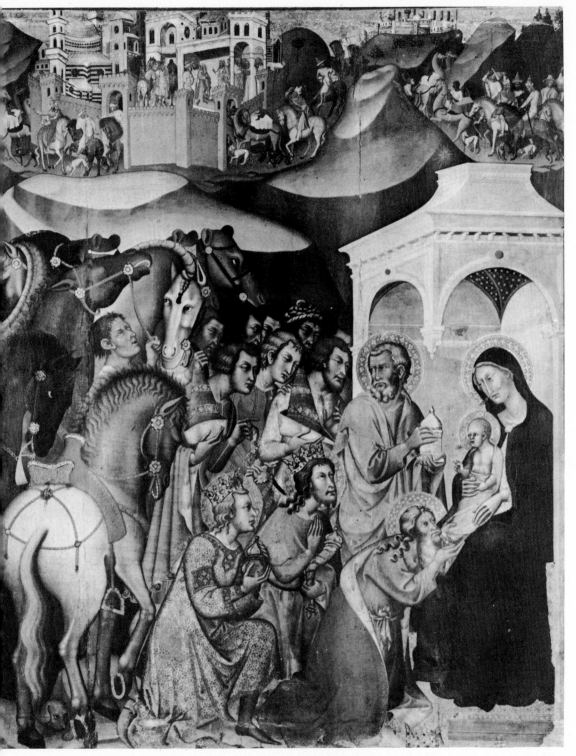

138. BARTOLO DI FREDI: *The Adoration of the Magi*. Siena, Pinacoteca

139. ANDREA VANNI: *St Catherine of Siena and a Suppliant*. Siena, San Domenico

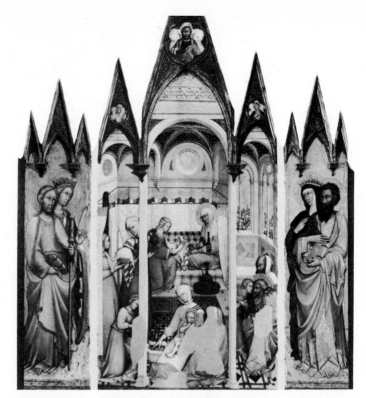

141. PAOLO DI GIOVANNI FEI: *The Birth of the Virgin*. Siena, Pinacoteca

GHERARDO STARNINA: *St Benedict*.
Completed 1404. Florence,
Santa Maria del Carmine

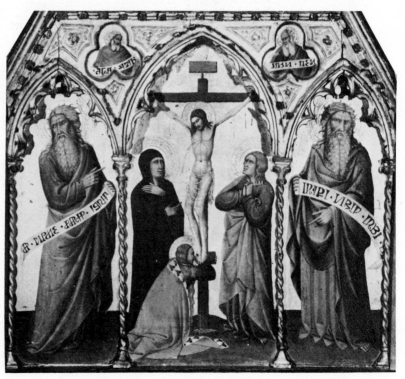

142. ANDREA VANNI: *Crucifixion Triptych*. Siena, Pinacoteca

143. MASTER OF THE CAMPOSANTO CRUCIFIXION: *Sinopia* of part of *The Crucifixion* (Plate 144)

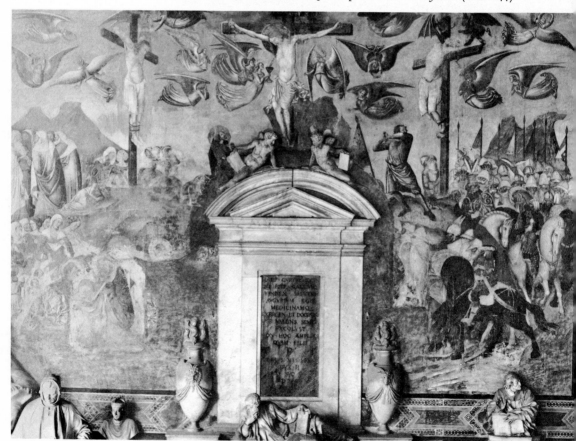

144. MASTER OF THE CAMPOSANTO CRUCIFIXION: *The Crucifixion*. Pisa, Camposanto

145. BUONAMICO BUFFALMACCO: *Soldiers* from *The Life of St James*. 1315. Badia a Settimo

146. BUONAMICO BUFFALMACCO(?): *Madonna and Child with Saints*. Arezzo, Cathedral

147. FRANCESCO TRAINI: *St Dominic and Scenes from his Life*. 1345. Pisa, Museo

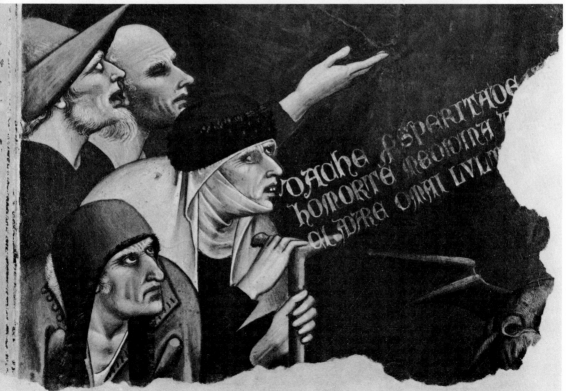

148–149. ORCAGNA: *An Eclipse of the Sun* and *Figures invoking Death*. Fragments of *The Triumph of Death*.
Florence, Museo, dell'Opera di Santa Croce

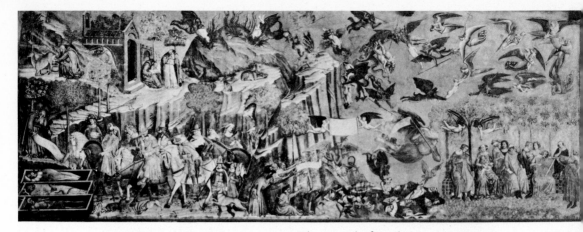

150. MASTER OF THE TRIUMPH OF DEATH: *The Triumph of Death*. Pisa, Camposanto

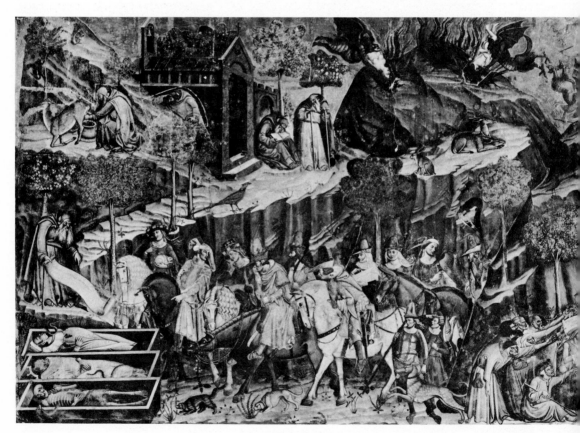

151. Detail of Plate 150

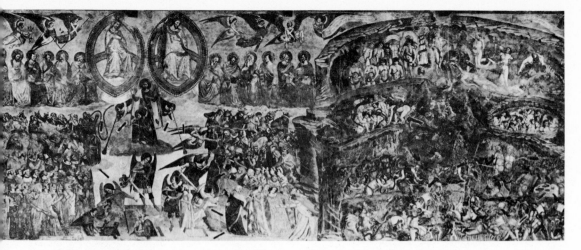

152. MASTER OF THE TRIUMPH OF DEATH: *The Last Judgment and the Inferno*. Pisa, Camposanto

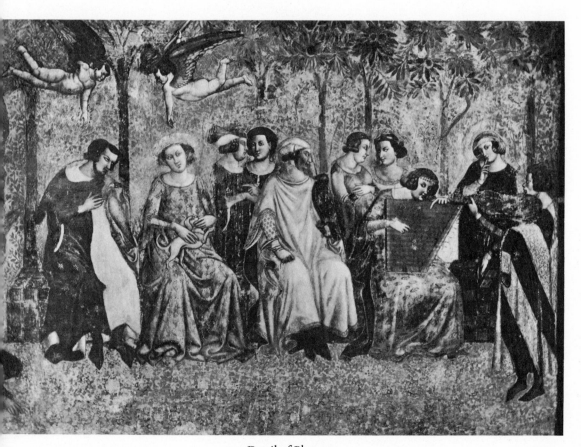

153. Detail of Plate 150

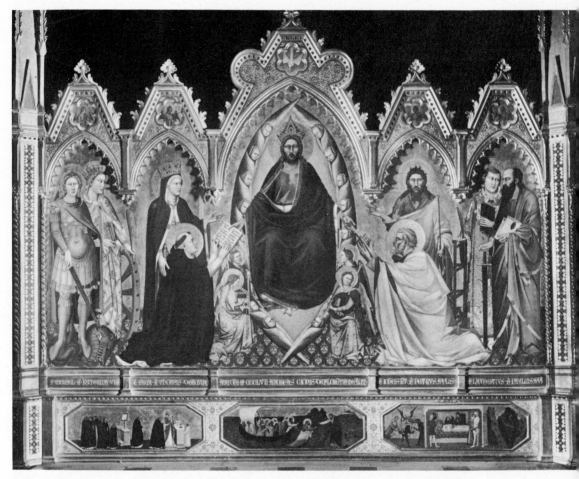

154. ORCAGNA: *Strozzi Altarpiece*. 1357. Florence, Santa Maria Novella

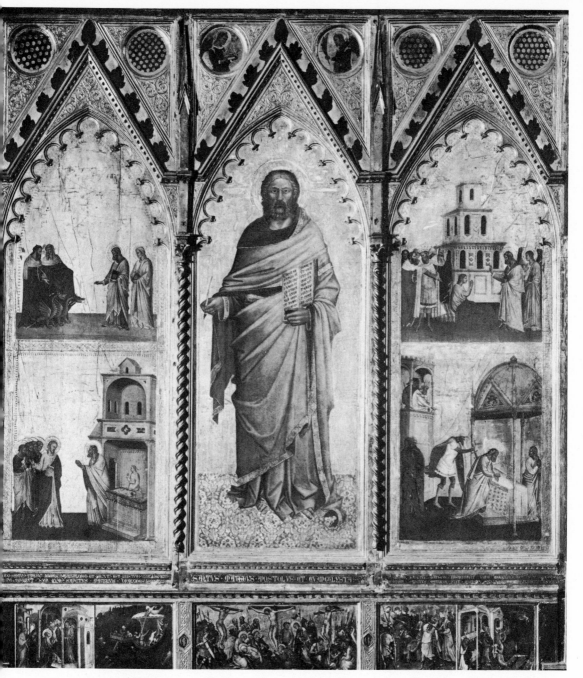

155. ORCAGNA (ANDREA DI CIONE) AND JACOPO DI CIONE: *St Matthew Altarpiece*. Florence, Uffizi

156. ANTONIO VENEZIANO: *The Death and Funeral of St Ranierus.* Pisa, Camposanto

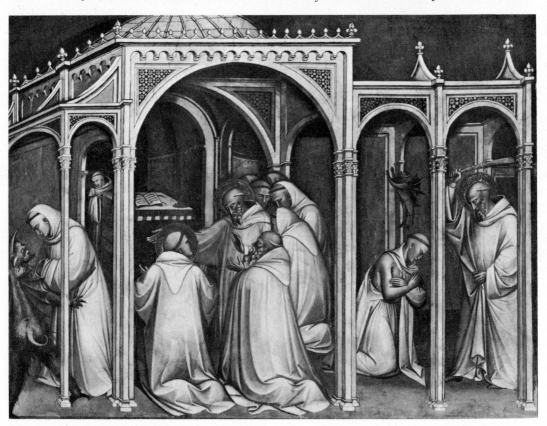

157. SPINELLO ARETINO: *St Benedict casting out a Devil.* Completed about 1387. Florence, San Miniato

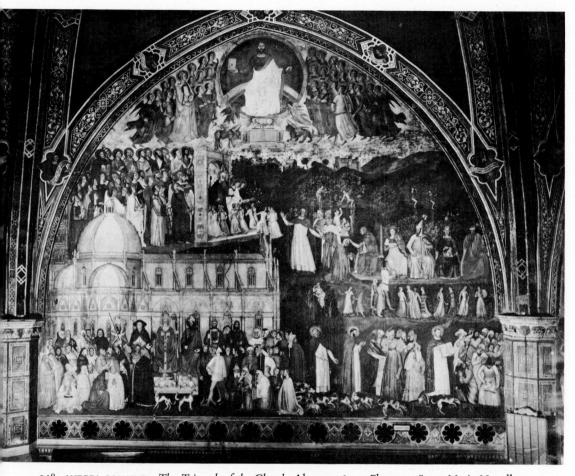

158. ANDREA BONAIUTI: *The Triumph of the Church*. About 1365-7. Florence, Santa Maria Novella, Spanish Chapel

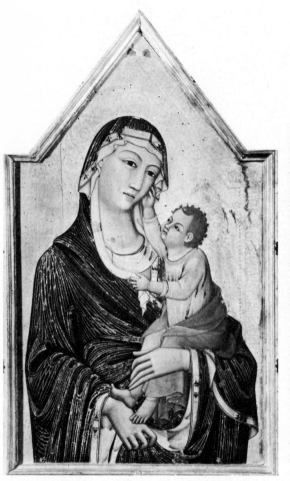

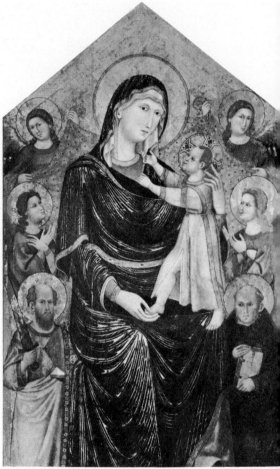

159. MEO DA SIENA: *Madonna and Child.*
Perugia, Galleria Nazionale

160. MARINO DA PERUGIA: *Madonna and Child with St Paul and St Benedict.* Perugia, Galleria Nazionale

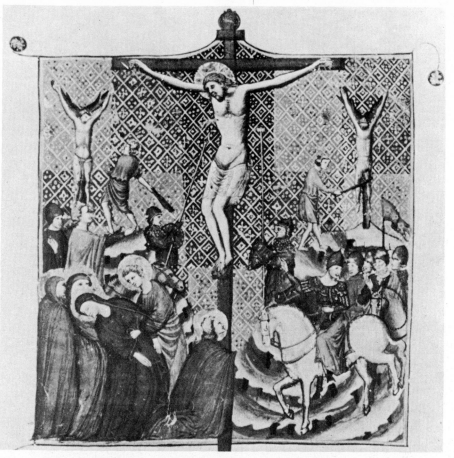

161. NERI DA RIMINI: *The Crucifixion*. Rome, Vatican Library

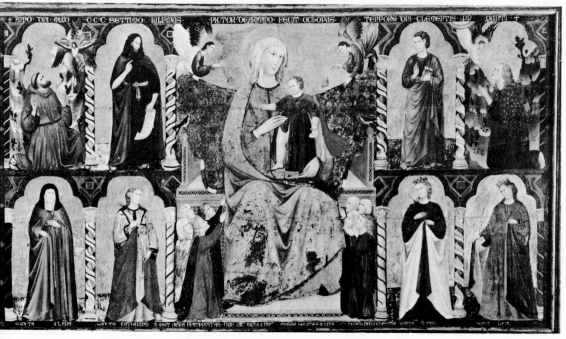

162. GIULIANO DA RIMINI: *Polyptych*. 1307. Boston, Mass., Isabella Stewart Gardner Museum

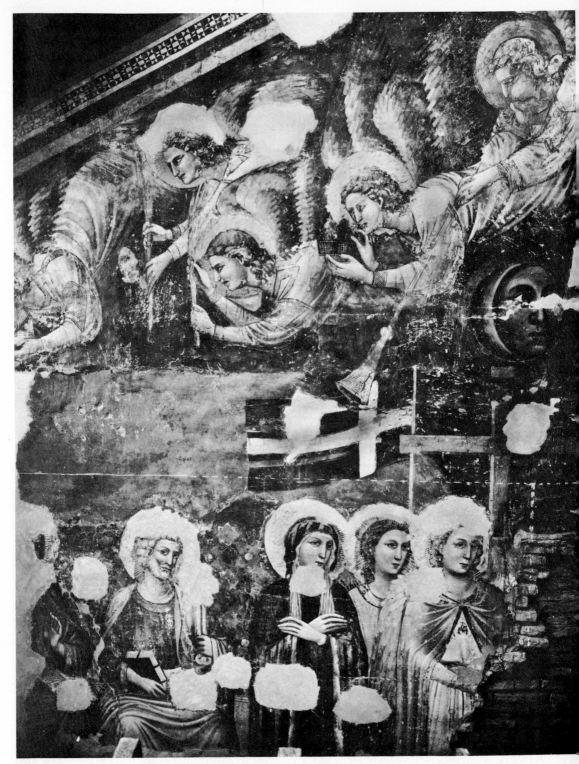

163. **RIMINESE PAINTER**: Detail of *The Last Judgment*. Rimini, Palazzo dell'Arengo

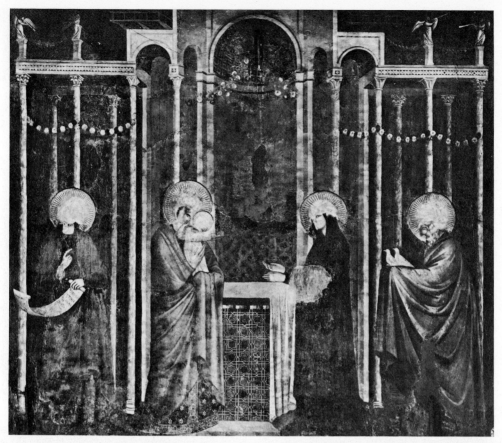

164. GIOVANNI DA RIMINI: *The Presentation of Christ in the Temple*. Rimini, Sant'Agostino

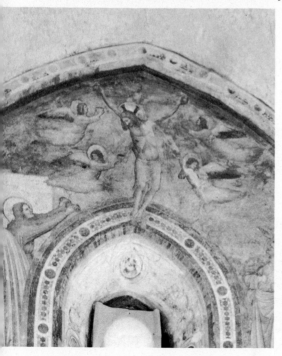

165. PIETRO DA RIMINI: *The Crucifixion*.
Ravenna, Former Convent of Santa Chiara

166. PIETRO DA RIMINI: *The Deposition*. Paris, Louvre

167. RIMINESE PAINTER: *The Young St Nicholas with Maestro Angelo*. Tolentino, San Nicola

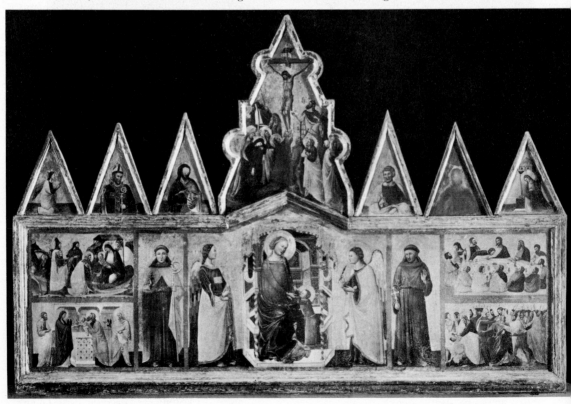

168. GIOVANNI BARONZIO: *Polyptych*. 1345. Urbino, Galleria Nazionale delle Marche

169. TOMASO DA MODENA: *Albertus Magnus.* 1352.
Treviso, Capitolo dei Domenicani

170. VITALE DA BOLOGNA: *The Miracles of St Antony Abbot.*
Bologna, Pinacoteca Nazionale

171. VITALE DA BOLOGNA: *The Obsequies of St Nicholas.* 1348–9. Udine, Cathedral

172. VITALE DA BOLOGNA: *The Nativity*. Bologna, Pinacoteca Nazionale

173. BARNABA DA MODENA: *Madonna and Child.* 1369. Pisa, Museo

174. PAOLO VENEZIANO AND SHOP: *Madonna from the tomb of Doge Francesco Dandolo*. Venice, Santa Maria dei Frari

175. LORENZO VENEZIANO: *Madonna and Child with a Rose*. 1372. Paris, Louvre

176. PAOLO VENEZIANO: *Madonna and Child*. Milan, Crespi Collection

177. PAOLO VENEZIANO: *St Mark's Body carried by Ship to Venice*. Panel from the cover of the *Pala d'Oro*.
Venice, Basilican Museum

178. GUARIENTO: *The Vision of St Augustine*. Padua, Chiesa degli Eremitani

179. TOMASO DA MODENA: Detail of *The Leave-taking of St Ursula*.
Treviso, Museo Civico

180. ALTICHIERO: *The Soldiers casting Lots for Christ's Garments*. Right-hand scene of *The Crucifixion*.
About 1379. Padua, Santo, Cappella di San Felice (formerly known as Cappella di San Giacomo)

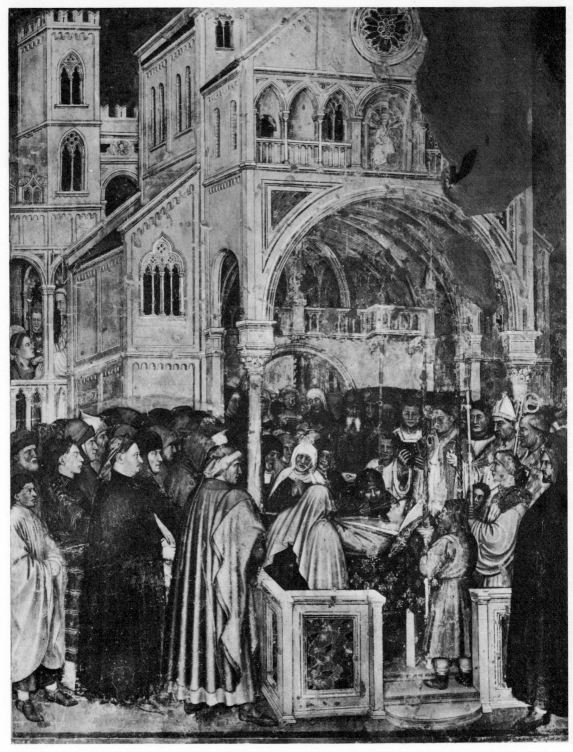

181. ALTICHIERO: *The Death of St Lucy*. Completed by 1384. Padua, Oratorio di San Giorgio

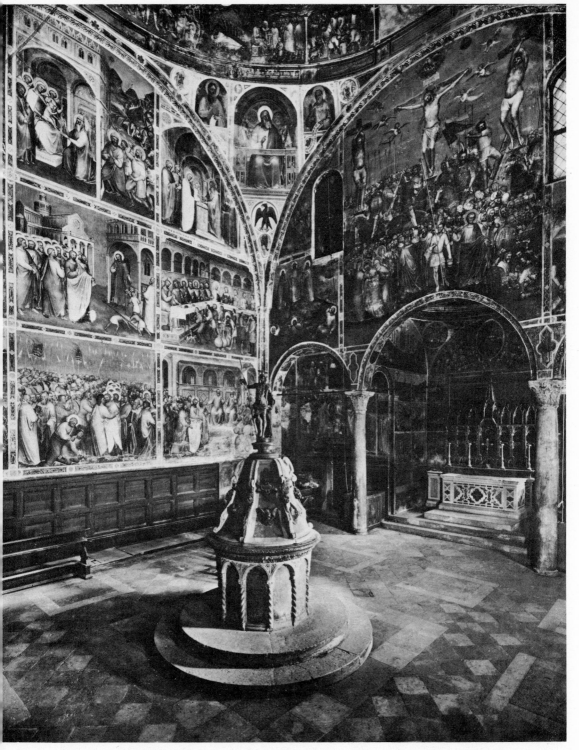

182. GIUSTO DE' MENABUOI: Frescoes in the Baptistery, Padua Cathedral. Frescoes completed 1376

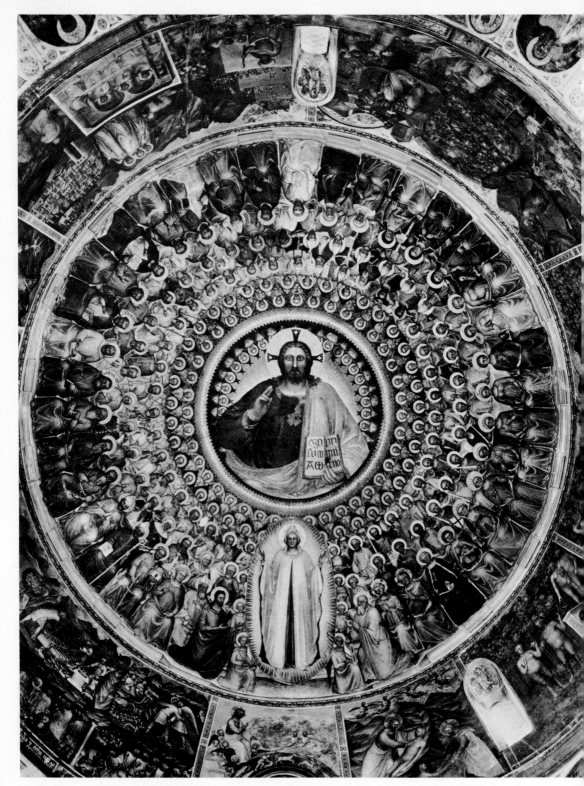

183. GIUSTO DE' MENABUOI: Fresco on the vault of the Baptistery, Padua Cathedral